GETTING IT PRINTED

GETTING IT PRINTED

(Revised Edition)

Mark Beach

ABOUT THE AUTHOR

Mark Beach's books are used for corporate training throughout the graphic arts industry and as required texts in over one hundred colleges and universities. In addition to the first edition of this guide published in 1986, titles include *Editing Your Newsletter* (1980, 1982 and 1988), *Papers for Printing* (1989 and 1991), *Graphically Speaking* (1992), and *Newsletter Sourcebook* (1993). Mark is a technical writer who lives on the Oregon coast.

Getting it Printed. Copyright © 1986, 1993 by Mark Beach. Printed and bound in the United States of America. All rights reserved. No part of this book may be reproduced in any form or by any electronic or mechanical means including information storage and retrieval systems without permission in writing from the publisher, except by a reviewer, who may quote brief passages in a review. Published by North Light Books, an imprint of F&W Publications, Inc., 1507 Dana Avenue, Cincinnati, Ohio 45207. (800) 289-0963. Revised edition.

Other fine North Light Books are available at your local bookstore, art supply store or direct from the publisher.

99 98 97 96 95 7 6 5 4 3

Library of Congress Cataloging in Publication Data

Beach, Mark.

Getting it printed / Mark Beach - Rev. ed.

p. cm.

Includes index.

ISBN 0-89134-510-8

1. Printing. Practical-United States. 2. Graphic arts-United

States I. Title.

Z243.U5B4 1993

93-14534

686.2-dc20

CIP

Designed by Clare Finney

North Light Books are available for sales promotions, premiums and fund-raising use. Special editions or book excerpts can also be created to specification. For details, contact the Special Sales Manager, F&W Publications, 1507 Dana Avenue, Cincinnati, OH 45207.

Four experts studied the entire manuscript shortly before I completed the final draft. Their extensive experience in the graphic arts industry and careful attention to detail made this a much better book. Bill Langenes, of Portland, has directed marketing programs for several companies in the computer industry; Jon Motschall manages Motschall Printing in Detroit and teaches print production at universities in the United States and Canada; Kathleen Ryan is production manager for Elk Ridge Publishing in Manzanita, Oregon; Bob Shaw supervises the graphic arts program of Chemeketa Community College in Salem, Oregon.

The illustrations were drawn by Steve Cowden using Aldus FreeHand 3.1. Before joining the art department of *The Oregonian* newspaper in Portland, Steve graduated from the graphic design program at California Polytechnical University in San Luis Obispo and worked for the *Orange County Register* in Santa Anna, California. Steve's designs and infographics have won numerous awards throughout the newspaper industry. Photos and additional art by Kathleen Ryan, Mark Beach, Cherry Britton, Ken Russon, and courtesy of Graphic Arts Technical Foundation and Macbeth Company, as noted in their credit lines.

My associates in the graphic arts industry throughout the Northwest always answered my questions clearly and eagerly and, for good measure, added insights that enriched my writing.

At Portland area printers, I want to thank Stacey Bailey, Jack Derderian and Kurt Klein, Graphic Arts Center; Marilyn Riggs and Matt Fishback, Irwin Hodson Printing; Mike Basinger, Printek West; George Cattello and Kathy Wheeler, Western Computer Press; Linda Meinig, Rono Graphic

Communications; and Jill Wilbur, Wilkes Printing. Special thanks for clear answers, good cheer and convenient service go to Dave Hancock, Ron Laster and Tim Sheller at PIP Printing who have helped me produce manuscripts and printing for almost ten years.

At Portland area service bureaus and other graphic arts businesses, I want to thank Terry Bieritz, Sequent Computer Systems; Eric Kenly, Precision Imagesetting; Renee Leduc, Agency Litho; Doug Carr, Trade Litho; Verni Moore and Humberto Reyna, Qualitype; Rich and Lynn Sanders, L Graphics; Bob Bengtson, Lincoln and Allen Bindery; Kassia Dellabough, University of Oregon Desktop Publishing Center; Karel Shaw, Reed Harris Mailing Services; and Jack Holmes, Unisource Paper.

In the Seattle area I appreciate the help from Michael Bunch and Nick Allison, Aldus Corporation; Julia Dill, R R Donnelley & Sons Printing; Nathan Everett, The Dotson Institute; Jim Olsen, Pacific Printing Industries; Joy Ulskey, Microsoft Corporation; and Connie Sidles.

Elsewhere in the nation I got encouragement and technical information from Peter Brehm, Graphic Communications Association, Alexandria, Virginia; Brian Lawler, San Luis Obispo, California; Charles Seelig, The Sheridan Press, Hanover, Pennsylvania; Gail Cotton and Ray Roper, Printing Industries of America, Alexandria, Virginia; Frances Tuffy, Advanced Holographic Laboratories, Santa Fe Springs, California; Dick Gorelich, Graphic Arts Sales Foundation, West Chester, Pennsylvania; Terry Nagi, Washington, D.C.; George Platt, Harty Press, Hartford, Connecticut; Barbara Smyth, Apple Computer, Cupertino, California; and John Coburn, Screen Printing Association, Fairfax, Virginia.

CONTENTS

Foreword: "At the Printer's Knee" by John McWade vii

Introduction 1

ONE PLANNING FOR RESULTS 2

Precision planning 3
Timely scheduling 5
Optimal quantities 5
Compelling quality 6
Matching cost and value 8
Involving your printer 8
Managing production 9
Job coordinators 10
Working with suppliers 11

TWO USING TYPE AND GRAPHICS 12

Type sources 12
Fonts and faces 14
Measuring type 17
Ensuring type quality 17
Rules 17
Reverses 18
Screen tints 18
Illustrations 22

THREE MASTERING COLOR 24

The language of color 24 Flat and process color 26 Color reference systems 28 Ensuring color quality 32 Using proper lighting 34

FOUR CONTROLLING PHOTOGRAPHS 36

Black-and-white photos 38
Halftones 38
Duotones 43
Color photos 44
Separations 45
Process color printing 45
Tone compression 47
Taking advantage of ganging 50

FIVE PREPRESS, PROOFS AND PLATES 52

Creating mechanicals 54
Preparing photographs 55
Process cameras and imagesetters 57
Stripping film and flats 60
Proofing methods and materials 62
Proofs costs and brands 68
Making printing plates 69
Saving mechanicals and film 70
Prepress and imaging services 72

SIX PAPER FROM PULP TO PRESSROOM 74

How mills make paper 75
Paper grades, ratings and brands 77
Samples and dummies 79
Printer/merchant relationships 82
Reducing waste and spoilage 83
Surface, color and weight 84
Bond and writing 89
General purpose offset 93
Luxurious text 94

Sophisticated coated 95 Sturdy cover 99 Miscellaneous grades 99 Respectable recycled 100 Specifying paper 102

SEVEN OFFSET PRINTING 104

Best for most jobs 105
Press components 107
Press types, sizes and features 108
Quality expectations 111
Correct register 112
Ink density 114
Conquering dot gain 117
Miscellaneous quality problems 117
Industry quality guidelines 122
Printing inks 122
Special inks 123
Protective coatings 123
Successful press checks 125

EIGHT OTHER PRINTING METHODS 128

Photocopy and laser 130
Ink jet 131
Flexography 131
Screen 133
Gravure 135
Engraving 137
Thermography 138
Letterpress 138
Die-cutting 139
Embossing and debossing 140

Foil stamping 141 Holography 142 Costs and availability 142

NINE FINISHING AND BINDING 144

Cutting and trimming 145
Drilling and punching 146
Scoring and perforating 146
Folding 147
Collating 149
Common bindings 149
Selective binding 156
Converting 156
Packing 156
Final counts 158
Storage and transit 159

TEN WORKING WITH PRINTERS 160

Your regular printers 161
Occasional printers 162
Specialty printers 163
In-plant printers 164
Locating printers 165
Evaluating sales and service 166
Requesting estimates 167
Evaluating quotations 168
Interpreting alterations 170
Negotiating problems 171
Clarifying trade customs 175

Glossary 177 Index 195 by John McWade

I took art in college, but my real start in the business was working for a printer. Dynagraphic was the hot shop in town. Don Landek hired me to do pasteup, the kind of artwork a printer did. Real art came from creative agencies. We were pinch hitters, the subs. We did the quick, cheap stuff—business cards, fliers, class reunion brochures—for clients who didn't like, couldn't afford or hadn't the time for agency work, and often for clients who just walked through the door. In a room the size of a big closet, we had an IBM Selectric Composer, some clip art books, a supply of rubdown lettering and a stat camera with a vacuum motor loud enough to scare burglars.

It was great! There was plenty of pressure and miles of creative leeway. Clients were not especially fussy, which meant that they accepted our design "experiments" more often than not. The company soon entrusted us with jobs that real agencies would ordinarily have done. (When I say "we" I'm talking about my wife and me, except that we weren't married yet.)

Right from the start, we were immersed in the world of printing. Russ and Gene, the sales guys, actually took the time to explain what a client wanted, which means they had taken time to listen. Conrad, our chief stripper, taught us what the press needed. He was as close to a mentor as we had. From him we learned about film and cameras and chemicals and imposition and trapping and dot gain and things like "flash" and "bump." To Conrad, fine craftsmanship was the signature of a professional. It meant quality work when no one was looking or paying for it.

Don ran the shop, although his first love was art. He liked our work and tolerated our mistakes. Dave, the chief pressman, was just amazing, printing saturated, full-color jobs on a one-color press. His trademark was the use of almost no ink. The drier he got the press, the

more brilliant his colors became. At the time I didn't know this was unusual. Twenty years later I've never seen anything like it.

In this baptism, printing became our native tongue. We saw how the gears fit—how sales affected design affected stripping affected printing affected binding—and how a good team compromises, experiments and adjusts. It became as natural as breathing to regard design and printing as two peas in the same pod.

Only after I was out on my own did I encounter pure, school-trained designers, an airy breed who, to my complete astonishment, didn't have a clue how a job actually got printed. They often didn't care, either. Some couldn't be bothered. Others didn't get it. The worst concealed their ignorance by dismissing printers as mechanics ("Don't tell me what's wrong with it, just make it run!").

Printing doesn't work that way. It is a unique craft, part locomotive, part ballet. Not merely a machine, the printing engine is driven by artwork, the makeup of which determines the levers and switches that a printer throws to run the mill. Your art is his blueprint. If it's ambiguous or wrong, you must do it over. Once six tons of steel are in motion, things don't change direction easily.

Nothing shows off fine printing better than beautiful design. But a printing press is heavy metal. Respect that. If you don't understand for sure what to do, ask your printer now. You'll learn. You'll also find printers an unpretentious lot—skilled, sensitive and invaluable partners in making real what you dream up.

©1993 John McWade, Used by permission.

In 1985, John McWade founded PageLab, the world's first desktop publishing studio. He designs and publishes **Before & After: How to Design Cool Stuff**, a magazine that pushes the envelope of graphic communication using computers. 1830 Sierra Gardens Dr., Suite 30, Roseville, CA 95661. Phone 916-784-3880.

.....

Producing a printed product blends art, craft and industry. Effective layout requires artistic vision; proper preparation and presswork call for skilled crafting; timely production demands industrial efficiency. In this book you learn the technical and business requirements needed to make this blend work for you.

This guide helps everyone who plans, designs or pays for printing:

- Sales and customer service reps for printers, paper merchants and imaging services.
- Designers, photographers and illustrators who create graphic communications.
- Production managers for agencies, studios and corporations.
- Public relations and marketing professionals who rely on newsletters, brochures, directories or annual reports.
- Writers and editors who produce books, magazines, catalogs or manuals.
- Teachers, trainers and consultants who explain how to get the most out of printing equipment, materials and processes.

The skills you build using this book increase your control throughout the production sequence. And you improve communication to produce more satisfactory results, on-time deliveries and lower costs.

With almost thirty thousand commercial and eighty thousand in-plant shops, printing is one of the nation's most widely dispersed industries. From the standpoint of the customer, the variety and number of printers have both pros and cons. On the positive side, printers compete for your business. Shopping pays. On the negative side, it is often hard to judge which printer is right for which job and even harder to know when a printer gives reasonable quality at a fair price. In this guide you discover how to find the right printer at the right price for each job.

Chapters in this book follow the sequence of typical printing jobs from idea through delivery.

You'll find information presented in several ways in addition to text:

- Illustrations, examples and photographs convey concepts that seem most understandable in a visual format.
- Forms help you pinpoint needs and record individual information.
- Checklists relate to quality standards and help you spot problems with items such as mechanicals and transparencies.
- Charts present data that allow for easy comparison when planning or shopping for prices.
- Anecdotes capture the creative flavor of the graphic arts.

For ease of reference, the text refers to all illustrations, forms, checklists, charts, examples and photographs as "visuals." Each visual is numbered by chapter and sequence. For example, Visual 5-5 is the fifth visual in chapter five.

A few graphic arts terms, such as "keyline," have different meanings in different parts of the country. In addition, some terms, such as "reverse," that have technical meanings in the graphic arts have other, nontechnical meanings. I limited each term to only one meaning, as defined in the glossary, and avoided using a word in any sense other than its technical one.

Thank you for buying this book. I hope that it helps you with all your printing jobs. If you find ways to make it more useful, please write to me in care of the publisher.

Mark Beach January 1993

1. PLANNING FOR RESULTS

Precision planning
Timely scheduling
Optimal quantities
Compelling quality
Matching cost and value
Involving your printer
Managing production
Job coordinators
Working with suppliers

Whether you are a customer of a printer, a graphic arts professional or both, planning even the most simple printing job requires many decisions. Complex projects may demand hundreds. Each decision affects all the others in the sequence from concept to finished product.

Careful planning helps you control the quality, schedule and cost of printing jobs. Planning leads to a vision of the final product and results in clear communication among people involved in production. And planning helps you avoid costly changes made after production begins.

Decisions about printing jobs involve both business and technical information. This chapter focuses on business considerations as a framework for technical decisions. You'll learn how to answer the key questions found on the opposite page and why the success of your printing job depends on your answers. You'll meet the graphic arts services most commonly used to coordinate printing jobs.

This chapter also introduces four categories of printing quality. I refer to these categories frequently throughout this book and summarize them in chapter seven. The categories of quality are used to classify printing, not to judge it. Controlling costs and schedules includes selecting which quality category is appropriate for each specific job.

PRECISION PLANNING

Getting printing done at the quality level you want and within your budget and schedule calls for answers to eleven key questions. Details emerge as plans develop, but the general outline applies to all projects.

What is your purpose?

You may want to entertain, inform, sell or inspire. Maybe your product is for keeping records, impressing clients, recruiting members or gaining customers. Goals help you answer questions about design, quality, quantity and cost. For example, a brochure to build membership in a trade association might include a postpaid response card.

Who is your audience?

You may want to reach customers, members or employees who already know you, or people who have never heard of you. Your readers may be old or young, men or women, active or sedentary.

As you define your audience, think of traits that affect design. A poster advertising a concert may look very different from one announcing a lecture. If your average reader is older than forty-five, consider how type size affects legibility.

Thinking about your audience and the impression you want to create suggests the

quality you need. Engraved, watermarked stationery may seem pretentious. If you are an aspiring doctor, however, a quick-printed letterhead might encourage patients to think speed is your approach to surgery, too. Your printed products should be consistent with the best standards that your clients, customers or members expect from organizations similar to your own.

What text and graphics will your piece contain?

Try to imagine the ideas you need to communicate. Take plenty of time to test your ideas on typical readers.

Poor writing and editing can ruin a printed piece as easily as poor design. Equally important, generous use of a delete key or red pencil cuts production costs faster than any other tool. Every word, sentence or paragraph eliminated saves on paper and printing.

How will your piece look?

Even in the earliest phases of planning you have some ideas about the right mix of type and visuals. You imagine a handsome annual report, efficient form or enticing catalog. You have in mind a size and approximate page count. Knowing your goals, audience and budget shapes your vision.

Your concept of yourself, your business,

1-1 BASIC PLANNING QUESTIONS

Regardless of your printing job, answers to the following key questions help you control costs, ensure quality and stay on schedule.

- What is your purpose?
- Who is your audience?
- What text and graphics will your piece contain?
- How will your piece look?
- How will readers use your printed product?

- How will other businesses work with your product?
- How will your piece reach your audience?
- When do you need the job delivered?
- How many pieces do you need?
- What quality do you need?
- How much can you spend?

1-2 POST OFFICE PROBLEMS

You cannot plan too carefully whenever you plan to mail your printed piece. The U.S. Postal Service has hundreds of complex definitions, categories and rules that affect every aspect of your printing job. Consider the following examples:

Content. To qualify for second-class rates, publications must include a specific percent of space devoted to advertising.

Design. Copy on the address panel must remain a specific distance from each edge.

Format. Pieces that qualify as "letters" cost less to mail than those considered "flats."

Size. Postcards, letters and flats all have minimum and maximum dimensions.

Paper. Stock for business-reply cards must measure at least .007 inches thick.

Printing. The contrast between ink and paper must meet standards.

Folding. Folds must face specific directions, depending on format.

Packing. Pieces bundled and put on pallets according to guidelines qualify for lower rates.

Before making any decision about design, show a dummy to a postal official. Ask for a signature affirming that it meets the standards of the class of mail you have in mind. Make sure that the official who signs your mockup works at the post office where you plan to mail.

organization or client also affects design. Should your audience perceive you as dignified or informal, conservative or speculative? Do you offer products, sales or services? Answering questions such as these helps stimulate the creative processes of writing and designing. The answers also influence decisions about ink colors, papers and printing quality.

How will readers use your printed product?

People read books gradually, but signs at a glance. Readers sort quickly through newsletters and direct mailings, more slowly through brochures and catalogs. A menu must have strength at the fold, resist spills and greasy fingers and be readable in low light.

Thinking about use includes considering life expectancy. You may use one loose-leaf binder only during a weekend workshop, while another must last years as a reference tool. If your catalog must serve two years, consider a separate price sheet that you can change every few months.

How will other businesses work with your product?

Printed pieces often coordinate with other products and services. Labels must fit bottles, and instruction sheets fold to fit boxes. Show a dummy to people who will handle your piece to verify that it meets their needs.

Printing customers often run into problems when they take products to mailing services. Machines for folding, inserting, addressing and sealing may not handle the pieces. If you are managing printing for direct-mail advertising, go out of your way to coordinate carefully with your mailing service before deciding about design.

How will your piece reach your audience?

Perhaps the message goes into an envelope with other printed pieces such as a business-reply envelope and flier. If so, you may need matching papers and coordinated sizes.

Some products need special packaging. Books with plastic comb bindings must be alternated within boxes. Wrapping must protect paper goods from moisture. If the standards of your industry are to ship in dozens, tell your printer to pack in boxes with twelve, twenty-four or thirty-six units.

Consider box weight and size. Materials for common carriers and mailing must conform to requirements for size, shape, weight, folds, colors and seals.

TIMELY SCHEDULING

Most printing customers feel more stress about meeting deadlines than about controlling costs or maintaining quality. Fast turnaround gets top priority. But customers often don't allow enough time. Some imagine that commercial or specialty printing takes only a little longer than quick printing.

A routine job at a commercial print shop typically takes about ten working days. Time starts when you deliver mechanicals. Writing, editing, design and approvals can add another two to six weeks before that. For complicated jobs and when things go wrong, these times can easily double.

When do you need the job delivered?

A printer's ability to deliver on schedule depends on many factors. You control some of them: submitting mechanicals on time and according to specifications; reading proofs promptly; keeping alterations to a minimum; and handling payments as agreed. Printers control others: scheduling jobs through various departments; ordering papers and inks early enough; and maintaining good business relationships with prepress services, binderies and other subcontractors. Sometimes fate steps in: The printer's number one account demands priority press time; blizzards block all roads from paper mills; or proofs show a photograph featuring an employee who just got laid off.

Printers constantly juggle jobs within the shop to assure efficient use of machines and people. Good customers may get priority, but "first in, first out" proves a good rule of thumb for most shops.

Realistic scheduling demands honesty

between you and your printer. If your originals may arrive late, say so. If you can accept a partial shipment, don't insist on full delivery; if Monday morning is soon enough, don't insist on Friday afternoon.

Keep in mind how delivery methods affect schedules. Mailing services require two or three working days to address, bundle and deliver to the post office. First-class mail takes another two or three days to reach readers, but third-class mail may require two weeks. Figure in weekends and holidays, too. U.S. mail moves at least a little bit every day of the week, but some commercial carriers work only five days.

To stay on schedule, set your final deadline in consultation with your printer and then stick to deadlines that apply to you. For every day you are late with mechanicals, expect your printer to delay delivery by at least one day. If you miss deadlines, your printer may rush too fast to achieve the quality you want. Or you may have to pay for overtime.

OPTIMAL QUANTITIES

Wrong decisions about quantity result in higher costs.

If you order too little, you pay for reprinting sooner than necessary. Because of additional setup charges, going to press a second time makes unit costs higher than printing all you need in one run. Also, unit price goes down as quantity goes up, so one large order costs less per piece than several small orders. For example, 5,000 maps might cost \$2.75 each if run all at once. Printing 3,000 now and 2,000 later might increase the unit cost of the entire 5,000 to \$3.90.

"We worked much better with printers after we wrote a profile of our printing needs. We described the jobs we need printed and explained how often, how many, how good and how fast we need them. Instead of printers sending samples to us, we sent samples to them. The shops that we work with understand us much better now than before."

If you order too many, you pay for printing and finishing on paper that you may never use. Generously estimating needs might save money, especially because next year printing will probably cost more than this year. Yet today's cost of the job is important. Large quantities are wasted if new information makes your piece obsolete or your market turns out smaller than anticipated. Cash tied up in printed inventory might be better invested elsewhere.

How many pieces do you need?

To help decide about quantity, ask people who will use the product for their best guess about how many they need. Remember to account for damage during packing, transit or storage. Keep in mind circumstances that could mean needing either more or less than seems like enough today. Finally, get prices for printing two or three quantities greater than your immediate needs. You might discover a price break, a number over which unit costs drop significantly. See Visual 10-4 for guidelines

about selecting quantities when you solicit quotations.

Stay conservative. More customers regret having too many than wish they had more. A year's supply of most products is plenty. You might revise new forms in two months; established forms might become obsolete in six months.

Although the matter of quantity may seem largely guesswork, it does have a bright aspect. Once you make the guess, you can express it clearly. No one should feel confused when you state the number you want. But be careful. Most printers follow the trade custom allowing 10 percent over or under production on jobs up to 10,000 units. If you need 1,000 folders and won't accept less, make this requirement clear when you place your order.

COMPELLING QUALITY

The market for printing ranges from simple, black-only fliers and forms to complicated, full-color books and art reproductions. Few printers, however, produce jobs spanning the

1-3 HOW TO CUT PRODUCTION TIME

Copyfit. Write and edit so that copy fits your layout the first time.

Simplify. Use fewer typefaces, photos and ink colors.

Standardize. Stick with conventional sizes and formats.

Avoid alterations. Get mechanicals and specifications right the first time, then resist the temptation to make improvements.

Exploit technology. Output at low resolution, transmit at night via modem, send change orders by fax.

Reduce buyouts. Keep the job under one roof and in the production sequence of one business.

Lower quality. Give up the goals of inspired prose and perfect colors. Just get

the job done.

Expedite approvals. Reduce the number of people who review copy and proofs.

Be clear. Use correct terms and symbols. Avoid confusion.

Cut dead time. Eliminate days that a job waits on a desk for approval, on a pallet for binding, or on a dock for delivery.

Speed delivery. Pick up the job today instead of waiting for tomorrow's delivery; pay for partial shipment via fast carrier.

Shop for speed. Find designers, prepress services and printers whose schedules can accommodate your rush work.

Pay for speed. Tell your printer that you have a tight schedule and need rush service.

entire range of quality levels. Most printers limit themselves to working within one or two quality categories.

What quality do you need?

Because the range of quality among printed pieces and printers is so great, planning requires decisions about how good the product must be. Customers who know exactly what quality they want can plan realistic schedules and budgets and select printers who can produce the work properly.

Throughout this book you encounter four categories of quality that help you identify specific quality features of printing jobs. The categories are defined here and the definitions refined in many other places in the text. Visual 7-9 gives details about ten features of each quality category.

Basic printing. Basic quality involves standard materials and quality control at quick printers. It gets the job done reasonably well without losing content. Basic quality pieces are usually in flat ink colors only, not four-color process. Photographs are recognizable, but may lose details from the originals. Political fliers, business forms and newsletters are usually printed basic quality.

Good printing. Good quality printing involves standard materials and quality control at commercial and publications printers. Colors are strong, color photos pleasing, black-and-white photos sharp, register tight but not perfect. Average direct-mail catalogs, most hardcover books, retail packaging, magazines such as *Time* and *Newsweek*, and this book show good printing.

Premium printing. Premium quality requires careful attention to detail and high-grade materials. Color photographs seem to match transparencies and black-and-white photos appear very sharp. Products have few flaws and seem almost perfect to people who are not graphic arts professionals. Many commercial printers do premium printing when schedules and budgets permit. The category

"We designed a fantastic calendar that all our outlets could imprint and mail to their customers, then went crazy trying to find square envelopes to match. Finally we had to have the envelopes custom made. It cost us two fortunes—one for the custom envelopes and one for the rush service. Next time we'll design envelopes at the same time that we plan calendars, not as an afterthought."

includes upscale clothing catalogs, most annual reports, and magazines such as *Communication Arts* and *National Geographic*.

Showcase printing. Showcase quality printing combines the best machines and materials, and operators who give scrupulous attention to detail. Everything from design to paper is first class. Color photos come as close as possible to matching products or original scenes. The category of showcase printing consists of products which themselves are forms of art that only a few printing buyers can afford or printers can achieve. It includes museumgrade art books, brochures advertising very expensive automobiles, and the finest annual reports.

Each printing job has its own appropriate quality level. You have no reason to take a simple catalog to a printer specializing in showcase quality annual reports or to pay an award-winning graphic designer to coordinate basic quality printing. Use this system of quality categories to help you decide what level of printing you want, select printers who can produce to that standard, and keep materials and production skills consistent throughout the job.

The four quality categories classify printing; they neither criticize nor praise it. Criticism is reserved for the printer who promises work to a certain standard, then doesn't produce it, praise for the printer who honestly describes what the shop can make, then delivers exactly what you expected.

Keep all components of a printing job, such as type, paper, print quality and design, within the same category of quality. Components below the average quality level for the job drag down the others; components above average don't look as good as they should and so waste time and money.

Consider a poster that includes photographs from top professionals who planned their work to appear on premium paper. Using ordinary paper is false economy because it doesn't reflect the quality of the photos. It makes sense in this instance to use a premium paper and to work with a printer who has precision equipment.

Quantity needs, costs and deadlines, as well as quality requirements, affect which printers are right for your job. The poster could be printed to the same quality by a small, medium or large commercial printer. The small printer might give the best unit price for 2,000 posters, the medium-sized printer prove most efficient for 10,000, and the large printer best for 50,000. The printer with the lowest price, however, might struggle to get the job done on time.

MATCHING COST AND VALUE

Many professionals approach budget planning by estimating how much the job is worth to them when properly done. A brochure that sells \$30,000 cars is worth far more than one that sells \$30 books. Even if the job you have in mind doesn't lead directly to financial profit, you hope it produces specific results. You must decide how highly you value those results and what you are willing to pay to achieve them.

"I was supposed to make our newsletter look better, but didn't know how. I'm a good secretary, but not an artist at all. Someone in marketing helped me persuade my boss to let me hire a graphic designer. The designer made us a nameplate that we preprint for color and helped us negotiate an annual printing contract. Maybe most important, she devised a format that fit my word processing program and looks great off my laser printer. With her professional help our newsletter not only looks better but gets done faster and costs less. What a relief!"

How much can you spend?

During early planning, it may be impossible to say how much you will spend for a specific job. It should be possible, however, to develop some rough estimates. Experience with previous jobs and knowledge of local rates help you make educated guesses about the cost of many products.

It's easy to underestimate the cost of design and other work done on a project long before it gets to the printer. Don't overlook the cost of writers, photographers and illustrators when computing the total cost of the job.

Experienced printing buyers keep budgets in perspective by thinking about fixed and variable costs. Fixed costs stay the same whether you print one copy or one million and include design, typesetting and printer preparation. Variable costs include the prices of paper, press time and bindery operations that go up or down as quantities change.

Consider fixed costs when determining unit price. For example, \$1,000 for a nameplate design to appear on 1,000 monthly newsletters means the nameplate costs a dollar per copy for one month. Putting the same nameplate on 50,000 newsletters cuts the unit cost to two cents. The design that seemed a luxury for 1,000 copies becomes a bargain for 50,000.

Considering the value of your time and the unit cost of your piece leads to an approximate budget for a job. To produce a small book, for example, might take you twenty hours a week for a year, including writing, and cost \$2.00 per unit for paper, printing and binding. Your cost for 1,000 books is \$2,000 plus the value of about 1,000 hours of your time.

INVOLVING YOUR PRINTER

For any but those jobs you consider routine, talk with a printer as early in the planning as possible. When planning a large or complicated job, consult with more than one printer.

Discussing possible jobs with you is part of a printer's marketing. Describe your needs and ask whether the shop can produce your piece practically. Consider suggestions about alternate papers, formats and other ideas about how to save time and money. A printer may even find ways to do the job better and cheaper than you thought possible.

When talking with a printer, try to have a mock-up to help visualize the final printed piece. Depending on your experience and planning needs, the dummy might be anything from a simple thumbnail rough to a comprehensive layout that looks much like the final product. The printer can use the dummy as one basis for estimating cost. When a printer makes a dummy for you, or gets one from a paper merchant, it costs you nothing and may save you thousands.

You can make a dummy showing bindery needs by folding one or two sheets of paper to simulate the format you want. On larger jobs, such as books and annual reports, a paper distributor will assemble and bind a dummy to your specifications. If you need a dummy of pages, 8½" x 11", 60# ivory vellum, perfect bound with a 10-point cover, ask for it from your printer or paper representative.

Comprehensive layouts, known simply as "comps," tell the printer precisely how you expect the job to look. You can make comps with colored markers or transfer lettering or using a color computer printer or photocopier.

Dummies and comps help printers think about practicalities such as ink coverage and accuracy of folding. A printer looking at exactly what you have in mind may suggest printing smaller solids or point out that borders may not line up properly when sheets are assembled.

As you look at a dummy with a printer, some specifications are clear in your mind. You probably know at least how many copies you want and when you need them. The printer's comments help pin down other facts, such as what kind of paper you need. When discussing ink colors, both you and the printer should refer to a color matching system, as described in chapter three.

To get the quality you want, tell the printer

what you expect. If you demand close register and vivid colors, say so. If you wonder about the printer's ability to hold shadow details in photographs, ask. Also ask for examples of the printer's work that are similar to your job. Study them carefully, knowing that they represent the shop's best work, not its average.

MANAGING PRODUCTION

Getting printing done at the right quality level, on time and within budget requires careful supervision of each step of the process.

If you're like most printing buyers, you have several projects—perhaps lots of projects—happening all at the same time and all in different stages of production. Each project involves three or four people at each stage, so you coordinate the work of dozens of professionals every day. To make matters even more complicated, projects range from simple business forms or newsletters to complex catalogs or posters.

Many people working on projects that you coordinate know more about the specifics of the printed piece than you do. You build effective working relationships by treating them as colleagues, not subordinates or vendors. Try to help others focus on the writing, design or production that forms their piece of the puzzle. When you concentrate on setting schedules, defining quality and controlling costs, you act like a coach, not a supervisor.

Print production managers often get locked into schedules that describe each stage of the project, which moves in a predictable lockstep from editorial to design to prepress to printer. Whether schedules come from in-house conventional wisdom or the latest version of jobtracking software, they often hurt more than help. Creative people don't work on schedule, nor do supervisors give approvals on schedule. Even more important, new production methods—software, networks and machines—constantly shift the relationship of people and activities in work groups, making schedules obsolete.

To keep your jobs on schedule, plan backward from the deadline, not forward from the starting date. Tell everyone when you need the job delivered, then let them help decide intermediate deadlines for the specific project.

JOB COORDINATORS

If you lack time or skill to coordinate a printing job, the graphic arts industry has several categories of professionals who can do the work for you.

Printers

Most graphic arts specialties, such as design and illustration, were once handled exclusively by printers. Many printers still offer these services in addition to printing. Printers who offer in-house design can often produce the entire job, starting with your rough copy and thumbnail sketch. Some printers subcontract certain steps in the production sequence. They may rely on other businesses for separations and bindery work. They may even subcontract printing itself instead of working overtime or running a job on an inefficient press.

A few printers build their businesses around the concept of full service. They begin a job when it's only an idea and take it all the way through writing, photography, design and production. Some full-service printers also handle distribution and maintain mailing lists.

Dealing with a quick printer means working with customer service staff "over the counter." Dealing with a commercial or specialty printer means working with a sales representative or printing broker.

Printing brokers

Printing brokers coordinate printing jobs at many different printers. Unlike brokers in many other fields, printing brokers take their fees from the buyer, not the seller. Their profit comes from markups added to the cost of printing.

Brokers shop for printing just as you would if you had the time, skill and network of contacts. They may deal with trade printers who do not have sales reps and specialty printers located at great distances. They often get discounts based on high volume. As a result, brokers may get jobs done faster and for less money than you could.

If your department or organization spends at least \$50,000 per year on printing, you may find that working with a broker saves you time and money. A broker probably worked for a

1-4 COMPLETING THE JOB

Don't let the press of tomorrow's job keep you from completing today's project. Take the following four steps to help you, and others who follow you, produce the job next time or work with the same printer again.

- 1. Compare bills of lading and invoices with specifications and change orders. Note whether the printer delivered on time and the correct quantity. Are you satisfied with quality?
- 2. Use Visual 10-6 to analyse the invoice before approving payment.
 - 3. Verify return of all materials relating to

the job and make a written record of their location:

- mock-ups and dummies
- hard mechanicals
- photos and illustrations
- electronic files
- all proofs, press sheets and finished samples
- specifications and change orders
- 4. Write down anything about the job that would make it cost less or proceed more efficiently next time.

few years for a paper merchant, ad agency or variety of printers, whereas a sales rep probably has worked with just one or two printers. For that reason, you can use a broker to handle all your printing needs. To accomplish the same objective through sales reps, you might work with six or eight printers.

Advertising agencies

An ad agency builds an overall plan that may range from corporate logos to television commercials, then carries out the plan by contracting with media and producing messages. Clients hiring an agency may assume the campaign will involve some printed products but may have no specific ideas in mind.

Not all ad agencies deal knowledgeably with printing. Some specialize in broadcast media and others in public relations. If you have printed pieces in mind as part of your ad campaign, make sure that the agency you are considering has experienced printing buyers.

The staff at ad agencies that handle a lot of printing includes copywriters, graphic designers, production artists and at least one person, the production manager, who works with printers. In addition, ad agencies subcontract a great deal of work to freelance specialists.

Graphic designers

Graphic designers build on ideas from customers to create printed messages. The "graphic" part of graphic design refers to art that communicates, the "design" part to planning for production.

Designers subcontract for services and pass the charges on to clients along with a markup. Often, however, designers stop short of contracting for the printing itself. Few design studios have sufficient cash flow to broker major printing jobs; most prefer to have the customer contract directly with the printer.

If you coordinate printing for yourself, insist that your graphic designer and printer consult with each other. Unless you have agreed differently, your designer's responsibili-

ty stops when you accept mechanicals or disks. To assure appropriate quality at reasonable costs and to keep alterations to a minimum, the designer must know specifics about the prepress, press and bindery requirements of the printer.

WORKING WITH SUPPLIERS

People in your industry can recommend local brokers, ad agencies and designers. So can sales representatives for printers and graphics consultants for paper distributors. Because these people routinely call on agencies and designers, they can recommend services suited to your needs.

Hiring expertise in design and production does not exempt you from planning. To get the best work from designers and agencies, you must explain your goals and audiences and give them rough ideas about format and budget. If the people who want your business don't ask you planning questions, ask yourself how helpful they can really be. On the other hand, don't waste their time and your money because you have no idea what you want. Describe what you consider appropriate quality by showing samples you find satisfactory.

Accountability for the accuracy of final copy lies with you. Conscientious professionals ask clients to approve all proofs. An agency, broker or graphic designer should show bluelines and other proofs and ask you to sign just as a printer would.

Printers claim that some buyers don't pay enough attention to price, so printing jobs cost clients more than necessary. If someone else buys your printing, you should occasionally ask to see job specifications, quotes and other evidence that they keep costs competitive.

Working with a creative or production service increases the complexity of electronic interfacing. Before entering production, verify that all the computers and printers that you believe can work together actually can. Don't hesitate to run several tests before signing a contract.

2. USING TYPE AND GRAPHICS

Type sources
Fonts and faces
Measuring type
Ensuring type quality
Rules
Reverses
Screen tints
Illustrations

Printers think of the visual elements of printing jobs as either line copy or continuous-tone copy. Line copy is high contrast, usually black on white. It includes all type, rules and many illustrations. Continuous-tone copy has dark and light areas but also has many intermediate shades of gray. It includes all photographs and some illustrations.

The fact that you can choose from many typefaces, sizes and styles while using a computer may tempt you to use many fonts within a publication or different fonts for each new project. Resist that temptation. Stick with type that works for your designs on your blend of hardware and software. Remember that your audience wants communication, not novelty.

Using familiar type cuts costs and helps you meet deadlines, so it helps production as well as design. When everyone from writer through designer to prepress uses tested materials and procedures, you ensure both accuracy and speed. Relying on familiar fonts is especially important when you supply copy on disk or other electronic medium.

TYPE SOURCES

For hundreds of years, typesetting was exactly what the name implied. Printers set individual wooden or metal blocks with raised letters next to each other in a tray, called a galley. Blocks with no letters yielded spaces between words; thin strips of lead separated one line of

words from the next. The first sheet printed from the finished assembly was the galley proof.

There are four kinds of type commonly used in printed products. Which kind works best for a specific job depends on needs for quality, speed and economy.

Transfer lettering

Also called rub-on or press-on, transfer lettering offers the greatest range of typefaces for the least money when making headlines, advertisements and other copy with only a few large words. Materials are simple to use, and you can enlarge them up to 200 percent without losing sharpness. For best results, use transfer sheets within a year of purchase.

Dot printer

Many computer printers form characters from dot patterns. Tiny needles in a dot matrix printer create the pattern as they strike a ribbon. Tiny drops of ink from an ink jet printer create the pattern as they hit the paper.

The pattern of dots may look either loose and washed out or tight and dense, depending on its resolution. Dot resolution is expressed in numbers of dots per inch horizontally and vertically. A resolution of 90 dots per inch (dpi) makes characters of the quality often seen on paychecks and address labels. As resolution gets higher, image quality goes up and the output speed goes down.

The paper used in a printer influences the legibility of dot type when reproduced. For

2-1 BASIC TYPE FONTS

Art applied to letterforms is as ancient as writing itself. Today there are over five thousand published typefaces. The huge variety of fonts and almost infinite range of sizes, however, often leads to typography that confuses instead of communicates.

You can design almost any publication by selecting from a handful of type families that you know well. Here is a basic list.

- One sans-serif family such as Helvetica, Futura or Avant Garde. Use fonts in this family for headlines, in posters and display ads, for callouts and data in infographics, and for short reference listings such as in an index. Make sure the family includes the full range of bold, light, extended and condensed.
- One serif family such as Bookman, Century Schoolbook, Garamond, Palatino or Times Roman. Use fonts in this family for text, captions and long reference listings such as in a glossary. Make sure the family

includes italic, semibold and roman.

- One script family such as Zapf Chancery. Use fonts in this family for pull quotes and on certificates.
- One modified-serif family such as Optima. Use fonts in this family for business forms and catalog sheets and as an occasional alternative to your sans-serif family. Make sure the family includes the full range of bold, light, extended and condensed.
 - A collection of symbols and dingbats.

To ensure the best quality from your hardware, make sure that fonts are installed in your printer as well as in your computer.

In addition to facilitating design, working with just a few type families controls costs and speeds production. You limit the risk of errors in electronic files, make it easier to work with imaging services, enable faster turnaround time, and reduce the danger of miscommunication among creative and production services.

"Each month I lay out a front page for our twentyseven affiliate newsletters with our logo, a lead story and a photo. I send a disk to every editor who adds three pages of local information. That system gives every local editor a starting point for each issue and, as a bonus, keeps us all on schedule."

best results, use bright white, smooth paper that is at least 60# book or 24# bond. Avoid commodity-grade computer paper with low brightness and high absorbency.

Laser printer

Laser printers create images using toner, a powder that sticks to areas of a drum electrically charged by a laser beam. The drum transfers the image to the paper.

Laser beams are far more precise than the needles or ink drops in dot printers, producing more dots per inch. The industry standard for dot resolution from desktop laser printers is 300 dots per inch, although many more costly machines produce 400 or 600 dots per inch. In addition to having tight dot resolution, laser printers operate extremely fast because the beam pulses at rates of up to several million times per second.

Laser printers are valuable when making mechanicals for basic quality printing and for proofing higher quality jobs, because they can output any combination of type and graphics that you can generate on a computer screen. The software that drives some laser printers also works for preparing higher quality output from an imagesetter.

Imagesetter

Type from laser printers is suitable only for basic and good quality printing. For printed products requiring higher quality type, or for pages that merge type and graphics, use an imagesetter.

An imagesetter is a machine found at prepress services, also known as service bureaus, and at many printers, agencies and large corporate production departments. It uses laser beams guided by a page description language, such as PostScript, to produce images ready to enter the print production process.

Imagesetters produce higher quality type than laser printers because of several factors:

- Higher resolutions. An imagesetter may produce resolutions of from 1,200 to 5,000 dpi, depending on the machine.
- Better materials. Imagesetters use paper or film that produces dots from chemical emulsions, not from spots of toner.
- Precision of machine. Imagesetters consist of stronger materials made to finer tolerances than laser printers.

Both laser printers and imagesetters can output images on film and, in some cases, directly onto printing plates. An imagesetter, however, works faster than a laser printer and can produce larger pages. Most desktop laser printers are limited to 8½" x 11" or A4 sheets, while imagesetters can handle sheets at least 17 inches wide by almost any length. (Imagesetters take materials from rolls, not from stacks of sheets.)

The resolution of dots or lines affects both the quality and speed of output from digital typesetters. As a general rule, quality goes up and speed goes down as resolution gets tighter.

FONTS AND FACES

A type font is a complete assortment of upperand lowercase characters, numerals, punctuation and other symbols of one typeface. A font is a concept, not a physical object. Fonts can be stored in the memory of a computer, on sheets of transfer lettering, on film or in boxes of metal type.

Typefaces are grouped into families with similar letterforms and a unique name such as Prestige or Garamond. The "parent" of the

2-2 Characteristics of type (opposite page) Typography has many features that affect both readability (easy to read and understand) and legibility (sufficient contrast with background). Using standard terms to describe these features helps you communicate clearly with graphic designers and printers.

Roman *Italic* Book

(1)(nfi lime

style

Light Regular

Bold Ultrabold weight

Condensed Expanded

width

Avant Garde Bodoni Berkeley

Courier

Futura Garamond Helvetica Melior

Palatino Times

typeface

abcdefghijklmnopqrstuvwxyz

ABCDEFGHIJKLMNOPQRSTUVWXYZ 123456789)(*&^%\$#@!?><.,'"'";:

type font

Bodoni Book Bodoni Book Italic

Bodoni Regular Bodoni Italic

Bodoni Bold Bodoni Ultra Bold

type family

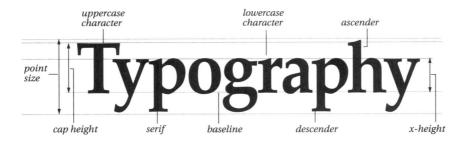

serif type san serif type

Leading is the 28 points baseline to space between baseline

26-point type set with 2 points leading

"The only art I could find for our flier was in our last year's ad in the yellow pages. My quick printer scanned the ad, enlarged the image, and combined it with our type. I had no idea that a quick printer could work such miracles."

family is the letterform in book or light; the "relatives" are derivations such as bold, italic or condensed.

Useful type families include typefaces with a variety of weights such as light and bold and come in both italic and roman. In addition, you may find bold weights in condensed, extended and other versions for headlines.

Fonts of the same typeface from different manufacturers may vary slightly with regard to fractions and special symbols and even design of the letterforms themselves. If you must switch from one manufacturer's font to another while staying with the same typeface, ask to see complete font printouts so you can compare characters.

You may find specifying typefaces confusing when different manufacturers give different names to typefaces that seem identical. Helvetica, for example, may also be called Helios, Claro, Newton, Megaron or Swiss. Furthermore, typefaces that have identical names may in fact look slightly different among manufacturers. The differences are small but may show up in the overall appearance of a page of text.

2-3 SELECTING AND SPECIFYING TYPE

Type and its page placement govern how well printed pieces attain their goals because how words look affects how readers receive their message. Thorough knowledge of type results in effective communication as well as sound management of printing jobs.

Over the five centuries since the introduction of typesetting, five basic rules for readability have emerged. Modern science, using techniques to measure eye movement and comprehension, has validated these rules.

Keep typography simple. Stick with one type family. If your job calls for captions, quotes and several levels of subheads, use a type family with an appropriate variety of weights, both for roman and italic, and perhaps small capitals. Build variety by changing size, weight and slant, not by switching type families.

Stay consistent. Stick with the same typeface for each element of your publication. If you set your first major headline in 30-point Times bold, use that typeface for all major heads.

Use both upper- and lowercase. The shape of whole words helps people read as much as the form of individual letters. Words in all capital letters are more difficult to read than words using both upper- and lowercase. Words formed from lowercase letters have unique outline patterns, so readers see familiar words as whole ideas. Words in all caps have no distinctive outline and force readers to slow down to grasp their meaning.

Keep lines short. The average reader takes in three or four words per eye movement and comprehends best when making two eye movements per line. The ideal line length is seven or eight words. Figuring an average of six characters per word, lines containing between forty-five and fifty-five characters work best.

Use serifs. Materials such as books and magazines that take more than a few minutes to read call for a typeface with serifs that lead the eye from one letter to the next. Serifs make type more readable and reduce eye fatigue.

MEASURING TYPE

Graphic arts professionals use many units of measure to describe typography. The three most important units are points, picas and inches. Points describe the height of characters (type size) and space between lines (leading). Picas describe width of columns, alleys and gutters. Inches describe height of columns.

Printers developed the concepts of points and picas centuries ago, but their usage continues in the computer age. In practice, inches are often used instead of picas – but never instead of points. To make matters even more confusing, there is a system of points and picas used in France and a few other countries in which the units are slightly different from points used in the United Kingdom and North America. The rest of the world, quite sensibly, uses metric units (millimeters) to describe typography.

You can see these units of measure on your computer screen along the rulers of page assembly software and some word processing software. Many programs allow you to switch from one unit to another. Menus in all programs ask you to specify type size in points.

One pica equals .166 inch (4.218mm) and has 12 points. One point equals ½12 pica and .013875 inch (.351mm). Note that type points are different from points used to express the thickness of paper.

You often hear the terms "text type" and "display type" used to express size. Text type is any type smaller than 14 points; display type is any type larger than 14 points. Depending on its use, 14-point type may be either text or display.

ENSURING TYPE QUALITY

For basic quality printing, type from almost any source communicates adequately. For good, premium and showcase printing, however, type should meet quality standards appropriate to the job.

Type that is fuzzy at the edges is less legible than type that is sharp. Fuzzy type can

Writing has always been both art and communication. Cave paintings, hieroglyphics, and ideograms all expressed creativity and content. Scribes were designers, not copyists.

Like ancient writing, modern typography is art. Because of the versatility of

300-DPI laser printer, toner

Writing has always been both art and communication. Cave paintings, hieroglyphics, and ideograms all expressed creativity and content. Scribes were designers not copyists.

Like ancient writing, modern typography is art. Because of the versatility of typewriters, computer printers, and typesetting machines, editors can make newsletters pleasing

1200 lines-per-inch photo type

2-4 Type from two sources The quality of type depends partly on the device used to make it. Type in both examples above is satisfactory for basic quality printing, but only the high-resolution output is good enough for higher quality jobs.

come from low-resolution dot printers, printers out of alignment, laser printers low on toner, and imagesetters that are out of alignment or focus.

Type should appear sharp and consistent. Type from an imagesetter is sharper and more consistent than type from a laser printer.

All systems that set type have mechanisms to feed paper through the machine. If the paper goes through with uneven tension, lines of type may not look parallel to each other. In addition, factors such as developing procedures, adhesives used for pasteup, and storage conditions also affect the useful life of type.

RULES

Lines in the graphic arts are called rules and must meet specific quality standards. Straight rules must look straight. Rules drawn by hand or laid from border tapes sometimes look like sagging telephone wires or cutaways of mountain ranges. Curved rules should have uniform arcs.

Like type, rules should have clean edges. Felt-tip and ballpoint pens and border tape that has collected dust and lint in the bottom of the desk drawer all give poor results. Rules made by graphic arts and technical pens are good, and those made by laser printers and imagesetters even better.

Rules from a laser printer aren't as uniform, smooth or straight as those from an imagesetter. With basic and good quality printing, the variations make little difference. With premium and showcase jobs, they detract from overall quality.

Use points to express the thickness of a rule and picas or inches to express its length. Avoid the word "hairline" unless your organization has a precise meaning or you can accept wide variation. In addition to the large number of subjective viewpoints on the size of a hairline, there are at least four specific definitions used by graphic arts professionals that range from .003 inch to ½ point.

REVERSES

A reverse is type, a graphic or an illustration reproduced by printing ink around its outline, thus allowing the underlying color or paper to show through and form the image. The image "reverses out" of the ink color, as shown in Visual 2-6.

While type printed as a reverse can catch the eye, it can also lead to problems. Lines less than ½ point thick may fill in with ink when reversed. Text type becomes less legible when reversed, whether or not the typeface includes fine lines and regardless of type size. Use reverses only to accent messages and as part of designs such as nameplates, never for blocks of text type.

A large reverse out of solid ink means printing a large solid that may lead to mottling or ghosting. Consult with your printer before making final decisions about design.

SCREEN TINTS

You can use screen tints to highlight copy, accent charts and graphs, and simulate changes in the density of ink. The areas of the illustra-

2-5 INSPECTING TYPE

Sharp, dense type in high contrast with its background yields legible copy. Use this list as a guide when you examine type to make sure it meets your standards:

Specifications. Confirm correct point sizes, styles, leading and line measure.

Dark characters. Check characters for adequate density and uniform blackness. Inspect type for holes or breaks.

Straight lines. Put a ruler under a few sample lines to ensure they have no hills or valleys.

Parallel lines. Study lines to make sure they are parallel to each other.

Even justification. Lay a ruler down the left edge and, if set flush right, down the right edge to verify proper alignment.

Sensible hyphenation. Certify that words are divided correctly. With ragged right copy, divisions should avoid awkward gaps.

White paper. Note whether paper looks bright white and free from stains or flaws that might reproduce.

Consistency. Check that features such as density, point sizes and line measures stay identical with type set on different days, by different machines, or originating in different software.

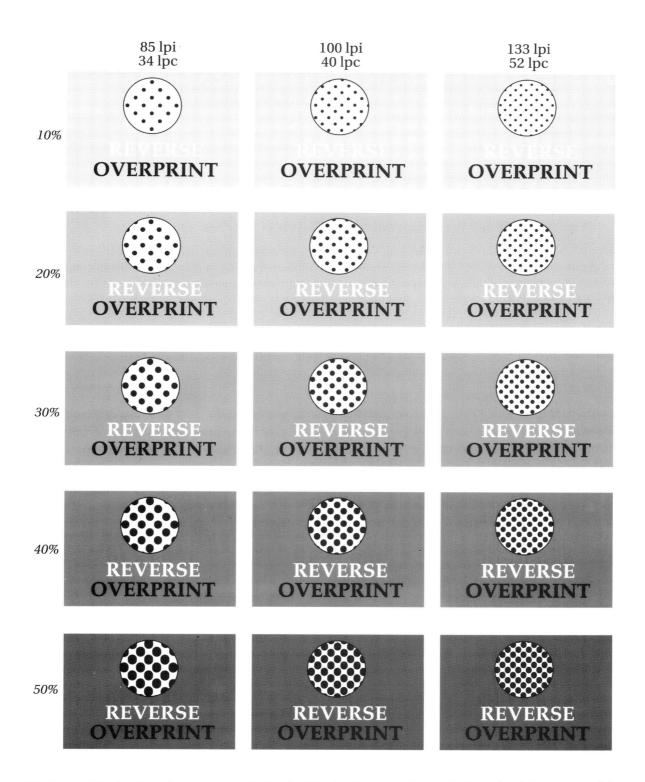

2-6 Screen tints Density, ruling, ink color and dot gain determine how screen tints look when printed. Hues become lighter when screened. Paper, printing method and quality requirements determine ruling and percentage for a specific job. Plan carefully for overprints and reverses to ensure that words stay legible and fine lines stay visible.

tions in this book that look shaded are screen tints. You may also hear a screen tint called a fill pattern, tint, tone, screen or shade.

Screen tints create the illusion of shading because they are printed in tiny dots instead of solid blocks. Each dot has the same density as all other ink on the sheet, but dots vary in size according to the ruling and percentage of the tint required.

Every screen tint has three features that you need to specify:

- Ink color is usually the same as used for type, most often black.
- Ruling refers to the distance between the rows of dots expressed in lines per inch. Screens with relatively few lines per inch are coarse; fine screens have many lines per inch. You may also hear screen ruling called line count or screen value.
- Density refers to the relative size of dots that a screen allows to print and is expressed as a percentage. Dot size determines how dark or light screen tints seem. Lots of paper showing around the dots makes the tint seem light; not much paper showing makes it seem dark. For example, a 10 percent screen allows ink to cover 10 percent of the image area. A 90 percent screen is close to solid; a 10 percent screen seems very light. Density may also be called screen percentage.

Screen ruling affects how screen tints and halftones look when printed. When printed on coated paper, fine screens yield sharper images than coarse screens, but are more difficult to print. A 100-line screen has 10,000 dots per square inch, whereas a 133-line screen has 17,689 dots per square inch—almost twice as many.

Lines-per-inch or -per-centimeter screen rulings and dots-per-inch or -per-centimeter digital outputs have different meanings. With digital output, each dot consists of several pixels. A dot built from two or three pixels at 300 dpi is much less precise than one built from four or five pixels at 1,200 dpi.

The best screen ruling for a printing job is determined by the image to be reproduced, the technique used to make the screen, and the press and paper used for the job. No job has a "correct" screen ruling.

There are three ways to create screen tints to reproduce on a printed product:

- Catalogs of transfer lettering materials show standard screen rulings and percentages and offer tips on using the tint material. Most art supply stores carry a wide selection. Presson tints must be firmly burnished edge to edge. The slightest bubble puts the dots out of focus. Cut edges cleanly with artist's knives.
- You can add tints to your design on a computer screen, then output them from a laser printer or imagesetter. Most design applications let you choose ruling and density. Sophisticated programs also allow you to choose ink color and create graduated screens (vignettes).
- A printer can create screen tints using film containing rows of dots. When operators place a screen over a printing plate and expose it, they reproduce its pattern of dots on the light-sensitive emulsion.

Tints from transfer materials or a laser printer are strictly for basic quality printing. If you want good, premium or showcase work, let the print shop add tints or have them output by an imagesetter.

When your design calls for screen tints, keep in mind a few rules of thumb. Some papers, especially those without coatings, absorb more ink than others, and so require coarser screens. Coarse screens yield fewer dots per inch so the dots are less likely to run together when they spread on absorbent paper.

Tints of less than 10 percent tend to disap-

[&]quot;The public relations director at our hospital has a degree in journalism and spends about \$500,000 per year on printing. She invested \$1,500 on a two-day print buying seminar and now saves her department almost \$50,000 per year—and meets all her deadlines. As a bonus, she leaves her office every day at 5:30 instead of 6:15. Well, maybe not every day."

scattergram

map

pictograph

bar chart

organizational chart

diagram

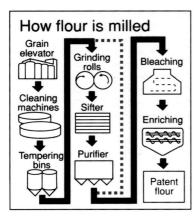

flow chart

pie chart

line chart

2-7 Infographics Rules, reverses and screen tints combine in hundreds of ways to make charts, graphs and maps. When producing infographics, keep in mind the relationships among paper, ruling, and percentage that apply to tints and reverses when used alone. If tints in infographics include overprints or reverses, make a printout from an imagesetter, not just a laser printer, to verify legibility.

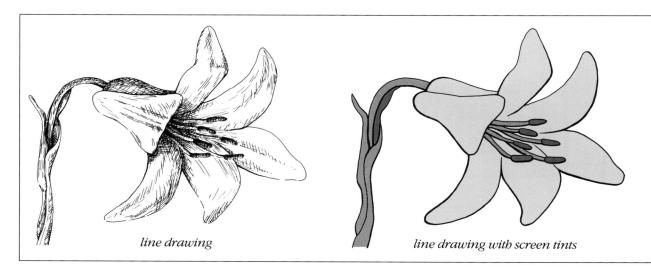

2-8 Four ways to treat an illustration These lilies show four ways to add texture to an illustration. Cross-hatching in the line drawing gives an effect similar to nineteenth-century engravings. The version with screen tints uses tints of 10 percent, 30 percent and 50 percent. The watercolor and pencil drawings are halftones.

pear, especially when printed using a light ink color; tints of more than 70 percent tend to look solid, especially when using a dark ink color. Some ink colors look better screened than others. Dark blue becomes light blue, while red becomes pink.

To judge how colors look when screened, consult a tint chart available at most graphic arts stores, commercial printers and design studios. Several paper mills also make tint charts showing popular ink colors on their brands of paper. If you evaluate a tint on a computer screen, keep in mind that its color when printed may look quite different from its color on the screen.

You can screen and overlap two inks to create the illusion of a third color, as illustrated in Visual 3-6. Ink colors, paper absorbency, screen rulings and percents, and the way screens align all affect the results. Improper alignment of

"For fifteen years I've been buying printing and hearing from printers about hairline register. Finally I asked how wide a hairline is. My printer didn't know but guessed it might be the width of one dot on whichever screen we were using at the time. That definition would let hairlines vary from 1/100 inch to 1/200 inch—a 100 percent variation. We settled on 1/100 of an inch as the definition. Someone should put that in a book."

screens by the printer can cause distracting moire patterns. If you are at all uncertain about the outcome, get advice from your printer.

ILLUSTRATIONS

Illustrations in the form of line copy can come from a variety of sources. Clip art and original pen-and-ink drawings are most common.

Clip art means copyright-free drawings ready to insert into computer designs or adhere to mechanicals. Many ad agencies, design studios and print shops, as well as most art and stationery stores, have files of clip art arranged by topic, such as holiday themes, health care or family life. Extensive collections come from producers who sell them in books, on disks or on transfer sheets.

Any dark drawing on light paper will work as an illustration ready to scan into memory or include on a mechanical. Images on off-white or colored paper may lack sufficient contrast to scan or reprint well, but might be enhanced by first making a PMT or photocopy. Images should be in a dense, uniform black without fuzzy or broken lines.

When buying clip art on floppy or compact disks, verify that file formats work with your hardware and software. Popular subjects usually come as EPS files or in some other generic

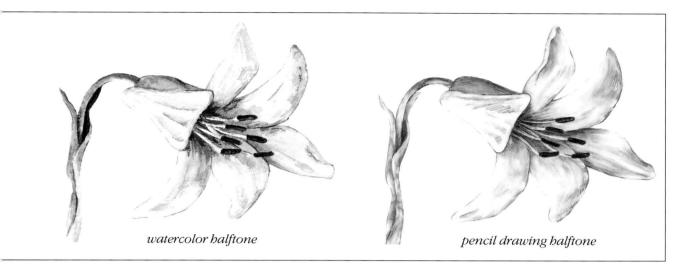

format. More specialized images, however, may remain in applications such as Illustrator or FreeHand. Read the fine print before you buy.

If you have a large library of visuals in electronic memory, consider using an application such as Aldus Fetch to locate them and display them at low resolution.

Original drawings for line art should have sharp, black lines to reproduce without halftoning. Professionals use graphic arts pens with precision tips or a computer using illustration software. Illustrations in continuous tones made with pencil, felt marker, airbrush, ink wash, charcoal, paint or computer must be screened into halftones or color separations. The processes are identical to those for photographs explained in chapter four.

An illustration done originally in full color may be printed in a single color, but requires special attention. If you are uncertain about how an illustration will print, show it to a printer before including it in a design.

Many graphic designers also do illustrations. The best illustrators, however, tend to specialize in this single aspect of the graphic arts. Illustrators need to know what information drawings must convey and in what style they should be done. Showing the artist some drawings you like and asking if your work can be done in the same style is the first step.

Clear job definition leads to satisfactory illustrations and means that costs can be closely estimated in advance. A good illustrator asks questions, then develops rough sketches for approval before drawing final art.

Fine artists produce work for enjoyment in its original form; commercial illustrators create work for reproduction by printers. A commercial illustrator's knowledge of printing means jobs should reproduce well on press. The art doesn't have delicate lines that might disappear when images are reduced or reversed. Plan art to reduce or enlarge at similar percentages to ensure consistent appearance.

When soliciting business, illustrators show examples of their work. To be sure illustrators are sufficiently aware of printing processes, ask to see their examples in printed form as well as original art. Verify that drawings reproduced as well as you think they should have.

3. MASTERING COLOR

The language of color
Flat and process color
Color reference systems
Ensuring color quality
Using proper lighting

Adding color to a printing job makes it more complicated and expensive. You can control costs and help ensure color success by knowing how design, ink and paper interact to produce colors.

People experience color subjectively because of how they perceive it and react to it. Age, gender, culture and many other factors affect the physiology of vision and the psychology of response.

The wide range of color sensation means that most people, including graphic arts professionals, often find it difficult to communicate their ideas about color. They need training and tools. They need ways to standardize viewing conditions and calibrate machinery. And they need ways to speak clearly about color to people in other fields that relate to printing, such as photography and illustration.

In this chapter you'll learn about terms and tools that printers use to help make reproducing colors precise and consistent. When you use the language and aids used by printers, you reduce uncertainty and help avoid costly mistakes in printing jobs calling for color.

THE LANGUAGE OF COLOR

No topic in the graphic arts elicits less precise language than color. Experts use different terms to describe identical features and sometimes identical terms to describe different features.

3-1 BASIC COLORS

You can design almost any publication by selecting from a handful of colors whose effectiveness you know well and that readers find attractive. While it's tempting to follow trends, the colors listed below prove most popular year after year.

- *Violet*. Pantone Violet or Trumatch 39-b4
- Warm red. Pantone 032 or 185, or Trumatch 6-a
- Cool red. Pantone 199 or Trumatch 2-a
- *Burgundy*. Pantone 201 or Trumatch 2-b6
- Blue. Pantone 286 or 300, or Trumatch

36-b1 or 34-a

- Green. Pantone 347 or Trumatch 19-a
- Brown. Pantone 469 or Trumatch 49-a6

In addition to facilitating design, working with just a few colors controls costs and speeds production. You limit the risk of errors in electronic files, make it easier to work with imaging services, and reduce the danger of miscommunication among creative and production services. Furthermore, as flat colors these hues are so popular that many ink companies keep a premixed supply, so they cost less for printers to buy.

To see the problem, look at Visual 3-2. The column at the left shows five different colors, also called different hues. Simple.

Now look at the middle column showing five versions of the color red. How would you describe the differences among the reds? If you're a photographer, you say some reds look more saturated than others. If you're an artist, you say some reds look more pure or intense than others. If you're a graphic designer or printer, you say some reds have more depth or value than others. If you're a scientist, you say some reds have more chroma than others.

Notice that each professional refers to the identical group of reds. To make matters even more confusing, maybe you use another word for that red.

Again, look at Visual 3-2. The column at the right shows five versions of blue. How would you describe the differences among the blues? Professionals from various fields use terms such as value, tone, lightness, brightness and shade. More confusion here, especially because value was also a term referring to differences among the reds.

Confusion and inconsistency about the lan-

guage of color have practical consequences. For example, many computer programs refer to HLS or HVS. In this case, L (lightness) and V (value) have identical meanings. But if you told a service bureau that you wanted red with more value (meaning saturation) and it gave you red with more value (meaning lightness), who do you hold responsible for producing the incorrect color?

Researchers have developed many systems to organize colors into logical relationships. The most widely used in the graphic arts was developed by a group called Commission Internationale de l'Eclairage (International Commission on Light), abbreviated CIE.

The CIE system describes colors according to the three characteristics of hue, lightness and saturation. As represented in Visual 3-2, "hue" refers to the color itself, "lightness" to its relative lightness or darkness and "saturation" to its density. Other systems, such as the Munsell Color System widely used by scientists and professional artists, use the same three categories but different terms.

Most software, computer printers, press controls, spectrophotometers, and other equip-

"When my graphic designer planned separations to 'match product,' I wish I had known how expensive that would be. We paid for color correcting, three rounds of proofs, and fancy paper just to make an ordinary catalog for selling tools. Who cares if the brown in the picture doesn't match the brown on the hammer handle?"

ment and supplies for the graphic arts rely on the CIE system. For example, PostScript uses the CIE color model.

You don't need to understand the theory behind color models, but you do need to communicate clearly about color if you want colors to look on paper the way you see them in your imagination.

In addition to terms referring to the three basic traits of color, you often hear a color called warm or cold. Temperature analogies are used to describe colors of both inks and paper. For example, a press operator might say that cool paper destroys the effect of warm reds.

Cool colors are blues, greens and some grays that suggest cool places or scenes. Paper with a slight blue cast is called cool.

Warm colors are yellows, oranges and reds that suggest warm places or scenes. Paper with a slight yellow or light brown cast is called warm.

You often hear neutral hues, such as gray and beige, described by how warm and cool they seem. For example, a designer might call for a cool gray background for one ad and prefer warm gray for another. Cool gray has a slightly blue tinge and warm gray looks slightly brown.

FLAT AND PROCESS COLOR

Printers have two ways to reproduce color. Flat color requires blending different inks into one ink with the required hue. The method resembles blending paints for household use. You may also hear flat color called spot color.

The second way to create a color involves using four hues called process colors. Dot patterns of the four process colors simulate the desired hue as shown in Visual 3-3. This technique is four-color process printing.

The process colors are cyan, magenta, yellow and black and are abbreviated CMYK. (Authorities disagree on whether *K* stands for "black" or "key") You can see the process colors printed as flat inks (without dots) in Visual 3-11.

Process colors have identical names—but not identical hues—everywhere in the world. Yellow and cyan used in North America are

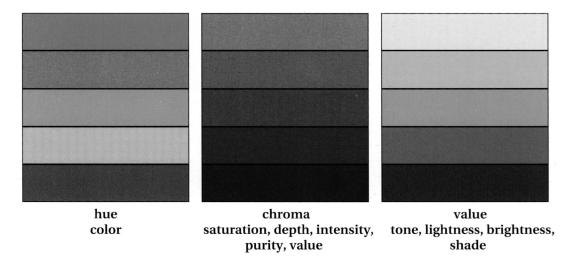

3-2 Features of color Scientists agree that color has the three traits represented above, but they don't agree on what to call those traits. For that reason, you need to recognize each of the terms that might apply to any trait and, whenever you suspect confusion, insist that communication become clear.

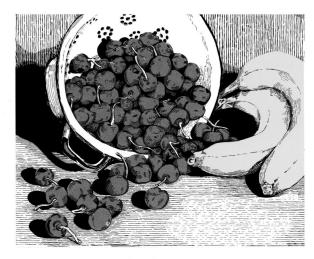

multicolor printing

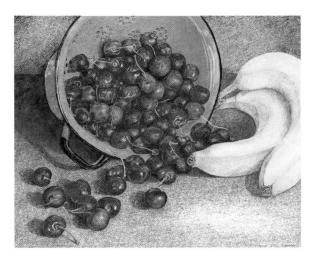

4-color process printing

multicolor enlarged to 600%

4-color dots enlarged to 600%

3-3 Flat color and four-color process Printers can use flat inks or process inks to create color. The multicolor image is reproduced in black, magenta and yellow printed as flat inks. The red is produced by printing 100 percent yellow over 100 percent magenta. Process color printing is for reproducing continuous-tone copy. Printers must use all four standard ink colors and only these four. Other ink colors won't work. Multicolor printing, on the other hand, is simply to give color to line copy. Any colors work.

slightly less dense than the yellow and cyan used elsewhere. There are three hues called magenta—one common in North America, the second in Europe, and the third elsewhere in the world. If you print outside your own country and color match is critical to your job, verify that samples and proofs coordinate with the process hues on press.

Printers use four-color process to reproduce color photos and illustrations. If design requires four-color printing for photos, then it's convenient to simulate flat colors using the same four ink colors. If design doesn't require four-color printing, use flat colors. They cost less and give better fidelity.

The four-color process requires one inking station per color. Most printers use a four-color press, although some produce process color work using a two-color press (two passes through the press) or a one-color press (four passes through the press). Printing on a fourcolor press costs more than printing on a oneor two-color press but produces process color jobs more quickly.

4. CONTROLLING PHOTOGRAPHS

Black-and-white photos
Halftones
Duotones
Color photos
Separations
Process color printing
Tone compression
Taking advantage
of ganging

Choosing photos for reproduction requires a further understanding of the complex relationship between design, prepress and printing. This understanding helps you predict how images appear when reproduced and leads to lower costs and fewer missed deadlines.

Original photographs on film are continuous-tone copy containing many shades and hues from dark to light. Continuous-tone copy must be converted into halftones before printers can reproduce it. Original photos on disc are digital images already partly halftoned.

In this chapter, you'll learn what to look for when examining photographs for printing and see differences between images that will reproduce well and those that will not.

Photographic terms are so similar to printing terms that you need precise language to avoid confusion. I refer to black-and-white prints, color prints and transparencies simply as photographs to make clear that these are originals. To identify reproductions made on a printing press, I use the standard graphic arts terms halftone, duotone and separation.

Although this chapter is about photographs, much of its information also applies to continuous-tone illustrations. They too must be converted into halftones or separations prior to printing.

get your fair share

- every student is eligible for some type of financial aid regardless of grades or family income
- unclaimed scholarships
- results guaranteed!

Please detach and mail

SCHOLARSHIPS, FELLOWSHIPS, **GRANTS AND LOANS**

tudent Services has a databank of over 180,000 stings for scholarships, fellowships, grants and pans, representing billions of dollars in private secor funding. We can provide you with a list of funding ources most appropriate to your background and ducation goals.

Mail this card for complete details...today!

Please print CURRENT	ADDRESS legibly:	RAJ
Name:		
City:		
	Zip:	
Please print HOME ADD	RESS if different from above:	
Name:		
City:		
State:		

Yr. of Graduation School Name

Yes! I also want to receive information and an application for (/)

Federal Stafford Loans (undergraduate and graduate)

Federal PLUS Loan (parents of dependent students)

Graduate Loan

vices Different n A Financial sector funding from cor-Services specializes in ons, religious groups, is, memorials, trusts, y other philanthropic nd federal funding ntinue to face serious SIND DOOR rivate sector funding to grow even faster ices has current ormation that pro-Igent alternative es; at the very tate and federa esent a signifint to governfirst step to receiving more Start Today... and educational goals. priate to their background provide students with a list of vate sector funding. We can ing Billions of dollars in prigrants and loans, representof scholarships, fellowships, bank of over 180,000 listings SOUPCES... TIMINA IN CINCINI card today. Make this you funding sources most appro-Many Obscure Each Year Because Detach and mail this poststudent Services has a datatudents Are ioes Unclaimed n Financial Aid Inaware Of The

College Financial Aid.

UNITED STATES

NO POSTAGE **NECESSARY** IF MAILED IN THE

4-1 EVALUATING PRINTS AND TRANSPARENCIES

To ensure halftones and separations that meet your goals, start with good originals. Don't try to salvage images unsuited to your publication. When examining photos, get images off to a good start by using the following guidelines.

For basic quality printing

Focus. Important features instantly recognizable.

Grain. Enlargement to publication size doesn't make the image look too grainy.

Flaws. No scratches, dirt or stains.

Density range. Contrast and some middle grays.

Photos for basic quality jobs are often made using snapshots from inexpensive 35mm cameras and produced at automated photo finishing services, and so may meet these standards only marginally.

For good quality printing

Focus. Important features look sharp.

Grain. Enlargement to publication size doesn't make the image look too grainy.

Flaws. No scratches, dirt, blemishes or stains. No distracting features in the image.

Density range. Good contrast and a full range of grays showing detail in both highlights and shadows.

Color. For "pleasing" reproduction. Colors look saturated. No distracting cast.

You can use a single-lens reflex 35mm camera to make photos for good quality jobs that meet these standards with only occasional exceptions.

For premium quality printing

Focus. All features look sharp throughout controlled depth of field.

Grain. Enlargement to publication size doesn't make the image look grainy.

Flaws. No scratches, dirt, blemishes or stains. No distracting features in the image. No patterns that might cause moires.

Density range. Full tonal range measurable at 1.7 for black-and-white prints, 2.0 for color prints and 2.4 for transparencies. Density range visibly consistent for all photos throughout the publication.

Color. For "match photo" reproduction. Colors close to original scenes or products.

Photos for premium quality jobs are made by professional photographers, so should meet these standards with rare exceptions.

For showcase quality printing

Focus. All features look sharp throughout controlled depth of field.

Grain. Enlargement to size for publication reveals no grain.

Flaws. None.

Density range. Full tonal range measurable at 1.8 for black-and-white prints, 2.1 for color prints and 2.5 for transparencies. Density range measurably consistent for all photos throughout the publication.

Color. For "match original" reproduction. Colors true to original scenes or products.

Photos for showcase quality jobs are made by top professional photographers; they should meet these standards with no exceptions.

BLACK-AND-WHITE PHOTOS

Imaging services preparing photos for reproduction must start with the best quality originals that you can provide. Quality may go down during the many steps between originals and printed pieces, but it is unlikely to go up. To get good halftones, start with good originals.

When ordering prints, keep in mind that semigloss photographic paper looks more like the printed piece than gloss, so it gives a better idea of the final outcome. High-gloss photo paper makes blacks look too dense and may have a surface that cracks.

Contrast tends to decrease during printing, so originals need good contrast and a full range of tones. The original should not look flat (low contrast) or have either highlights or shadow areas without detail (high contrast).

The emulsion coating of photographic film consists of grains of silver salts that are sensitive to light. Films with rather large grains capture images using less light than films with smaller grains. Because of this versatility, photographers refer to large-grained film as fast and small-grained film as slow.

Images made on fast film don't look as sharp as those made on slower film. Moreover, enlarging photographs makes grains seem bigger. The lack of sharpness carries over into printing plates, detracting from the clarity of the image.

When considering photos for black-andwhite printing, you evaluate individual, enlarged prints or contact prints of unenlarged negatives. The groups of unenlarged images on one sheet of paper are proof sheets. Choosing photos from proof sheets (also called contact sheets) lets you see every image, not just those the photographer wants to show you.

Use a loupe to inspect images on proof sheets from 35mm film. Place the magnifier directly on the surface of the print to examine focus and detail.

Even using a magnifier, it is difficult to detect on proof sheets distractions such as

white coffee cups and reflected strobe flashes that can ruin a picture. If you plan to enlarge an image more than 150 percent or feel uncertain about focus, flaws or distractions, order a photograph made to size. The new photo reveals whether the image is worth reproducing.

When using proof sheets, specify choices and instructions in red. Use a permanent felt marker or grease pencil to show cropping and areas to lighten or darken during darkroom printing. Remember that all the images on the proof sheet were made at once with one exposure. Some may not look as good as they would if made individually.

If you have original images on a floppy or compact disk, you examine them on a computer screen rather than on paper. Keep in mind that the screen gives the image much higher contrast than it can have on paper. To simulate the image in your printed product, have it output from a laser printer with at least 600 dpi resolution or by an imagesetter.

HALFTONES

Photos must be changed from continuous tones to halftones before a printer can reproduce the images on press. Halftones have thousands of tiny dots that create an illusion of the original image. The pattern of dots tricks the eye into thinking it sees continuous tones. In areas of the image with small dots, more paper shows through, creating highlights; portions of the image with large dots show less paper, reproducing shadow areas.

Black-and-white photographs converted into dot patterns are called halftones; color photographs prepared for printing in color are called separations. Use these terms for all images converted to dot patterns, whether they appear as negatives, as proofs or in the final printed product.

Operators can make halftones and separations using a process camera or an imagesetter. When halftones are made using a process camera, a screen breaks light reflected from the

detail dropped out in highlights

good contrast and detail

detail lost in shadows

flat contrast

flaws

grain enlargement

4-2 Black-and-white photos To get good halftones, start with good originals. Four of the photos above were poorly exposed, developed or printed, and would not look good when reproduced. Look for full tonal range and good contrast. Good originals show details in their lightest and darkest areas (highlights and shadows). Photos with too much contrast may lack detail, while low-contrast images reproduce as flat and lifeless. Images made on fast films may lose sharpness or look grainy when enlarged.

photograph into dots and records the results on paper (positive) or film (negative). When halftones are made using an imagesetter, the device outputs a computer file that can originate from:

- A scanner, which converts images on film or paper into digital information and records it onto electronic memories such as magnetic discs.
- A motion video camera, which has the original photo on tape. You select one frame at a time that a computer digitizes for print output.
- A still video camera, which has the original photo on a floppy disk that a computer digitizes for print output.
- A digital camera, which takes the original photo as digital information.

If you don't have a scanner and want to work with film photos on your computer screen, take your film to a processing service that can output results to a photo compact disc. Use CDs or another electronic medium to store a library of photos ready to insert into

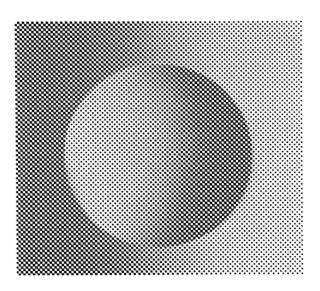

4-3 Continuous tones to halftones Screening the ball and background at 40 lines per inch makes individual dots easy to see. Even these large dots create the illusion of the original image when viewed from several feet away. Proper screen ruling takes into account viewing distance as well as factors such as device resolution and printing paper. (Airbrushing by Kathleen Ryan.)

newsletters and brochures. Stock photo services and some professional photographers also supply preview photos on CDs.

If you are concerned about the environmental impact of your printing jobs, consider electronic photography. Switching to video or digital photography helps reduce the tons of sludge, chemicals and effluent involved in making and processing film.

Quick printing requires that you include halftone positives on mechanicals. Halftone positives from process cameras are made using the photomechanical transfer (PMT) process. Halftone positives from scanners are made by imagesetters as they print out fully composed pages.

A halftone positive can be made by making a whiteprint of a halftone negative. Whiteprints, often called Veloxes, are useful supplements to blueline proofs because they allow you to verify the quality of halftones. They also cut costs when you need many prints of the same image, such as for advertisements.

Take care that you plan ahead for screen ruling when ordering PMTs or Veloxes, or when scanning photos. Reducing the mechanicals on which the positives appear makes screen rulings finer by moving dots closer together; enlargement makes screens coarser. A 133-line Velox shot at 125 percent ends up having a 106-line screen and gives no better detail than a less expensive PMT.

Good quality commercial printing uses metal plates made from halftone negatives. The negatives may come from process camera exposures of photographs given to the printer separately from mechanicals or from scans output on an imagesetter. Premium and showcase quality printing always uses halftone negatives, not positives.

You can specify halftone negatives at a variety of standards depending on whether your job prints good, premium or showcase quality. Some of the quality distinctions come from extra care by process camera or scanner opera-

tors. Be sure to tell your imaging service if you plan premium or showcase printing.

Like screens for tints, screens for halftones are measured in lines per inch. Coarse screens such as those used by newspapers and quick printers are 65 to 100 lines; medium screens in news magazines and company publications are 133 to 150 lines; fine screens in premium or showcase quality brochures or annual reports range from 150 to 300 lines.

The paper that you specify for the printing job affects screen ruling for the halftones. Uncoated paper absorbs ink quickly; dots may soak in, spread out, become fuzzy at their edges and touch. A somewhat coarse screen helps shadow areas retain detail on uncoated paper. Coated paper holds ink on its surface, so you can use a finer screen.

With most jobs at commercial printers, 133-or 150-line screens give effective results. As screen rulings get finer, every step in the process takes more care, so costs increase. Shadow detail is especially hard to reproduce when using fine screens. Showcase quality pieces printed offset might use 300-line screens with 90,000 dots per square inch—nine times the number of a 100-line screen. While yielding extraordinary results, 300-line screens are very difficult to print by offset and only a few printers are capable of reproducing their showcase quality.

Your choice of screen ruling affects quality, cost and schedule. Consult with your printer. For specialized help, ask your printer or paper distributor for demonstration materials made by paper manufacturers. Paper mills such as S.D. Warren and Hammermill publish booklets and charts showing photographs in many screen rulings and colors, with special effects, and on a variety of papers. These materials are free and make good visual aids for learning

4-4 Halftones in three screen rulings There is no "correct" screen ruling. Which ruling to use requires a compromise influenced by factors such as the resolution of input and output devices, printing paper and method, and quality requirements.

halftone reproduction using an 85 line screen

halftone reproduction using a 120 line screen

halftone reproduction using a 150 line screen

Photo by Mark Beach.

gray levels

133 line halftone screen scanned at 16 levels of gray

100	93	87	80	73	67	60	53	47	40	33	27	20	13	7	0

133 line halftone screen the limit at scanned at 256 levels of gray

line reproduction

no screen
no gray scale levels

4-5 Gray levels Scanners, laser printers and imagesetters build halftone dots from tiny spots of light. High-resolution devices produce a greater range of halftone dot sizes and yield a greater range of tones.

The bottom version of the image shows what happens when a photo is reproduced without being halftoned. Sometimes photos are reproduced as line reproductions to create a special effect known as posterization.

about halftones, duotones and separations.

When prepress services and printers charge for halftones and separations, they use guidelines that take into account number of images, size of images and output speed. You can cut costs by ganging several images onto one piece of film and, in the case of scanned images, outputting at the lowest resolution that yields satisfactory quality.

Color photographs may be halftoned for printing black and white, but they don't look as good as starting with a black-and-white photo of the same image. If you must start with color originals, remember that graphic arts film and scanners see red as black. Red areas of the original photo lose detail, and the resulting halftone may have too much contrast.

Some illustrations require halftoning. Images made with soft pencil lines or brush-strokes have the same continuous tones as photographs.

Whether to treat a specific illustration as line art or a halftone is a matter of judgment. When an illustration is made into a halftone, fine lines may vanish (drop out). On the other hand, the same illustration treated as line copy loses detail as midtones become either white or black.

DUOTONES

Printers produce a duotone using two plates made from two separate halftone negatives printed in register. The two plates can both carry black ink, black plus a second color, or use a separate color for each.

Black-and-white photos result in better duotones than color photographs.

There are two reasons to use duotones. First, a single halftone can't capture the full tonal range of a good photo. A plate made from a single halftone cannot print shadows dark enough without sacrificing quality in highlights. Using two negatives, printers can make one to favor highlights and the other, shadows.

The second reason to use duotones is to achieve a color effect different from black and white, as shown in Visual 4-7. Sample books from paper companies show a variety of color combinations. Samples also help you specify whether you want "normal" duotones using both ink colors about equally or whether letting one color dominate might yield a more pleasing effect.

Because you can use duotones to create such a variety of effects, you need to tell your printer or imaging service what effect you want. Show printed examples to convey the

drop out half tone

ghost half tone

outline half tone

4-6 Halftone effects For some images you can improve on the original photo. Outline halftones, also called silhouettes, drop outs and ghosts are made using computer programs during design or photo techniques during stripping.

blue impression

black impression

blue and black duotone

4-7 Duotones Printers create duotones from halftones produced to expand the tonal range or yield a special effect. In the example above, the negative for the cyan impression was slightly overexposed in the highlights to drop out highlight dots. Using computer software, the same effect is accomplished by changing the reproduction curve for the cyan printer. The result was a plate that printed cyan in the water without printing many cyan dots in the sails or sky.

outcome you seek. When you specify a duotone, write the percentages of each ink color: "50 black/50 cyan" or "40 black/60 brown," for example.

Duotones are more expensive than simple two-color printing because they require more precise register. To proof duotones, ask for an overlay color proof as described in chapter five.

Printing jobs that call for two colors but lack the budget for duotones can be done in fake duotones. This technique requires printing a halftone in one color over a light screen tint of the second color. Fake duotones do not demand tight register and look exactly as their name implies.

COLOR PHOTOS

Color prints and transparencies must be changed into halftones before they can be reproduced by a printing press. The quality of the resulting separations, like halftone quality, depends on the originals from which they are made. The best separations originate from transparencies because they have greater tonal range than prints.

When you examine color photos, use a correct light source as described in chapter three. Standard viewing conditions are the first key to color quality control.

When projecting transparencies or viewing them on a light box, be cautious. Looking at sharpness and studying key elements under backlit conditions is fine, but the intense brilliance may deceive you about how bright images will appear when reproduced. Backlighting also shows more shadow detail than a press can reproduce.

Transparencies are viewed properly with emulsion side away to assure that you see the scene as the photographer saw it. Put the emulsion side down on a light table or toward the screen during projection. The printing on cardboard mounts appears on the same side as the film emulsion.

You may know about transparencies only in the form of 35mm slides. The 35mm format is

popular because of the convenient size of its cameras and accessories. Larger format cameras, however, produce photos better suited to many printing jobs.

There is a direct relationship between size of the original film image and sharpness of the image when enlarged for printing. A 35mm slide enlarged to 8" x 10" grows by 700 percent. If the image is cropped even slightly, enlargement can be over 1,000 percent. Enlarging decreases sharpness because it magnifies the grain structure of the film. Keeping enlargement to a minimum guarantees the sharpest possible printed image.

All printing should begin with the sharpest possible photographs. Ideally, showcase and premium printing should begin with large format transparencies. In the parlance of photography, 35mm is small format, $2\frac{1}{4}$ " x $2\frac{1}{4}$ " is medium format, and 4" x 5" and 8" x 10" are large format. It is unlikely that you will get 8" x 10" aerial or wildlife photos, but you should expect large format images from studio work.

SEPARATIONS

Printers use four-color process printing to reproduce color photos and continuous-tone color illustrations.

Because four-color process printing uses four ink colors, original images must be changed into four negatives so the printer can make four plates. The act of dividing a color image into four negatives is called color separating. The negatives themselves are separations.

Technically speaking, color separations are halftones. Plates made from each separation could be printed with black ink or ink of any other color. It is only because the four halftones are printed in register with each other using specific colors of ink that they simulate the original full-color image.

Prepress services make separations using the same devices and techniques used to make halftones. In practice, many halftones are made using a process camera, but most separations are made using a scanner and an imagesetter.

Printing color separations is much more difficult than printing single halftones. The dots of each color must align correctly with the dots of the other three colors.

Because four-color process printing requires precise register of four separate images, it is not suitable for quick printing. Basic quality jobs, even when printed by commercial printers, should not involve four-color process printing. The technique is suitable only for jobs in the good, premium and showcase quality categories.

Color separations are made using scanners that may output results directly onto film or store results in electronic files. You may have images stored as electronic files color corrected, assembled with other images or with type, and then output as separations by an image-setter.

Once the four separation negatives are made and composed with type and graphics, they are used to make printing plates. When on press, one plate is inked with yellow, one with magenta, one with cyan and one with black. Printing the dots from the four plates in register puts the separation back together to give the illusion of a continuous-tone photograph or illustration.

Size, quality, turnaround time and the kind of originals you submit determine the cost of separations. Transparencies cost the least to separate, followed by color prints and other reflective art. Rigid art that must go on a large flatbed scanner or process camera costs the most.

PROCESS COLOR PRINTING

The mechanics of printing can't match the chemistry of photography. Printers work with inks in dot patterns, not with dyes or pigments in continuous tones. Printed images are themselves reflective art influenced by inks, coatings and especially paper. Working with only four colors of ink, printers must try to create

the illusion of all other colors.

Consider the matter of brightness. A good transparency appears twenty times brighter than ink on gloss paper. There is no way that even the best color printer can come close to reproducing its vivid tones.

The process of separating and printing compresses the color gamut and results in loss of detail and contrast. Even a good color photographic print is better than most color press work. Color prints are about twice as bright as four-color process printing on glossy paper.

To get an idea of how the image on a transparency will appear after separating and printing, make a photographic print first. The print will look much more like the printed piece than the transparency.

Color depends on taste. What is vivid to

normal exposure, good detail

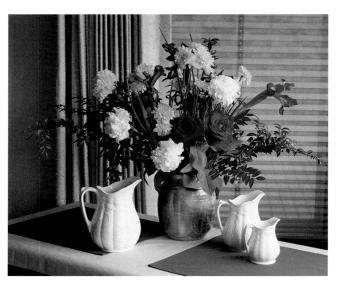

blue color cast

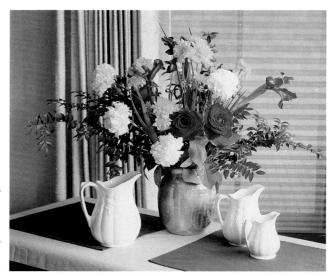

overexposure, poor highlight detail

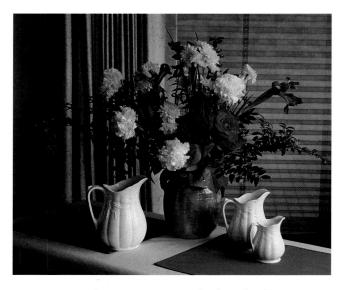

underexposure, poor shadow detail

4-8 Color photos Color films exposed under improper lighting may have a color cast. Underexposure or overexposure can also lead to loss of detail in shadows or highlights. Prepress services may eliminate casts when making separations, but they can't put details into separations when none exist in originals.

Photo by Kathleen Ryan

one person seems flat to another; a little more red for the designer may seem like a lot more red to the printer; the photographer might see a blue cast that no one else can detect.

Color is subjective, but you can talk about it in plain English. At a press check, say that you think there is too much orange or that the greens aren't bright enough, and let them worry about adjusting the magenta or the cyan. Describe the problem, but don't tell the printer how to fix it.

Printers can make some colors more vibrant by adding a fifth color of ink. For example, red areas already printed magenta become much brighter when printed again with rubine or rodomine. This technique requires a separate halftone negative, plate and inking station for the fifth color.

A few prepress services and printers are experimenting with separating color photos into five, six and even eight halftones. New combinations, known as high-fidelity color, might include a second yellow and a second and even a third red in addition to the standard process colors. High-fidelity color costs much more than four-color process prepress and printing.

Prepress services can make color in the printed product look quite different from color in the original. Color correcting the overall image, such as eliminating a green cast, is easy and inexpensive. More precise correcting, such as improving skin tones, takes more attention and thus costs more.

Color looks most vivid when printed on coated, white paper. By preventing ink from being absorbed, coatings ensure sharp images. White paper provides a background that interferes very little with ink colors.

TONE COMPRESSION

Images and scenes have less contrast on printing paper than as photographs and much less than our eyes see in the real world.

The difference between the lightest whites and the darkest blacks in everyday scenes may be as much as 1000:1. The human eye can perceive this difference. Photographs are limited to a difference of approximately 100:1 and halftones on premium coated paper to a difference of approximately 20:1. The darkest blacks on press sheets are much lighter than those in photographs or in nature; the lightest whites on press sheets are much darker than in photos or nature.

Tone compression is unavoidable in the transition from original scene to photograph to printed product. It can, however, be taken into account by using measured photography. In measured photography, a photographer controls lighting to produce a photo whose critical details fall within the tonal range of four f-stops for color printing on coated paper. In addition to ensuring more predictable results on press, the technique eliminates bracketing and produces consistent images for scanning in groups (ganging).

Notice the phrase "critical details." As with every aspect of printing, measured photography represents compromise. By targeting critical details, you may sacrifice detail in other portions of the image.

Measured photography deliberately compresses tones to ensure faithful reproduction by reducing densities in shadows and holding densities in highlights. Viewers notice loss of details in highlights more easily than in shadows. As a rule of thumb, coated paper can reproduce photos having a density range of 1.90, and uncoated paper can reproduce photos with a density range of 1.40.

Density range—the difference between the darkest and lightest areas of copy—determines contrast. A photo having relatively dark highlights or relatively light shadows has a small density range and thus has low contrast.

Density range is measured using a densitometer. For example, a bright highlight on coated paper might have a density of .10 and a dark shadow a density of 1.90. Therefore, the density range of the image is 1.80 (1.90 minus .10).

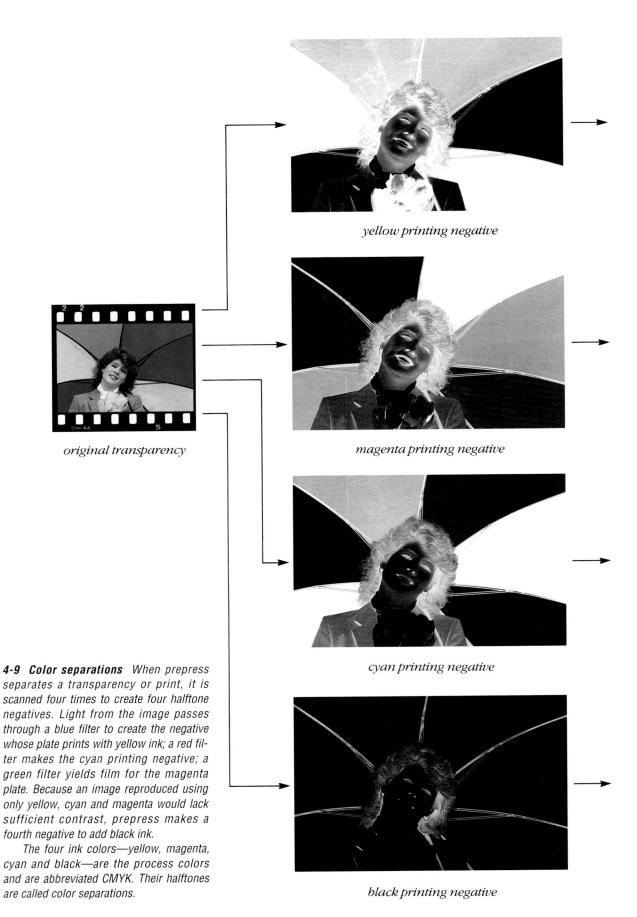

48 GETTING IT PRINTED

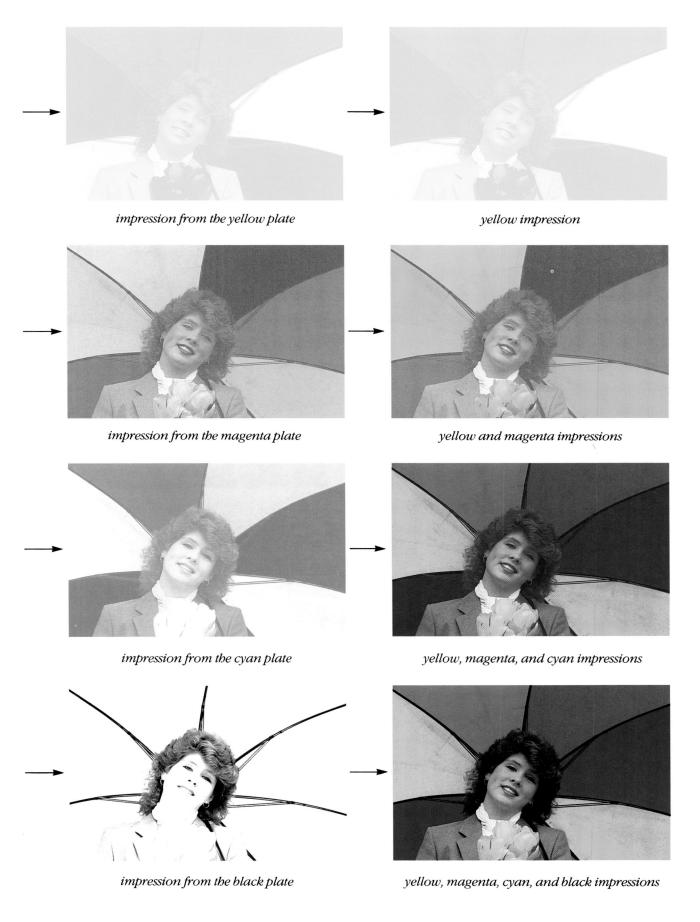

electronically assembled image

unmanipulated images

4-10 Image assembly and retouching Prepress services can change an original image or regroup portions from several images to create a new image. Color correction, retouching and assembly require powerful computers with large memories and complex software operated by highly skilled staff.

4-color process printing in register

4-color process printing out of register

4-11 Register of process color Register affects color as well as sharpness. Whenever you inspect proofs or press sheets, verify correct register before evaluating color. If color changes during printing, check register before looking for other possible causes.

TAKING ADVANTAGE OF GANGING

Ganged images are all shot at a common exposure rather than at exposures determined for the needs of individual images. When a prepress service halftones or separates more than one photo at once to save time and materials, the photos have been ganged. Getting the best possible quality requires careful planning. Even with the best planning, however, ganging cannot result in quality as good as exposing to capture the best of each original.

You must scale all photographs for ganging to the same percentage. No camera or scanner can reproduce one original at 100 percent and another at 75 percent in the same shot.

To gang photographs at different sizes, order duplicate transparencies or prints to the desired size, then gang the duplicates.

Successful ganging depends on selecting photographs with certain characteristics in common. All must have similar contrasts. Transparencies for ganging should have equal color balance and density and be from the same brand and type of film. Ganging may result in some loss of quality, but costs less than having many images shot separately.

5. PREPRESS, PROOFS AND PLATES

Creating mechanicals
Preparing photographs
Process cameras and
imagesetters
Stripping film and flats
Proofing methods
and materials
Proofs costs and brands
Making printing plates
Saving mechanicals
and film
Prepress and imaging
services

Graphic design combines art, skill and technology for purposes of communication. The designer imagines how a piece will look and perform, then plans the route from vision to reality.

This chapter deals with the plan. It explains the stages known collectively as prepress and describes alternative ways of taking each step.

Prepress begins when you assemble images that you want a printer to reproduce. You may gather the images:

- On paper or acetate overlay. These media form hard mechanicals, also called art boards. Because prepress operators use them to make film for platemaking, they are called camera-ready copy.
- As computer files. This medium forms electronic mechanicals.
- *On film*. This medium is used during stripping and for making printing plates.

Printers use mechanicals as the starting point for making film and plates. When you understand the relationship between mechanicals, film and plates, you have a great deal of control over the quality, schedule and cost of printing.

Many printing jobs enter prepress as a mix of hard and electronic mechanicals. For example, you might use a computer to assemble type and graphics, but transmit photos as prints or transparencies. Sending photos as

loose proof

composite proof, integral

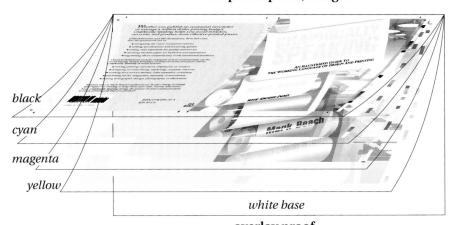

overlay proof

5-1 Common proofs Blueline, overlay and composite laminate proofs are each made from film ready to make plates. Read pages 62 to 68 to learn how to use each kind of proof most efficiently for your printing jobs.

camera-ready copy instead of as computer files means that you reduce requirements for computer hardware, software and skills.

Prepress activities point toward making plates and use proofs to measure success along the way. Working proofs reveal errors and opportunities to improve the job. Final proofs confirm that the printer is ready to make plates.

Because of the frequency of alterations and poor planning for efficient stripping or output, prepress expenses are the most likely job costs to get out of hand. Controlling quality and costs requires knowing how to read proofs and understanding how much work is involved to make various types of changes. Both you and your printer stand to gain or lose more money in prepress than anywhere else in the production process.

CREATING MECHANICALS

Regardless of whether you design using simple pen and paper or the most complex computer software, a printer needs your vision in a form that meets precise technical requirements. That form is a mechanical, the first step in print production.

There are two kinds of mechanicals: hard and electronic. A hard mechanical is a combination of mounting board and overlays from which a printer makes film or plates. An electronic mechanical is a group of computer files used for the same purpose.

Techniques for preparing mechanicals span the entire range of graphic arts technology, from simple hand pasteup to complex electronic assembly. For many jobs requiring basic quality printing, novices can do pasteup. Making mechanicals for premium or showcase quality printing, however, requires professional skills found at graphic arts studios, ad agencies and prepress services.

Hard mechanicals

Production artists can assemble type and graphics onto a mounting board and overlays made of tissue or acetate. The name of the procedure and its end product varies from one part of the country to another. I refer to the procedure as pasteup and to its end product as hard mechanicals. Some professionals use the terms "keylines," "artboards" or "pasteups" instead of mechanicals. People who make hard mechanicals are sometimes called keyliners or pasteup artists.

Pasteup requires a knowledge of both technology and art. There are lots of tricks, but few absolute rules; problems often have several solutions. Variations follow schools of thought

among graphic designers and their teachers. Styles vary over time, from one city to another, and from one prepress service and printer to another.

Electronic mechanicals

You can supply computer files ready to output as film or printing plates. An electronic mechanical usually represents creative work done using several computer programs that is merged into one program before final output.

For products with rather simple design requirements, such as directories, proposals and in-house newsletters, you can produce an electronic mechanical using word-processing or database software. These applications include an ample selection of fonts and graphics. And they let you import drawings and infographics created in other applications such as spreadsheets.

Products requiring complex design use art and desktop publishing software to create electronic mechanicals. These applications, with brand names such as QuarkXPress, Page-Maker, and Ventura Publisher, let you create pages composed from many complex graphic elements.

Electronic mechanicals have both pros and cons when compared to hard mechanicals. On the plus side, computer-aided production offers:

- *Speed*. A skilled operator can produce an electronic mechanical much faster than a pasteup artist could produce a hard mechanical.
- *Control*. Production becomes part of design.
- *Creativity*. A designer can try an idea, view it on the screen, and decide instantly whether to include it with the mechanical.
- *Dummies*. You can see a printout of the mechanical at any stage of development.
- *Precision.* Machines operate within .001 inch tolerance from one negative to the next, assuring precise and consistent register.

Disadvantages of computer-aided production include:

- *Skill level*. Operators require extensive and, even more important, continual training in using software.
- *Invisible mistakes*. Typos and errors that would jump off a page seem to hide on a computer screen. Furthermore, just one wrong keystroke or misplaced layer can make the entire file print out incorrectly.
- *More complex design*. It's so easy to add one more element or technique that redesign never stops.
- *Cost.* Continual training, new hardware and software, and rising design expectations all lead to higher costs. In addition, more sophisticated design—more color, reverses, trapping and photos—results in higher printing costs.

Desktop publishing software uses computer code known as page description language. The code makes page design independent from the software or hardware used to create it. You can work on pages using various machines or applications, then print them out using still more devices. This flexibility among systems is called open prepress interface.

The most common page description language is PostScript, which enables a wide variety of computers, printers, imagesetters and software applications to work together.

5-2 Hard mechanical Film made from the mechanical at right would go into two flats to make two plates for a two-color printing job. The base mechanical leads to the black that prints black ink; the overlay leads to the plate that prints the second ink color.

PREPARING PHOTOGRAPHS

When you supply a hard mechanical, you present photos separately as prints or transparencies. You identify the location of each photo on the mechanical with keylines, a window or a copy of the photo.

Although it is possible to include photos on computer files for electronic mechanicals, high-resolution photos require large amounts of memory for storage and powerful machines to build them into designs. You may find it faster and more convenient just to supply them as loose art.

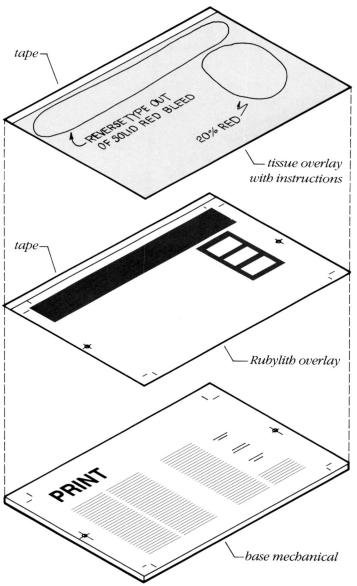

5-3 CHECKING A HARD MECHANICAL

Your eye makes pasteup appear as your brain wants it to look; a process camera shows elements as they actually are. Dust and smudges get photographed along with type and rules.

Use the following list to verify that hard mechanicals are ready for prepress. Also remember an important intangible: Mechanicals tell printers how professionally you approach your work. Clean, complete work with clear instructions gets the respect it deserves.

Identification. Mark each mechanical and each photograph or illustration with a personal name and phone number, and the name or number of the job. Place information on the front of the board outside the image area.

Correctness. Verify that words say what they are supposed to and that photos and art are what you want.

Completeness. Check that each board and overlay includes all the type, art and graphics it is supposed to have. Keep the job together by giving all mechanicals, loose art and dummies to the printer at one time.

Accuracy. Verify marks for cropping, corners, folding, trimming, scoring and perforating. Register and trim marks must align

correctly on mounting boards and overlays.

Security. Tightly adhere and burnish all copy. Mechanicals should have strong backings protected by heavy tissue during handling, transit and storage.

Cleanliness. Inspect boards, overlays and tissues to ensure they have no smudges, fingerprints, bits of glue or wax, or stray guidelines.

Coordination. Examine loose copy such as photos, graphs, maps and illustrations to verify they are clean, cropped, scaled and keyed according to some system understood by the printer.

Communication. Look at each board and overlay to ensure it includes specifications about ink colors, screen rulings and densities, masks and reverses.

Proofs. Make sure that you have two photocopies of each board and overlay so you and the printer each have a proof.

When you deliver mechanicals, make a final check of job specifications. Your printer should agree that mechanicals represent the work described in specifications. If not, determine differences, decide on how they affect production and costs, and write the new information on the specifications sheet.

When you give loose photos to a printer or prepress service, you must clearly identify, crop, scale, and relate each image to your mechanical. Identify every photograph with your name, the job name and a number. For best results, mount each print on a backing sheet. Write instructions and place crop marks on the mount board or tissue overlay, or in the image-side margins of unmounted prints.

Avoid writing directly on the back of a print or attaching anything to it with staples or paper clips that may scratch. If you have no margin or mounting board on which to put instructions, write on a lightweight piece of paper and tape it to the print as an overlay. If you must write on the back of the print, write on a peel-off label first, then attach it to the photo paper.

Crop each photograph to indicate the portion you want printed. Ask your printer whether to draw crop marks in black on the white margins, cover each print with a tissue overlay and draw lines on it, or provide scaled and trimmed photostats. The last method gives printers the most accurate, complete

information and can be used for transparencies as well as prints. It also allows you to see how the job looks with photographs in position. You can also photocopy images at enlarged or reduced sizes and draw crop marks on the copies.

Cropped, scaled copies are called position stats and should be pasted up within keylines. Mark each position stat with a piece of white tape showing the number of its corresponding photograph and the words "for position only," usually abbreviated FPO.

Enclose each transparency in a clear envelope taped to its corresponding print or photocopy. Write a numeral or letter on the envelope, print and mechanical so all three are keyed to each other. In the case of slides, you can show crop marks on the cardboard mountings.

Relate photographs to your mechanical using the method that your printer suggests. Keylines and position stats work better than windows because printers can make windows faster, more accurately, and with higher quality results than you can.

A prepress service can easily reduce or enlarge photos to make them fit your layout, but you must identify the new size that you want. Scaling determines the new size expressed as a percent of the original as follows:

- Same size as the original = 100 percent
- Smaller than the original = less than 100 percent
- Larger than the original = more than 100 percent

If you want the image 10 percent smaller, tell the operator to reproduce it at 90 percent; if you want it 10 percent larger, ask to have it at 110 percent. With no instructions, prepress assumes that you want 100 percent. Writing "same size" or "SS" makes it clear that you want copy reproduced without changing its size.

Graphic arts professionals figure reproduction size with a simple, inexpensive device called a scaling, proportional or percentage wheel. You can purchase wheels at art and graphics stores. Operating instructions are printed on them.

Remember that enlarging copy magnifies film grain and jagged edges. Reducing copy shrinks every aspect. Fine lines or dot patterns may end up too thin to print or disappear altogether.

When you scale a photo, specify dimensions that allow it to overlap the keylines or windows by at least ½16 inch on each edge. This extra ½16 inch gives printers plenty of room to ensure that photos fit properly. Photos to bleed should overlap the bleed edge by ½8 inch.

When you use only parts of an image, remember to crop first, then scale the new image, not the entire photo with which you started.

For basic quality printing, a photocopy machine produces scaled results adequate for camera-ready copy. Process cameras, however, give better quality reductions and enlargements for good, premium and showcase work.

PROCESS CAMERAS AND IMAGESETTERS

When you supply a hard mechanical, prepress uses a process camera to translate it to film. An electronic mechanical travels from computer memory to film or plate via a machine called an imagesetter. Prepress services may prepare loose photos using either a process camera or, more likely, a combination of scanner and imagesetter.

The "camera" part of "camera-ready copy" refers to process cameras, devices at the heart of preparation for printing based on hard mechanicals. Process cameras are optically sim-

"After two days of shooting on location, my client decided to reverse titles out of the sky. If I had known they wanted that, I could have framed for more sky. Of course, prepress can always use computers to add fake sky, but that costs much more than having me shoot real sky in the first place."

ilar to personal cameras. With both, operators control the amount of light passing through the lens and focus images onto the film.

The color of camera-ready copy does not relate to ink colors used when the images are printed on presses. The film sees the images as either black or white; if a color isn't strong enough to record as black, it drops out entirely to become white. When the plate made from the film is on press, the images that recorded as black can be printed with ink in any color. Words that were black in typesetting can print green or brown.

Quick printers have process cameras that make plates directly from hard mechanicals.

Platemakers make plates within the camera itself in an automated sequence begun by exposing the image, a process called photodirect platemaking. The machines can reduce or enlarge an entire mechanical.

When you supply an electronic mechanical, prepress uses an imagesetter to output your computer files as film or plates. An imagesetter is a sophisticated cousin to a laser printer. Compared to a laser printer, it has:

- *Higher resolution*. Laser printers output at 300, 400 or 600 dpi, whereas imagesetters' output ranges from 1,200 to 5,000 dpi.
- Larger substrate size. Maximum output size on a laser printer may be $8^{1/2}$ " x 11" or 11"

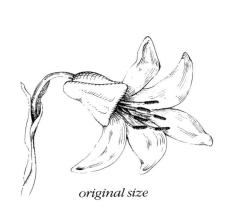

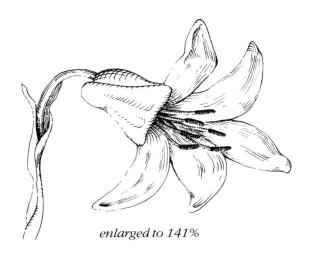

reduced to 83%

original size

5-4 Enlarging and reducing The arithmetic of scaling involves only one dimension (width or height), so it's easy to forget that copy shrinks or grows in two directions. A photo enlarged to 120 percent may appear much bigger than you expected; one reduced to 50 percent may lose too many details. Enlarging to 200 percent means the new copy occupies four times the area as the original—twice as high and twice as wide.

Resolution of	Screen ruling in lines-per-inch											
laser printer	60	65	80	85	100	110	120	133	150	175		
or imagesetter	line	line	line	line	line	line	line	line	line	line		
in dots-per-inch	screen	screen	screen	screen	screen	screen	screen	screen	sgreen	screen		
300	25	21	14	12	9	7	6	5	4	3		
400	44	38	25	22	16	13	11	9	7	5		
600	100	85	56	50	36	30	25	20	16	12		
800	178	151	100	89	64	53	44	36	28	21		
1000	278	237	156	138	100	83	69	57	44	33		
1270	448	382	252	223	161	133	112	91	72	53		
1700	803	684	452	400	289	239	201	163	128	94		
2540	1792	1527	1008	893	645	533	448	365	287	211		
3250	2943	2500	1650	1462	1056	873	734	597	469	345		

Chart courtesy Robert SI

5-5 Output resolution, gray levels and screen rulings The resolution of your laser printer or imagesetter determines the number of gray levels that you can achieve at various screen rulings. The chart above shows the gray levels you can expect from common output resolutions.

To produce effective halftones or separations and reduce the risk of banding, you need at least 256 levels of gray. Satisfactory results require using a combination of output resolution and screen ruling that keeps gray level in the shaded area of the chart. For example, if your magazine calls for 133-line screens, you should output separations on an imagesetter capable of at least 2,540 dpi. A newspaper using 85-line screens, on the other hand, requires an imagesetter capable of only 1,700 dpi.

- x 17". Most imagesetters produce four-page impositions film 25 inches wide and many produce eight-page forms up to 40 inches wide.
- *More precision*. The material and placement of rollers or drums, the construction of the overall machine, and even the kind of laser light used is far superior to a laser printer.
- *Higher cost.* You can spend \$1,000 to \$20,000 on a publication quality laser printer and \$50,000 to \$200,000 on an imagesetter.

Imagesetters vary greatly in how precisely they output a file. One machine may output the same file at ± .0001 inch, another machine at ± .0002 inch. The same machine may vary ± .0001 inch today and ± .00015 inch tomorrow. These variations, known as repeatability, have little effect on one-color or flat color printing. They can, however, cause major shifts in process colors because of how they influence register and dot size. For example, if your color build calls for C 20 percent, M 30 percent, Y 50 percent and K 10 percent, and each color varies by only 5 percent, the result will look totally different from the color you specified.

Top quality imagesetters have almost dotfor-dot repeatability. If a prepress services company assures you that they calibrate their imagesetters every day or every shift, you might wonder why the machines need such frequent attention.

When two ink colors abut on the printed sheet, the images must register precisely. Precise register is called kiss register and is difficult to achieve and maintain throughout the press run. If register isn't perfect, variations in output or on press may lead to sheets with thin, unprinted lines between colors.

To avoid the exacting needs of kiss register, printers overlap colors approximately .01 inch. Overlapping ink is called image trapping. Flats and negatives for each color must register for trapping. Halftones and separations designed to print with abutting borders must trap the border lines.

Traps are made by spreading or choking images—making them slightly larger or slightly smaller. Operators do this with a process camera or with a computer using page assem-

mounted photo with instructions and crop marks

mechanical with keyline

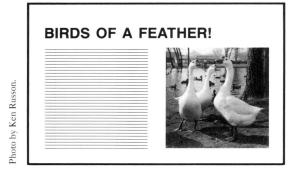

printed piece

5-6 Keying photos to mechanicals Using keylines combined with for-position-only (FPO) copies is the most reliable way to key photos to mechanicals. Even if you make windows, FPO copies ensure that your printer knows how you want images cropped and scaled.

bly software. Knowing when to trap, how much to trap, which colors to spread and which to choke calls for judgment based on screen ruling, anticipated dot gain, and quality expectations for the specific job.

STRIPPING FILM AND FLATS

Most printing plates are made from film negatives. While it is technically possible to use a process camera or an imagesetter to go directly from mechanical to plate, prepress staff usually produce film first.

Graphic arts film is different from film for personal cameras. Personal photographic films make continuous-tone images by responding to the full range of colors and intensities. Film used in process cameras and imagesetters produces high-contrast negatives. Portions of negatives are either black (transmit no light) or clear (transmit all light). High-contrast film has

no middle ground for intermediate tones.

Printing presses apply ink on an all-or-nothing principle. An area of paper either receives ink from the press or it doesn't. Negatives transmit light on the all-or-nothing principle required by the printing process. The clear, image areas of graphic arts negatives correspond to the areas of paper that receive ink when on press.

Graphic arts film responds to red and light blue quite differently from personal film or the human eye. Red records as black, meaning that red copy can substitute for black. Light blue does not record at all. The disappearing act is highly useful because you can write instructions on hard mechanicals in nonreproducing blue that doesn't transfer to the film.

Prepress staff must assemble negatives from process cameras and imagesetters before platemaking. The procedure, called stripping,

mechanical with position stat inside keyline

involves affixing negatives in correct position on a masking sheet of opaque paper or film often called by the brand name Goldenrod.

Working at light tables, strippers tape the negatives to the masking material. They then cut away the mask covering the image area of the negative to form a window. Light can pass through the image area of a negative and through the windows in the mask, but not through the masking material surrounding them. The final assembly is called a flat.

One flat may contain all the negatives needed to make a specific plate or only some of them. For example, one flat might contain halftone negatives and a second flat contain negatives for type. Both flats would be required to make the same plate for a piece having both type and halftones that print in the same ink color.

Negatives include register marks and keylines added during pasteup or computer design. Strippers use the guides to position negatives and art precisely in relation to each other. If the guide marks are slightly off, the printing could end up out of register or photos could be in the wrong places. Strippers also refer to layouts and dummies to show how the iob should look.

You cut costs and assure quality with stripping by getting as much copy as possible onto base negatives. Base negatives are those made from copy fixed to the mounting boards of hard mechanicals or the first layer of electronic

mechanicals. When all line copy appears on one surface, not on overlays, you save money by avoiding the need for additional film, camera work and stripping.

Mechanicals often include overlays. Each overlay requires its own negative and so increases the cost of preparation. When copy on the overlay prints in the same ink color as copy on the mounting board or first layer, making the overlay is simply a waste of money. When copy on the overlay is for printing in a different ink color, it saves money only if the color breaks are very complicated or if the inks overlap.

Simple color breaks are more efficiently handled by placing all copy on the mounting board or first layer, indicating breaks on a tissue overlay or laser printout, and letting the prepress make the proper negatives.

Letting strippers make color breaks has the additional advantage of ensuring correct register. If all copy is on the mounting board or first layer, it's already registered. There is no second item that might get out of alignment.

Strippers lay out flats so that, when press sheets are folded, pages appear in proper sequence. Correct arrangement of pages is called imposition.

Imposition can involve complicated plans. Consider a simple one-color, sixteen-page booklet with no halftones, to fold from one sheet of 23" x 35" paper, printed eight pages on each side. The top portion of Visual 5-7 shows

"Never show proofs to a committee. One person always finds something to change and pretty soon everyone plays the game. Showing proofs to a committee is like tearing up your job and starting from scratch."

such a booklet. Depending on the mechanicals and process camera or imagesetter, as many as sixteen negatives might be stripped into two flats to make two plates; one plate to print each side of the paper.

Now consider that same sixteen-page booklet printed black and red and with ten halftones. That product may require as many as forty-two negatives: sixteen for the black, sixteen for the red, and ten for the halftones. The forty-two negatives go into six flats, three for each side of the paper. The three flats are (1) type and line art for printing in black ink, (2) type and line art for printing in red ink, and (3) halftones for printing in black ink. A large catalog or book such as this one may have a thousand negatives assembled onto a hundred flats.

Folding affects imposition almost as much as printing. You can experience the possible variations by folding a piece of typing paper into eight-page or sixteen-page signatures. Every variation you can devise is also found in folding machines.

Imposition depends on the specific press and bindery equipment used to produce the job. Make sure that dummies and layouts show accurately and completely how you want the job to appear when finished, but rely on prepress staff for imposition.

While making flats, strippers check negatives for scratches, pinholes and other flaws. Using either a paint called opaque or red litho tape, they cover defects or unwanted copy. Opaquing or taping a negative is similar to using white correction fluid to cover a typing mistake: The flaw is simply covered.

Some complicated jobs require producing flats in two stages. The first involves making working film. Changes at this stage are relatively easy and inexpensive. In stage two, composite film is made from the working film. Composite film is assembled ready for making plates. Even a simple change after the composite film is ready may require a whole set of new negatives.

PROOFING METHODS AND MATERIALS

You can avoid feeling confused or intimidated when producing printing jobs by learning how to ask for the right proofs. Knowing which proof goes with which job helps you verify quality, stay on schedule and prevent costly mistakes. And knowing what to look for at each proof stage helps establish who's responsible for what—which becomes important if things go wrong.

Typically, a print job passes through three or four principal stages before it's printed: as an electronic file created using word-processing or page-layout software; as hard copy such as mechanicals or transparencies (unless you bypass this step); as film (either output by an imagesetter or exposed from mechanicals); and as printing plates. At each stage you can inspect a variety of products that serve as proofs.

A proof is any test sheet made to reveal errors or flaws, predict results on press, and record how you intended the job to appear when finished. Notice the word "sheet." The outcome of printing is images on paper. Don't proof a printing job on a computer screen.

Checking proofs as jobs progress is the only way to verify that mechanicals, negatives, and flats are accurate and complete before making

5-7 Imposition (opposite page) Many printing jobs have several ways that prepress staff can impose pages. Layout takes into account press and paper size and configuration of the folding equipment that will run the job.

The illustrations at right represent three ways that a printer could lay out a sixteen-page booklet. These are typical ways, not all the possible ways.

Although several software programs for desktop systems help with imposition, they are made for printers and prepress services, not for printing customers. Unless you have clear agreements and have made several satisfactory tests with your printer, you should arrange your publication in single pages and let your printer plan imposition.

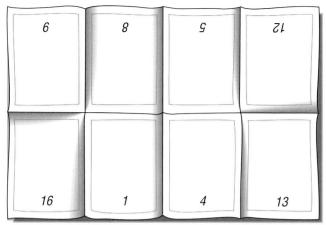

16-page press sheet on 23" x 35" stock

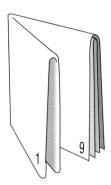

16-page signature

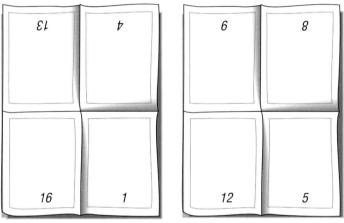

Two 8-page press sheets on 17" x 22" stock

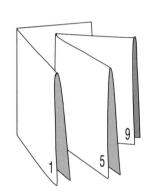

Two 8-page nested signatures

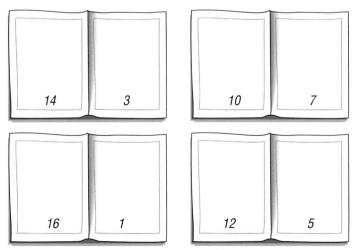

Four 4-page press sheets on 11" x 17" stock

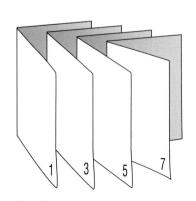

Four 4-page nested sigs

plates. Having proofs at press time means that you can efficiently check the first printed sheets. Proofs also help determine who is responsible for mistakes and who should pay for corrections.

When examining proofs, follow two strict guidelines:

• Verify that a proof of a computer file represents the latest version of the file. Even one keystroke or mouse click can change the file to make the proof irrelevant.

• When evaluating color, use the proper lighting conditions described in chapter three.

Some proofs show only portions of a job, such as photos. These are called loose, random or scatter proofs. Others, which are called composite proofs, show fully assembled type, graphics and art.

You can see how color images will appear when printed by ordering loose proofs of separations. Loose proofs reveal needs for color cor-

5-8 PROOFS FOR TYPICAL JOBS

Here are some printing jobs and the kinds of proofs each would typically require.

Newsletter two-color with halftones for quick printing (paper plates).

- Laser printouts of type and scanned halftones.
- Duplex photocopies of 11" x 17" imagesetter printout in printer spreads.

Newsletter two-color with halftones for commercial printing (metal plates).

- Laser printouts of type and scanned halftones.
- Blueline. Also possibly loose whiteprints of the halftones.

Book, directory or manual with one-color text and two-color cover.

- Laser printouts of text type and cover art.
- Overlay of cover.
- Blueline of entire job.

Catalog or magazine with four-color process separations. Color photos stripped by hand for "pleasing color" quality.

- Laser printouts of assembled type, line art and keylines.
- Overlays of imposed flats.

- Blueline of entire job.
- Routine press check.

Brochure or poster with four-color process separations. Color photos scanned into electronic files for "match transparency" quality.

- Laser printouts of fully assembled pages.
- Composite digital color printouts.
- Loose laminates of separations.
- Blueline.
- Careful press check.

Brochure or annual report with separations for "match original quality," fifth flat color to match swatch, and foil embossing on cover.

- Laser printouts of fully assembled
- Two or three rounds of composite digital color printouts.
- Two rounds of loose laminates of separations.
- Two rounds of composite laminates.
- Production proof of dies and foil on actual cover stock.
- Ink drawdown on actual text stock.
- Blueline of entire job.
- Scrupulous press and bindery checks.

5-9 THREE LEVELS OF PROBLEMS

When a proof reveals a flaw, assign it to one of the following categories. Defining the importance of flaws helps you decide quality questions and control costs and schedule. Whether a specific situation calls for signing an imperfect proof depends on the nature of the flaws, your confidence in the printer, and your budget and schedule.

Critical flaw. A critical flaw ruins your job so you cannot use the printed product.

A critical flaw means the job is unacceptable. It requires fixing the problem, then getting another proof. If it appears on the final product, the job must be printed again.

Major error. People notice a major error and it may detract from the value of your product.

A major error means the job is acceptable, although not satisfactory. Whether you fix a major error depends on the cost of repair, your deadline, and your guess about its impact on the printed piece.

Minor defect. Probably only you and your printer notice a minor defect. If anyone else notices, they don't care.

Almost every job contains minor defects that could have been avoided if you had had more time, money or skill.

recting before separations are assembled with type and graphics. In addition, loose proofs show images scaled to finished size, thus revealing whether cropping was properly done.

Loose proofs of separations, however, do not show overprinted or reversed type. For a prepress evaluation of how mechanicals and photographs have been blended for the job as a whole, ask for a composite proof.

Proofs come in many forms. Which form you use for a specific printed product depends on what you consider important about that product. If your catalog must have zero typos, output from a laser printer is a sufficient proof of type. If the products it shows must match photos of those products, you need a color proof made from final film. And if flat colors must match corporate color standards, you can only trust a press sheet to reveal whether you have attained that goal.

Photocopy

A photocopy of a hard mechanical is the most common kind of proof for quick printing. Make two photocopies of every mechanical, one for you and one for the printer. Stick pages together back to back for two-sided jobs. Collate, fold, trim, staple or drill just as you expect to receive the job from bindery. Leave nothing to the printer's imagination.

Use a photocopy to check:

- text and headline typos and placement
- keylines or halftone cropping, size and position
- placement of rules, reverses and tints
- guide marks for trims and folds
- shadows, blemishes, stains or glitches

Laser print

A laser print shows in low-resolution black and white the contents of computer files or portions of documents, such as layers.

Use a laser print to check:

- text and headline typos and placement
- keylines or halftone cropping, size and position
- placement of rules, reverses and tints
- guide marks for register, trims and folds

Blueline

A blueline is a photographic contact print of plate-ready negatives, so it is a composite proof. Bluelines are made on paper with the same dimensions as the press sheets for your

Full Bench Press Haystack OR 94782 (423) 598-3000 • Fax (423) 598-3119 job name _ \square first proof \square second proof \square third proof ☐ OK to print with no corrections. ☐ OK to print with corrections. ☐ DO NOT PRINT. Make corrections and supply new proof. Art returned with this proof. Type of new proof needed. all art ☐ blueline of form # accorrection art only complete blueline no new art ☐ loose whiteprints ☐ whiteprint of form # ____ overlays of form # ____ Customer must sign ☐ loose laminates before work can proceed. ☐ laminate of form # ___ signature date & time signed

5-10 Proof approval slip An approval slip such as the one above accompanies proofs from your printer or prepress service. The job is on hold until you sign the slip and return it with the proofs. Here's how to decide which box to check.

- If you spot a critical flaw, ask for another proof showing corrections.
- If you identify a major error, authorize printing after changes are made.
- If you see minor defects, approve printing without changes. But circle the defect. Often prepress can correct a minor defect as simply as blowing dust off the flat.

job. Operators can fold and bind bluelines so you can check crossovers, backups, page sequence and photo placement. You may also hear a blueline called a silverprint or by the brand name Dylux.

Use a blueline to check:

- text and headline placement
- halftone cropping, size and position
- placement of rules, reverses and tints
- page sequence
- crossovers and backups
- scores, perforations, and drills
- trims, folds and binding

Whiteprint

A whiteprint is also a contact print of plateready negatives. Whiteprints are usually used as loose proofs, not composites. You may also hear a whiteprint called by the brand name Velox.

Use a whiteprint to:

- check halftone fidelity
- compare a variety of screen tints
- back up a hard mechanical

Digital color

You can make color proofs of computer files using a wide range of color printers based on toner, thermal wax, dye sublimation or ink jet printing. Low-end machines are inexpensive and fit easily into desktop environments. More expensive, high-end machines require skilled operators and are typically found at larger agencies, studios, service bureaus and printers.

Use low-end digital color to check:

- text and headline placement
- cropping, size and position of separations
- placement of rules, reverses and tints
- "pleasing color" relationships

Use high-end digital color to check:

- color builds
- "match original" quality

Use digital proofs only if your job goes directly from computer to plate. If your job goes to film first, check an integral proof made from film, not a digital proof.

Overlay

An overlay proof shows each color of a flat on a separate sheet of polyester film. Sheets are laid over each other in register and taped to backing paper. Overlay proofs for four-color process jobs have four pieces of film taped together, one for each process color, as shown in Visual 5-1. The proofing material is also available in colors that simulate popular flat ink colors. Proofs are known by brand names such as Color Key, Cromacheck and Color Check.

Overlay proofs are fast and inexpensive to make but have the disadvantage that the overlays themselves have a slight color cast, either yellow or gray. Looking through three or four layers can distort colors and sharpness.

Use an overlay proof to check:

- placement, trapping and register of flat
- "pleasing color" four-color process
- position of varnish or other coating

5-11 HOW TO READ A PROOF

Use proofs to help control quality and cost and ensure good service. When examining a proof, keep these items in mind.

Slow pace. Take your time. Don't let a deadline make you careless.

Individual features. Make a list, then check each feature throughout the entire proof. For example, go through once just to confirm page sequence. Next check borders and rules for alignment and crossovers. Continue to examine headlines and display type for typos and placement. Finish by studying areas of critical register and color.

Photos. Check every photograph to verify that the correct image is in the correct space, is scaled and cropped properly, and faces the proper direction. Look for sharp focus, especially in portions of the image farthest from the center.

Flaws. Boldly circle every blemish, flaw, spot, broken letter, and anything else that seems wrong.

Previous corrections. Double-check any corrections made on previous proofs.

Instructions. Write directly on the proof in a clear, vivid color. Be very clear and explicit.

Finishing. Anticipate bindery problems. Measure trim size. Check that folds are in the correct direction and relate to copy as planned.

Colors. Confirm that you know what copy prints in what color when proofing multicolor jobs on bluelines. Double-check to make certain.

Overview. Stand back to view the proof as a whole. Everything should work well together to make the message clear and attractive.

Questions. Ask about anything that seems wrong. Asking questions that seem stupid is a lot better than printing mistakes.

Costs. Discuss the cost of changes and agree about who pays for what.

Integral

Integral color proofs are made from either working film (for loose proofs) or flats (for composite proofs). They look similar to color photographs or to finished printing done on glossy paper. Printers can match dyes and toners to inks, ensuring the best possible parallel between proof and printed product. Integral proofs are known by several brand names such as Agfaproof, Cromalin, Color Art, Matchprint and Signature.

Integral proofs sometimes look better than the printed product because they do not show dot gain. If made from film adjusted for dot gain, on the other hand, color in integrals may look too weak.

Use an integral proof to check:

- trapping and register of process colors
- "match original" four-color process

Press proof

Press proofs come from plates put on press, inked, and run on paper specified for the job. Being nearly identical to production sheets, they are the best proof. Only press proofs, for example, show the true effect of dot gain or the way in which the color of paper may affect ink colors when printed. For this reason, some customers regard them as essential to premium and showcase four-color printing. Press proofs, however, are costly in both time and money and are becoming less necessary as new technology makes overlay and integral proofs increasingly accurate.

Use a press proof to check:

- trapping and register of process colors
- "match product" four-color process
- ink density
- flaws such as doubling and slurring
- to further your education about print production

PROOFS COSTS AND BRANDS

Proofs gobble dollars and hours. Meeting your budget and deadline requires evaluating only proofs that relate to critical aspects of your "Sometimes you can proof too much. My boss thought her reputation was at stake with every little flier or throw-away piece we designed. She couldn't let proofs go, so we always ran late. She just didn't know which jobs to glance over and which jobs to sweat over."

printed product. If you know what matters most to you in a given job, you can choose the proofs that show it to you most cost effectively. Careful choice keeps costs down and lets you fix problems at the least expensive stage.

As a printing job moves from concept to press, proofs take longer to make, they represent the final result more accurately, and you pay more to make changes. Regarding cost, many production managers use the 5-50-500 rule: It costs \$5 to correct a mistake on the desktop, \$50 to correct the same mistake when found on a blueline, and \$500 when it's found on a composed laminate proof. Paying to correct a critical flaw discovered during a press check requires access to corporate gold reserves.

Your service bureau or printer includes the cost of proofs in the estimate for your job. Every job using plates made from film should include a blueline; for color process jobs, most printers want a laminate proof in addition and may produce one even if you don't ask for it.

Normal costs for good quality printing include one round of proofs. If you need a second or third proof, expect to pay extra, as you would for any alteration. Another blueline costs more time than money; another overlay absorbs the extra dollars you stashed in case of trouble; another composite laminate trashes your entire budget.

Normal costs for premium printing include two rounds of proofs, loose and composite. Showcase printing may involve three or four rounds.

Printers often refer to color proofs by the brand name of the system they use. Until you learn the brands, don't feel afraid to ask whether it's an overlay or laminate so you can decide whether you need it. Differences among brands of proofing systems influence the profit of printers and service bureaus but mean very little to you. As a customer, you face larger issues of quality, service and price that convince you to use one shop and avoid another. Unless your jobs involve the best possible color reproduction, pay little attention to brand names.

MAKING PRINTING PLATES

After you have approved final proofs, prepress makes the plates that form the last link between design and press work.

A printing plate carries the image that ink transfers to paper. No amount of adjustment on press can improve the quality of images coming off bad plates.

To understand how most plates for offset printing work, think of a fresh printing plate as you would a fresh piece of photographic paper. Both come from their package with no image and both have light-sensitive coatings. Exposure to light produces an image on the surface of either the paper or the plate.

Light passing through the clear areas of a negative transfers the image from the negative to the paper (photography) or plate (lithography). When portions of a plate are exposed to light, the exposed coating fuses to the metal backing and becomes receptive to ink.

The clear area of the negative through which light passes is the image area. Technically speaking, image areas may be as small as one dot in a halftone or as large as the entire plate. Printers, however, refer to the image areas as the portions of the plates that carry ink. The margins of this book page lie outside its image areas.

Lithographic plates are smooth: Both image and nonimage areas lie on the same plane. Chemistry attracts ink to image areas and repels ink from nonimage areas. Plates for letterpress, flexography and gravure printing (explained in chapter eight) feel rough and carry ink mechanically, not chemically; image and nonimage areas lie on separate planes.

Most lithography plates are based on the incompatibility between ink, which is oily, and water. A plate on press gets a thin coating of water each time the cylinder on which it is mounted revolves. Water adheres to the nonimage area, giving it a coating to prevent ink from also adhering. The image area has exactly the opposite reaction: It repels water and accepts ink. Some plates, used for waterless printing, have a silicone surface instead of a coating of water that repels ink.

Printers refer to exposing a plate to light as burning it. Making one plate from one flat requires a single burn (one exposure). Using two flats to make one plate is double burning (two exposures). Strippers may make separate flats for reverses, tints or corrections, so they might burn some plates three, four or more times.

Metal plates are burned by contact printing the plates with negatives stripped into flats. The procedure requires a device called a platemaker.

To burn a plate, operators put a fresh plate with its emulsion side up in the platemaker. They place the flat with negatives emulsion side down over the plate, then lower a glass cover. A vacuum system forces the flat into tight and uniform contact with the plate. Once contact is made, the plate is burned (exposed) by intense light that passes through the glass cover and negatives before striking the plate.

Platemakers use a pin register system to assure plates and flats are in proper register. The system consists of a row of small metal posts (pins) corresponding to holes at the edges of both plates and flats. When flats and plates are slid over the posts, they lie correctly registered to each other. Because printers use

"We used to think that time mattered more than money. We'd give files and art to prepress and let them figure out how to put them together. We could always run late. Now we think money matters more than time. Every file going out of here is complete down to the last pixel." "If I had to choose a new service bureau (thank goodness that I don't), I'd find the one with the best guru — part nerd, part magician, part robot. My guru would know my software better than I do and could run a printing press if necessary. Finding that person would cut my headaches in half."

different pin register systems, repinning may be necessary when flats are used by a printer who did not make them.

Once exposed, plates are developed by wiping chemicals across their surface. The chemicals remove portions of coating that were not exposed to light, leaving the image behind. Watching the image emerge as a metal plate develops is much like watching the development of an instant photo.

Paper and plastic plates for quick printing are made by an automatic platemaker. The "quick" part of quick printing refers in part to the fact that plates are made directly from mechanicals without the intervening steps of making and stripping negatives. Camera-direct plates are often called masters to distinguish them from metal plates.

Quick print plates work well for jobs that don't require fine detail. Designed for short runs, masters typically show signs of wear after approximately 5,000 impressions. Masters stretch and wiggle on press, making tight register impossible.

Shops doing quick printing can mount metal plates on their presses if necessary. A quick print press, however, even when using metal plates, is not capable of premium or showcase quality work that calls for more than one ink color.

Some offset plates are made directly from computer memory without the intervening steps of either hard mechanicals or films. Digital plates may be paper, plastic or metal, depending on the press and quality requirements for the job. They are burned by laser beams or electrostatic charges that form images from pixels similar to a laser printer or imagesetter.

Digital plates can move a job from design to press in a few minutes. Because they don't require film, however, you pay for speed in restricted proofing. Digital plates and final proofing are currently (early 1993) appropriate only for basic quality jobs, but their quality will improve to the good and premium levels by the end of the decade.

SAVING MECHANICALS AND FILM

If you're like most people, you're careless about filing materials and keeping records. You move on to the next job before the printer delivers the last one. Later—perhaps months or years later—you or your replacement wastes hours trying to figure out, locate or re-create something that you should have kept with the records.

To avoid the waste and stress caused by poor records, follow the advice in the next few paragraphs.

Delivery of your printing job should include materials that originated the printed product. If you don't have physical possession, you should know where they are stored on your behalf. Materials could include hard mechanicals, computer files, loose art, working film, proofs, final film (flats) and sample press sheets.

Keep hard mechanicals, loose art, proofs and press sheets together with your specifications form and other notes about the job. You'll need large, flat boxes to avoid folding some of the materials.

Prepress staff probably did further work on your computer files, so their versions went to film, not your versions. You should receive duplicates of the files from prepress clearly identified with information about your job. Store backups of computer files along with the paper records.

Service bureaus and printers save flats, but not plates. Negatives stay usable almost indefinitely, but plates can bend and get scratched during storage. In addition, you can easily update negatives, but not plates. Even for exact reruns, printers prefer to make new plates.

Flats store easily in horizontal file folders. For jobs frequently reprinted at a shop that you know you will continue to use, ask that operators write print quantities and dates on the folder holding flats for each job or in some other recording system. As the record builds over the years, it helps you plan and budget by telling you how many you printed in what months and years.

Few printers store flats indefinitely. If you think a particular piece will ever go back to press, ask about company policy. Some printers throw away flats after storing them for a year or two, but should notify you first.

The question of who owns mechanicals, negatives, flats and plates is different from the question of where they are stored. Generally speaking, the organization that creates the item owns it. That might mean that you own mechanicals and loose art, a service bureau owns film, and a printer owns plates.

Despite the claim of trade customs to the contrary, the issue of ownership remains cloudy unless it's part of a contract.

Furthermore, building good business relationships with service bureaus and printers renders the issue meaningless. To avoid any question, however, specify with each job that you own computer files and negatives even though they are stored elsewhere.

Few printers want to store your hard mechanicals or photos. If you want them stored at the printing company, make special arrangements. If not, make sure that the printer returns them promptly, check to confirm they are complete and sign for them. Mechanicals left at a print shop without instructions may be thrown away after the job is printed and delivered. Even if you still have mechanicals after a year or two, they may have degenerated so badly that no printer could make new negatives.

If you store any property at a printer's building, examine storage conditions to feel confident that your materials are reasonably safe from fire, humidity and water damage. Most printers feel responsible for your materials while using them but not while storing them.

Although computer disks, mechanicals and

5-12 INFORMATION TO ACCOMPANY MECHANICALS

When you transmit mechanicals to a printer or imaging service, verify that you supply all the following data.

Hard mechanicals

- job name and number; purchase order number
- customer name, address, contact person, fax and phone numbers
- printer name, address, contact person, fax and phone numbers
- list of loose art (photos, illustrations)
- mock-ups or dummies supplied
- color specifications and swatches
- list of proofs required

Electronic mechanicals

All of the informaton related to hard mechanicals, plus:

- hardware used (platform and models)
- all software used (name and version)
- all fonts used (manufacturer, name and style)
- number and names of files for output
- file formats (EPS, DCS, etc.)
- laser printout of last versions of all files
- list of special effects (such as graduated screens)

flats aren't worth much as physical objects, they are priceless because of the effort required to replace them. Insurance on your property while in the shop varies among printers, but ranges from none to marginal. Don't discover too late that mechanicals or photographs waiting for camera work are not insured. Check whether your business insurance covers the cost of making new flats or the value of your time to furnish new mechanicals.

PREPRESS AND IMAGING SERVICES

When you have mechanicals and art ready for prepress, you transmit them to your printer or to a prepress service. The separate service may be known by one of several names, such as service bureau, color house, imaging service or prepress service.

Equipment for prepress at a printing company includes light tables, process cameras and platemakers and may involve computers, scanners, proofers and imagesetters. An imaging service typically has more digital equipment than a printer but less photographic equipment.

Skills and equipment for prepress at printers and imaging services can overlap. A large printer may almost match the capacity of a large imaging service, while a small printer may do no prepress at all. A large imaging service may have specialists rarely found at printers, while a small imaging service may be able to duplicate what half the printers in town can do.

Prepress services change faster than any other phase of production, so insiders use many terms with imprecise meanings. For example, you often hear prepress systems referred to as "high end" and "low end." Each phrase relates to the power and cost of hardware and software currently available.

Generally speaking, "low end" means what you have in your organization and "high end" means what an imaging service or printer has, but today's high end is tomorrow's low end.

Many jobs involve prepress at an imaging service and further preparation at a print shop. For example, an imaging service might make color corrections, then output separations on film as part of one-up pages composed with type and graphics. The printer would strip the film into flats.

Whether you use an imaging service or give your materials directly to your printer depends on the nature of the job and your experience. If you produce a variety of printing jobs and work with several printers, you need a relationship with an imaging service. If you produce a printing job only once in a while or produce essentially the same job over and over again at the same printer, leave prepress in the hands of your printer.

Selecting an imaging service calls for different criteria than selecting a printer. Because printers are more specialized than imaging services, you work with several printers. Ideally, you work with only one imaging service whose staff, hardware and software become an extension of your own. Establishing smooth work flow and predictable output may require months of experience with a variety of jobs.

When you evaluate an imaging service, keep in mind the following considerations:

Printability. Consult with printers about prepress, not vice versa. Ask printers about their experience with film or plates from the services that might handle your jobs. If you're just starting, pick your printer first, then your imaging service.

Compatibility. Verify that your files show on the screens of the service's computers and output from its imagesetters. Test, then test again. Don't take a sales rep's word for it. Test at least two files created by every application that you might use.

Recommendations. Ask other customers if their jobs ran smoothly through prepress and

[&]quot;All the really good printers in town know that our studio works with clients that demand top quality and service, but that we do our own prepress right every time. We never cost a printer extra money."

printing. Listen especially closely to stories about problems (you'll hear lots) and how staff handled them. Everyone on the electronic frontier is a pioneer, so you expect some mistakes and confusion.

Focus on output. Ignore brand names of equipment. Concentrate on your own specific interface, whether you like the kinds of proofs supplied, and what the service delivers to your printer.

The cost of prepress represents a small fraction of the overall cost of the typical printing job. Many factors contribute to prepress costs, including:

Complicated designs. If color breaks don't involve image trapping or graduated screen tints, prepress could be simple.

Quality expectations. If you have complex designs and need match original colors, prepress may take longer and cost as much as printing.

Quantity. Prepress is a fixed cost, so its portion of overall costs drop as print quantity increases. Short print runs bring relatively higher prepress costs.

Regardless of who does prepress, make sure that you keep track of costs separately. Exact reprints only require making new plates. Other factors being equal, total costs for an exact reprint within a year of the first printing should drop. Knowing original prepress costs helps you evaluate quotes and invoices for reprints.

Imaging services making separations need to know the name and phone number of printers using their film. Close communication is imperative. For premium and showcase quality "You can't proof the important jobs too long, too often, or too carefully. Once I saw a glitch on a blueline that looked like a squashed bug. I thought it was a flaw in the proofing paper, so I signed the approval tag. When I saw the same bug on my 50,000 booklets, I checked my mechanicals. Sure enough, there it was—a camera-ready fly. Now I circle every ding, flaw and hole for correction, no matter how silly or insignificant it seems. And I don't accept phone calls when proofing. Even then, I often feel so nervous that I pay for a second blueline just to make sure that prepress made all my changes."

printing, prepress needs to know what paper and press your job calls for.

Separations for advertisements must conform to specifications supplied by the publication in which they will appear. If you don't know those requirements, tell the imaging service the name of the publication. Prepress services own guidebooks in which they can look up specifications for thousands of newspapers and magazines.

Prepress services have a variety of practices regarding ownership of materials made in the course of preparing jobs. If you anticipate any dispute about ownership, settle it in writing before authorizing work to begin. And make sure to read the terms and conditions on the back of any contract before you sign.

To locate prepress services, look in classified directories under "Color Separations," "Desktop Publishing" and "Typesetting." Ask for recommendations from your printers and from other printing customers who buy jobs similar to yours.

6. PAPER FROM PULP TO PRESSROOM

How mills make paper Paper grades, ratings and brands Samples and dummies Printer/merchant relationships Reducing waste and spoilage Surface, color and weig **Bond and writing** General purpose offse Luxurious text Sophisticated coated Sturdy cover Miscellaneous grades Respectable recycled Specifying paper

The cost of paper represents 30 to 40 percent of the cost of your typical commercial printing job. With a larger job, such as long runs of magazines, books or manuals, paper can represent 50 percent of costs. Moreover, your choice of paper affects every aspect of printed products from design to delivery. It pays to choose carefully.

In this chapter you'll learn about papermaking, terms used when talking about paper, the paper business as it relates to you and your printers, major types of papers and their uses, and recycled papers. Using this information, you can control paper costs and select papers best suited to your products and deadlines.

Printing papers fall into five major grades: bond, uncoated book (offset), text, coated book and cover. In addition to these major categories, there are many other grades such as board and newsprint. Each grade has characteristics appropriate to specific applications. You have greater control over quality and cost when you know the features that distinguish one grade of paper from another and how to coordinate papers from different grades.

In the following pages I can only summarize information about printing papers. To learn details, consult my book *Papers for Printing*. In addition to extensive text and charts, that volume contains 8½" x 11" printed samples of the papers most commonly specified for commercial printing jobs.

HOW MILLS MAKE PAPER

About three dozen major manufacturers in North America make printing papers. Most have mills in several states or provinces. A manufacturer might produce fifteen or twenty brands of printing paper plus industrial and sanitary papers. A mill, however, concentrates on making only one type of paper such as bond or newsprint.

Mills make paper from cellulose fibers from trees or from recycled paper. A few mills also make paper using cotton fibers.

Fibers from softwood trees, such as pine, are long and produce strong, relatively rough paper; those from hardwoods, such as maple, are short and yield weak, relatively smooth

paper. Commercial printing papers contain a blend of softwood and hardwood to combine the best features of both. Papers made with long, supple cotton fibers are durable and smooth.

After removing bark, mills cut trees into chips. Mechanical grinders pulverize the chips for groundwood pulp; chemical digesters break up the fibers for chemical pulp.

Newsprint and other inexpensive papers, such as tissue, come from groundwood. They are called coarse papers. Printing and writing papers, called fine papers, come from chemical pulp. Fine papers are also called free sheets because they lack the impurities found in groundwood.

6-1 MOST USEFUL PRINTING PAPERS

Printing and writing papers offer thousands of combinations of grade, rating, color, surface and weight. You can, however, create most of the printed products that your organization needs by using only seven sheets.

- 1. White 24# wove 25 percent cotton bond for letterhead and envelopes. Put this paper in your copy machine or laser printer when you need a certificate, premium presentation or legal document.
- 2. White 20# wove #4 bond for everyday photocopies and laser printing. Also use this paper for notepads, fliers and statement stuffers. Use paper with a high percentage of recycled fiber.
- 3. White 60# smooth #1 offset for newsletters, brochures and direct mailers using only line copy and solid ink colors. Use this paper for booklets and staff directories. Put it in your laser printer when you output masters for copying or printing.
- 4. White 70# matte coated #1 for newsletters, brochures and catalogs that require bright colors and faithful halftones.

Also use this paper for calendars, maps, small posters and technical manuals, and when you produce color photocopies. Specify this surface for labels and nametags.

- 5. White 8-point C1S cover for book, calendar and program covers. Also use this paper for membership cards, menus, dividers in binders, large posters and table tents.
- 6. Light blue or gray 80# felt text for announcements, envelopes and presentation folders. Use this paper also for coupons and tickets.
- 7. Light blue or gray 65# felt cover (matching the felt text) for business cards. Also use this paper to cover premium presentations and booklets.

Consult with your printers to select one brand representing each paper, then learn all you can about its availability, how it reacts on press, and what it costs in various amounts. This knowledge greatly increases your control over schedule, quality and cost.

Both coarse and fine papers come from the same raw materials, processes and machinery, except that pulp for fine papers passes through the digester. Bleaching makes pulp white and chemically stable. White pulp yields white paper and is easily dyed to make colored papers.

The papermaking process begins with beating, refining and dyeing to prepare pulp for the kind of paper desired. Refining is the most important step. Minimum refining yields thick, rough paper such as that in shopping bags. Maximum refining yields thin, smooth paper such as glassine for envelope windows.

After preparation, mill workers mix pulp with water. The mixture, called furnish, flows onto the Fourdrinier wire, a wide, continuous belt of material similar to fine-mesh window screening. The wire moves forward and also shakes slightly from side to side. Fibers catch on the wire, but water falls through. The shaking ensures that fibers settle and lock together. By the time the fibers reach the end of the wire loop twenty or thirty feet away, they contain about 90 percent water and can support their own weight. The pulp has become paper.

The press and dryer sections remove more water, make the paper smooth and can impose texture on its surface.

Later in the sequence, mills may apply sizing and coatings. Sizing makes paper better able to interact with water on press. Coatings make the surface stronger and improve ink holdout.

As steel rollers in the calender section press paper, it becomes smoother, thinner and more shiny. Many uncoated papers and all coated papers are calendered.

Mills make paper in huge rolls called reels or logs. A typical reel could measure eighteen feet long and five feet thick and weigh several tons, much larger than even the largest web press can print. Mills cut sheets and smaller rolls from these master rolls.

"Until I actually visited the sample room of a paper distributor, I never realized how much they can help. I thought they only worked with printers, not with buyers like me. Once I needed a dummy of 128 pages, $8^{1/2}$ " x 11", 60# ivory vellum, perfect bound with a 10 point cover. I felt reluctant to ask for something so complicated, but they said 'No problem' and delivered it the next morning."

PAPER GRADES, RATINGS AND BRANDS

Professionals divide papers into large categories according to their end use, method of printing and pulp content.

End-use categories include:

- fine paper made for printing and writing
- industrial paper made for wrapping and packaging
- sanitary paper made for cleaning and personal hygiene

Method of printing categories include:

- sheet papers for sheetfed presses
- web papers for web presses

Pulp-content categories include:

- Groundwood made from mechanical pulp that has impurities. Paper for newspapers and general news magazines is groundwood paper.
- Free sheet made from chemical pulp with the impurities washed and bleached away. Most commercial printing jobs are run on free sheet.

Fine papers are divided by grade, rating and brand name, the categories used most frequently when discussing printing jobs.

Grades

Mills make printing papers in five major grades: bond, text, uncoated book, coated book and cover. Most of your printing projects use one or more of these grades. I describe each grade in detail later in this chapter.

Mills make bond for individual products such as letters and legal documents. Bond is also used for photocopies, laser printout and

6-3 MANY USES OF "GRADE"

Grade is a general term used to distinguish between or among printing papers, but its specific meaning depends on context. Grade can refer to the category, class, rating, finish or brand of paper. All the following examples represent correct and common usage.

Category. One of the major categories of paper determined by how it is made. "I prefer groundwood grade for this job, not free sheet."

Class. One of the major classes of paper such as bond, uncoated book, coated book, text, cover, bristol and board. "Bond is a better grade for letterhead than cover."

Rating. One of many ratings of paper, such as 100 percent cotton or #4 gloss. "Our

separations look better on a #1 grade than a #4 grade."

Finish. One of several finishes such as wove or laid. "Which grade do you want, antique or vellum?"

Brand. One of thousands of brands of paper. "The mill makes twenty-seven grades of paper, but SilkSmooth is most popular."

Other. Any paper that differs from any other paper in any one respect. "Grain long is a better grade for this job than grain short."

To avoid confusion in this book, I use the word "grade" only to refer to a category of paper such as bond or text.

business forms. Sometimes you hear the terms "business papers" or "communications papers" used to refer to bonds.

Graphic designers specify text paper when surface pattern and paper color form integral parts of design. Text is used for annual reports, announcements, brochures, presentation folders, and other products that must seem elegant and be durable.

Printers use uncoated book for all kinds of products. You see it every day in books, newsletters and direct mailers. You often hear the term "offset" used interchangeably with uncoated book.

Printing jobs needing vivid ink colors and faithful reproductions of photos and drawings call for coated paper. Those jobs include most magazines, calendars, catalogs and posters and many brochures.

Book covers, presentation folders, postcards and similar products call for cover paper that is sturdy. Cover paper is available in both uncoated and coated surfaces and in colors and patterns that match sheets in other grades.

Ratings

Manufacturers rate papers based on characteristics such as brightness, opacity and fiber content. You often see these ratings in swatch books, ads, specifications and price books. People rate papers so they may conveniently think, talk and write about them. Consider the ratings as guidelines, not rules.

Knowing how papers are rated makes communication among graphic arts professionals more precise and cost control easier. Rating systems help you eliminate inappropriate papers and focus on those best suited to your specific printing job.

Ratings use numbers from 1 (highest) through 5 (lowest), and words such as "premium" and "commodity," although not every grade uses every number or descriptive word. In your day-to-day work, you probably select from only one or two ratings within each grade.

Sometimes ratings seem arbitrary and inconsistent. Mills assign ratings to their own papers, so one mill's #2 dull may look similar to another mill's #1 matte.

Names

Every paper has a brand name given to it either by a mill or a merchant. Names assigned by mills remain the same from one merchant to another; names assigned by merchants, called private brands, are unique to that distributor.

Mills choose names to build respect and brand loyalty. For example, names for lines of recycled papers include Retreeve, Evergreen and Renewal, which suggest responsibility to the environment.

Private names are given most commonly to bonds and offsets packaged for small presses and office machines. Many paper merchants and office supply stores feature their own brands. Private brands and mill brands come from the same mills and may even be identical except for name and price.

SAMPLES AND DUMMIES

Mills sell paper to merchants who sell to printers and print buyers. Paper merchants operate locally and regionally. Several merchants in a region may carry the same brand of paper. Merchants sell mill brands but may also sell their own private brands.

To find paper merchants in your local area, look under "Paper Distributors" in a classified directory for businesses (not consumers).

Paper merchants often employ a specialist to advise buyers. Known as specifications consultants or graphic arts consultants, these experts meet with individuals and groups to discuss the paper industry. They report trends concerning cost, availability and design and explain how those trends affect the products that most interest buyers.

Large paper merchants and the mills they represent occasionally sponsor events where they exhibit new brands and colors. These events attract printers, graphic designers and print buyers eager for samples and information. Ask your printer to make sure you are invited to such events in your area.

Paper mills supply distributors with swatch

books, printed samples, training materials and other sales aids. Distributors keep the materials in a samples room with its own manager. Sales reps for distributors work with the samples manager to give materials to printers and printing buyers.

Printed samples are useful for checking opacity and noting how a stock receives the ink colors you like. Printers and merchants have printed samples of various papers, although samples of printing on paper of uncommon weight, finish or color may be hard to find.

A swatch book shows small, unprinted samples of a brand of paper and tells what sizes, weights, colors and finishes the mill makes. Swatch books are especially useful for examining a range of colors.

A few mills make swatch books showing their entire line of papers organized by brand, color and weight. These swatch books are especially popular with mills that make text/cover or writing/cover papers.

Paper merchants put labels on swatch books to identify who sells the paper locally. When you get a swatch book from a printer, note the name of the shop and the merchant. The typical print shop buys most of its paper from one merchant, so it's useful to know which printers deal with which merchants and which merchants sell papers that you like.

Unprinted sample sheets come in cut sizes provided by mills and larger sizes that merchants take from inventory. Large sheets help you think about ganging jobs because you can

"I'm a member of our local convention bureau and I know that they pay high fees for the best designers in town, but they sure wasted their money with last year's membership directory. It looked really artsy, with color photos on fancy paper and even gold foil on the cover, but it was too long to fit in a file folder. When I punched it for a ring binder, it stuck out over the top and wouldn't go on my bookshelf. Maybe they thought people would feel impressed and use it to decorate their coffee tables. I finally just threw it away."

6-4 TWENTY-SIX WAYS TO CUT PAPER COSTS

You can cut printing costs by using many techniques to cut the cost of paper. Most techniques also save trees, energy, air and water quality, and landfill space by reducing consumption. It pays to think green.

Reduce trim size. Shaving ½4 inch off your book, magazine or catalog might save thousands of pounds—and dollars—per year. Lower weight cuts postage costs as well.

Reduce basis weight. Heavier basis weight sheets cost more per sheet than lighter ones. Use the following figures as guides:

60# costs 20 % more than 50# 70# costs 15 % more than 60# 80# costs 12 % more than 70# 100# costs 20 % more than 80#

Use house sheets. Design routine jobs for paper that your printer buys in huge quantities, not on stock that you specify on a job-by-job basis.

Learn price breaks. The more paper you buy, the less you pay per unit. When you plan a printing job to take advantage of price breaks, you ensure the lowest possible unit cost per printed piece.

Prices for paper decrease at specific quantity levels as follows:

partial carton costs	15-60 %	above base
1 carton costs		base price
4 cartons cost	6-15 %	below base
8 cartons cost	7-19 %	below base
16 cartons cost	9-23 %	below base
24 cartons cost	24-26 %	below base
5,000 lbs. cost	29-32 %	below base
10,000 lbs. cost	30-38 %	below base
20,000 lbs. cost	33-40 %	below base
carload costs	37-43 %	below base

Shop the sales. Paper merchants publish closeout lists showing stock available at sig-

nificant savings. By examining lists sent to your printer, you can plan print runs that take advantage of low-cost paper.

Consolidate needs. Work with others in your organization or in similar organizations to merge printing jobs. When you gang runs or cooperate for long-term contracts, your printer can commit to quantities of paper that may drive prices down as much as 25 percent.

Reduce print runs. Look in your supply closet, back room and warehouse to identify printing jobs where you ordered too many. You may have to look in your dumpster, too. Make an extra effort to specify quantities that you're sure you need.

Avoid overruns. Slight overruns are inevitable, but you can work with your printer to keep them to a minimum. Don't get stuck with printed paper you didn't order and can't use.

Avoid coated paper. Uncoated paper is easier on the environment than coated paper. Coated paper is more difficult to make and recycle. Recycled coated paper contains a lower percent of recycled fibers than comparable uncoated paper.

Avoid dark colored paper. Dark paper costs more to make and more to recycle than light paper. Produce dark colors with ink, not paper.

Print less often. Encourage readers to save items for future reference or use items a few weeks or months longer. Consider producing your newsletter ten times per year instead of twelve.

Reduce page counts. Use fewer words, photos and illustrations to get your message across. Choose most efficient typefaces and sizes. Put specialized information in separate

publications that only a few readers need.

Use standard sizes. Design your printed pieces to take maximum advantage of common sheet sizes. Don't fill dumpsters with trimmings.

Reduce makeready. Specify quality in measurable terms. Simplify design to run printing jobs on the fewest possible machines. Make final decisions about color on proofs, not on press. Gang projects by running two or three projects on the same sheet. Use printers whose machines perform multiple functions, such as print and perforate, instead of doing one function per machine.

Avoid bleeds. Bleeds require larger sheets and create more waste.

Reduce paper quality. Change from premium to #1, from 100 percent cotton to 25 percent cotton, or #4 free sheet to #5 groundwood. In addition to cutting costs, lower quality paper is more likely to contain recycled fibers than stock that must look bright and flawless.

Write and design carefully. Make sure your printed piece communicates clearly and completely to reduce the need for additional publications.

Consider nonprint media. Think about using voice mail, electronic mail, computer bulletin boards, LANs, meetings, CD-ROMs or videos instead of printed products.

Explore on-demand printing. Print upto-the-minute forms, manuals, catalogs, newsletters and even books as needed. Ondemand printing reduces overruns and uses relatively inexpensive paper.

Think twice. Does the entire staff really need a copy of the whole report, or would some find an abstract sufficient? Do you

really need to send five hundred holiday cards, or would one hundred be enough? Will every legislator and related organization treasure your newsletter, or would an occasional special letter do a better job?

Target distribution. Make your publication available only where readers want it. Don't put it on counters, newsstands or bulletin boards where it's ignored or considered a nuisance.

Clean your mailing list. Merge and purge. Don't print items that the post office can't deliver. And don't send free copies to everyone whose name exists on some database of VIPs. Use the National Change of Address (NCOA) system and your own common sense to keep your list up to date. Contact NCOA through your post office.

Reject dirty mailing lists. Don't send duplicate items to the same person or household. Examine lists that you rent for matching names, job titles and addresses.

Ask readers if they care. Don't send materials to people who just throw them away. Provide business-reply cards that let readers notify you to delete their names. Encourage readers to notify Mail Preference Service, 6 E. Forty-Third Street, New York, NY 10017, if they want their names deleted from rented address lists.

Negotiate a lower cost. Ask your printer or paper merchant for a lower price on stock that you currently use. The worst you can hear is "No" and maybe you'll hear "Yes."

Ask for better credit terms. Many paper merchants invoice 2 percent/ten days instead of net 30 days. Maybe you can get 2 percent/30 days or net 60 days. Save by protecting your cash flow.

visualize two or three pieces printed on one large sheet.

Dummies are blank sheets folded and bound to simulate the product you have in mind. They are important to any job involving binding because they let you see, feel and weigh the final outcome. You can also use paper dummies for preparing comprehensive roughs so clients, supervisors and vendors know exactly what you have in mind.

Whenever a printer suggests unfamiliar paper, ask for a printed sample. Ideally, images and ink colors on the sample resemble those you have in mind. If you have any doubts about how the paper suits your job, ask the printer to get additional samples from the merchant.

PRINTER/MERCHANT RELATIONSHIPS

For most printing jobs, let the printer order paper for you. You can take advantage of samples and advice offered by merchants, but in most cases you have greatest control over quality, schedule and cost when buying through your printer.

Printers typically buy most of their paper from one merchant. They cut costs by consolidating quantities and they build trusting relationships with sales reps and people in customer service and accounting.

Buying paper through a printer saves you the time required to get dummies, check on availability, compute quantities and write specifications.

You can benefit from printer/merchant loyalty by learning about papers offered to your printers by their favorite merchants. Knowing what's available and what your printers like on

"When I took over coordinating all the printing jobs for our company, the first thing I did was plan how to use paper. I reduced the quality of paper for internal publications such as reports that don't need to impress anyone. The money saved by that step let me specify better quality stock for brochures for our potential customers." press helps production go smoothly.

When buying quick printing, you select paper from the sheets the printer offers and don't normally consult a swatch book. Quick printers keep a variety of standard weights and colors in stock and can get alternates easily. They include cost of paper in their perhundred printing prices, so you have only two or three cost decisions.

Commercial printers use paper in much greater variety and quantity than quick printers. When buying paper as part of commercial printing, your printer's sales rep or a merchant's graphic arts consultant can help you decide what stock to use. Either can give you samples and dummies and tell you about costs and availability.

Most commercial printers keep an inventory of two or three types of paper they call house sheets. A #3 offset, a #1 matte and a #2 gloss would be typical. To keep costs down, printers buy house sheets in large quantities for routine jobs. Specifying the house sheet may mean printing on paper that isn't quite what you had in mind. On the other hand, often the house sheet is perfectly adequate and costs less than other possibilities.

When you specify paper for a commerical printing job, your printer checks with one or two distributors to determine that it's readily available. If the stock is locally warehoused, printers may not even order until a few days before press time. Never assume, however, that printers can get any paper you want in a matter of days. Stock that must come from a distant warehouse or directly from the mill may take several weeks.

Specialty printers buy paper in large quantity but small variety. You might choose from only four or five stocks, each suited to the special product that the printer manufactures. For example, a book printer typically offers uncoated paper in only three weights (50#, 55# and 60#) and two colors (white and natural) and may not offer any bond, text or coated stocks.

When you ask printers to quote on a job,

tell them you want the cost of paper itemized on the estimate. Breaking out paper costs helps you consider the costs of alternate sheets. Equally important, itemized paper costs highlight the different amounts that different printers charge for the same paper.

To get lower prices by increasing the amount of paper you specify, compute your needs for several jobs at once. Resist the temptation to increase your print run simply to reduce unit costs. For example, if you produce four rack brochures every few months, write specifications for a full year so your printer can commit to that much paper.

Specifying on a job-by-job basis keeps your orders to a minimum and drives up unit costs. Specifying for several jobs at a time lowers the unit cost of paper and lowers printing costs because it ensures your printer of your continuous business.

You can also increase quantities by working cooperatively with other print buyers. Talking to the folks down the hall or around the corner often reveals paper needs very similar to yours. Joint planning and specifying may save everyone thousands of dollars.

Like other businesses, paper distributors have sales. Orders get cancelled, specifications change, color and weights go out of style, discontinued items are closed out. If you have a job where precise color or weight and availability for reruns aren't crucial factors, check for bargains on specials or closeout lists or have your printer check for you.

Although the cost of paper represents 30 to 40 percent of the average invoice for printing, it is a much lower percentage of the total cost of the job. Total costs include research, writing, design and distribution as well as printing and binding. When viewed from this standpoint, paper becomes a much smaller percentage of the overall budget.

Upgrading papers is an easy and often dramatic way to improve an entire publication. The cost difference between routine and outstanding paper might be tiny compared to the "I thought I was pretty smart designing a rack brochure 9½ inches high to stick out above the others. I realized my mistake when it was time to mail to last year's visitors. My oversized brochures were too big to be machine stuffed into #10 envelopes."

cost of the job as a whole. Upgrading paper adds nothing to the cost of writing, design or printing.

REDUCING WASTE AND SPOILAGE

You can cut your costs for paper by reducing waste and spoilage.

Printers often use the terms waste and spoilage as synonyms. In fact, they represent quite different concepts. Waste is unusable paper or paper damaged during normal printing or bindery operations. Spoilage is paper that, due to mistakes or accidents, operators must throw away instead of delivering to the customer.

Printers anticipate waste, most of which is makeready, and plan for it when buying paper. They do not anticipate spoilage that might have been prevented.

Printing estimators express waste as a percent of the paper needed to produce the quantity specified. If a job calls for 10,000 sheets and the estimator predicts 4 percent waste, the order is placed for 10,400 sheets.

The amount of waste that a printer forecasts for a specific job depends on many factors. Some general guidelines are: Shorter press runs produce a higher percentage of waste than longer ones; web printing yields more waste than sheetfed printing; waste increases with number of colors printed, complexity of bindery operations and quality expectations. Spoilage could result from poor conditioning, defective plates or blankets, poor presswork, poor operation of bindery equipment or many other unintentional situations.

Many of the cost-cutting tips in Visual 6-4 help reduce waste and spoilage. In addition, you can help your printer use paper efficiently by providing measurable quality guidelines.

Precise specifications for quality reduce waste. When you specify quality in subjective terms such as "saturated colors," you invite extended discussion during setup or a press check. During the discussion, paper runs through the press into the dumpster. More precise language such as "meet SWOP target ink densities" tells press operators exactly what you expect. Less paper goes into the dumpster before you see a sheet that you can approve.

SURFACE, COLOR AND WEIGHT

Paper has ten characteristics that determine its cost and influence its suitability for a particular printing job. When you understand these traits, you add to your control over the cost and quality of your printing jobs.

Surface

As mills turn pulp into paper, they adjust its surface to affect look, feel and printability. Each grade of paper has its own set of terms that describes surfaces for that grade. Surfaces for each grade are listed on the chart as Visual 6-13.

Rollers at the mill press paper to make it smooth. Paper becomes smoother as it passes between each set of rollers, a process called calendering. Uncoated paper may or may not be calendered; all coated paper is calendered to some degree. With uncoated paper, the process yields vellum, antique, wove and smooth finishes. With coated papers, minimum calendering yields matte finish, medium calendering results in dull finish, and extensive calendering creates gloss and ultragloss.

The process of calendering affects paper in several ways. As the degree of calendering increases, paper becomes smoother and more glossy and has better ink holdout. The heat and pressure of calendering also makes paper thinner, less bulky and opaque, and often less bright.

Embossing is done off the papermaking machine by steel rollers that press patterns

"Why are people always so fussy about using exactly the right color or finish of paper? With some jobs I'm very particular, but with others I'll use almost anything the printer has gathering dust on a shelf. Like our newsletter. Each member of our club only gets one copy, so who cares if the whole batch was printed on three different papers? My printer is always happy to get rid of odd quantities of paper left over from other jobs and gives it to me practically free when I use it."

into paper surfaces. Embossed finishes have special names such as stipple and canvas.

A paper's surface determines how easily it accepts ink, how rapidly the press can run while maintaining uniform ink coverage and other elusive factors affecting printability. If a printer grumbles about the printability of a particular sheet, listen.

Color

Most printing papers are white, but not all whites look the same. Examine four or five samples of white paper. Try to decide which is whitest or "true white."

Mills use many names to distinguish one white from another. You can buy white called bright, radiant, colonial, polar, elegant, cloud and many more. You can also buy colors simply called pearl, oyster, foam or birch, all of which are white. Experts claim that white is warm when it tends toward yellow and cool when it tends toward blue.

A very white sheet helps ensure wide tonal range in photos. Contrast between the lightest and darkest parts of an image creates tonal range. A white sheet results in lighter lights, thus increasing details in highlights and making dark inks seem darker.

Paper that is slightly off-white comes in many shades with many names, such as natural, cream, ivory, eggshell, mellow and soft white. These shades have little glare, so are popular for novels, technical manuals and other publications that are read for long periods at a time.

Mills add dyes and pigments to create

paper of virtually any color. Color varies from mill to mill and there is no standard for naming hues. What one mill calls ivory another mill may call buff or cream. Colors from the same mill might show slight variations from one run to the next.

When you evaluate color, put samples next to each other so you can view two or three at once. Don't rely on memory. And use the proper lighting conditions described in Visual 3-13. If you don't have standard viewing conditions, use sunlight.

Bulk and finish affect color. Your favorite gray may seem a shade lighter in 24# bond for letterhead than in the 80# cover stock for business cards designed to match.

Colors go in and out of style. Mills add and drop colors every couple of years, following color trends in fashion and interior design.

If you're choosing paper whose color must appeal to readers over many years, as when selecting corporate letterhead, resist any temptation to follow trends. Safe, basic colors cost least and last longest.

Because color is subjective, color match can change from run to run. The mill supervisor may think Sky Blue made in August is an acceptable match to that made in March, but you may disagree. If you print half your brochure on the March run and the other half on paper made in August, you may not have a perfect color match.

Color match is especially difficult to achieve with recycled paper because of inconsistency of raw materials. In the case of recycled sheets, it's easier to match darker colors than lighter ones and most difficult to match whites.

White is the least expensive paper. Colored paper costs more because it is in less demand and because dyes are expensive. Light colors such as cream and natural cost slightly more than white and costs increase as colors get darker. Coated stock tends to come exclusively in whites with a few mills making tones they call cream or natural; uncoated stock, in white

plus light colors; and text papers, in white plus a full range of intense colors. Color in paper increases opacity and decreases brightness.

Brightness

Mills measure the light that white paper reflects and report results as percentages. The brightest possible paper would reflect 100 percent of the light striking it. Most papers have brightness ratings between 60 percent and 90 percent.

Whiteness and brightness are different features. Brightness is a quantitative measure, whiteness a subjective judgment. No standards dictate either brightness or whiteness for specific printed products. Papers with high gloss can measure very bright but not appear as white as less glossy sheets.

Brightness affects readability. Type on a sheet with low brightness lacks contrast, but type on a very bright sheet can cause eyestrain. Papers for books, technical manuals and the financial sections of annual reports need less brightness than papers for magazines and brochures.

Opacity

Printing on one side of the paper should not interfere with printing on the other, nor should images on a sheet underneath the one being viewed. Good opacity prevents unwanted images from showing through.

Paper mills rate opacity on a scale of 1 to 100, with 100 being completely opaque. Most printing papers fall in the 80 to 98 percent opacity range.

Opacity increases with basis weight and bulk and is affected by coatings, colors, chemicals, ink color and coverage, and impurities. Because of its residue of ink, recycled paper is

"It seems that everyone around here feels like a design expert. I couldn't get a committee to agree on anything until I became more assertive. Now when someone has a bright idea that means last minute changes, I ask if the cost for alterations can come from their budget." slightly more opaque than comparable virgin stock. The average difference is about 2 percent.

Opacity affects readability. High opacity helps readers concentrate and reduces confusion and eyestrain. Opacity also prevents photos, screen tints or reverses on one side of a sheet from showing through to the other side.

Use Visual 6-5 to compare the opacities of papers and decide which papers have adequate opacity for a specific printed product.

Grain

During papermaking, fibers tend to become aligned in one direction. The result is grain. When fibers run parallel to the length of a sheet, the stock is grain long; when fibers run crosswise, the sheet is grain short.

Mills have several ways of indicating grain direction on labels and in swatch books and price books. They may print "grain long" or "grain short." They may underline the dimension parallel to the grain; for example, "11 x 17" means grain short. They may write "M" for "machine direction" after the dimension parallel to the grain; for example, 890 x 1130(M) means grain long.

If you have a sheet with unknown grain direction, you can determine the grain by moistening one side of the sheet. Paper curls parallel to the grain. You can moisten a piece of letterhead enough by placing it on a surface that has been wiped with a damp cloth.

Grain direction affects printing because

6-5 Opacity comparison bars The opacity of paper determines the extent to which printing on one side interferes with printing on the other. To compare the opacity of two pieces of paper, lay the sheets so that their edges meet at the center line of the pattern above. The sheet that makes the bars most difficult to see is the more opaque.

moisture in the air and in dampening solutions causes the fibers in paper to expand slightly. Fibers become wider (fatter), but not longer; a sheet expands against the grain. Printing that requires tight register is done on grain long paper so that fibers parallel the length of the cylinder, giving press operators maximum control over register as sheets expand.

Knowing grain direction helps design for folding and strength. Heavy stock folds most smoothly with the grain. Folds against the grain may need scoring first. Grain long book pages turn more easily than grain short; grain long letterheads and counter displays are more rigid than grain short.

Recycled paper has relatively short fibers, so it scores, folds and embosses more easily than comparable virgin stock.

Weight

Each grade of paper, such as bond and offset, has one basic size used to determine basis weight. Visual 6-13 shows basic sizes for the various grades. Note that basic size is only one of the many standard sizes for each grade.

Basis weight is expressed in pounds and is figured using one ream (five hundred sheets) as a standard quantity. To see how this works in practice, take five hundred sheets of paper at the basic size for its grade, then weigh the pile. The result is the basis weight of the paper in the pile. Visual 6-6 illustrates this concept.

When writing basis weight, the word "pound" is abbreviated with the symbol #. Fifty-pound coated is written 50# coated. You may also see it written as BS 50.

Sometimes paper is designated in substance weights, as in "sub 24." Substance weight and basis weight are identical concepts. Both refer to the weight of five hundred sheets of the basic size.

Often packages of paper identify both the basis weight of the contents and basic size of the grade. For example, a carton of $17^{1}/2$ " x $22^{1}/2$ " 80# text might be marked "80# (25 x 38)."

To help understand the concept of basis

weight, consider pulp that yields 80 pounds of paper. The mill could make the pulp into five hundred sheets of 25" x 38" book paper or into five hundred sheets of 20" x 26" cover grade. Both reams would weigh the same and both would consist of 80# paper. The cover paper would measure almost twice as thick as the book paper and its sheets would only be about half the size (520 square inches vs. 950 square inches). In this example, each individual sheet of book grade and cover grade would weigh the same, therefore each sheet would have the same basis weight.

Understanding paper weight increases cost control because paper is sold by the pound. For example, 70# book costs about 15 percent more per sheet than 60#. If you plan 25,000 copies of an 8½" x 11", sixteen-page brochure, the cost difference of the paper might be four hundred dollars. You might save even more when considering postage. If the brochure on 70# stock takes you over a per piece weight limit at the post office, you might pay more to mail than to print.

Often you have to compare papers whose basis weights are computed using different basic sizes. For example, you might consider printing an invitation on either bond or text. In such situations, knowing equivalent basis weights helps you decide.

The relationships between book and bond basis weights are:

40# book equivalent to 16# bond

50# book equivalent to 20# bond

60# book equivalent to 24# bond

70# book equivalent to 28# bond

The relationships between book and cover basis weights are:

90# book equivalent to 50# cover

100# book equivalent to 55# cover

110# book equivalent to 60# cover

120# book equivalent to 65# cover

When using equivalent weights to design printed pieces, keep in mind that book weights apply to uncoated book, coated book and text, all of which have the same basic size.

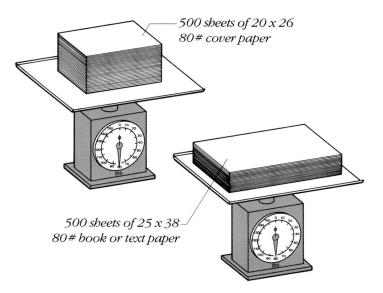

6-6 Basic size and basis weight Papers can have different basic sizes but the same basis weights. The scales each hold one ream (five hundred sheets) of 80# paper, one book grade and one cover grade. The basic size of the cover paper is smaller than the basic size of the book paper. The cover paper, however, is thicker than the book, so the two piles weigh exactly the same.

You may also hear book weights called text weights.

Laser printers and photocopy machines can run heavier paper than most users realize. Using your knowledge of equivalent weights, you can find book and cover papers that work fine in office machines. For example, you could use 100# text, equivalent to 55# cover, to print out report covers. Running this stock through your laser printer means you could add individualized information, such as a personal name, to each cover.

Caliper

Paper thickness is defined as caliper. It is measured in thousandths of an inch and expressed as point size, so .001 inch equals one point. Stock called 7 point is .007 inches thick and abbreviated "7 pt."

Note that points describing caliper of paper are not the same as points describing size of type. Paper points refer to thickness, type points to height. A type point is 1/72 inch, which is almost fourteen times larger than a

6-7 COMMON BASIS WEIGHTS

Some grades of paper have more weights available than others. In practice, the differences are as follows:

Bond. The majority of bond is either 16# for forms, 20# for photocopying and quick printing, or 24# for stationery. You can get other weights, such as 13# and 28#, but rarely need them.

Text. Text papers come only in relatively heavy weights required to carry the texture of the paper. Most jobs using text run on 70# or 80#. A few use 60# or 100#.

Uncoated book. You can get offset in

many weights, but 50#, 60# and 70# are most common. More printing jobs run on 60# commodity offset than on any other paper.

Coated book. Print buyers specify a greater range of weights in coated than in other grades. Sheetfed jobs use weights from 60# to 110#, web jobs use weights from 30# to 70#.

Cover. Most cover is specified as 60#, 65#, 80# or 100# or in calipers of 8 pt., 10 pt. or 12 pt. A few mills make "cover plus" in 88# and 110#.

point describing paper.

Buyers often specify cover stock and other thick paper by point size. The most common calipers for cover paper are 8 pt., 10 pt. and 12 pt. The typical telephone directory has a 10 pt. cover. If you want paper thicker than 12 pt., look for stock called tag, blanks or board.

The U.S. Postal Service requires that postcards and business-reply cards measure at least 7 pt. Any paper merchant carries a supply.

Publishers often express caliper in pages per inch (ppi). Knowing ppi is important when specifying type sizes for printing book spines. Visual 6-8 shows how ppi can affect the thickness of a book.

When thinking about pages per inch, remember that one sheet of paper equals two pages.

Bulk

Bulk refers to thickness of paper relative to its basis weight. An uncalendered sheet is relatively bulky compared to a calendered sheet of the same basis weight. Gloss coated paper has low bulk; uncoated paper has moderate bulk; reply-card paper has high bulk.

Caliper and bulk are not related to basis weight. One paper may be thicker or bulkier than another but have the same basis weight.

Size

The graphic arts industry in the United States and Canada measures paper in inches. A 25 x 38 sheet is 25 inches wide and 38 inches long. Paper comes in the standard sizes described in Visual 6-9.

Efficient design reduces waste by coordinating paper and press size. You pay for the paper in your printer's dumpster; keep waste to a minimum.

Knowing how many products come out of one press sheet and designing with paper sizes in mind increases control over production times and costs. Often you can design your product to fit available paper rather than choosing paper after finishing design. Visual 6-11 shows the variety of printed pieces that might be cut from one parent sheet.

Paper mills ship sheets in a variety of sizes. Large pieces, often called parent sheets, are usually printed to fold into smaller pages or to cut into smaller products. For example, a 17" x 22" sheet could fold into a sixteen-page booklet measuring $5^{1}/2$ " x $8^{1}/2$ " or could cut into four $8^{1}/2$ " x 11" sheets of stationery. Both the booklet and the stationery are standard sizes. Often, however, products are made to a non-standard size. The 17" x 22" sheet, for exam-

ple, might cut into twelve handouts, each five inches square.

Quantities

Reams have five hundred sheets. "Ream wrapped" means sheets are packaged in bundles of five hundred.

Cartons of paper weigh approximately 150 pounds, but may contain any number of sheets depending on the size and basis weight of the

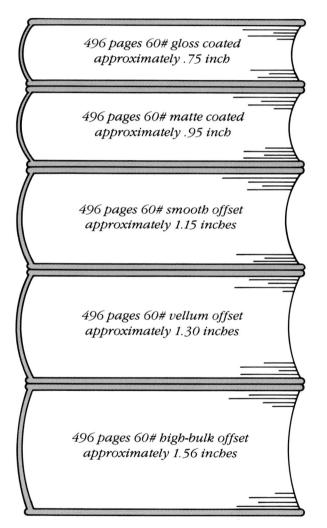

6-8 Comparing caliper Paper caliper determines thickness of the printed piece, an important consideration with products such as books, catalogs and directories. This chart represents books made from 248 sheets (496 pages) of typical 60# papers.

When imagining the books represented in this chart, keep in mind that all five have identical weights. Although some are thinner than others, all contain 496 pages of paper with the same basis weight.

"People in sales and production have different interests. Sales people work on commission, so they want to generate work and satisfy customers. Production people work on wages, so they concentrate on efficiency and the needs of the plant. Sometimes the two sets of interests prevent jobs from going smoothly."

paper they contain. For example, a carton of 25" x 38" 70# paper holds one thousand sheets. Paper of the same size in 100# comes eight hundred sheets per carton. Page 56 of my book *Papers for Printing* contains a chart showing carton contents for various combinations of sheet size and basis weight.

Paper distributors use cartons as units of sales. Ordering less than a full carton means increased packing and inventory costs, so the price per ream or pound goes up.

Skids are wooden platforms loaded with ream marked sheets, then covered to keep out moisture. Paper that is bulk-packed on skids costs slightly less per sheet than paper in cartons. A full skid of paper normally weighs about 2,500 pounds. As with cartons, the number of sheets on a skid depends on size and basis weight.

CWT means hundred weight. In paper parlance, cost per CWT means dollars per hundred pounds. CWT prices apply to all mill orders and roll stock for web presses. Paper not bought by the CWT is purchased by the thousand sheets. Pages from price books give prices per thousand sheets and per CWT.

Carloads weigh anywhere from 20,000 to 100,000 pounds, depending on the mill or merchant using the term.

BOND AND WRITING

Mills make bond paper for individual correspondence such as letters and forms. Bond lacks the opacity of book and text paper. Because it is designed to carry ink only on one side, show-through may be a problem. Two-sided photocopy on bond works better than two-sided printing on bond because paper doesn't absorb toner as it does ink.

6-9 THE LETTERHEAD BUILDING BLOCK

You can plan printing most efficiently when you keep in mind that the entire graphic arts industry in the United States and Canada, from making paper to using it, revolves around the 8½" x 11" sheet. This dimension is embedded in the public mind. Almost every laser printer, small press, photocopy machine, fax machine, typewriter and file drawer is designed for 8½" x 11" sheets. So are binders, file folders, envelopes and other products related to paper.

Large sheet sizes are multiples of $8^{1}/2^{1}$ x 11". Some multiples, such as 17" x 22", are exact; others, such as 23" x 35", are slightly oversized to allow for grippers and trimming. Still others, such as 25" x 38", are even more oversized to allow for bleeds and color bars. Visual 6-10 shows common sheet sizes;

Visual 7-3 explains how printers create bleeds.

The most common multiples of $8^{1/2}$ " x 11" are:

- 11" x 17" sheets used to print jobs such as letterhead two-up, four-page newsletters, and saddle-stitched covers for $8^{1}/2$ " x 11" booklets.
- 17" x 22" sheets used to print jobs such as letterhead four-up, brochures and eightpage newsletters.
- 23" x 35" sheets used to print jobs such as sixteen-page signatures requiring no bleeds, small trims and narrow color bars.
- 25" x 38" sheets used to print sixteenpage signatures and other products requiring bleeds, large trims, wide color bars and bindery laps.

Bond paper is made as either sulphite or rag. Sulphite refers to chemicals used to create paper from wood fiber; rag denotes paper with high cotton content.

Mills distinguish rag bond according to percentage of cotton; 25 percent and 100 percent are most common. Both are usually watermarked and are available in the same variety of finishes as #1 sulphite. Rag bonds are for prestige stationery or materials that must be extremely durable. The rag content comes from cotton fabric trimmings left over in clothing manufacture. U.S. currency is printed on 100 percent rag (75 percent cotton and 25 percent linen).

Bond without cotton fibers is called sulphite bond and comes in two common quality levels, #1 and #4. The first level, #1 sulphite, is used for routine business stationery. It may have a watermark and texture and is whiter and more opaque than #4. The everyday stock for typing, mimeo, photocopy and quick print-

ing is #4 sulphite, which costs about 35 percent less than #1.

Mills make bonds in a variety of finishes and textures that vary from mill to mill. A laid pattern at one mill may appear quite different from another mill's laid. Some mills make a kind of bond called writing. Writing has shorter fibers than standard bond, making the sheets slightly softer and more able to accept ink from pens. Certificates traditionally are made from standard bond whose long fibers give the crisp feel of a formal document.

Laid bond has a handmade look and dates back to Chinese methods of making paper in bamboo molds. Mills make linen finishes by embossing dry paper. Because embossing compresses fibers, linen bond is slightly calendered and has better ink holdout than laid. Bond with a visible finish should be printed on the pattern side.

Bond must stand up to abuse and be versatile. Products printed on bond may get folded, stapled, collated, filed, mailed and handed around at meetings. Sheets might be embossed, engraved or die cut, and printed offset, letterpress or photocopy. Bond may also pass through office machines using key strike, dot matrix, ink jet, photocopy or laser printing.

If you plan to run preprinted bond through a laser printer, keep in mind the way the machine may affect the previous printing. The heat and pressure of a laser printer may damage thermography, engraving, foil stamping or embossing.

Mills place watermarks on some bond to identify brand and sometimes cotton content. In addition to enhancing image, custom watermarks guarantee that stationery is from a particular author or organization, an important feature for prestige legal and financial documents.

Make sure to load watermarked bond into presses, photocopy machines and laser printers so the machine places the image on the correct side of the sheet. When you can read the watermark, you are looking at the correct side.

If papers are part of a package including letterheads, cards, envelopes and other coordinated materials, it's important to choose sheets with matched characteristics in several grades. Many mills make grades, such as text and cover, in colors and weights to complement their bond, although slight color variations may occur between paper batches. If you want a perfect match and are buying in very large quantities, have envelopes made from the same mill run as letterhead. Remember that colors and finishes on matching cover grades for business cards may seem different from bonds. For example, a laid finish business card may feel smooth on one side and rough on the other, while the side-to-side difference of its matching letterhead may be more subtle.

Forms bond must be light and strong, handle writing whether from pens or computer printers, and make a good carbon copy—all while standing up to the rigors of web printing and a wide combination of finishing steps. The

6-10 North American sheet sizes Using paper economically requires knowing the most common sheet sizes used by printers. Quick printers use two cut sizes, $8^{1/2}$ " x 11" and 11" x 17"; commercial printers may also run cut sizes but generally use larger sizes, often called parent sheets.

To get the most from your budget, design printing jobs to use as much of the sheet as possible. Learn to think in terms of multiples and divisions of $8^{1}/2^{n} \times 11^{n}$.

6-11 Products to cut out of a 23" x 35" sheet Understanding how paper in standard sizes cuts to yield printed pieces leads to more efficient use of paper. Above, solid lines represent trims and dotted lines folds. Shading represents areas of the paper that become waste.

stock must resist moisture so individual sheets do not expand or shrink to distort the entire form. Forms bond comes in a variety of colors to make easily distinguishable snap-out sheets.

GENERAL PURPOSE OFFSET

Offset paper, technically known as uncoated book paper, is for general printing of all types. This paper comes in several shades of white plus six or eight standard colors, depending upon the mill. Some sheets are more opaque than others, and mills may add the word "opaque" to the name of their product to indicate extra opacity.

You can find offset paper that works in copy machines and laser printers and looks fine with halftones that are specified with appropriate screen rulings. It's the general purpose, workhorse paper.

You can think of offset papers in three quality groups:

group one: #1 opaque and #1
group two: #2 opaque and #2

• group three: #3 and commodity

Price and quality differences among sheets within each group are small, so further rating

categories aren't needed.

Printers often refer to offset as #1 or #3. The first is brightest, most opaque, comes in the greatest variety of colors and finishes, and is most costly. For example, one mill makes #1 offset in twenty colors and seven finishes. In contrast, #3 offset offers more limited choices, lacks the high-grade feel of the premium version and costs less.

Offset paper comes in a vast array of colors, although mills don't keep offset colors as upto-date or fashionable as colors available in text papers.

Most offset papers are available in two categories of surface: rough and smooth. Finishes within categories have many names, but differences are so subtle that few people can tell which is which.

rough/low finish smooth/high finish antique smooth vellum lustre

vellum lustre
eggshell satin
machine wove
high bulk English

Rough finishes are relatively absorbent, allowing ink to dry quickly. Experts refer to

6-12 CATEGORIES OF BOND

Mills make bond papers in several varieties that ensure stock best suited to each application.

Writing has extra sizing to make its surface accept handwriting and printing well. It comes in 20# and 24#.

Onionskin, also called manifold, is thin and is used to make carbon copies. It comes in weights of 7#, 9# and 10#.

Ledger is relatively thick and is used for bookkeeping and account books. It comes in 28#, 32# and 36#.

Laser is extra smooth and has higher moisture content to run well in laser print-

ers. It comes in 20# and 24#.

Xerographic paper, also called copier paper, is smooth and made for photocopy machines. It comes in 20# and 24#.

Dual-purpose bond, labeled DP, is smooth and uniform and is made for printing using either ink on press or toner in a photocopy machine or laser printer. It comes in 20# and 24#.

Form bond, also called register bond, is made for business forms and computer paper. It comes in 16# and 20# and is available in rolls for web presses or continuous forms (fanfolds) for computer printers.

rough surfaces such as vellum, antique and high bulk as toothy finishes because they feel coarse.

Smooth finishes do not absorb ink as quickly as rough finishes, so have better ink holdout. Mills use words such as "satin" and "silk" to make their papers seem smoother than the competition. To choose between brands, compare samples and decide which you like.

Lightweight versions of uncoated book paper run well on web presses and are popular for large books, catalogs and direct-mail items. Although lightweight stock costs more per pound than medium weight, you might save the extra money several times over at the post office. Many mills make lightweight papers with good bulk and opacity. Most of these papers come only in rolls because the long print runs of high-volume direct mailers and catalogs typically go on web presses. Finding a printer who can do your job on lightweight stock might save you thousands of dollars.

Make dummies before deciding on a specific paper. Lightweight papers are often hard to run through sheetfed presses and folding machines. Both setup time and paper waste may be higher than when using medium-weight stocks.

LUXURIOUS TEXT

Text (short for texture) paper, an uncoated stock, looks impressive even in the unprinted areas of a brochure or announcement. Light striking textured surfaces gives added depth by making printing seem three dimensional. Specific finishes have special characteristics.

"The most important thing I learned during my first year as Advertising Manager was how many dollars and hours it takes just to get a job ready for printing. We spend thousands on writers, photographers and illustrators, then thousands more for design, proofs and plates. Now I'm alert to those costs ahead of time. If a department wants elaborate work but only a small quantity, I make its people justify those high unit costs."

The name "text" comes from the deeply textured look and feel of most sheets in this grade. "Text paper" has no relationship to textbooks or to the text portion of publications. Mills use the word "text" to help sell papers they want you to consider first class. The word means almost the same as "premium."

Offset printing works best for papers with surface patterns because offset presses put ink on paper from a soft blanket, not a hard plate. The blanket pushes ink into the patterns, ensuring uniform coverage. Printing by photocopy, laser printing and gravure looks best on very smooth paper.

Some mills rate texts using categories such as #1 and #2. Others do not assign numeric ratings, assuming that all text is premium.

Ratings are less important for text than for other grades because design decisions involving text rely more on appeal of the surface rather than on quality differences. Their wide range of colors and surface patterns makes text papers difficult to compare.

Price books often organize text papers by surface. Categories include felt, laid, linen and flocked fiber (also called tinted fiber).

Felt text is made by rollers applying the pattern to paper that is still wet. The process requires little pressure, thus yields stock with high bulk and stiffness. Because fibers have not been compressed, felt text is ideal for embossing.

Laid text is made the same way as laid bond. Mills occasionally put both laid and felt patterns on the same sheet, yielding a very distinctive surface.

Vellum text has passed through calendering rollers just enough to make its surface uniform, but not smooth. The result is good bulk and stiffness with a somewhat dull surface well suited to printing soft illustrations.

Rollers create embossed finishes after the stock has dried, yielding paper with good ink holdout due to slight calendering. Linen and canvas are common names for embossed finishes.

Text comes in a wider range of colors than other grades. Colors include whatever hues are currently in fashion as well as standard shades. Moreover, mills make a good selection of cover stocks in the same shades as their text so, for example, invitations made from cover match envelopes made from text. Whether white or colored, text often looks brighter than book or bond papers because mills add fluorescent dyes to the pulp.

Because of its high quality, text runs well on press and handles easily in the bindery. It works well in operations such as die cutting, foil stamping and folding. Top of the line text has some cotton fiber for long life.

Text papers bring combinations of color and finish to jobs that otherwise might seem flat. Photographs of materials such as carpeting, which itself has texture, have good depth. Illustrations that feature high or wide objects look more vivid when printed on a text surface with pattern lines running the same direction as the art. Text makes a good choice for products such as quarterly reports, programs, posters, invitations and greeting cards.

Not all papers called text have surface patterns. You can find very smooth sheets, both coated and uncoated, that mills call text papers.

SOPHISTICATED COATED

Mills apply clay coatings to uncoated paper to create coated papers. Coatings come in a range of thicknesses. Wash or film, coated paper gives just enough clay to improve ink holdout. Think of wash coating as being something like priming raw wood—enough to seal, but that's all. Wash- coated papers are good for publications such as club directories with pictures of members.

Take the concept of coated paper literally. Mills start with uncoated paper, then apply coatings. They refer to the uncoated stock as the base sheet.

Matte coat has more clay than wash coat and offers good bulk. It works well with body "Two years ago I printed circulars for people planning to exhibit at a trade show. They were just going into business and had no way of knowing how many they would need. I suggested that they order a conservative amount and promised to keep the plates until after the show. Sure enough, they called me during the middle of the second day to ask for 5,000 more. I delivered circulars the next morning and sealed a business relationship that's been great ever since."

copy and multicolor printing, but may not look good enough with color photos. Matte coat tends to appear mottled in areas of heavy coverage of dark ink.

Dull coat, also known as suede or velvet, is heavily coated and moderately calendered, yielding good contrast between paper and high-gloss inks or varnish. Like matte, dull is well suited to printed materials with extensive type because its low glare minimizes eye fatigue.

Gloss coat has the same amount of clay as dull, but sheets are more highly calendered and polished. Colors reflect well, and dull inks and varnishes give good contrast. Color photographs look crisp. Gloss papers cost slightly less than dulls and tend to run a little less white than dulls of the same name. The heat required to polish gloss stock also slightly browns it.

Mills rate coated papers according to brightness and opacity. Ultra-premium rates highest and costs the most, followed by premium, #1, #2, #3, #4 and #5. Paper with the highest ratings is available only as sheets; #4 and #5 coated is used for catalogs and magazines and is available only in rolls.

Coatings hide flaws and impurities, so the lowest-rated coated papers include some groundwood pulp. You can use #4 or #5 for directories, programs and other products with minimal quality requirements and short lifetimes.

Coated papers come in shades of white identified by terms such as balanced, warm and cool. Be sure to view samples of each

Grade and Basic Size	Common Names	Features	Surfaces
Bond 17 x 22	bond, ditto, erasable, forms, ledger, mimeo, onionskin, photocopy, rag, writing	lightweight, matching envelopes, pastels, light colors, watermarked	cockle, laid, linen, parchment, ripple, wove
Uncoated Book 25 x 38	book, offset, opaque	easy folding, wide range of colors	antique, smooth, vellum, wove
<i>Text</i> 25 x 38	text	deckle edged, textured, wide range of colors	antique, embossed, felt, laid, linen, vellum
Coated Book 25 x 38	coated offset, dull, enamel, gloss, matte, slick	good ink holdout, ink gloss, smooth surfaces, usually white only	cast, dull, embossed, gloss, matte
Cover 20 x 26	bristol, CIS, C2S, cast coat, cover, text cover	durable, stiff, strong	uncoated: antique, embossed, felt, laid, linen smooth, vellum,wove; coated: cast, dull, embossed, gloss, matte
Board	blanks, bristol, board, card, chip, index, plate railroad, sulphite, tag	stiff, strong, thick, variety of colors and surfaces	coated, embossed, plate, vellum, water resistant
	carbonless	standard colors	wove
	kraft brown or manila, opaque, strong		vellum
Specialty	gummed, label, presure sensitive, self-adhesive	variety of colors, glues, and surfaces	uncoated: English finish, vellum; coated: dull, gloss: synthetic: acetate, Mylar,vinyl
	newsprint	inexpensive, lightweight	vellum
	synthetic	durable, tearproof, water resistant	smooth, textured

⁶⁻¹³ Guide to printing papers This chart summarizes the characteristics and uses of printing papers. Use it to stimulate ideas and inquiries, not as an exclusive guide to ordering paper. Keep in mind that not all paper in a grade comes in every combination of size, weight, color and finish. Most merchants, however, can supply paper of each grade in the most common sizes, weights and calipers.

Standard Sizes	Weights	Thickness Range	Uses
8½ x 11, 8½ x 14, 11 x 17, 17 x 22, 17 x 28, 19 x 24, 19 x 28, 22 x 34, rolls	9, 12, 16, 20, 24, 28	.002006	certificates, directories, fliers, forms, handbills, letterheads, newsletters, photocopy, quick printing, resumes
17½ x 22½, 23 x 29, 23 x 35, 25 x 38, 35 x 45, 38 x 50, rolls	30, 32, 35, 40, 45, 50, 60, 70, 80	.003006	books, brochures, calendars, catalogs, direct mail, fliers, manuals, newsletters, programs, rate books
17½ x 22½, 23 x 35, 25 x 38, 26 x 40	70, 75, 80, 100	.005008	annual reports, announcements, art reproductions, books, brochures, calendards, posters, self-mailers
19 x 25, 23 x 29, 23 x 35, 25 x 38, 35 x 45, 38 x 50, rolls	sheets: 60, 70, 80, 100, rolls: 40, 45, 50, 60, 70, 80, 100	.003007	annual reports, books, brochures, calendards, catalogs, directories, direct mail, magazines, newsletters, newspaper inserts, posters
20 x 26, 23 x 35, 25 x 38, 26 x 40	56, 80, 100; calipers: .007, .008, .010, .012, .015	.006015	business cards, calendars, covers for annual reports, books, catalogs, and directories, folders, greeting cards, invitations, menus, point-of-purchase displays, postcards, posters, table tents, tickets
22 x 28, 22 ¹ /2 x 28 ¹ /2, 23 x 29, 23 x 35, 24 x 36, 25 ¹ /2 x 30 ¹ /2, 28 x 44	67, 90, 100, 110, 125, 140, 150, 175; <i>ply:</i> 4, 6, 8, 10, 14	.006050	business-reply cards, covers, displays, file folders, paper boxes, signs, screen-printed posters, tags, tickets
bond sizes	$12^{1/2} - 38$.003007	forms
rolls	30, 40, 50	.003006	bags, envelopes, fliers
17 x 22, 20 x 26, 24 x 30, rolls	60, 70	various	labels, signs, stickers
rolls	30	.003	directories, fliers, newspapers, tabloids
23 x 35, 25 x 38, 35 x 45, rolls	various	.003010	banners games, maps, tags

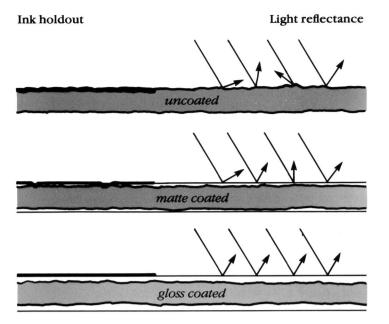

6-14 Ink holdout and light reflectance This edge view of paper illustrates how coatings affect ink. The left side shows the amount of ink that sheets absorb, the right side the way they reflect light. Uncoated paper absorbs ink quickly and has a rough surface that scatters light, reducing image brightness. Matte paper holds more ink on its surface and is smoother and brighter. Gloss paper has superior holdout and is very smooth and bright, yielding sharp photos and vivid colors.

before specifying. Cream and natural tones are also popular. Stronger colors are rare because coated stock is often used to show off color printing; it doesn't need to have color. Customers using premium coated papers typically have fine or premium printing in mind.

Coated paper enhances ink gloss. Ink contains varnish and other chemicals to make it glossy. The sheen stays on the surface of coated stock better than on uncoated. Coated paper is also smoother than uncoated, which shows hills and valleys around the fibers when magnified. Coating produces a flat surface ready for uniform ink coverage.

Mills coat papers to improve ink holdout, which is the ability of ink to dry on the surface of the paper rather than being absorbed. When ink dries on the surface, images stay sharp; when paper absorbs ink, edges of images become fuzzy as the liquid feathers into fibers. Holdout also affects color saturation, drying

time and many other printing factors.

Uncoated paper absorbs fine-screen dots so much that they may touch because they are too close to each other. Highlights may plug up and shadows become gray or fill in solidly, hiding the paper. Generally speaking, absorbent sheets call for coarse screen rulings. As holdout improves, you can specify finer screens.

Because paper surface affects dot gain, many computer programs for electronic design allow users to specify coated or uncoated paper before outputting halftones or separations. This simple choice does not, however, allow precise control of image quality on press. Dot gain on uncoated stock can range from 15 to 40 percent and on coated stock from 10 to 30 percent. The amount of gain depends on the specific paper surface, method of printing and several other factors. Leave decisions about compensation for dot gain in the hands of your prepress service or printer.

Coating and calendering increase gloss and holdout, but reduce bulk and opacity. Using coated stock may also result in a product that seems surprisingly heavy. For example, 60# uncoated has about the same bulk and opacity as 70# matte coat. A book printed on the 60# premium uncoated may look just as good but weigh 15 percent less than one printed on 70# matte coat.

You don't necessarily pay more for coated papers than for uncoated. Relative costs depend on the quality of each sheet in each category. It's true that the best coated costs more than the best uncoated (but far less than the best text or bond), but there are plenty of economical coated sheets.

Most readers find type on glossy paper hard to concentrate on for more than a few minutes because of glare. If you need coated stock in a book or manual, use matte or dull. The National Geographic Society prints its magazine on 60# gloss but its maps on 50# matte. Gloss gives better fidelity with photos, but matte is easier on the eyes.

STURDY COVER

Cover sheets are usually just extra-heavy bond, book or text papers. Printers use cover stock to cover books and catalogs, make folders and run brochures and cards.

Mills identify some cover stocks by caliper rather than basis weight. Cover that is 10 point measures .010 inches thick. The most common thicknesses are 8, 10 and 12 point. Small paperback books typically have 8-point C1S covers, meaning the stock measures .008 inches thick with clay on the printed side only.

Mills integrate cover papers with other grades so that printed products coordinate. One example is letterhead and envelopes made from bond and matching business cards made from cover. Another example is a booklet whose cover matches its inside pages, which are printed on text paper.

Some mills consider the match between text and cover papers so important that their swatch books showcase papers from both grades. They refer to their papers as text/cover papers, meaning that the papers are identical in surface and color even though they have different basis weights and calipers. Other mills put similar emphasis on matches between bond and cover.

You find cover coated on one side or both sides. C1S (coated one side) is for the book cover or folder that prints only on the coated side. Stock coated on two sides is called C2S. For additional protection and gloss, printers often coat the sheet again with varnish, plastic or laminating film after printing.

Mills also make cover papers not linked to other grades. At the premium level, cast-coated cover papers have a very thick coating dried slowly over a chrome drum to achieve almost a mirror finish. Cast-coated stock comes in several colors and is ideal for fine postcards, presentation folders and covers of prestige annual reports. Cover paper at the commodity level is coated only on one side (C1S) because it's normally printed only on one side.

Not all covers are made from cover paper.

For many products, such as consumer catalogs, any paper sturdier than that used inside will work. Covers for other products, such as direct mailers, can be made from the same sheet as the inside pages. Such products are known as self-covers and are illustrated in Visual 9-6.

MISCELLANEOUS GRADES

Mills make a wide range of papers such as index, bristol, tag, board and newsprint that have special sizes and uses. Many are used in both the packaging and printing industries. Several manufacturers produce specialty papers that resist tearing and moisture. You've seen them as envelopes, labels, maps, menus and textbook covers.

The paper industry refers to heavyweight, bulky stock as board. The material is rigid, strong, hard and durable. Names such as index, bristol and tag are common in addition to the general term "board." Sometimes an additional name gives a clue to intended use. For example, weatherproof bristol makes good lawn signs; plate bristol has a hard surface for business cards; vellum bristol is soft with good bulk for direct-mail cards.

Because there is no consensus about basic sizes for board stock, basis weights vary greatly. Furthermore, some boards are described in caliper and others in ply. Ten-ply board, for example, consists of ten sheets of paper laminated like plywood. Ply board, also called railroad or poster board, comes in many colors and may be weatherized for outdoor use.

Mills make chipboard from mill waste without concern for strength or printability. This inexpensive material is used for light-duty boxes and backings on notepads. Chipboard may be designated by caliper or by number of

"We needed an image of our hospital, but the street has so many power poles that we couldn't get a decent photo. We could have spent a fortune having a prepress service scan and retouch an image, but decided to hire an illustrator instead. We got a line drawing that works extremely well on a variety of our publications." sheets in a fifty-pound bundle.

Board paper is very thick and used primarily for posters and signs. It's usually coated on one side and is available in traditional sizes for advertising inside buses and trains. Board is printed in a variety of ways depending upon its thickness. Thinner board runs satisfactorily on sheetfed offset presses; board over 20 point is generally printed letterpress or silkscreen.

Bristols come in various finishes. Vellum bristol is used for business-reply cards and self-mailers. Bulky and very porous, it runs well on quick print presses. Index bristol is used for file and index cards as well as direct-mail pieces. Its hard surface gives good ink holdout. Tag is a heavily calendered, dense, hard paper for products such as labels, scoresheets and notecards.

Bristols, tags and similar grades seldom carry numerical ratings. That does not mean, however, that all sheets are equally good. As with most papers, price is a guide to quality.

Newsprint comes from groundwood pulp and usually runs on open web presses. It can be sheetfed but runs slowly due to lack of body and impurities that lead to frequent cleanings of plates and blankets. The impurities also make this very inexpensive stock opaque but likely to yellow with age.

Kraft is a cousin to newsprint made for wrappings and bags. It costs very little, may be hard to find for commercial printing, prints slowly, and comes only in the familiar brown and manila. Because of its distinctive color and feel, kraft paper works well to give an old-fashioned look to mailings, newspaper inserts and menus.

Dry gum paper has glue on the back ready to activate with either moisture or heat. Mills

"When I show a printer an example of what I want, I don't worry about what the example says. I pay attention to physical features such as color, paper and folding. I pick up samples of what I like everywhere from trade shows to hotel lobbies, then ask my printer how I can make my jobs more like those good examples."

apply water soluble glues to stock for stamps, shipping labels and sealing tape. Heat sensitive glues are used for labels in retail applications such as meat packing.

Pressure sensitive papers, often called stickyback, are printed to make the popular peel-off label. Adhesives can be either temporary or permanent. Almost any kind of paper is available with a self-adhesive backing.

Carbonless papers have chemical coatings that duplicate writing or typing on an undersheet. The stock is used primarily for multiplepart business forms. Sheets come in three types: CF (coated front), CB (coated back) and CFB (coated front and back). A four-part carbonless form would have a CB top sheet, CFB second and third sheets and a CF bottom sheet. Special glues adhere to the coatings, but not to the papers. Glue applied along the edge of a large stack of carbonless sheets assembled in proper sequence pads them into sets, each having the correct number of sheets.

Synthetic papers are petroleum products with smooth, durable surfaces. They are very strong, as anyone knows who has tried to tear a synthetic envelope. Synthetics make fine maps, covers for field guides, game boards, and other products that must withstand weather, water and hard use. Synthetics cost about three times more than comparable premium coated book papers.

Specialty papers include metallic paper coated with either Mylar or powdered metals and synthetic paper, which is actually plastic film. These papers are expensive and may require special inks and printing techniques. If your design calls for using a specialty paper, discuss it with an experienced printer first.

RESPECTABLE RECYCLED

Paper accounts for approximately 40 percent of the solid waste that overflows landfills in North America. In addition, making paper consumes trees and energy and pollutes air and water. The health of our environment demands use of recycled fibers instead of vir-

6-15 USING RECYCLED PAPER

You can choose the recycled paper best suited to your message and budget if you keep in mind the following features.

Grades. Available in all the writing and printing grades—bond, text, offset, coated and cover.

Ratings. At the middle and lower quality levels in each grade. The high-quality levels contain the brightest, most durable and most uniform papers—those hardest to make using recycled fibers.

Surface. Full range of textures, patterns and coatings.

Ink holdout. Slightly worse ink holdout than comparable virgin stock because it is slightly less dense. As a result, recycled paper has higher dot gain. Use coarser screen rulings than for comparable virgin stock.

Paper color. Full range of whites and colors. Whites may seem less clean. Color matches from batch to batch and grade to grade are slightly less dependable than in comparable virgin stock.

Ink color. Ink colors slightly less consistent and predictable than on comparable virgin stock because of variations in raw materials going into recycled papers.

Brightness. Slightly less bright than comparable virgin stock because of variations in raw materials and difficulty of removing 100 percent of ink and dye.

Opacity. More opaque than comparable virgin stock because it contains some residue of ink and dye.

Basis weight. Available in basis weights of 60# and over. Lightweight recycled paper is too weak to withstand the pressures and tensions of web printing, the customary method of printing lightweight papers.

Caliper. Slightly thicker than virgin stock of the same basis weight and surface.

Grain direction. Fibers are shorter than virgin fibers, so grain direction in recycled paper is less important than with virgin stock.

Sizes. Available in the full range of sizes. Permanence. Acid free, but slightly less strong and durable than comparable virgin stock.

Cost. Some recycled paper costs more than comparable virgin stock, some costs less and most costs about the same. Cost differences are dictated more by supply and demand for specific grades and brands than by costs of recycling.

Availability. Specific grades, ratings and brands become easier or harder to get in response to the same market forces that influence virgin papers. Small quantities are readily available in common colors and sizes and in weights other than lightweight. Larger quantities and paper with unusual features take longer to get.

gin fibers whenever reasonable.

Mills can put old paper back into the pulping process and blend it with virgin pulp. Old paper that mills recycle into new paper comes from two sources.

Preconsumer waste is paper that has never reached the user of a printed product. It includes unprinted paper such as trimmings from making envelopes, roll ends, damaged paper that printers couldn't use, and waste from the mill itself. Preconsumer waste also includes some printed paper such as printer makeready and unsold books and magazines.

Postconsumer waste is printed paper that has been discarded by the end user. It includes publications, office paper, bags and hundreds of other products. Postconsumer waste is gathered from end users and returned to paper

6-16 SAMPLE PAPER SPECIFICATIONS

The following ten orders for paper show how to specify quantity, size, grain, weight, color, name, surface and grade. Sometimes grade is omitted when the name is so specific that misunderstanding is impossible.

- 62,500 sheets, 23 x <u>35</u>, 100# white, Lustro dull coated book
- 5,000 sheets, 26 x <u>40</u>, 65# Del Monte Red. Beau Brilliant cover
- 78,525 lbs., 35 inch, 80# Lustro dull web coated book
 - 5,000 sheets (10 reams), $8\frac{1}{2} \times 11$, 24#

Chiaro gray, Filare script bond

- 2,500 sets, 4 part 8½ x 11, precollated sets NCR, black print bond
- 1,000 sheets, 20 x <u>26</u>, 60# white, Fasson satin litho Crack 'n Peel Plus label
- 1 skid (approximately 16,000 sheets), 25 x 38, 60# blue white, Halopaque satin uncoated book
- 1 carton, 23 x <u>35</u>, 105# blue white, Halopaque satin reply card
- 16 cartons, $17^{1/2}$ x $22^{1/2}$, 35# white, Flecopake #1 opaque offset

mills instead of going into a landfill.

The huge volume of postconsumer waste creates the urgency to recycle paper. But postconsumer waste costs more to recycle than preconsumer waste because of the logistics of collection. Coated papers cost the most to recycle because of the difficulty of removing coatings as well as inks. Color in paper also drives up the cost of recycling because of the expense of removing dyes.

Guidelines, laws and goals regarding recycled paper deal with the percentage of recycled fibers in paper and the source of those fibers. A paper listed as 50 percent recycled may use entirely preconsumer waste and no postconsumer waste.

The recycling process shortens fibers and may not remove 100 percent of the ink. As a result, recycled papers have slightly different characteristics from comparable grades of virgin paper.

Recycled fibers are most appropriate in products whose quality is lower than the quality of the original product. For example, fibers from offset paper work better in newsprint than when recycled into more offset paper. Fibers from newsprint work better in corrugated cartons than in more newsprint.

Pay particular attention to recycled fiber content when buying lower quality stock, such as commodity offset and xerographic bond.

Some papers recycle better than others. Uncoated papers with little ink coverage are easiest. Coated papers and papers with dark dyes are hardest. Use uncoated papers that require the least energy and water and generate the least pollution when recycled.

The language of recycling is not precise. For example, mills disagree about the difference between preconsumer and postconsumer waste. Some mills call press makeready preconsumer waste, and others call it postconsumer waste.

Don't assume all recycled papers contribute equally to the environment. Ask for definitions and details about sources of fibers.

SPECIFYING PAPER

After deciding what paper you want, you must describe it clearly to your printer or paper distributor. The description, though short, must be accurate and complete in order to prevent confusion.

Good paper specifications address eight characteristics. If you are buying paper yourself, you must handle all eight; if your printer is buying for you, you need only deal with the first five. Visual 6-16 shows examples of properly written paper specifications using all eight characteristics.

- Quantity. How many sheets or pounds?
- Size. Describe sheet or roll size in inches.
- Grain direction. Grain long or short? Show grain direction by underlining the correct numeral. A 25" x 38" sheet is grain long—grain running parallel to the 38-inch edge.
- Weight. Use the basis or sub weight as listed in the sample book or price page.
- Color. Write the exact name that the mill uses for the color.

"People who don't know what they are doing with a large printing job could really help themselves by hiring an experienced graphic designer for a few hours as a consultant. It might cost a couple of hundred dollars to get proofs examined or help with doing a press check, but it could save thousands."

- Brand name. Usually this is the name for an entire line of paper made by a specific mill.
- Texture or finish. If the finish isn't part of the brand name, be specific.91
- Grade. State whether you want bond, book, text or cover, or use the name of a specialty paper.

7. OFFSET PRINTING

Best for most jobs Press components Press types, sizes and features **Quality expectations** Correct register Ink density Conquering dot gair Miscellaneous qualit problems Industry qualit guidelines Printing inks Special inks Protective coatings Successful press checks

Offset lithography is the most popular commercial printing method because printers using it produce quality results relatively quickly and inexpensively. Other processes work better in specific situations, but lithography performs best for most jobs.

Lithography yields excellent results because plates carry sharp images and precise dots. It's fast because plates are easy to make and, once on press, allow for long runs at high speeds. Easy platemaking and setup and fast press speeds mean lower costs.

Knowing how offset presses work means you can plan jobs to take full advantage of different machines and avoid expensive problems. Understanding presses leads to sound decisions about quality and how it relates to costs. Finally, familiarity with presses makes you a better judge of whether you are getting good service and are likely to stay on schedule.

Printers vary greatly in the types, sizes and abilities of the presses in their shops. Customers who understand the limitations and advantages of various presses make better choices among printers to ensure economy and quality.

In this chapter you will learn about offset plates and presses. You'll discover what quality levels you can reasonably anticipate from printers using presses of different sizes and complexity. Using concepts such as register and ink density, you'll identify what to expect of jobs printed at the four quality categories introduced in chapter one. Finally, you will learn about coatings to protect and enhance your printed product.

The information about quality in this chapter can guide you through most offset printing jobs. Consult Visual 9-1 for guidelines about quality in binding.

BEST FOR MOST JOBS

Lithography means "writing with stones." The technique began as a way of manufacturing art prints. Artisans inscribed images on flat stone, then used the stone as a printing plate.

From its beginning, lithography was based on the chemical principle that water and oil repel each other. Ink is oily. Images were carried on the stones by keeping water on the nonimage area, thereby forcing ink to stay only on the image area.

Modern lithographic plates function on the same chemical principle. The ink-receptive coating on plates is activated only in the image area. Some modern plates prevent ink from invading nonimage areas by coating them with water. Other plates use a technique called waterless printing in which the nonimage areas are coated with an ink-repelling substance such as silicone.

Waterless plates yield images with lower dot gain and higher ink densities than plates using water. The technique also reduces makeready, makes presses easier to control, permits screen rulings up to 500 lpi (lines per inch) and allows digital (filmless) platemaking. There are disadvantages as well. Waterless plates cost more and wear out faster. Proofing systems are designed for plates using water, so proofs may not predict press outcome.

The original lithographers printed images by pressing paper directly against the inked surface of a stone. Modern presses transfer images from an inked plate to a rubber blanket. It's the blanket, not the plate, that comes in contact with the paper and actually prints the image. The image offsets from plate to blanket, then offsets again from blanket to paper. Because all lithographic presses use the offset principle, the method is simply called offset printing.

7-1 SHEETFED OR WEB?

No formula can reveal the type of press best suited to a specific printing job. Compare printers based on the cost, quality and schedule of your jobs, not on the machines used to produce them.

Although there is no formula, there are some very general guidelines. Generally speaking, web presses print long runs more economically than sheetfed presses. The point at which one type of press becomes more economical than the other, however, varies greatly from job to job and shop to shop.

Web may work best when:

- paper basis weight is under 50#
- paper is relatively inexpensive

- stock is newsprint
- number of impressions is over 25,000
- the job can print both sides at once
- the job has standard folds and binding in line

Sheetfed may work best when:

- paper basic weight is over 70#
- you need showcase quality
- paper is relatively expensive

Folding and binding requirements may influence cost and speed as much as printing. In addition to simple folds for publications, many web presses can do in-line folds for complicated direct mailers and brochures.

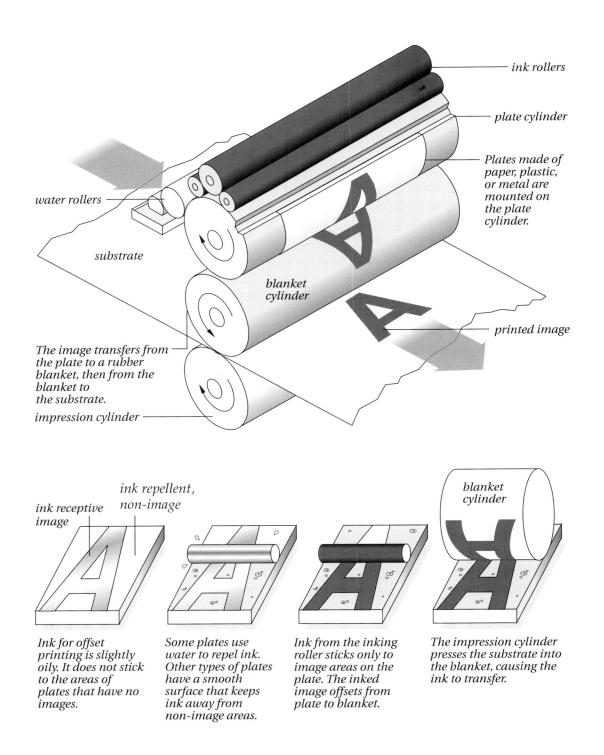

7-2 Offset printing Offset printing produces a sharper image than printing directly from plate to paper because the rubber blanket conforms to the tiny surface variations of paper. In addition, offset plates are right reading. If images went directly from plate to paper, they would have to appear backward on the plate. You could read them in a mirror, but not on the plate itself. Right-reading plates are easy to inspect because the image reads exactly as it should on the printed product.

PRESS COMPONENTS

All offset presses have five basic components. Feeding units deliver paper into the machine. Register units assure paper arrives under the printing units in the same place each time an image is made. Ink units convey liquids to plates. Printing units transfer images to the paper. Delivery units remove the printed paper. Most presses also have a water unit that brings dampening fluid to the plate.

The feeding and register units of a sheetfed press take one sheet of paper at a time and position it ready for printing. Good register requires that each sheet enter the printing unit from precisely the same position. Guides on one side and at the leading edge hold the sheet in place while it waits for grippers to draw it under the rotating cylinder holding the blanket.

The feeding and register units of small, inexpensive presses may vary the position of each sheet by as much as ½16 inch. Large, costly presses may have register tolerances close to ½1000 inch. Perfect register is difficult for a machine running three sheets per second.

After the sheet comes into position, grippers like metal fingers pull it into the printing unit. There the impression cylinder presses the sheet against the blanket cylinder, transferring ink from blanket to paper. While the press actually prints, operators register images by adjusting plate cylinders.

When printers talk about the gripper edge of paper, they mean the leading edge that enters the printing unit first. Paper for small presses goes in shortest dimension first. On an 8½" x 11" sheet, the 8½-inch side is the gripper edge. Large presses take paper along its width. A 35-inch press takes a 23 x 35 sheet, with the 35-inch side providing the gripper edge.

Grippers hold tightly to about 3/8 inch of paper, forming a strip that cannot receive ink. With large presses, the gripper edge is usually no problem because paper is almost always trimmed or cut up after printing. Small press-

es, however, usually run stock cut exactly to $8^{1}/2$ " x 11" or 11" x 17".

When planning jobs that run on stock already cut to final trim size, plan carefully so that grippers don't run into the image area. Designs for pieces printed on small presses should avoid placing the image within 3/8 inch of the leading edge of the sheet.

Grippers also affect planning for bleeds. A bleed is any image that goes directly to the edge of the paper, seeming to run off (bleed) from the sheet. Printers create the illusion of a bleed by trimming the edge of the paper into the inked area as shown on Visual 7-3. Designs calling for bleeds always require using more paper (large sheet size) and sometimes a larger press, both of which may increase costs.

Inking units affect printing in many ways. Ink is a pasty liquid held on press in a trough reservoir or in plastic bottles tipped upside down. Press operators control ink flow onto the rollers. Operators can increase or decrease the flow to control the amount of ink applied to specific sections of the plate.

A small press has only one ink fountain with ten or twelve outlets. A very large press may have eight ink fountains, each having fifty or sixty outlets.

Ink rollers transfer ink from fountain to plate. The number of rollers varies with press size. Small presses have four or five rollers per plate while large presses have eighteen or twenty. Rollers work together to smooth the ink and spread it evenly across the plate to help achieve uniform density.

Presses that use dampening fluids to pro-

"When I first learned about web presses, I started specifying web or sheetfed for each job. I thought I was very sophisticated, but I really didn't know what I was doing. I'm sure I once paid too much for a rerun that the printer had to restrip for web. Now I just pay attention to how much the job costs and when I can have delivery. I let the printer worry about what kind of press to use while I worry about getting copy and files ready on time."

tect nonimage areas of plates keep the fluids in a water fountain. The fluids contain ingredients such as acid, gum arabic and alcohol in a base of water. Dampening units transfer fluids to the plate via a system of rollers similar to the system of inking rollers.

Plates using water must receive just enough fluid to prevent ink from adhering to nonimage areas, but not enough to transfer water to either blanket or paper. The fountain solution, also called dampening solution, must evaporate instantly from the plate, leaving only a thin film of ink on the image areas. The craft of offset printing depends heavily on proper balance between ink and dampening solution.

A printing unit consists of the series of rollers and cylinders that transfer the inked image to paper. Presses may have one or more printing units. Printers describe the number of printing units a press has by referring to how many colors it can print. A press with four printing units is known as a four-color press.

Once a sheet has been printed, the delivery unit removes it from the last printing unit and deposits it in a pile. This simple task becomes

7-3 Bleeds Press operators produce bleeds by printing on sheets larger than the trim size of the final piece, then cutting away edges. Trims for bleeds cut into the inked image to create the illusion that the press printed to the very edge of the sheet.

Producing jobs with bleeds requires either increasing size of paper or reducing the number of printed products cut from each sheet. Make sure that you specify bleeds before your printer orders paper for your job and remember that bleeds increase cost because they increase the amount of paper needed.

complicated as the amount of ink on a newly printed sheet increases. Exit wheels and guides must not mark areas of heavy coverage.

Delivery units normally include a system for spraying fine powder over the sheets to inhibit wet ink from transferring from the front of one sheet to the back of another. The unwanted ink transfer is called offsetting and is especially likely to occur when using gloss coated paper with good ink holdout. The dust is known as antioffset powder. A heatset web press passes printed paper through an oven to dry ink before cutting the web into sheets.

Quick print presses are not equipped with antioffset units and so don't usually run coated paper.

PRESS TYPES, SIZES AND FEATURES

Offset presses are categorized according to format of paper, size of paper and number of printing units. Each type can have many special features.

Format of paper

Offset presses are either sheetfed or web. Paper feeding into a web press comes off a roll and is cut into sheets after printing. Paper feeding into a sheetfed press has already been cut. Visual 7-2 shows a typical sheetfed press, and Visual 7-4, paper for web presses.

Size of paper

Press size is identified according to the widest sheet or roll of paper the machine can handle. A 40-inch press can run a sheet up to 40 inches wide.

Small sheetfed presses print sheets 12" x 18" or less. That size includes most presses at quick and in-plant shops whose maximum is typically 11" x 17". Printers use these machines to run letterheads, business cards, fliers, envelopes, newsletters and forms.

The printing industry refers to inexpensive small presses as duplicators. The term sounds derogatory, implying the machines and their operators cannot attain the quality of large

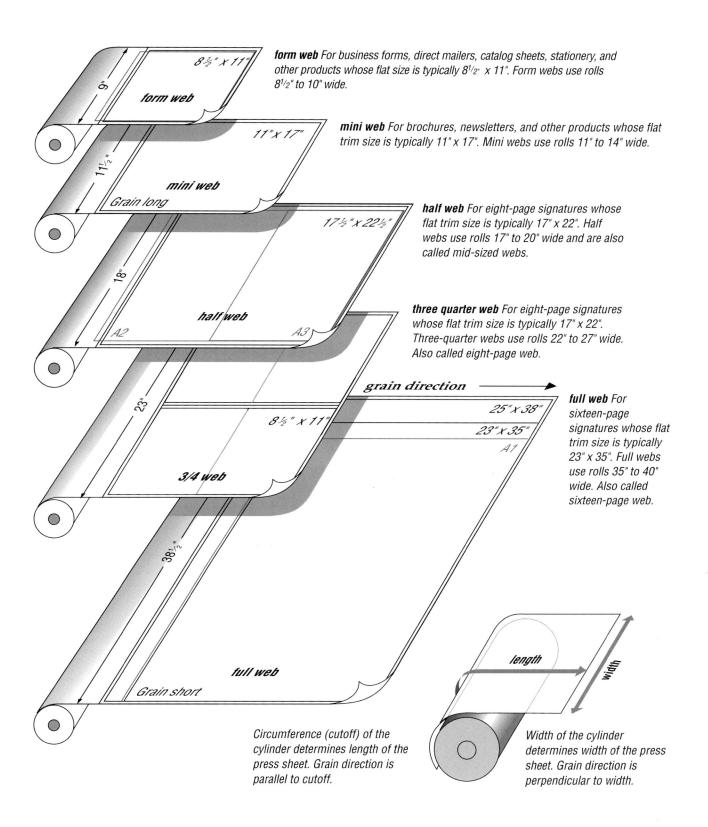

7-4 Web presses Sizes of printed sheets produced on a web press are the same as sizes for sheetfed presses. The range of common finish sizes for printed products is the same whether the products are printed sheetfed or web.

presses. The implication is often true and always irrelevant. Small presses are made for printing small jobs efficiently. Criticism because of their limitations is pointless.

Small presses run solid ink on uncoated paper 90 percent of the time, but many are capable of much more. Look for shops that display samples of multicolor printing or pieces on matte coated stock.

Large sheetfed presses can run stock anywhere from 12" x 18" up to 55" x 78", although few printers have machines larger than 40 inches. Most commercial printers consider 19" x 25" and 25" x 38" sheet sizes versatile enough to handle almost any job.

Large presses prove highly efficient for many jobs because they gang images. An 8½" x 11" flier prints eight up (eight copies of the flier) on one 23" x 35" sheet, so a press able to run 8,000 sheets an hour can print 64,000 fliers in sixty minutes. Sheets from large presses yield signatures with more pages than sheets from small presses, reducing time and expense in binding.

Web presses come in five general sizes described in Visual 7-4. Printers refer to paper going through a web press simply as "the web." If the paper tears coming off the roll or while passing through the press, it's called a web break. Operators must shut down the press and thread the paper all over again.

The circumference of the impression cylinder on a web press is its cutoff and determines the maximum length of the image area. A web press with a 23-inch cutoff and running a roll 35 inches wide would print images imposed similarly to a sheetfed press running 23" x 35"

"When I was doing only small printing jobs, I could miss a press date and the printer would always work me in a few days later. I figured that I was a regular customer and that's how everyone in the printing industry scheduled time. When I started doing long runs on web presses, I had to learn that a missed press date might cost me five or six weeks. Time on those huge presses is scheduled that far in advance." stock. On most web presses, cutoff is not adjustable.

Knowing cutoffs for specific presses helps plan for efficient use of paper. For example, a nine-inch rack brochure produces efficiently on a press with an 18-inch cutoff, but a press with a 23-inch cutoff would waste five inches of paper on every impression. This translates into wasting 22 percent of the paper.

Printing units

Most large sheetfed presses and many small ones can print more than one color at once. Sheets pass under two, four or as many as eight blanket cylinders, each adding a different ink or varnish.

Although presses could have any number of printing units, the typical configurations are one-color, two-color, four-color, six-color and eight-color. A four-color job run on a six-color press leaves two printing units idle. Many four-color jobs, however, call for using a fifth unit for flat ink (hence the term "fifth color") and a sixth unit for varnish.

Each time a sheet passes through a sheetfed press, it's called one impression. During one pass, a four-color press prints a sheet having four ink colors. Note that "impression" refers to press sheets, not final products. One sheet of paper or one web cutoff equals one impression regardless of how many products it yields after being cut into pieces.

Press speeds are measured in number of impressions per hour (iph). A sheetfed press might run at 12,000 iph, meaning that it prints 12,000 sheets in one hour. A two-color press running at 10,000 impressions per hour yields 10,000 press sheets in one hour. You may also express web speeds as iph, referring to the number of cutoffs per hour.

Perfecting presses print both sides of the paper during the same pass through the machine. Some sheetfed and most web presses are perfectors. Some perfecting presses print both sides simultaneously as paper goes between two blankets; others automatically

turn paper over to print the other side.

Presses that print more than one color on both sides during one pass through the press are multicolor perfectors. A large web press, for example, might have eight printing units for each side of the paper.

Special features

Web presses are categorized not only by size but according to their ability to dry inks. Open webs allow the paper to dry unaided. Heatset webs speed the drying process by passing the printed paper through ovens before cutting it into sheets.

To achieve high ink gloss on coated stock, heatset webs also have chill rollers that harden ink and return the paper to room temperature. In contrast, open web presses can only print uncoated stock. Open webs work economically for products such as newspapers, telephone directories and direct mail inserts. Forms presses are usually open webs.

Web presses can often fold and bind in sequence with printing. Paper enters the first folding unit immediately after being printed and before being cut into sheets. In-line finishing saves time and money because of efficient manufacturing. Materials move quickly through the printing process.

Web presses can also print relatively light stock. Paper less than 50# tends to wrinkle passing though a press as sheets. Because they keep the paper under tension, webs commonly print 40# and even 30# paper.

Sheetfed and web presses perform equally well for basic, good and premium printing. Only a few of the most sophisticated web presses, however, are capable of showcase quality.

QUALITY EXPECTATIONS

You make the most important decisions about quality when you plan jobs and select printers. You signify to printers what quality you want by the appearance of specification sheets, layouts and mechanicals; by how precisely you

"Sometimes I can work miracles to get things printed on a tight schedule. I've laid the groundwork for the miracles by insisting that our accounting department pay suppliers promptly. I can ask for super service from people who apprepiate quick payment."

identify features you consider critical to success; and by how expertly you examine samples and proofs. Printers use these signs to decide how much quality you recognize and demand.

Many printers refer to a job in terms of the effort they believe it requires. Some jobs are routine; others call for the shop's best effort. You need to know the difference between routine and superior work at an individual shop and to tell the printer which you want. When the printer knows which level of effort you want, its staff produces and prices your job accordingly.

The different levels of effort within a shop may not correspond to the four quality categories of printing introduced in chapter one. For example, routine work at some quick printers is not good enough to meet even the standards of basic quality. In those situations, basic quality requires the best the shop has to offer.

An individual print shop can produce different printing categories for different kinds of jobs. For example, a shop might produce showcase single-color work, but only premium four-color process printing.

Basic quality printing doesn't receive a great deal of attention at any stage of the job. Speed and legibility count for more than dense color or premium paper. Many customers never even proofread basic work. Good quality jobs get more attention to preparation and proofs and more care in press operation. With good quality, printers express more concern for pleasing and consistent appearance.

Attention increases significantly with premium quality printing. Pressroom and bindery operators are especially trained in quality con-

trol. Customers buying premium quality printing are more sophisticated and more likely to be graphic arts professionals than those buying basic and good quality. With showcase quality jobs, everybody involved strives for perfection.

Quality-conscious printers regard printing as a craft, not merely a manufacturing process. Press operators must watch constantly for dozens of variables and make frequent adjustments, often while machines are running at high speeds. Mistakes can cost thousands of dollars in wasted paper and time.

As quality expectations increase, demands on press operators become intense. Operators at all quality levels, but especially for premium and showcase jobs, must have a distinctive mix of physical and mental attributes. They must feel confident controlling complicated machinery, pay meticulous attention to detail and work easily as members of a production team.

Controlling printing costs as well as achieving quality demands matching individual jobs with individual printers. Too many customers take good- and even basic quality jobs to premium and showcase quality printers. They are wasting money on quality control they don't need.

CORRECT REGISTER

Register means that printed images appear where they were planned to appear. Properly registered images are correctly placed in relationship to each other and to the edges of the paper. If a mechanical shows a headline to begin one inch from the left edge of the paper, but the finished product has the headline only ¹¹/₁₆ inch from the edge, the headline is not registered correctly.

Factors such as the quality of prepress work, the press and paper being used, and the objectives of the printed piece all define what register is close enough. For example, art reproductions, sales brochures and newspapers have totally different requirements for register.

Register on one-color jobs simply requires getting the image onto the sheet correctly positioned and aligned to the edges. Two-color jobs are more difficult to register because operators must align two images to each other as well as to the edges of the paper. Each color requires paper to pass under a separate blanket inked by a separate plate. Variations of ½4 inch can ruin traps.

With multicolor work and especially with four-color process printing, register becomes critical. Good quality four-color process work calls for register tolerances of .01 inch; show-case separations must register with no variations. Visual 4-11 illustrates register of four-color printing.

Register affects trapping. Guidelines about trapping assume precise register. Most jobs, however, show a slight variation in register throughout the run. For example, if you design a .01 inch trap for a job that prints .015 inch out of register, you lose your trap on at least one side of the image. When you plan traps, keep in mind all factors that affect register as well as trapping estimates for common screen rulings.

Register also affects color with four-color process printing. Even one color slightly out of register can cause a hue to shift or produce a cast across the entire sheet, especially if that color is magenta or cyan. For that reason, you should verify register before checking color when doing a press check.

Plates and presses vary greatly in their ability to register. Equipment at quick printers should align one-color jobs to the edges of the paper with no more than ½16-inch variation. Those machines can handle two-color register

[&]quot;People ask me how our printing company can stay so profitable when we spend so much money on training employees and customers. I say that we get our profit because of training, not in spite of it. For example, training means that we prevent most mistakes before they happen. We hardly ever do a rerun because of poor quality. Some printers eat hours of press time every month because they didn't do a job right the first time. When we run a press, a customer pays for it."

where the colors need not align precisely. Presses found at most commercial printers should handle tight, multicolor register easily. A good operator should get pleasing four-color process work from most medium and large presses.

Problems with register often begin long before a job goes on press: Laser printers and imagesetters may output images whose placement on paper or film varies from one printout to another; paper and film image surfaces can stretch or warp; film may be stripped out of register.

To determine whether operators can solve a problem with register on press or must return the job to prepress, examine every edge of the press sheet. If images appear uniformly out of register, the press operator can probably make corrections. If register varies from one portion of the sheet to another, the problem lies in prepress.

Paper that absorbs moisture on press can affect register. As its moisture content increases, paper can expand across the grain by as much as .5 percent. That much expansion would hardly affect simple jobs on small sheets, but it could cause major problems with four-color premium or showcase quality jobs on large sheets.

The concept of register includes backups and crossovers. Backups refer to images on opposite sides of the sheet. The line at the bottom of one page should back up the corresponding line on the other side of the sheet.

Crossovers are type, rules, art or photographs planned to line up at the gutter after sheets are folded, trimmed and bound. Crossovers require precision stripping, printing and folding. Even keeping a line of headline type properly aligned across the gutter can prove difficult and expensive. You should expect perfect crossovers only with showcase printing.

Technically speaking, images that do not appear precisely where they are intended are out of register. As a practical matter, however,

7-5 DEFECTS NOT RANDOM

Quality problems that originate in prepress occur consistently throughout the job, but variations that originate on press or in bindery usually occur in clusters. For example, if you spot washed out halftones it's likely that a press operator saw the same problem and corrected it. The press operator may have considered the problem minor, however, and allowed the problem sheets to stay with the production run.

When you identify a problem, examine other sheets produced in the same sequence. Examining sheets or final products at random tends to hide the true extent of a problem.

many printing jobs are slightly out of register. Printers and customers approve those jobs because precise register is difficult to achieve on every sheet—and the untrained eye doesn't notice or care.

The meaning of terms such as "hairline register" and "commercial register" varies according to who is using the term and in what circumstances. In four-color process printing, hairline register may mean register within one row of dots or half a row of dots, depending on the size of the dots. Regarding reverses or traps, commercial register may refer to a choke or spread made extra large.

You should expect the best register that equipment at the print shop can provide. Your printer has a corresponding expectation that you design jobs appropriate to the machinery in that specific shop. You and your printer should agree before the job is contracted that the shop is capable of the register you want.

The correct term is "register," not "registration." Printers plan for register, schools plan for registration. Printed images are in register or out of register. Strippers register film when making flats and press operators adjust presses

"No, it's not only your printed jobs that always seem to have something wrong. Everyone's jobs have something wrong. It's just that you know your jobs intimately. You recognize flaws in your jobs instantly and flaws in other jobs rarely."

for register. Visual 4-11 shows printing both in and out of register.

INK DENSITY

Getting the right amount of ink onto paper requires controlling density. Proper density means that line copy looks vivid and has sharp edges. Halftones have contrast without losing shadow detail. Separations show satisfactory color detail and fidelity.

Too little ink produces washed-out images: Type looks thin and pale; colors seem weak; photos look flat; dots in highlights of halftones and separations may drop out.

Too much ink makes type appear fat and fuzzy. Large dots in screens and halftones may run into each other, plugging up shadows and causing loss of detail.

Proper ink density is more than a matter of aesthetics. Legibility requires good contrast between type and paper. Washed-out type lowers contrast and makes your message difficult to understand.

Problems with ink density are most common with jobs printed in the basic and good quality categories, especially those run on small presses. Small presses deliver ink less efficiently than larger presses.

Press operators are responsible for achieving satisfactory density and then maintaining it. In quick print shops, operators are often hurried and typically judge density only by watching sheets as they come from the press. In commercial shops, operators have more training and time to set up jobs and should use a densitometer to measure density.

Most commercial print shops assure proper ink density by running quality-control strips. The strips, known as color control bars and reproduced in this book as Visual 3-11, are

printed along the edge of the paper.

Density readings are the printer's responsibility, not yours. You should inspect a sheet for satisfactory results and let the printer worry about how to achieve them. Specify densities only when you feel certain that your target numbers yield the results you want on the specific paper and press used for the job.

Putting appearances first doesn't mean ignoring density readings. On the contrary, approval sheets that you file with other materials for the job should have densities written along their color bars. That information permits faster makeready during reprints and may save you another press check. And you can use density requirements to specify quality in measurable terms.

Different printers have different ideas about proper density. Some shops think yellow at 1.05 is about right, but others think .80 gives best results. Magenta varies from .95 to 1.50. Cyan and black have even wider ranges. No standards exist for sheetfed jobs, so after you have approved a press sheet a printer needs to know what densities satisfied you.

Adding ink on press requires less time than taking it away. In other words, increasing density is easier than decreasing it. Furthermore, printing at maximum densities leaves no margin for error. For those reasons, many press operators like to run jobs at the lowest densities that yield satisfactory results. On basic and good jobs, that technique works. On premium and showcase jobs, however, a little extra time at a press check may bring much better results.

Ink density should measure satisfactory across the sheet. In some cases, satisfactory means uniform across the entire sheet. In other cases, it means varying density to achieve specific results in certain areas of a sheet. For example, achieving satisfactory skin tones might call for slightly less magenta in one separation than in another. If the adjustment wasn't made quite well enough during prepress, operators might make it on press.

Occasionally a job shows a portion of the

sheet with a density problem that repeats sheet after sheet. Low spots in blankets cause areas that print too light. A worn gear or ink roller can cause a light streak running perpendicular to the direction in which the paper moved through the press. If these density problems make your message less effective, don't accept the sheets on which they appear.

Basic quality jobs should have at least 75 percent of the sheets printed with satisfactory density; good quality should have at least 95 percent; and premium and showcase quality should have 100 percent.

Consistency from one press run to the next is harder to achieve than consistency during one run. Brochures printed in March may look different from those reprinted in July; logos on envelopes may look different from those on stationery done at another shop. Big jobs such as magazines, books and catalogs often have consistency problems page to page because one signature may print today, another tomorrow, or the front of one sheet today and the back tomorrow.

Presses whose ink flow is controlled by a computer reduce problems with consistency throughout the run and from one run to the next. Operators adjust flows until they achieve satisfactory results, then make a densitometer reading of the color control bars or across the sheet itself. From that point on, the computer controls ink flow.

Large solids often look washed-out. As a rule of thumb, small presses have problems

"We wanted to work with an ad agency whose printing buyer would keep a sharp eye on costs while also watching quality and deadlines, but recommendations from previous customers didn't seem helpful. Talking with sales reps for printers got us nowhere. One day our new computer graphic artist got into a discussion with a press operator. The press operator knew the printing buyers at every agency in town and recommended two that seemed to fit our needs. Both worked for the same agency, so it was pretty easily to decide where to take our business."

with areas larger than about 3" x 3" square and with type larger than 72 point. Large presses can easily handle solids 9" x 9", but bigger solids may require special attention. On very large solids, especially with metallic or opaque inks, the printer may need to print two layers of ink to eliminate streaks and spots. To achieve a uniform, dense black, a printer may suggest an underlying layer of dark blue to increase the density of the black ink and reduce the risk of hickies.

Large screen tint areas, like large solids, are tougher to print than small ones, as the slightest density variation across the image makes the tint appear uneven. Producing tints that are consistent from page to page is very difficult, even for large presses.

Mottled, blotchy and uneven images may stem from either press conditions or paper. Poor ink transfer or worn blankets can cause mottled images. Inadequate paper coating, formation, calendering or sizing can also cause uneven ink absorption and mottling. Paper with coarse fibers tends to mottle more readily than stock with more delicate strands, and uncoated or lightly coated sheets mottle more easily than fully coated stock.

Mottling is especially noticeable in large solids, halftones and screen tints printed in dark colors. All require highpremium presswork and materials to assure uniform coverage.

If you see what appears as mottling in a duotone, color separation or overlapped tint, double-check that it's not a moire pattern. Moires are caused by screens that overlap at incorrect angles, so the effect is consistent. Mottling is caused by uneven paper formation or poor trapping, so is random.

Trapping refers to the ability of one ink to capture a second ink printed over it. If the second color adheres to the first, drying dense and uniform, it is well trapped. Poorly trapped second colors look mottled. Trapping is not difficult with good, premium and showcase printing, and mottling is unacceptable at those quality levels.

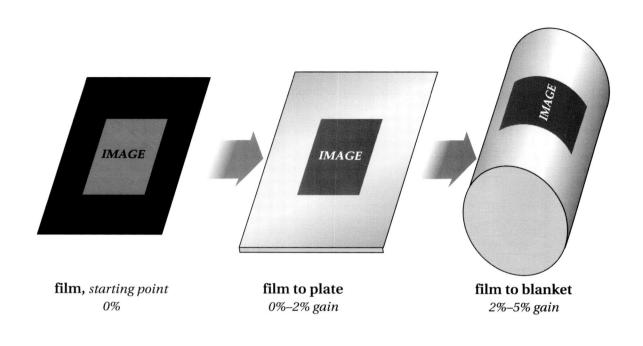

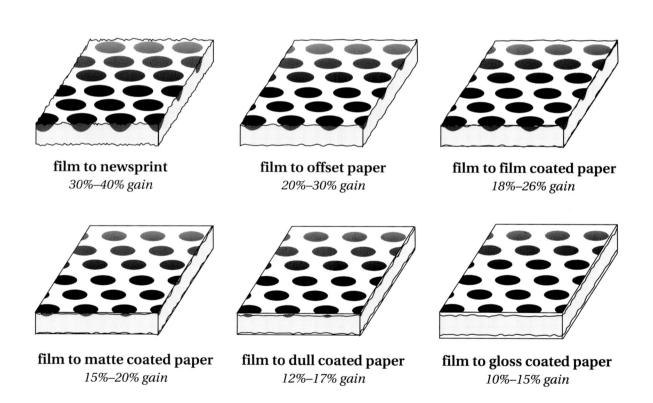

7-6 Dot gain Printers express dot gain as a percent. For example, a 50 percent screen tint that measures 70 percent on the press sheet has a 20 percent dot gain. Gain is most noticeable in midtones and shadows, where dots are largest, and least noticeable in highlights, where dots are smallest. Because dot gain is a percent of dot size, small dots (dots of fine screen rulings) have greater gain than large dots (on coarse screen rulings).

CONQUERING DOT GAIN

Dots and fine lines print larger on paper than they appear on films or plates, reducing detail, lowering contrast, making small type look fat, and sometimes changing colors. The phenomenon is called dot gain and is illustrated in Visual 7-6.

Every printing job involves some dot gain, which varies with printing process and substrate. With offset printing, gain can range from 5 percent for sheetfed printing on premium coated paper to 40 percent for web printing on newsprint. With flexography, gain can range from 25 percent to 40 percent, depending on the substrate, kind of plate and specific press.

Because dot gain is a predictable occurrence, not a flaw, prepress services can estimate how much gain to expect with a given paper and style of press. Then camera and scanner operators can control halftones and separations to compensate.

Computer software used for graphic design may offer dot gain control by allowing choice between coated and uncoated paper. Resist using this option. Dot gain is affected by variations in paper surface far more complicated than the simple distinction between coated and uncoated. Gain is also affected by screen ruling and by press and ink features that printers can forecast.

When you buy basic printing where image sharpness isn't critical, don't quibble about dot gain or try to adjust output to compensate for it. When buying halftones or separations for good or premium quality jobs, the output service should take into account the press and paper your printer will use. For showcase jobs, people making separations should consult with the printer to coordinate separations to specific presses and inking conditions.

If you want measurable quality standards or statistical process control, ask your printer to run dot gain scales in addition to color control bars. Visual 3-11 shows one dot gain scale.

Although dot gain relates mainly to halftones and separations, it also affects line

art. Dot gain may mean that fine lines on small type fill in when the type is reversed or that fine rules seem too wide or uneven.

Specifications for advertising printing often include requirements for maximum ink density, also called total area coverage. For example, specs for a card deck insert might call for maximum ink density of 260 percent.

Maximum ink density refers to the dot percentages of the process colors in the final film. Color separators and printers compute the figure by adding CMYK dot percentages in areas of dark shadow. For example, if CMYK each equal 75 percent, total area coverage equals 300 percent.

Publications printed on relatively porous paper, such as newsprint or uncoated replycard stock, specify a total area coverage of approximately 250 percent. This maximum helps ensure that shadow areas hold detail. Coverage specifications for film-coated replycard stock are typically 280 percent and for gloss coated paper, 300 to 325 percent.

MISCELLANEOUS QUALITY PROBLEMS

Although most quality problems occur with register, ink density or dot gain, several other problems sometimes develop.

Conscientious press operators check every fiftieth or one-hundredth sheet throughout a run to confirm that the press consistently delivers its best work. Basic quality print shops let more marginal sheets remain than do other shops. The refuse containers at premium and showcase quality printers are full of sheets that, at first glance, may seem acceptable. Good press operators instantly see flaws that come to the attention of most customers only after careful inspection.

"Last year our accounting department hired a CPA who used to work for a publisher. She taught our marketing people to include the value of their time and overhead when figuring the unit costs of catalogs and brochures. That opened their eyes to what they were truly paying for the blizzard of paper."

Ghosting

When an unplanned image appears within an area of heavy ink coverage, it's called a ghost. The phantom image is always a pattern of something else on the plate. As the name implies, the image looks faint and elusive.

Ghosts begin with layouts that have not taken the potential problem into consideration. You need to recognize layouts that are prone to ghosting. Printing salespeople and production planners should also help spot layouts with potential ghosts, but often they don't. The job may get past the production department and pressroom supervisor before the problem finally shows up on press.

Ink starvation can lead to ghosts of two kinds: a light pattern within a solid or a dark pattern within a lightly screened area such as a 20 percent tint. Eliminating either kind requires running the job on a larger press or changing the layout.

Ghosts are most likely to appear with layouts having large solids. Large, bold headlines, clusters of halftones, large tints and reverses are all possible problems. Whenever you plan large solids and want premium or showcase quality printing, consult with your printer to ensure that no spirits haunt your job.

Hickies

Dirt and fibers from paper can lead to hickies and other flaws. Conscientious printers keep their presses clean and well adjusted during the press run.

Hickies look like tiny white donuts with a spot of ink as the donut hole. They come from specs of dirt or dust on the plate or blanket that prevent ink from transferring properly. The particles can be dirt from the press itself, imperfections in the ink, or flecks of coating or fiber from the paper. When sticky ink pulls off particles of paper or coating, printers call it picking. Good paper resists picking.

Although hickies may appear in type and halftones, they show most commonly in large solids. Because hickies are caused by loose particles, they wander around the sheet and come and go during the run. They are difficult to prevent. Good printers spot the large hickies, but a few small ones are inevitable on most jobs.

Smudges

Sheets showing smudges, dirt or fingerprints have no place in your job. An occasional bad sheet slips through the best quality control, but you should reject work that shows consistent problems.

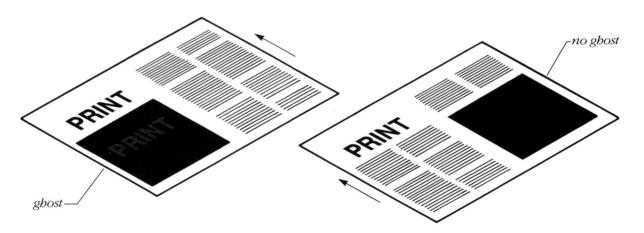

7-7 Ghosts Ghosting usually results from poor coverage of a solid, tint or halftone that follows a heavily inked image on a press sheet. The ghost represents an ink-starved version of the preceding image. To cure the problem, you can change the layout or print on a larger press.

Setoff

As printed sheets are delivered into a pile, the accumulating weight of sheets falling on top of each other while the ink is wet may transfer the image from the top of one sheet to the bottom of another. Printers call the phenomenon setoff or offsetting and prevent it by spraying a fine powder over the wet sheet to separate it from the next one falling on top.

Customers sometimes incorrectly identify setoff as showthrough. It is rare that a sheet is printed so heavily that ink from one side soaks through to the other.

Freshly printed sheets should sit a few hours or even overnight before handling. Some papers have setoff if trimmed too soon after printing because paper cutting machines hold piles of paper under heavy pressure to make sure sheets don't move while being cut. Ink can also setoff if sheets are folded too soon. Give your printer plenty of time to allow ink to dry between press runs and before trimming or folding.

Wrinkles

Occasionally a printing job includes some wrinkled sheets, especially when run on lightweight paper. Don't accept wrinkled sheets.

Web pull

Heatset web presses may yield sheets with a slight waviness, especially when there's heavy ink coverage. Experienced operators believe that paper going through a web press under tension ripples as it wets with ink. Drying units bake in the distortion. Some presses and papers ripple more than others, but web pull may happen with almost any job.

Doubling and slurring

Doubling happens when dots or type blur because of a slight second contact between paper and blanket. When dots double, each shows a tiny shadow. Slurring makes dots appear oblong instead of round. The problem shows as smears on trailing edges and comes

7-8 Hickies Hickies may appear as small, white donuts anywhere that ink covers paper. They are most obvious in large solids and the shadows of halftones. The dust or bits of paper that cause hickies can come from many sources, so it's almost impossible to produce a printing job totally free of this common problem.

from poor blanket pressures or ink tack. Slurring is especially difficult to prevent on a perfecting press but is rarely a problem when using uncoated paper.

Printers use quality control images, such as the GATF Star Target shown in Visual 3-11, to detect doubling or slurring.

Scumming

Presses often have a problem with scumming. It may appear as a streak or tinge of ink running the length of the sheet or show up as fat or fuzzy type. Scumming occurs when the plate receives too little water, leading ink to stray into nonimage areas. Often scumming looks so faint that you hardly notice it. Scummed sheets, however, show poor presswork and don't belong in your job.

Tracking

Small rollers or wheels on the delivery units of some sheetfed presses can cause narrow streaks parallel to the direction the paper moved through the press. When the exit wheels pick up ink, tracking shows as a light streak of the ink color. When the exit wheels go over freshly printed, heavy solids, tracking shows as streaks lighter than the surrounding image area. Neither form of tracking is acceptable, even with basic quality work.

7-9 GUIDE TO PRINTING QUALITY

	Register	good	Density range 1.20, some
basic	Variation limit ± .015 inch		shadow detail, sharp
	(0.38 mm)	premium	Density range 1.50, full
good	Variation limit ± .010 inch		shadow detail, very sharp
	(0.25 mm)	showcase	Density range 1.80, almost
premium	Variation limit ± .005 inch		match original prints
	(0.13 mm)		
showcase	Precise register; no variation		Separations
		basic	Not applicable
	Density	good	Pleasing color, density range
basic	Variation limit \pm 7%		1.20
good	Variation limit \pm 5%	premium	Almost match transparen-
premium	Variation limit ± 3%		cies, density range 1.60
showcase	Variation limit ± 1%	showcase	Almost match product or
		Ť	scene, density range 2.00
	Screen percentages		
basic	Variation limit ± 10%		Minor flaws
good	Variation limit ± 5%	basic	On maximum 10% of sheets
premium	Variation limit ± 2%	good	On maximum 5% of sheets
showcase	No variation	premium	On maximum 2% of sheets
		showcase	On 0% of sheets
	Dot gain		
basic	Variation limit ± 10%		Coatings
good	Variation limit ± 5%	basic	Not applicable
premium	Variation limit ± 3%	good	Uniform, slight cast and flaws
showcase	Variation limit ± 1%	premium	Uniform, no cast or flaws
		showcase	Uniform, no cast or flaws
	Color match		The 1 de 1
basic	Slight perceptible differ-		Finishing
_	ences	basic	Variation limit $\pm \frac{1}{16}$ inch
good	Just noticeable differences		(1.6 mm)
premium		good	Variation limit $\pm \frac{1}{32}$ inch
showcase	No measurable differences		(0.8 mm)
	** 10	premium	Variation limit $\pm \frac{1}{64}$ inch
	Halftones		(0.4 mm)
basic	Density range .90, no shad-	showcase	Variation limit $\pm \frac{1}{64}$ inch
	ow detail, slightly fuzzy		(0.4 mm)

The chart at the left identifies ten features of printed products and spells out standards they should meet to fall within one of the four quality categories. The chart helps you select the quality category appropriate for a specific job and evaluate work that a printer claims is within one of the categories.

Register. Use inches or millimeters to specify register, not subjective terms such as "tight" or "hairline." Even the term "rows of dots" means little because it doesn't tell dot size. One row of dots equals .02 inch on a 150-line screen but is twice that size on an 85-line screen.

Density. Appropriate ink density depends on the job. Once established, however, you can record densitometer readings and measure percent of variation from the approval sheet. Percents apply to:

- the same sheet throughout the run
- signature to signature throughout
- exact reprints on identical paper

Screen percentages. If you specify 20 percent screens for good quality printing, you shouldn't get 26 percent on one sheet and 17 percent on the next. Most color control bars include tint patches so you can keep track of screen percentages.

Dot gain. Appropriate dot gain depends on the job. Once established, however, you can record dot gain and percent variations from the approval sheet. Percents apply to

- the same sheet throughout the run
- signature to signature throughout
- exact reprints, including identical paper

Color match. Match applies to both flat and process colors. Compare the swatch or proof color with color on the press sheet. Do not compare color on a computer screen to color on a press sheet. Remember to use standard lighting conditions. Keep in mind that register, density and dot gain all affect color. After achieving satisfactory color, variation should stay within limits for each quality level.

Halftones. Guidelines assume that photos have been taken with reproduction in mind. Density ranges of originals should lie within the ability of a press to reproduce. Premium highlights should include 5 percent dots, showcase highlights 3 percent dots. Premium shadows should run to 90 percent, showcase shadows to 95 percent.

Separations. Guidelines assume that photos have been taken with reproduction in mind. Density ranges of originals should lie within the ability of a press to reproduce. Good color at the start of a press check should resemble digital proofs. Premium and showcase color at the start of a press check should match proofs from film.

Flaws. Flaws include scumming, setoff, hickies, smudges, wrinkles, doubling, slurring, smudges, streaks, smears, scratches, nicks, gear and roller marks . . . a long list that includes any visual defects that could be eliminated in prepress or on press.

Coatings. Varnish, UV, aqueous and film laminate should not crack, blister, peel or cause curling. They should cover uniformly.

Finishing. The accuracy of finishing includes die cuts, drills, folds, trims, scores and perfs. Remember that trims occur during binding and affect saddle stitching, perfect binding and other binding methods. For additional quality guidelines in bindery, see Visual 9-1.

INDUSTRY QUALITY GUIDELINES

The graphic arts industry has several sets of quality guidelines used for specific kinds of printed products.

The most widely used set of guidelines is SWOP, an acronym for Specifications for Web Offset Publications. SWOP guidelines apply to film, proofs and web printing for magazines and catalogs on #5 groundwood paper. Guidelines are very specific about such topics as screen ruling, dot gain and ink density.

Other sets of guidelines include CCUP (Commercial/Catalog and Upscale Publications), PGS (Premium Groundwood Specialties), SNAP (Specifications for Nonheatset Web Advertising Printing) and guidelines for newspapers developed by American Newspaper Publishers Association.

Quality guidelines are developed by trade associations of printers and printing customers. They are suggestions, not standards, and have no legal standing unless included with your contract. And they change along with new technology and processes. To learn about guidelines relating to your printing jobs, consult with your prepress service, printer or the Graphic Communications Association in Alexandria, Virginia.

Some large companies develop guidelines suited to their own products and packaging. For example, both Microsoft and Apple specify print quality for manuals, labels and cartons. Rand-McNally and National Geographic have guidelines for maps, *Newsweek* and *Time* for magazines, and *USA Today* for newspapers. Such corporate guidelines, often developed in consultation with vendors, become standards when made part of contracts for printing.

PRINTING INKS

Of all the factors to consider when managing print jobs, ink seems least complicated. After choosing a color, most customers give it little thought. That's appropriate. Let your printer choose inks that perform well on press. Your printer does, however, need to know if you want paper with an unusual surface or have a special need such as fade resistance.

Most printing inks are glossy when dry. Darker colors look glossier than lighter ones; heavy layers of ink increase gloss.

Paper influences ink gloss more than ink itself. Uncoated stock absorbs ink rapidly, making it appear dull. Coated and heavily calendered sheets absorb ink more slowly, allowing more to dry on the surface and bringing out luster. Presses with heaters enhance ink gloss. After heat evaporates solvents, the printed paper runs through chill rollers which set the glossy ink surface.

Matte images are easy to achieve—in fact, hard to avoid—with ordinary inks on uncoated stock. If you want a matte look on coated stock, specify dull or matte ink or varnish. They cost a bit more and may be harder to run on press.

Ink for offset printing has the consistency of thick honey. To change colors, printers must thoroughly clean presses of one color before a new color goes on. Press operators wipe every trace of ink from the fountain, blanket and rollers. Washup may take ten minutes on a small press or an hour on a large one.

If your job requires changing colors, you pay for washup. Presses run black ink most of the time. Almost every time you use a color other than black, you pay for at least one washup.

Ink is a relatively small part of the cost of most print jobs, especially large ones, but special inks for short runs may drive up costs. Printers buy ink by the pound, which is far more than needed for a few hundred letterheads or fliers. The price of a pound of ink for the letterhead job may represent 10 percent of

[&]quot;Some printers seem to regard a press check as automatic conflict between printer and client—between production efficiency and product effectiveness. I don't see it that way. If everyone doesn't focus on both, neither the printer nor the client can stay profitable."

the total invoice, while the same pound of ink entirely used up printing a forty-eight-page magazine may represent only 1 percent of total costs.

After black, the most common and least costly inks are the basic colors used by color matching systems and the three process colors cyan, magenta and yellow. As with black inks, printers like certain brands and plan press chemistry to conform. Basic and process colors are standard mixes, and every printer doing color work has a supply on hand.

Pigments that give color to inks are suspended in an oil that must evaporate quickly. Inks based on petroleum products contain volatile organic compounds (VOCs) that damage the environment as evaporated chemicals. Inks based on oils from plants, such as soybeans, have less environmental impact.

Ink formulas change according to printing method and substrate. Flexography, gravure, engraving and other forms of printing have individual standards for viscosity and tack. Formulas also differ according to end use. For example, offset inks used for products that will pass through laser printers don't contain waxes that react to the heat of the printer.

SPECIAL INKS

Metallic inks in gold, silver and bronze hues come from a mixture of varnish and metal dust or flakes. They tend to tarnish and scuff when dry, so they should have a coating of varnish or plastic.

Metallic inks show off best on coated paper. Even stock with good ink holdout, however, may require two layers of metallic ink for satisfactory coverage of large solids. Although printers can't mix metallic inks from basic colors, several swatch books show standard colors.

Fluorescent inks seem extra bright because they absorb ultraviolet light and come in many colors. They must appear on white paper to achieve full effect. Because fluorescents have more opacity than standard inks, they overprint other colors effectively. Use fade-resistant and sunfast inks for window displays and other materials exposed to strong sunlight. Formulas are easy to make and print but cost a bit more than standard inks. Cool colors such as blues and greens resist fading better than warm colors such as reds and yellows. Even these special inks, however, fade in a few weeks when subjected to direct sunlight.

Packaging, book covers and other products exposed to a lot of handling call for scuff-resistant inks. They work best when coated with scuff-resistant varnish or plastic. Scuff-resistant inks must pass rub tests by a machine that rubs printed surfaces against each other at a pressure of three pounds per square inch. Normal inks show significant scuffing after a few rubs; scuff-resistant inks stand up to one hundred or more rubs.

Printers can get many other specialty inks. The U.S. Food and Drug Administration approves nontoxic inks for printing items that contact foods. Scented inks are made to smell like just about anything: strawberries, chocolate, roses or sweat socks. They work best when printed on highly absorbent, uncoated paper. Use scratch-off inks for contest forms and lottery tickets. Magnetic inks allow machines to read numbers on checks. Sublimated inks are heat sensitive so they transfer from printed paper to polyester items such as T-shirts.

Special inks cost more, may take extra time to obtain, and may require special handling on press. Consult with your printer well beforehand whenever considering a job using special inks.

PROTECTIVE COATINGS

All dried inks show fingerprints, scuffing and other blemishes from handling, especially in dark solids. Readers can ruin a beautiful report cover in only a few minutes. The answer is some form of protective coating.

Printers think of coatings in two categories: coatings applied like ink on press and coatings

applied during finishing or binding. Press coatings are thinner and cost less than bindery coatings, which are applied over dry ink at relatively slow speeds.

Pens, rubber stamps and glue don't work very well on most coatings. If you plan to write or stamp on a product like a catalog, leave an uncoated window to accept the individual message. Foils stamped over coatings may bubble from trapped gas. Coating should be the final step in production.

Coatings tend to deepen the color of the underlying ink, slightly discolor white paper and yellow with age. Printers not skilled with coating on press may use too much antioffset powder, resulting in sheets that feel like fine sandpaper. The coarseness comes from powder trapped in the coating.

Coating is supposed to protect your product from abrasion. Insufficient coating may point to an incompatibility with ink or fountain solution or insufficient curing. Poor packing means products rubbed against each other in transit, causing coatings to scuff.

Varnish

Varnish costs about the same as another ink color and comes in either glossy or dull finishes. It can also be lightly tinted, thereby achieving both color and protection for the cost of only one. For a deeply matte effect, print dull varnish over dull ink. Varnish works best on coated papers and, in fact, may absorb so completely into uncoated stock that it neither protects nor beautifies.

Printers either flood or spot varnish. Flood varnishing means covering the entire sheet; spot varnishing refers to hitting only certain areas, such as photographs. Gloss varnish adds sheen to highlight and protect. Spot varnished photos on glossy paper can appear as glossy as original prints.

Aqueous

The very glossy coating that you often see on magazines is an acrylic mixture of polymers and water. It has better holdout than varnish and doesn't crack or scuff easily. Printers can apply aqueous coating as gloss, dull or primer (very thin).

A press can apply aqueous coating in line only when equipped with a special coating unit. For this reason, aqueous costs are about double the cost of varnish.

Ultraviolet

For even more protection and sheen than varnish or aqueous, some printers can coat with a plastic that dries under ultraviolet light. These products give tough surfaces for book covers, record jackets and table tents. As with varnish, you can ask for dull or gloss finishes and flood or spot coverage. Spot coverage is done using screen printing and yields an exceptionally thick covering.

Some web printers can apply ultraviolet coating in line with printing, but the task is most commonly performed as a separate finishing operation.

Because plastic liquid coatings are cured by light instead of heat, they have no solvents to enter the atmosphere. They are, however, sometimes brittle, and may crack when scored or folded.

Film laminate

The toughest coatings cover paper with a thin layer of polyester applied on one side or both sides. Laminating is a relatively simple operation available from many binderies and special services. Although slow and costly, it yields an exceptionally strong surface that is washable.

Laminates are available in thicknesses of from .001 to .010 inch and with either gloss or dull finishes. Specify thinner films on products such as book jackets and counter displays and thicker films on products such as menus and nametags.

Some film used for lamination prevents moisture from reaching or leaving the underlying paper. The product can curl when atmospheric conditions are different from those present during manufacture. To prevent curling, ask for porous laminating film made to lie flat.

SUCCESSFUL PRESS CHECKS

No proof substitutes for examining first sheets from the press. Furthermore, no proof from the same file or film can predict results at different printers. At a press check you confirm that your job prints as you planned.

During a press check you meet with the press operator for your job and one or two other people from design and production. The meeting takes place at the print shop when the production run is about to begin. Some printers do press checks at the delivery end of the press. Others meet with customers in special proofing rooms.

Keep your schedule flexible on the day of a press check. Your printer tells you when production has scheduled your job, but that time is a goal, not a promise. You can't predict whether the check will last fifteen minutes (routine) or two hours (nightmare). In addition, many jobs require several press checks. You might hang around the plant or return after lunch to inspect another signature, then return tomorrow to check the second sides of signatures you approve today.

Many printers work two or three shifts, so you may have a press check at 8:00 P.M. or 4:00 A.M. Production tries to avoid causing you inconvenience but must juggle the schedule of many other customers at the same time.

Press time may cost your printer several hundred dollars an hour. Arrive promptly for a press check, pay close attention and help get the job moving quickly. If you ask to correct a mistake that was not your printer's fault, expect to pay for down press time.

Your printer builds the cost of an average press check into the price of your job. If you take longer than average, you probably won't get charged extra. You may, however, get quoted higher prices on future jobs.

Asking for a press check does not signal

"Even after approving a press sheet I feel nervous. I always take a sheet back to my studio so I can be sure the rest of the job matches the press sheet I signed."

mistrust. On the contrary, a press check means that you continue your close working relationship with your printer through the final stages of production. A production manager or graphic designer may do several press checks per month, sometimes traveling thousands of miles to show up at press time.

Do a press check when you produce a job:

- at premium or showcase quality
- that uses a paper or process unfamiliar to you
- at a print shop that you haven't used before
- or when you feel even the slightest uncertainty about how it may turn out

Press checks, also called press OKs, sometimes make people feel tense. The press operator and your sales representative wait for your reactions. The room may sound noisy, you may feel rushed, and responsibility for final approval may make you feel nervous. You focus on successful product while the printer focuses on efficient production. Use the checklist in Visual 7-10 to calm your nerves and help you manage your part of the event.

Checking jobs on web presses causes more headaches than checking sheetfed jobs. Operators can run a sheetfed press slowly during a press check but must keep a web almost at full speed. Makeready, the paper wasted in setting up the press, from a web can double makeready running sheetfed. When you press check a web job, skip the small talk and move quickly through your checklist.

Unless you have lots of experience in print production, speak to technical people in plain English. Say, "Overall color looks a little weak," instead of, "Black is not running dense enough." Let the press operator deal with color bars and densitometers while you decide whether your job looks right.

Slight adjustments in density or register

7-10 STEPS TO A SUCCESSFUL PRESS CHECK

Before you start evaluating press sheets

- Introduce yourself. Try to help everyone feel comfortable.
- Confirm that the session takes place under proper lighting conditions and that production people have a densitometer.
- Make sure that you have available your original specifications and all alterations in writing, the printer's job ticket, all final proofs and any color matching swatches used while planning the job.
- Remind yourself not to look for errors or flaws that you should have caught on a proof. It's too late!

Evaluate press sheets in the following sequence:

- 1. Determine that the paper is what you specified. Verify grade, basis weight, color, finish and grain direction. The information is all on the label on the carton, skid or roll near the feed end of the press.
- 2. Ask someone to trim and fold the press sheet while you continue with the next steps.
- 3. Check for physical flaws such as scratches or multiple hickies.
- 4. Check register. Especially with fourcolor process printing, verify that separations register within tolerances appropriate to the quality level of the job.
- 5. Assess overall color. Does it seem too weak, too strong or about right? Is it consistent across the sheet?
 - 6. Examine critical color. Study features

that most affect the success of this job.

- 7. Compare the press sheet to proofs to confirm that prepress made all the corrections that you indicated.
- 8. Examine the trimmed and folded sheet to verify features such as page sequence, bleeds and adjustment for creep. Measure the trim size.

Anytime you identify a problem, if it's a:

- *Critical flaw* that means you cannot accept the job, stop the press run and go back to prepress. This takes guts.
- *Major error* that detracts from the value of the job, consult with others on the scene to decide how to fix the problem, how much time and money it would take and whether to do it. This takes leadership.
- *Minor problem* that most readers won't notice, call it to someone's attention but approve the sheet anyway. This takes common sense.

When you feel satisfied with a press sheet:

- Ask to see three more sheets to verify that they match the one you like.
- Ask the press operator to write density and dot gain values along the color control bars of all four sheets.
- Sign and date two sheets for the printer's records and keep two for your files.
- Thank everyone for their efforts and say how much you look forward to seeing the final product. Don't forget the assistant press operator who loads the paper.

often result in significant color changes. Adjustments are easy to make. After the third or fourth adjustment, however, press sheets look about as good as they're going to get. Unless you're checking a showcase job, sign off and go celebrate another job well done.

Most press checks are positive experiences with competent printers hosting satisfied customers. Occasionally things go wrong. Press problems force long delays, dirty paper causes hickies, or the perfect halftone prints too light because of a solid in line. These rare situations

call for an extra measure of understanding from both you and your printer as you strive to keep quality up, costs down and schedule intact.

Treat signing a press sheet as you would signing any other proof. If it has a hickie or other minor flaw, circle it before signing. Don't insist on waiting for a perfect sheet. If the sheet has a major defect or critical error, however, you can refuse to sign. Whether you sign, wait for a new sheet or return for another check depends on the nature of the problems and your faith in the printer to solve them.

8. OTHER PRINTING METHODS

Photocopy and laser
Ink jet
Flexography
Screen
Gravure
Engraving
Thermography
Letterpress
Die-cutting
Embossing and debossing
Foil stamping
Holography
Costs and availability

Although offset lithography is the most popular method of commercial printing, several other methods are useful for specific purposes or products. In this chapter you'll learn about these other methods and ways to locate printers who use them. Several of the methods are available from printers who focus on a single process and can often give the fastest, best and least costly service in their special field of expertise.

Some printers using nonoffset methods specialize in printing particular products such as labels, clothing, magazines or boxes. You can buy these products through an offset printer but usually at a substantial markup. Going directly to a specialty printer saves money and speeds production. Knowing about nonoffset printers also increases options in design and management because many items simply cannot be printed using offset.

You may discover that some of the printing methods found in this chapter are available only from trade printers, meaning that they limit their business to other graphic arts professionals. If you are not part of the trade, you may find it necessary to let your commercial printer subcontract for some method other than offset.

Printing is any mechanized process that repeatedly transfers an image from a master (such as a plate, die, negative, stencil or electronic memory) to a substrate (such as paper or

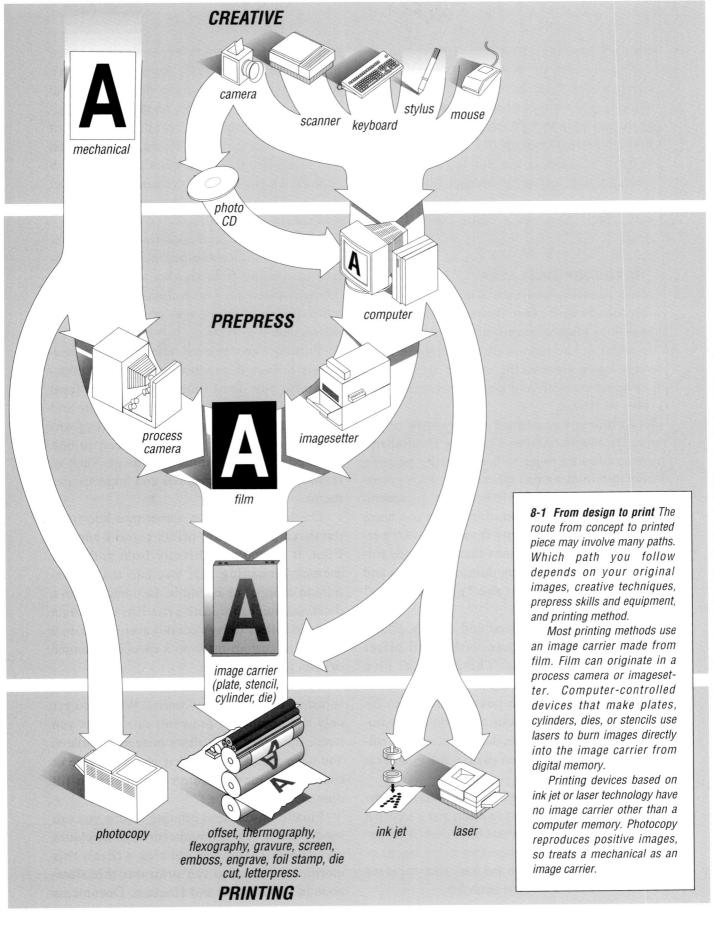

cloth). All of the following methods fit that definition. Not all, however, are available in every locality. In chapter ten, you'll learn about working with out-of-town printers.

In this chapter I do not systematically refer to the four quality categories for offset printing defined in chapters one and seven. Although concepts such as register, density and dot gain remain the same, reasonable quality standards vary widely from one printing method to the next.

PHOTOCOPY AND LASER

Most printing systems use ink, a liquid. Photocopy and laser use toner, a powder. Machines place electrostatic charges on a belt or drum in the shapes of type, graphics and dots. Toner sticks to the charged areas. When the toner contacts the paper, it transfers and fuses with heat.

Photocopy machines vary greatly in the quality they produce. The best yield sharp, dense blacks similar to basic quality printing available from a small offset press. First generation copies are perfectly adequate as cameraready copy for quick printing. Some machines reduce and enlarge copy from 50 to 200 percent. Photocopy machines that reproduce colors are useful for making dummies, roughs and proofs of color jobs at the "pleasing color" quality level.

Because of their speed and quality, photocopy machines compete with small offset presses for short runs. The machines give instant results, often can print on both sides of the paper during one pass, usually can be loaded with paper of your choosing and reproduce passable halftones. Larger machines collate, side stitch and even paste bind. Quality is

adequate for proposals, reports, plans, price lists and business letters. Some copiers have built-in halftone screens and densitometers to reproduce black-and-white photos.

Copy machines have an entirely different economy from printing presses. With presses, unit costs drop as print runs increase. With copiers, unit costs stay the same throughout the run. Copy number one thousand costs the same as copy number one.

High-volume copy machines may reproduce images from computer memories in addition to copying from another sheet of paper. These copiers use laser technology to produce basic quality printed pages at rates up to two per second.

Printing "on demand" refers to using photocopy or laser to produce only as many documents as you need immediately. The term applies to high-volume copiers that collate and bind in line. Publishers use printing ondemand to produce short runs—ten to one hundred copies—of thick documents such as textbooks, technical manuals and impact statements.

On-demand printing, sometimes known as database publishing, offers three benefits. First, it reproduces directly from computer memory, meaning that you can make last-minute changes or assemble documents from a database. You can update price lists or contract terms to reflect today's conditions or produce a document custom-made to a specific audience or even just one person.

The second benefit of on-demand printing is just-in-time inventory control. When you get only the number of proposals or manuals you need, inventory is on disks instead of pallets. You have no documents that go out of date or can't find a market, so no documents to fill dumpsters or landfills.

Finally, on-demand printing means you can send data via telecommunications to machines elsewhere. Insurance policies written this morning in Chicago can print out this afternoon in Los Angeles and Houston. Documents

[&]quot;People in our stockroom thought they were doing me a big favor when they'd call to report that a brochure or catalog was down to the last box. I could never get them reprinted in time, especially with changes in copy. I finally met with them and asked them to call me when there were two or three boxes left."

go out by phone wire instead of in cartons.

Printing on-demand from computer files sometimes brings the same kinds of problems as desktop publishing. Software may not conform to OPI guidelines and may not interface smoothly. To avoid missed deadlines and surprises in design and printing, make several downlink tests before starting production.

On-demand printing works best on smooth, uncoated paper such as offset or bond. Depending on your quality needs, it may work on matte coated, but it's not suited to gloss coated. To produce covers using the photocopy process, use smooth, uncoated 65# cover or 110# index.

To locate centers for printing on-demand, check retail quick printers or copy centers. You may also get leads by asking the textbook manager at the bookstore of a large university, the documentation production manager for a software publisher, or sales reps for companies such as Kodak and Xerox that provide the hardware.

INK JET

Another form of computer-controlled printing uses equipment with tiny nozzles that release ink droplets through an electrostatic charging unit onto paper. The charge shapes droplets into letters. Ink jet as a commercial process is used for printing addresses at mailing services. Nozzles are mounted in line with collating and addressing equipment. Most periodicals and catalogs are addressed using ink jet.

Ink jet printing is quiet and very fast. Nothing mechanical strikes paper. Speed comes from computer control. One nozzle might generate 66,000 drops a second and print a business letter in two seconds. Ink jet systems have few moving parts; they are highly reliable and easily maintained.

The inks used for ink jet printing must dry instantly. Paper must be absorbent without allowing droplets to blur. Even when used with the right paper, ink jet printing yields very low quality. Imperfectly aimed droplets of ink hitting a highly absorbent, moving sub-

"Scheduling is the most difficult topic I deal with when teaching workshops. People just can't accept how long it really takes to plan and produce printed materials. I tell them to count days backwards from their deadline to today. Doing that seems to force a more realistic approach to what can actually be accomplished."

strate result in fuzzy characters.

Because ink jet technology is based on computers, operators can pattern the droplets in the same variety of fonts as mechanical dot printers. Ink jet messages can change in a microsecond. A printer making catalogs might have six nozzles to print individual sales messages on bound-in order forms and another six nozzles for a different message plus address on the cover.

Catalogs and mailers processed through ink jet equipment need no labels because each address is printed directly onto the mailing piece. Addressing machines can be driven directly from magnetic tapes storing lists. This last feature is especially appealing when nine-digit zip codes appear in optical character recognition (OCR) patterns, qualifying for additional savings at the post office.

While ink jet is most useful for direct mailings, its speed and economy make it practical for personalizing business forms, coding document entry systems and numbering tickets. The process also works well with rough and uneven surfaces.

Most printers and lettershops using ink jet offer one color only. Color work, however, is available. Using the three process colors plus black, color ink jet systems can produce anywhere from eight to five thousand shades, depending on software.

FLEXOGRAPHY

Printing on substrates that don't work well in offset presses calls for flexography, sometimes called web letterpress. The process uses rubber or plastic plates on a web press. Waterbased inks dry almost instantly, allowing fast running speeds. Flexo is popular for labeling

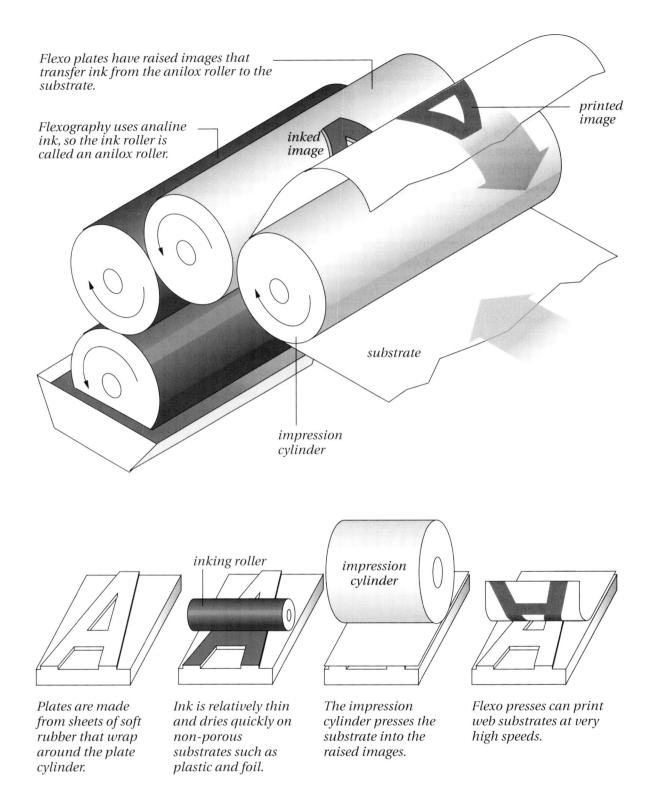

8-2 Flexography Because flexography uses a relatively soft plate and prints plate to surface (not offset), it works for rough materials, such as fabric, wallpaper, corrugated cardboard and paneling, where quantity requirements make screen printing prohibitive. It's also useful for printing labels and decals because the same plate that prints can also kiss die cut, meaning to cut the labels without cutting their backing sheet.

and packaging because offset cannot print well on nonporous or very thick substrates.

Presses printing flexography run rolls of plastic for products such as bread wrappers and may print one thousand feet per minute. Highly absorbent kraft paper for grocery bags can run even faster.

Plates for flexo are easy to make, beginning either with mechanicals or computer memory. When using mechanicals, prepress services expose film that leads to plastic or rubber plates. When going direct from digital memory, lasers burn plates mounted on press. Digital platemaking for flexography is more common in the newspaper industry than for commercial printing.

Flexography doesn't give the solid ink coverage or fine screen rulings of offset, so colors may seem weak and images washed-out. Furthermore, the soft plates stretch and bend on press, giving flexography standards of dot gain and register lower than offset.

Quality expectations for flexo printing vary widely according to substrates ranging from metallic labels to corrugated cardboard. You can see flexo color control images, small squares called eye markers, printed on the inside flaps of packages containing consumer goods such as food or cosmetics. Eye markers are used for automatic control of density and register and may be used to guide slitting and trimming machines.

To locate flexographic printers, look in classified directories under "Packaging" and under products such as boxes, labels and bags; inquire at a local prepress service, or ask for information from the Flexographic Technical Association in Ronkonkoma, New York.

SCREEN

Screen printing is the simplest of all printing processes. A printer needs only a screen stencil, ink and squeegee. The screen fabric is wire or polyester, not silk. Ink forced through the screen prints in the stencil's pattern.

Printers use the screen method for products

"As our business grew, our catalog grew, too. I used my original printer until last year when a catalog broker asked to quote the job. Was I surprised! The broker's price was 30 percent less than what I thought I would pay my regular printer. That broker saved me the cost of our new color desktop printer."

such as T-shirts, signs and bottles. Most products are printed after manufacture. Ring binders, for example, don't go through an offset press, but can easily be screen printed. Plastic comb bindings have screen printed titles on the spine.

Stencils for screen printing are cut by hand, stamped by machine or made photographically. Photographic stencils are made by exposing light through a negative onto light-sensitive emulsion spread on the screen.

Commercial screen printing may be done by hand using only simple equipment or on automatic presses of varying size and complexity. Large commercial presses use the same technology that you can use to print T-shirts for your softball team.

Halftones can be screen printed. On smooth surfaces such as bottles, 80-line screens work fine. On fabrics, halftone dots must be large enough to adhere to the mesh of clothing. Ideally, one dot prints at the intersection of at least four threads. Fabric mesh counts should be about four times the line count of halftone screens. Screen printed halftones tend to look better on synthetic rather than natural fibers because monofilament threads give sharper images and better register.

Screen printers make stencils photographically, so you need copy prepared to cameraready standards. Consult a printer for details. The shop may want type on acetate instead of mounting boards, prefer larger traps than needed for offset printing, or want film emulsion up instead of down. Screen printers vary widely in their preferences for halftone dot sizes, especially for billboards and other large signs.

Screen printing has several advantages over

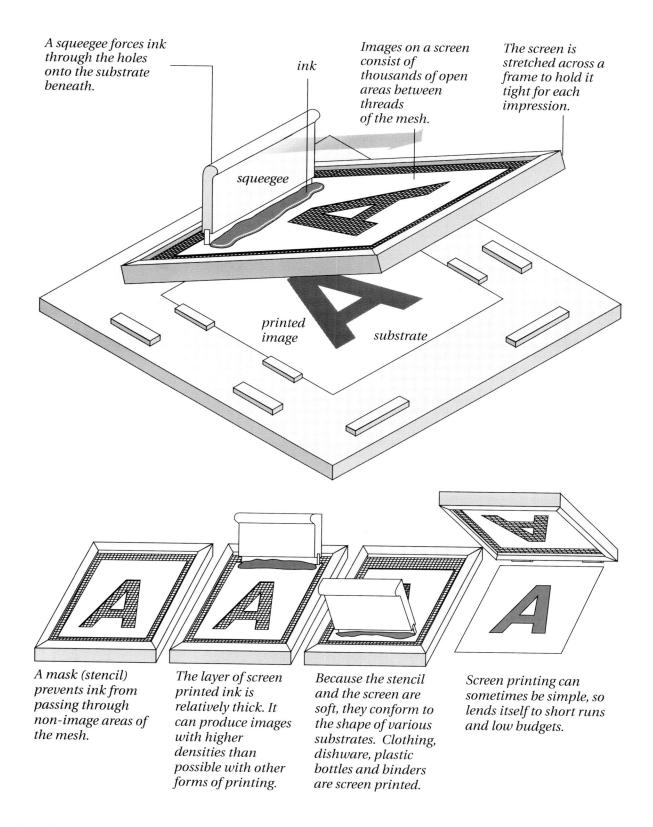

8-3 Screen printing You can use your computer to design for screen printing, but you should output as positive prints, not negative film. Keep screen rulings very coarse—85 lpi for smooth substrates, 65 or even 55 lpi for rough surfaces.

other methods in specific situations.

Short runs. If you need twenty lawn signs, fifty posters, or two hundred bumper stickers, think of screen printing.

Heavy ink coverage. Screen printing lays down ink up to thirty times thicker than lithography and five times heavier than gravure. Furthermore, inks are opaque. Colors are more dense and durable than from other processes. Screen works perfectly for outdoor advertising such as billboards.

Ink variety. Screen printing lends itself to ink with satin, gloss or fluorescent finishes and to ink that accepts flocks or other decorative substances. There are special inks to print on glass, metal, cardboard and other substrates. The electronics industry uses screen printing to etch circuits on copper-plated boards. Acidresisting ink covers image areas, allowing acid to etch away the nonimage copper surfaces.

Large images. Because the screen process is so simple, frames holding stencils can be larger than the largest offset presses. Screen printers make huge posters and banners.

Versatility. Advocates call screen printing the print-anything process. In addition to printing clothing and dishware, the process works well for menu covers, greeting cards and posters. Wallpaper, paneling, metal signs, glass and other materials that cannot be printed with lithography are easily screen printed. Inks go on so heavily they adhere to almost any surface. Applying ink requires only light pressure, so picking is rarely a problem.

Screen printing does have limitations. It's slow both in printing and drying. Register on some substrates can be difficult and dot gain unpredictable, especially with fabrics whose absorbancy varies.

Screen printers have their own classification in most directories. They are also listed under

the products they make, such as outdoor advertising, book and catalog covers and looseleaf binders. The industry has its own trade association, Screen Printing Association International in Fairfax, Virginia.

GRAVURE

Gravure plate cylinders carry images consisting of millions of tiny cells filled with ink. The cells vary in depth and width, so some hold more ink than others. Mounted on web presses, the cylinders transfer ink directly to paper. Presses have no blankets.

Printers use the gravure method for long runs (millions) of magazines and catalogs.

As with an offset web press, the size of a gravure press is expressed by the width of paper it can print. And compared to offset webs, gravure presses are huge, running rolls anywhere from 70 inches to 118 inches wide with cutoffs from 50 to 75 inches. Large widths mean that gravure commonly produces signatures of forty-eight or sixty-four pages.

Paper for gravure is relatively soft and extremely smooth. Stock with even minor irregularities tends to miss contact with some of the tiny wells carrying ink. But stock doesn't have to cost lots of money. In fact, gravure is attractive for jobs such as direct mail catalogs because it works well on relatively low-grade paper. To ensure that it releases from the wells onto paper, ink has almost no tack. Picking doesn't happen.

The ability to cut portions of the image to various depths into the plate gives gravure the ability to print a wide range of tones because the plate can deliver different amounts of ink to various parts of an image. Dense and varying ink coverage yields superior color, even on inexpensive papers. And inking remains constant throughout the run.

Printers use a diamond stylus to engrave a gravure cylinder (plate). The stylus is guided by lasers scanning halftone positives or by digital information directly from a computer. Because all gravure images consist of dots, the

[&]quot;I always had problems matching the color of my logo until I asked our print shop to save my ink and keep a record of its formula. Now I just specify 'logo blue' and I know I'll get the right color."

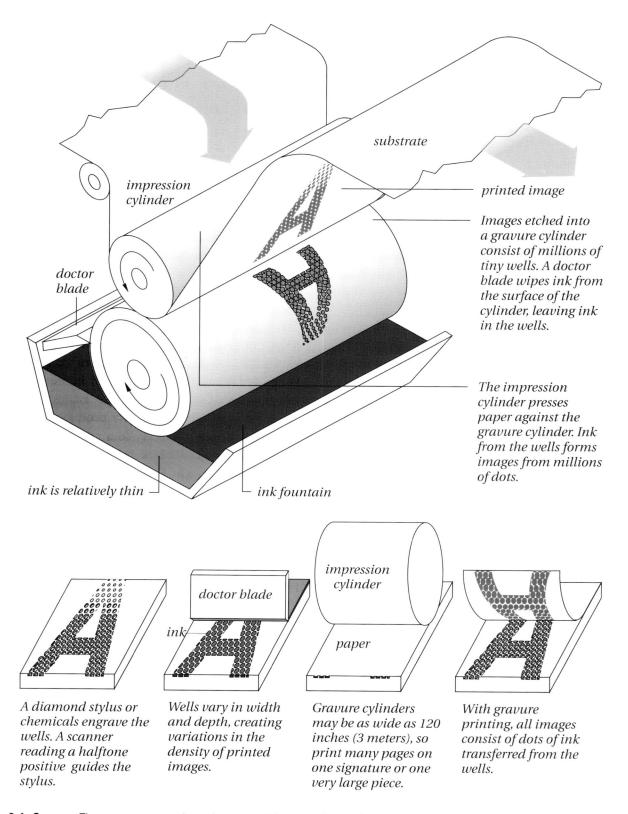

8-4 Gravure The gravure process has a large appeal for magazines and catalogs because it can print on lightweight paper. Many publications appear on 35# or even 30# stock, saving many dollars on postage as well as paper. The method competes with flexography for printing packaging materials and special products such as floor coverings. It rivals lithography for long-run publications such as supplements to Sunday newspapers.

process lends itself to electronic prepress.

Cylinders for gravure printing are expensive to make, so gravure works best for runs of over a million impressions. The typical customer of a gravure printer is a publisher with a magazine or catalog on press ten or twelve times per year. Each issue might require a week or more of press time. Buyers who work with gravure printers are experienced and specialized.

Gravure has specifications for film and plate making different from offset. For example, a printer may ask for film positives developed to density standards that you find unfamiliar.

To compare gravure with lithography, examine any copy of *National Geographic* magazine published since 1975. The editorial matter, both text and photographs, is printed gravure at approximately 175 lines-per-inch, while the advertising and cover are printed lithography.

Classified directories for major metro areas list gravure printers under "Rotogravure." Many gravure printers advertise in trade journals aimed at printing buyers for catalogs and national magazines and are known to printing buyers at companies that mail millions of consumer catalogs. The Gravure Technical Association in New York City is an additional source of names.

ENGRAVING

For years, commercial printers were called "printers and engravers." Printing used letter presses; engraving involved images cut (engraved) into thick metal plates. Although commercial printing today means offset lithography, engraving remains the method for making prestige announcements, invitations and stationery.

Engraving yields the sharpest image of any printing method and so is used to print currency and stock certificates with delicate details. Shading is produced using crosshatching, not halftone dots. "I've taken my last two jobs to ABC Litho without even getting prices from other printers. ABC costs more, but we've gotten so busy that I didn't want to worry about mistakes or missed deadlines. I'm happy to pay a little more for peace of mind."

Images for engraving are cut into the metal plate rather than raised above plate surfaces as in letterpress. The surface of the plate is covered with ink, then wiped clean, leaving the recessed engravings full of ink. The press then forces paper into the inked recesses, transferring the image to the surface of the paper.

Engraved paper feels slightly indented behind its image areas. The process uses thick, opaque inks available in both gloss and dull finishes. Gloss inks may appear metallic. When planning engraved letterhead destined for a laser printer, verify that inks are heat-resistant.

Presses for engraving apply high pressures over small areas and tend to be small. Images larger than approximately 4" x 8" require dividing. To get engraved images at both top and bottom of a letterhead, for example, requires two impressions.

Engraving takes special presses and techniques and costs more than offset. Operators either cut dies by hand or chemically etch them from camera-ready mechanicals. Handcut dies are made of steel, and chemically

8-5 Engraving The intense pressure of an engraving press forces paper into recesses etched into the plate. Engraving ink is very thick, making the raised image even more distinct.

etched dies are made of copper.

Whether to use engraving dies cut by hand or photochemistry depends on needs for quality, variety and quantity. Hand-cut steel dies give the highest quality and the longest press runs, but engravers making them may be limited to only a few typefaces. Copper dies are limited to press runs of up to about five thousand impressions.

People who appreciate engraved printing also recognize fine paper. Using anything less than the best reduces engraving's exquisite effect.

THERMOGRAPHY

Also known as raised printing, thermography costs less than engraving, can be produced more quickly and, to the untrained consumer, looks and feels similar.

Thermography is a four-stage process that begins with printing by any method that can deliver sheets with slow-drying ink. Offset is most common. Printed sheets exit from the press onto a conveyor belt taking them through the next three stages. First, sheets are sprayed with a fine resin powder. Powder sticks to the wet ink. Second, a vacuum unit collects all powder not adhering to ink. Third, a heating unit melts the remaining powder into the ink. The powder swells as it melts, so the printing rises above the surface of the paper.

Powder used for thermography may be fine, medium or coarse. The choice of powder depends on the image being thermographed.

"When we opened the new store, sales reps from two printers were among the first people to walk through the door. One thought I would buy printing because the two of us could swap fishing stories. The other arrived with samples of our own brochures and catalogs from previous printings and showed how we could cut turnaround time and costs without cutting quality. That rep did plenty of homework before getting to my office. You don't have to guess who has most of our printing business. And she doesn't take us for granted, either. We still get great service."

Very little powder can adhere to the wet ink of fine lines and small dots, but larger type and solids hold powder easily. Medium powder works well in most situations, but fine lines require fine powder for best results.

Although thermography powder takes on the color of underlying ink, it may not match perfectly. If your job needs precise color match, experiment with inks and papers before beginning production.

How much rise a thermographed image has depends on how much powder adheres to its ink when wet. Control over inks, powders and heat also determines whether the outcome looks uniformly glossy or has a stippled, orange-peel effect.

Thermographed images may scratch. Abrasion is no problem with lightly handled products such as announcements but can make images on catalog covers appear dull after heavy use. And thermography doesn't stand up well to heat, such as from laser printers. The powder may melt, losing its rise and luster.

Although thermography is used mainly for business cards, invitations and letterheads, the method is applicable to many other products. You could use thermography on the covers of booklets and directories, on greeting cards of all kinds, and on small fliers and posters. But avoid thermography across folds, where it can crack, and in large solids, where it can blister.

Thermography can use several ink colors and even works with screen tints having coarse rulings. The melting powder may, however, plug up finely ruled tints and fine lines in reverses.

LETTERPRESS

For centuries, printing meant letterpress. Asian artisans invented the technique, using individual letters made of clay. Gutenberg developed the process in Germany, using characters molded from lead. He assembled the characters into wooden trays (called galleys), inked their surfaces, then pressed paper against them to transfer the image.

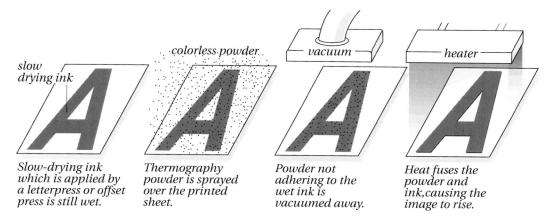

8-6 Thermography While slow-drying ink is still wet, a nozzle sprays thermography powder over the printed sheet. Powder that doesn't adhere to the ink is vacuumed away. Heat melts the remaining powder, making it rise. The powder has no color itself, so as it melts, it takes on the color of the underlying ink.

Letterpress is a form of relief printing, meaning that characters on the plate are higher than the material surrounding them. Rubber stamps work on the same principle. Type printed on a letterpress may feel indented because of the direct contact between type surface and paper.

In addition to setting letters by hand, printers can mold letterpress plates from a variety of materials, including plastic, and can etch plates by photochemistry.

Letterpress is a relatively simple technology often used for imprinting—the printing of information on items that have been previously printed and stored. Business cards are a typical example. A large organization may offset print twenty thousand three-color cards on 20" x 26" cover stock, then cut the sheet into individual cards. As employees are hired or job titles change, a letterpress imprints new names on a few hundred cards. Letterpresses work well for imprinting because they easily handle small items and short runs.

Photochemical etching makes halftones and illustrations. The etchings are called cuts, a term applied to all letterpress art. The process of etching removes the nonimage area from the plate, leaving raised lines, halftone dots or other matter to print. Before the day of camera-ready art, printers maintained a supply

of standing cuts to use much like today's clip art. Information set in type under the cut was called the cutline, a term still used as a synonym for caption.

Fine letterpress printing is cloaked in five centuries of graphic tradition that, for some hobbyists, lends its products an ancient mystique. Artistic letterpress printing is often enhanced by the use of handmade or especially beautiful paper.

To locate a printer or hobbyist who can print using a letterpress, ask owners of commercial art galleries. Letterpress printers may also be known to engravers, die-cutters and officials of your regional trade association of printers.

Although printing is rarely done using a letterpress, the machine is used extensively for die-cutting, embossing and foil stamping.

DIE-CUTTING

Letterpresses can cut paper using thin metal strips embedded in wood. The dies are pressed into the paper to cut the desired shape just as a cookie cutter produces shapes from dough. Die-cutting can make irregular shapes such as pocket flaps on presentation folders and large holes such as in door hangers.

Printers use die-cutting to produce decals and labels as well as outlines with tabs and slots that fold into packaging. Often they keep a supply of standard dies for common items such as door hangers and table tents. Custom dies, however, require using special tools and skills.

Dies are made from metal strips soft enough to bend into desired shapes. After being shaped and sharpened, strips are pressed into grooves in wooden blocks. The metal strips, called rules, are higher than the wooden backings, creating cutting edges. Dies are heat-tempered to withstand the pressure on press.

Metal rules for scoring and perforating can also be mounted into wood. In fact, the three functions—scoring, perforating and die-cutting—can all take place in one impression.

Because die-cutting is a press operation, it costs about the same as running one ink color. Costs depend on complexity of the die and length of the run. To reduce waste and keep the process simple, avoid intricate shapes. Also avoid too many cuts, which can weaken the overall sheet.

Labels and decals are made by kiss die-cutting on a letterpress or, for longer runs, on a flexographic press. Cuts are made through the printed paper but not through the release paper on which the label is mounted.

Complicated shapes not practical to cut using metal dies may be cut using lasers because pinpoints of laser light can burn away paper in intricate patterns. Lasers vaporize instead of cut. In order to locate a laser die-cutting service, inquire at a trade bindery or at a company that produces products such as placemats.

"We had to learn fast about all this new software for graphic design. After our first few disasters, we just stuck with our little group and our one prepress shop. They know what we want and we know what they can do. Let someone else be pioneers. It's the only way to stay profitable."

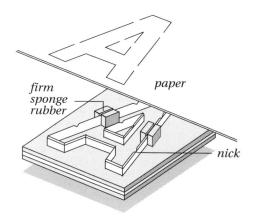

8-7 Die-cutting Diemakers use thin metal strips with sharp edges to make dies for cutting. After shaping the strips into patterns, they mount them on a plywood base. A press forces the cutting edge into paper. After cutting, rubber pads push the paper away from the die, allowing the sheet to continue through the press.

EMBOSSING AND DEBOSSING

Embossing and debossing take printing into a third dimension: depth. Paper is pressed between two molds, called a die, that sculpt its fibers by as much as ½ inch. Printers use the process for stationery, presentation folders, and covers for books and annual reports.

Images higher than the rest of the paper are embossed; images lower are debossed. Both are produced under heat to assure fine detail. Heat also makes the images smooth and shiny.

Embossing and debossing have identical requirements for type and graphics, skills in die-making and press operations, and have similar considerations for paper.

Embossed impressions made without having to register over a previously printed image are said to be blind embossed. Blind impressions cost less than impressions over ink because press operators don't have to register dies precisely.

Dies are made from either magnesium or brass. Magnesium is easy to engrave using chemical processes, so it can be made into dies photographically from camera-ready mechanicals. Engravers cut brass embossing dies by hand

Some printers do multilevel embossing. Chemicals etch dies in stages, each deeper than the last, to achieve a layered effect. Diemakers also make multilevel dies by hand. The craft is complicated because the design being cut is backward, yielding a right reading image when embossed or debossed. A complex multilevel die can cost lots of money.

Regardless of how embossing dies are made, designs should not call for lines so fine that paper doesn't press into them. Deep dies need beveled edges to avoid cutting the paper. And beveled edges optically reduce the size of images, so prepare original art slightly oversized.

Soft paper, such as felt text, takes impressions more easily than hard paper, such as laid bond, and textures may become smooth under pressure. Most customers using heavily textured paper view smoothness as an advantage because of its contrast with the surrounding texture. Ask experienced embossers for their advice before specifying paper and the depth of dies.

FOIL STAMPING

In foil stamping, hot dies with raised images press a thin plastic film carrying colored pigments against the paper. The pigments transfer from backing film to paper, bonding under heat and pressure. Printers use the process for presentation folders and covers for books and annual reports.

Any product that can stand up under heat and pressure can be foil stamped. Designers use it on pencils, toys and picture frames as well as on paper products. Foil adheres especially well to the cloth used to cover casebound books.

Foil stamping is done on letterpresses. The size of the foil image is limited only by the size of the roll of foil and the intense pressure required to transfer the image. Operators suggest keeping the image area of one impression within eight square inches.

Foil comes in over two hundred colors and patterns. The most common colors are bright metallics that take advantage of foil's shine, but foil is also available in dull, pastel, clear, matte and patterns such as wood grain and cobblestone.

Images that are foil stamped are so opaque that they completely cover any underlying color. For example, white foil stamped onto dark paper prints sharp and dense, whereas white ink for the same image might require two or even three impressions.

Because most foil is opaque, offset printers don't have to reverse out areas in halftones or solids that the foil covers. Foil, however, may blister when applied over inks or varnishes containing silicones or waxes and when applied over coated paper. The blisters come from trapped gas released by heat. Gas trap-

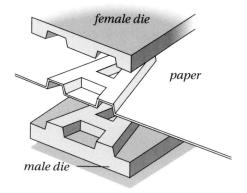

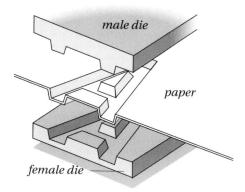

8-8 Embossing and debossing Embossing (left) and debossing (right) each require two matched dies, one of which is heated. Pressing paper between the dies creates the image. The techniques work best on text and uncoated cover papers and not very well on coated papers.

ping can also occur if the image area of foil is too large.

When designing for foil stamping, allow adequate space between letters or lines or the foil may not pull away from nonimage areas. How much space is needed depends on the material being stamped. Check with your printer.

Foil stretches, so foil stamping mixes well with embossing for dramatic results. The process is called foil embossing—foil applied first, then embossed—and looks best on high-grade text, cover and bond papers. Foil embossing is appropriate for portfolio covers and annual reports as well as letterheads. Successful foil embossing demands the right blend of paper, design and printer. Get advice and samples before going ahead.

HOLOGRAPHY

Holograms offer three-dimensional visual impact that no other form of printing can. You see holographic images on book covers, credit cards, sports trading cards, and labels for compact discs and beverages.

Holograms can originate from the same variety of artwork as used for other forms of printing or from photos made with special laser lighting. Starting with conventional art, the three-dimensional effect is simulated by divid-

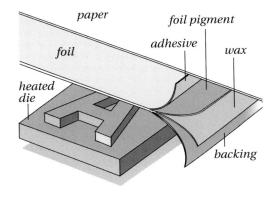

8-9 Foil stamping A heated die sticks foil to paper in the shape of a raised image. For best results, avoid designs with fine lines and intricate shapes.

ing the image into layers. Laser-lit photos have the third dimension embedded in the original image. In either case, image size should not exceed approximately 7" x 8".

Preparing a holographic plate, called a shim, involves lasers that etch the image onto a metal surface. The laser beams scribe lines one millionth of an inch apart. These microlines refract light, giving the image depth. Refraction also breaks the light into colors in the same way as a prism.

After making the shim, operators mount it on a press that uses a thin sheet of plastic as a substrate. Images are transferred when the plate presses into the plastic, a process called holographic embossing. The plastic holds the hologram as an embossed image.

After image transfer, the hologram is combined with other elements to become peel-off labels, laminating film or material for foil stamping, depending on the printing method used for other parts of the job. To stay cost effective, you need to order at least ten thousand impressions.

Holography is a highly specialized process performed by only a handful of creative services and printers. To locate one, ask the production manager for a printed product that includes a hologram or call the Foil Stamping and Embossing Association in Washington, D.C.

COSTS AND AVAILABILITY

Die-cutting, foil stamping, engraving, embossing and thermography are all options to dress up products. The first four of these processes require dies. Single level dies cost about the same regardless of how they print. Dies cost more as they get more complex, but the cost of dies stays about the same regardless of the printing method. Thermography doesn't require a die, and thus takes less time and money to get on press.

Despite the virtually equal cost of making dies, engraving costs almost twice as much as embossing and about 75 percent more than foil stamping. The difference lies in press makeready and running times. Engraving presses may run as slowly as one thousand pieces an hour.

Presses used for foil stamping set up relatively quickly. Operators simply install the dies and rolls of foil; there's no ink to wash up. Once ready, letterpresses with foil run at moderate speeds of about two thousand impressions an hour—slow compared to other printing methods but twice as fast as engraving. Embossing goes even faster than stamping once dies are on press. There's no ink to let dry and no foil to keep adjusted. A job that takes two hours of press time for engraving and one hour for foil stamping might take about forty-five minutes for embossing.

Many trade binderies do foil stamping, embossing and die-cutting, but the dies themselves are most likely made by independent diemakers. Engraving and thermography are usually special services performed at dedicated companies.

Because die-cutting, embossing, engraving, foil stamping and thermography are so often coupled with offset printing, they are frequently subcontracted by the lithographer. In many cases, it's easier and may not cost any more simply to let the offset printer buy out the additional work.

Classified directories help you locate printers able to use most of the methods described in the last few pages. Engravers are listed separately as "Engravers—Metal" to distinguish them from "Engravers—Photo" that do process camera work. If you need a thermographer, ask a printer or trade bindery to refer you, or look for display ads for raised printing in the general "Printers" section of a classified directory.

9. FINISHING AND BINDING

Cutting and trimming
Drilling and punching
Scoring and perforating
Folding
Collating
Common bindings
Selective binding
Converting
Packing
Final counts
Storage and transit

After printing, most jobs require more work to convert them into the final product. Large sheets may need cutting into individual pieces or folding to become parts of books. Printed sheets may need drilling, punching, stitching, or some combination of a dozen possible ending steps.

Printers lump everything that happens to paper after actual printing under the general category of bindery work. The category includes a process as simple as letterfolding one hundred fliers and as complicated as case binding ten thousand books.

Bindery operations take place in binderies that are either departments of a print shop or separate businesses. When they are separate businesses, they are known as trade binderies and are listed in classified directories under "Binderies" or "Bookbinderies." In addition to having all the basic equipment, many trade binderies offer less common services such as tab sealing and tinning.

Binderies may have only a few machines in a back room or be multimillion-dollar plants handling truckloads of printing per day. Large trade binderies serve printers throughout their region. Many jobs involve work at a trade bindery instead of in the printer's bindery. When complicated work goes to a trade bindery, it pays to consult directly with its staff as well as with the printer who sends it.

Mistakes in the bindery can prove disas-

trous. A short trim or crooked fold can ruin a job that has been expertly managed and produced from design through preparation and presswork. It is imperative to take bindery needs into account while planning the job.

Machines that perform bindery operations are the least accurate of graphic arts equipment. Even an average press can register to ½100 inch. In contrast, folding, trimming and binding are seldom done to tolerances greater than ½2 inch. Good design includes a clear understanding of what happens to the job in the bindery.

In this chapter, you'll learn about common finishing and binding operations and the implications of decisions about packaging, final counts, shipping and storage.

CUTTING AND TRIMMING

Most press runs use paper slightly larger than the finished piece or print several items on one large sheet. Waste must be cut away and items cut apart from each other.

All straight line cuts are called trims. Job specifications should include trim size as exact measurements of the final product and mechanicals should include trim marks. The trim size of this book is $8^{1/2}$ " x 11".

Printers usually have a paper cutter at least large enough to handle sheets from the largest press in the shop. Cutters all work on the same principle: With the paper held tightly under pressure to assure an even cut, a guillotine blade slices down and across, cutting anywhere from one sheet to a stack three inches thick.

Some slight variations in trim size are inevitable, but not ragged edges or cuts that are out of square. The ragged look comes from dull blades or stacks not held under sufficient pressure. Jobs out of square are simply sloppy work.

The stack of paper on a cutter is known as a lift. Although the lift is held under pressure during cutting, some movement of the sheets

9-1 QUALITY IN FINISHING AND BINDING

Before paying for a printing job, pull at least twenty production samples at random. With small jobs, check the samples when you receive delivery. With larger jobs, complete your inspection within ten days. Tell your printer or bindery about any problems within two weeks of delivery. Check the following features:

- Trims with 90° corners and square with copy.
- Drills, punches, scores, perforations and folds per mechanicals. See Visual 7-9 for tolerances.
- Folds square with copy and free from gusset wrinkles.
- No printer makeready or unacceptable signatures included.
- Pages in correct sequence and no missing pages.

- Bound pages run grain parallel to the spine.
- Covers bound and trimmed square with insides.
- Binding withstands reasonable pull testing.
- Number of products in shipment conforms to number claimed in manifest and invoice.
- Products don't stick together or show signs of abuse by machinery.
- Cartons within the shipment the same size, weight and quantity per carton. Carton weight per your specifications.
- No more than one partial carton per shipment.
- Every carton identified with title or job name of contents, quantity and other information per your specifications.

9-2 Trimming Good design takes into account the relative inconsistency and lack of precision of bindery equipment. A trim only slightly off ruins the above design. Consult Visual 7-9 for reasonable trim tolerances for the quality level of your job.

is inevitable. The movement is called draw and leads to variations in trim size within the stack. Draw is held to a minimum by keeping blades sharp and lifts small. If specifications on mechanicals are clear, production trims should conform to the tolerances shown in Visual 7-9.

Printed sheets that are trimmed before their ink is completely dry may smear or offset while in the cutter. Your printer should insist on ample drying time, depending on ink coverage and type of paper, and warn you if your schedule is too rushed.

Round cornering is a variation on trimming available at most trade binderies. The process itself is fairly slow and may require extra production time. Corners may be cut in a variety of standard sizes specified in radius from edge to edge. Round cornering prevents items such as membership cards from becoming dogeared.

DRILLING AND PUNCHING

Drilling holes for ring or post binding is as common and easy as trimming and almost as easy to specify. Hole diameters between ½ and ½ inch are commonly available. State what size holes you want and how far they should be from each other and the edge of the paper. Better yet, give your printer an example of the binder the sheets must fit. Your printer may know sizes for a standard three-ring

binder but may not understand drilling for five-ring binders or other less familiar formats.

Holes that are not round or are too small to die-cut must be punched. Punching for binding methods such as plastic combs and wire spirals costs quite a bit more than simple drilling.

Some binderies have equipment to reinforce holes in sheets that must stand up to hard use. Round holes can have protective metal eyelets identical to those in shoes. As an alternative, areas of the sheet to be punched or drilled can first be reinforced with mylar strips. Binderies can also lay strips of mylar or other plastic along the tabs of file folders and binder dividers.

It's easy to forget about drilling and punching during design. Do not start copy so close to an edge that holes pierce headlines or puncture borders. Avoid problems by drawing holes on roughs, mechanicals and proofs in nonrepro blue. Give the printer a drilled or punched dummy to show exact placement. Specify sizes in fractions of inches. If the size or shape of the holes you need has a name unique to your industry, verify that your printer knows the correct pattern.

SCORING AND PERFORATING

Scoring means to crease a printed piece so that it folds more easily. The procedure is necessary whenever paper thicker than .005 inches is folded by machine or when sheets need precise folding.

Scoring is done by equipment that presses paper against the metal edge of either a rule or a wheel. Coated stock, especially if printed with large solids of a dark color, may require the softer touch of string scoring to ensure that paper doesn't appear cracked.

Perforating is simply punching a line of holes to make tearing easier. Most bindery machines can perforate in only one direction and only in straight lines. Perforating in more than one direction or in curved lines must normally be done on a press. Specify scores and perforations on mechanicals by drawing a black line similar to a trim mark outside image areas. Label the line "Score here" or "Perforate here."

Scoring and perforating can each be done on offset and letterpresses as well as specialized bindery equipment. When done as part of offset printing, they require attaching metal strips to the impression cylinder. The procedure saves time on long runs because it happens simultaneously with printing, but it ruins blankets (cost charged to you) and may adversely affect printing.

When done on a letterpress, scoring and perforating can be done simultaneously with printing or die-cutting.

FOLDING

The number of ways paper can fold seems endless. Most printers have equipment to make common folds using sheets as large as their largest press. Trade binderies typically have machines with six or eight folding stations to accommodate complicated work.

Folding is not precise. Most folding machines can work within a tolerance of ½32 inch per fold, but even that is not close enough for near-perfect crossovers. Plan your design to allow for tiny variations in folds just as you would for variations in trims.

On a large sheet that must fold several

times, the accuracy of the first fold affects all subsequent folds. A ½32-inch variation on the first fold may shift the second fold by ½16 inch and the third by ½8 inch. Even the thickness of the paper causes a variation. Rollover folds, for example, require that panel widths increase by at least ½16 inch each as they move from inside panels to outside. To plan accurately for folds, make a dummy folded from the same paper that is called for in the specifications for your job.

Folding requires careful design. Poor positioning of copy means products may not read correctly when folded or a fold might run through important visuals.

Paper less than 50# may be difficult to feed into the folder and may wrinkle going through; paper more than 80#, especially coated stock, often needs scoring before folding. Designing for printing on medium and heavy stock should anticipate folding by assuring that most folds run with the grain of the paper.

Signatures created from three, four or more folds may develop a gusset wrinkle, a crease running down from the head of the signature. Gusset wrinkles are especially likely to occur with thick papers or when several sheets are folded at once. When they run into the image area, gusset wrinkles distract readers and may be a symptom of weak binding.

Although folding in a specific style may be

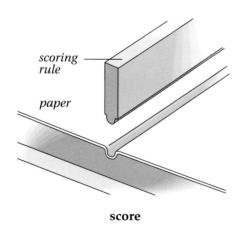

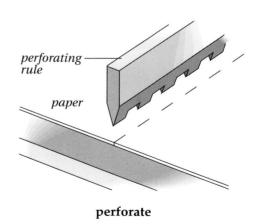

9-3 Scoring and perforating Binderies should score thick paper before folding, especially if it's coated stock, has heavy ink coverage across the fold, or must fold against the grain.

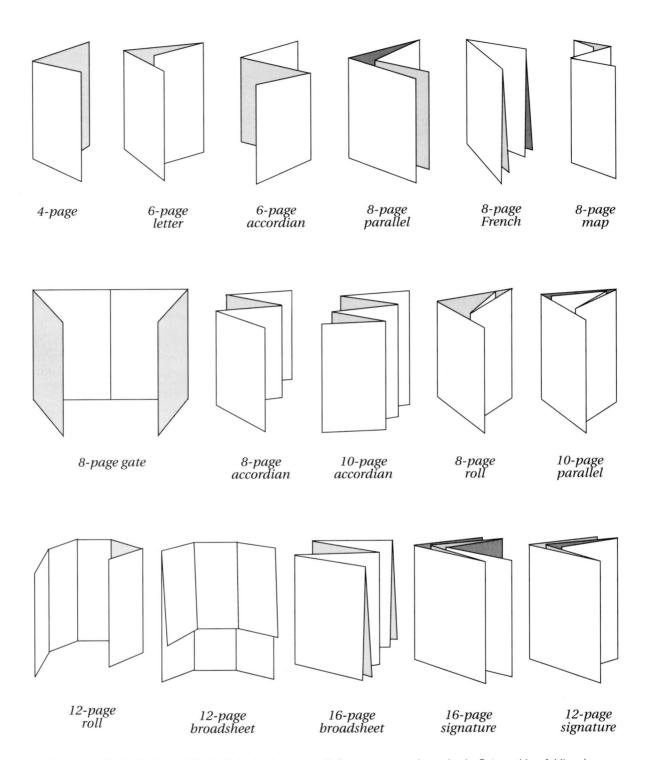

9-4 Common folds Referring to folds by their standard names helps you communicate clearly. But provide a folding dummy as well. A folding dummy also helps you find a vendor able to produce your product quickly and within budget.

Binderies and printers can do many folds not shown above, although they may have problems with especially light or heavy paper.

easy for the bindery, it may lead to problems elsewhere. For example, machines that stuff envelopes for mass mailings may not handle items with accordion folds.

COLLATING

Almost everyone has made endless trips around a table to assemble sheets for a book or report. Even for a printer or bindery, hand collating sometimes works best for small jobs.

Collating can be done automatically by equipment that holds stacks of sheets in pockets, then presents one sheet from each pocket for assembly. Machines have highly specific tolerances and capabilities. For example, they have a specific number of pockets, such as thirty-two or forty. If your job has more sheets than pockets on the machine, collating requires additional runs. Paper weight is also a factor. Machines may miss sheets that are too thick or glossy and wrinkle sheets that are too thin.

Products such as cookbooks with mechanical bindings (comb or wire) look like assemblies of loose pages, but in fact were probably printed and folded into signatures having several pages on each large sheet. After folding, the sheets were trimmed on four sides to cut away folds and leave a pile of collated, individual pages.

Signatures for publications must be collated so that, after they are trimmed, pages are in proper sequence. Nested signatures go inside of each other for saddle stitching. Gathered signatures go on top of each other for binding with square spines. Nesting and gathering take place on highly automated equipment that may also bind and trim in one operation.

Equipment for nesting and gathering holds signatures in pockets, taking one signature from each pocket to assemble one copy of the publication. Machines have a specific number of pockets, such as twelve or sixteen. Each unit of a publication, including order forms or inserts that might be two- or four-page signatures, occupies a pocket. Part of the charge for

binding depends on how many pockets the publication requires.

Printers specializing in publications produced on web presses may print, fold, trim and bind all in one machine sequence. Unit costs can be far lower than when working with printers who must set up new equipment for each stage of the job or who must send jobs to trade binderies.

COMMON BINDINGS

There are several ways to attach loose sheets, folded sheets or signatures to each other. Each method offers a different mix of aesthetics, permanence, convenience and cost.

Padding

Almost every printer can make pads from stacks of loose sheets, the most simple binding operation. For most printers it's a hand operation with brush and glue pot.

Gluing

Binderies and envelope makers can apply adhesives in strips for individual sealing by the user. They are available as either remoistenable glue or a sticky surface protected by a piece of peel-off paper.

Remoistenable glue strips cost little to apply and can be wet and sealed by machinery when necessary. Peel-off strips are handy for large envelopes and products to assemble by hand.

Tipping

When one sheet is glued to another sheet or signature, it's referred to as tipping. Most trade

"Our club publishes an updated cookbook every two years. Of course, every issue gets bigger. Last summer's book has so many recipes that we needed all six signatures and didn't have room for the order form. The printer's sales rep showed us how we could print the form on card stock and glue it to the end of the last signature. Our new forms are easier to use than the old ones that were printed along with the book itself."

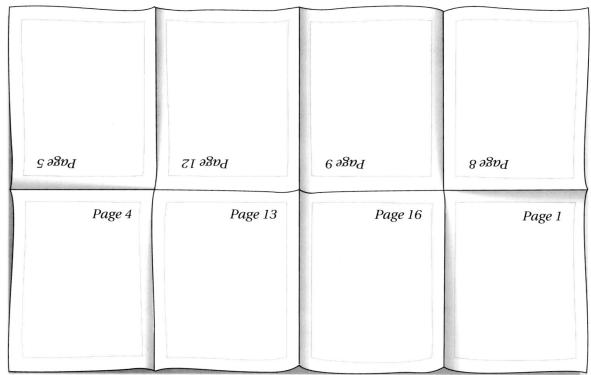

This press sheet with 8 pages printed on each side is a 16-page signature. Other common signature sizes are 4 pages, 8 pages, 12 pages, 24 pages, and 32 pages.

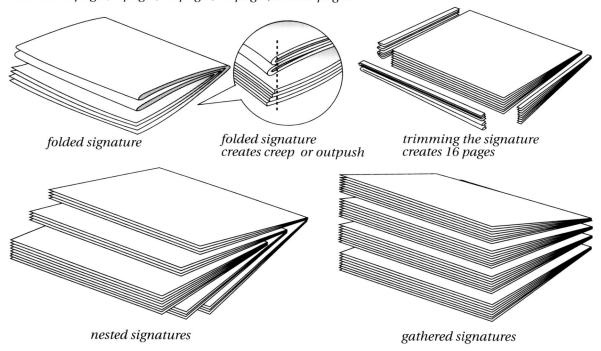

9-5 Signatures Prepress must plan press sheets that fold into signatures so that pages appear in correct sequence after folding and collating. Saddle stitching calls for nested signatures. Bindings with squared spines, such as perfect binding and case binding, require gathered signatures. Binding method influences imposition as much as folding sequence and sheet size. The concept of imposition is further illustrated in Visual 5-7.

The effects of creep are most apparent with thick paper, many folds or many signatures inserted into each other. Folding and binding dummies made from the paper that you plan to use for the job reveal whether the product has too much creep.

binderies have machines that do tipping.

Inserts, such as maps or special advertising sections, are often tipped onto an adjacent signature. Visual 9-6 shows a typical example.

Sealing

Often binderies have machines for sealing folded items ready to mail. Binderies that do tab sealing apply an adhesive circle or short strip of tape to the face of a booklet or self-mailer. Tab sealing is relatively inexpensive and helps products go through the mail in good condition.

Tinning

Tinning refers to clamping metal strips along the tops or bottoms of calendars. Although tinning machines are very simple, binderies that have them are hard to find. Begin by asking your printer.

Stitching

Stitch bindings are done with wire staples either through the crease of the spine or near one edge of the sheets.

Saddle stitching means staples go through the crease of the spine, as shown in Visual 9-7, allowing pages to lie nearly flat. Most magazines are saddle stitched. So are many brochures, catalogs, presentation folders and calendars. The method is fast and inexpensive but does not yield a flat outer spine that can show printing.

Any product up to about twenty sheets (eighty pages at four pages per sheet) of 60# or 70# paper lends itself to saddle stitching. How well the stitching holds depends on thickness of the sheets and length of the staples. Products having more than about twenty sheets (eighty pages) or thicker than 3/8 inch need some other kind of binding.

Saddle-stitched products can easily accommodate special inserts such as envelopes, membership forms or order blanks. Such inserts must fold into signatures and have a binding lip. Saddle stitching also accommo-

"My printer puts an 'Open Last' label on one box of every job. Inside that box is a slip addressed to me with the job number, date and quantity of the last printing. Our stock clerk sends me the slip, and I just call the printer to reorder. We never run out and the printer automatically gets repeat business."

dates a wider range of paper weights and surfaces than some other binding methods.

Because of the bulkiness of paper, saddlestitched products printed on heavy stock and/or having many pages need to allow for the effects of creep, especially when the products have narrow outside margins. Pages must be shingled to take creep into account and ensure equal margins throughout the printed piece. Shingling may be more trouble than it's worth if readers hardly notice slight variations in the margins. Make an untrimmed paper dummy to show whether and how much to shingle pages.

Loop stitching is a variant of saddle stitching where each staple has enough play outside the crease to go over the rings of a ring binder. The method is an alternative to drilling for catalogs that insert into ring binders.

Side stitching puts staples through an entire stack of sheets near its edge. The method results in a strong bind, but pages do not lie flat. Staples consume some margin, so plan copy to start well in from the edge. Heavy-duty equipment can side stitch products up to 1½ inches thick, but the result may look and feel cumbersome.

Stacks of paper that have been side stitched can have a wraparound cover applied with glue, thereby yielding a square spine on which to print copy.

Paste binding

Booklets with just a few pages of paper less than 80# can be paste bound as an alternative to saddle stitching. With paste binding, a web press or folder lays thin strips of glue along fold lines. When the sheet is folded, glued creases meet glued folds to form the bond. After trimming, glue along the creased spine is the only binding. Some photocopiers paste bind in line by laying glue along the edge of single sheets, adhering them as they fall on top of each other.

Paste binding is much more economical than stitching for booklets of eight, twelve or sixteen pages. The upper limit for the number of paste-bound pages depends on bulk of paper and capabilities of press or folder. Highbulk paper may be too thick to paste bind more than sixteen pages.

Mechanical binding

Cookbooks and technical manuals that must lie flat when open can be bound with plastic or wire shaped into either a spiral or comb, as shown in Visual 9-7. Two of these bindings are commonly referred to by the brand names GBC (plastic comb) and Wire-O (double loop wire).

Mechanical bindings cost more per unit than other binding methods except case. Spiral binding costs least and double wire the most, with plastic comb somewhere in the middle. The cost differences among all forms of mechanical bindings are not very large and cost relationships change with large quantities.

The most important differences among mechanical bindings concern how they function. Spirals may be either plastic or wire. They allow the product not merely to lie flat, but to double over, a useful feature for technical manuals, notebooks and calendars. Spiral-bound products have lots of play between individual pages and cannot have pages added

"When we did our first book, we thought we did a good job of market research, but we still guessed totally wrong about what percentage of the run to perfect bind and what percentage to case bind. In less than a year we ran out of the soft cover, but had 1,300 of the hardcover still sitting in our warehouse. With every book since then, we only bind half the run. We leave the other half as flat sheets at the bindery until we learn what kind of binding the market wants for that particular title."

to them. Furthermore, the spirals may get crushed.

Comb bindings are less subject to damage than spirals and allow for less play in the pages. They are relatively easy to install, thus can be done at many small printers and in-plant shops. Plastic combs come in a variety of colors and can be screen printed on the spine. They bend open to insert additional pages in the product. Combs have the greatest thickness capacity of any mechanical bindings, some allowing for products up to three inches thick.

Plastic comb bindings have the disadvantage that products bound with them don't bend past the point of lying flat. Combs are inserted by hand, which makes them very advantageous for just a few products and rather costly for large quantities. Unit costs do not drop very rapidly as quantities increase.

Double loops of wire allow the product to lie open doubled over but, unlike spirals, keep the pages lined up across from each other. They are very durable, come in several colors of wire, and give a more finished look than spirals.

Double loop bindings have the disadvantages of not allowing for insertion of new pages and having a maximum capacity of about one inch. They cannot be printed on the spine but can be case bound, yielding a handsome (and expensive) book. Most trade binderies can insert double wire, but not many printers can.

Screw and post binding, sometimes known as Chicago screw, works similarly to side stitching and has similar design considerations. Users can, however, take the product apart by removing screws from posts, allowing them to insert additional sheets.

Screws and posts are available in many lengths, from ½ inch to three inches. The binding accommodates a wide range and variety of materials but, because it's a hand operation, is appropriate only for relatively short runs.

Plastic grip bindings are applied by quick and in-plant printers to relatively thin reports and presentations. Some styles are removable; others are permanent. Materials are inexpensive and easy to assemble.

You can get ring binders with solid or padded covers, pockets inside or out, and a variety of ring shapes, sizes and configurations. If you have material drilled for a ring binder, make sure that operators doing the drilling have a sample of the binder. Because binders are printed after manufacture and usually in small lots, they are screen printed and provided to a printer or bindery by an outside vendor. You can cut costs by buying ring binders directly from a manufacturer or broker listed in a classified directory under "Binders—loose-leaf."

Mechanical bindings allow for unlimited use of inserts, foldouts and pockets. Like side stitching, they require generous margins at the binding edge. Be sure your layout allows at least ½ inch for no image along the binding.

Perfect binding

Perfect-bound books are made from gathered signatures. The left side of the stack, the spine, is trimmed to get rid of the folds and expose the edge of each page. The stack is then roughened and notched along the spine to assure maximum surface for glue adhesion.

The familiar paperback book is perfect bound. So are most annual reports and technical manuals and many magazines, such as *Reader's Digest*.

Glue for perfect binding is applied along the spine, as shown in Visual 9-7. When the cover is pressed against the surface wet with glue, it adheres to the pad as well as forces some glue between the sheets. After the glue is dry, the assembled book is trimmed on the remaining three sides.

Perfect binding works for publications with a wide range of thicknesses and trim sizes. Paper should be not more than 80# and—very important—should run grain parallel to the spine. Grain short bindings are weaker than grain long bindings, and pages may become wavey along the face as they absorb moisture.

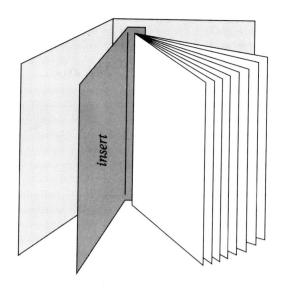

insert wrapped around 16-page signature

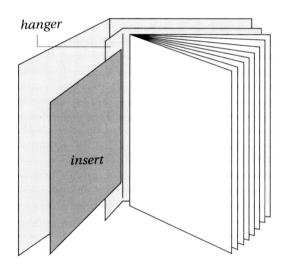

insert tipped onto hanger

9-6 Inserts A bindery can wrap an insert around a signature or tip it onto a hanger page. The insert can appear at any place in the publication where a break between signatures occurs. This illustration shows inserts for saddle stitching, but you could can plan inserts for any binding method. Keep in mind that each insert requires its own pocket in the bindery line.

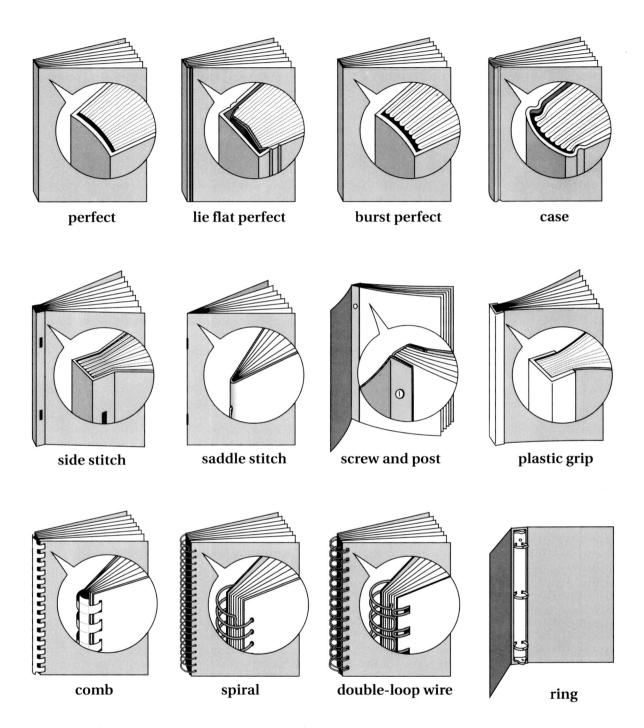

9-7 Common binding methods These twelve binding methods are commonly available at binderies and from printing companies. Each has pros and cons, depending on page count, kind of paper and how readers use your product.

Some printers caution against perfect binding coated cover papers because coatings prevent glues from adhering strongly to fibers. If you're concerned about adhesion to coated cover stock, specify C1S cover grade so that the uncoated side may face inward.

Binderies that do burst perfect binding make slits along the spines of signatures so that glue is forced toward the inside pages. Burst perfect signatures look similar to sewn signatures because they are not trimmed and roughened along the spine. They are almost as strong as sewn signatures and they cost much less.

Paper covers may also be glued over sewn signatures. This creates a cross between perfect and case binding that yields a very strong and—compared to case binding—inexpensive product.

Lay-flat binding

The cover of a perfect-bound book attaches to the spine across its full width. The spine is stiff and the book doesn't lie flat. When the cover attaches only at the corners of the spine and is loose across its width, as shown in Visual 9-7, the book can lie fully open.

Lay-flat binding is an alternative to mechanical binding for technical manuals, music books, cookbooks and directories. It costs more than perfect binding but less than comb or wire and isn't as durable or versatile. Paper weights and coatings are limited for both cover and text, and paper must run grain long to the spine. As with perfect binding, coated papers can be lay-flat bound by sewing signatures before gluing.

The key to successful lay-flat binding lies in water-based glue, also known as cold or polyurethane reactive (PUR) glue, that stays flexible for the life of the product. As an additional advantage, cold glues aid recycling because pulp mills can separate them easily from paper. Cold glues do require twenty-four hours to cure, so production schedules should take curing times into account.

"I don't care what downtown studio plans the job, I want to see a dummy before it goes to production. Specifications, too. I wouldn't stay in the bindery business very long if my people didn't remeasure trim and fold marks and check measurements against specs. You'd be amazed at how many designs I see for work that won't fit our machines."

Case binding

Nothing beats case binding for durability, good looks or high cost. The method, illustrated in Visuals 9-7 and 9-8 and also known as edition binding, results in the hardbound book.

Case binding begins with sewing signatures along the spine. Thread makes a stronger and more elegant adhesive than glue. Because the machine most commonly used for sewing signatures is made by Smythe, most signatures are Smythe sewn. There are, however, other patterns of sewing, such as saddle, cleat and McCain. If your book is for a market, such as school textbooks, that has technical production specifications, check what kind of sewing is required.

After signatures are sewn, they are gathered and trimmed on three sides. The stack is put inside a case made of binders board covered with paper, cloth, plastic or leather. The case is held to the signatures by glue along the spine and between end sheets.

To cut costs, some publishers skip the sewing by inserting perfect-bound or burst perfect-bound forms into cases. Case binding can also mix with other techniques such as comb wire and side stitching.

Printers and trade binderies who specialize in books customarily offer case binding. Most cities have a small bindery specializing in short runs, book restoration and presentation volumes involving handcrafted case bindings. Leather coverings and handmade endpapers yield lavish books at equally lavish prices.

Because case binding combines so many components, writing specifications is quite complicated. You must decide about endpapers, square or round backs, amount and quality of binding, headbands, cover material and dust jackets. Sales representatives at trade binderies help you decide. You might also benefit from the point of view of an experienced book publisher.

SELECTIVE BINDING

Regardless of what binding method you use, you can bind versions of a product custom-made for specific audiences. For example, you could produce one version of a clothing catalog for cold climates and another for mild climates. Or one version showing red coats and another showing the same coats in blue. Or ten versions with different covers and order forms but having identical page copy.

Selective binding allows versions of a product tailored to demographic factors such as age, income, education and job title—any variable that you can identify in a database. National magazines use selective binding to present a different mix of display ads to different audiences all reading the same editoral matter. Some even present different editorial matter. Used for this purpose, selective binding is a form of target marketing.

Machines capable of selective binding link your database to their binding lines. A computer reading your database instructs the machine to skip or add a signature, insert the correct order form, or apply the proper version of a cover. If your publication is destined for the mails, the database also governs the ink jet printer writing labels and personal messages.

Although selective binding permits many

"I thought I was doing my printing sales rep a favor by giving his shop our company holiday card every year, even though I knew we could probably get it printed cheaper somewhere else. I figured that the rep always gave us good service and deserved every job I could pass along. Last year I learned from a mutual friend that the job always got farmed out to a smaller printer and that, even though we paid a markup, the card job was more trouble than it was worth. My sales rep was actually doing me a favor, not the other way around."

combinations of signatures and other elements, it cannot handle variations in trim size. Products may have different page counts, but must be the same height and width.

Effective use of selective binding begins with planning and design. You need to know precisely how much flexibility of assembly you have and where the ink jet printer can write. Inserts must fall precisely at signature breaks and ink jet printing occur only on pages intended to receive it. You have zero margin for error, especially with your database.

Selective binding is most popular with saddle-stitched magazines and catalogs, where it can cut costs by reducing waste and speeding production. When conforming to USPS regulations for commingling, it can also reduce postage costs and speed delivery.

CONVERTING

A printed sheet changed into a substantially new product—a box, point of purchase display or envelope—has been converted.

Converting companies, like binderies, work primarily with printers. Unlike binderies, however, converters tend to specialize in products such as envelopes. Further specialization occurs in the category of boxes: Some companies focus on boxes and displays made from corrugated paper while others make them from chipboard. The chipboard products are known in the trade simply as paper boxes.

When working with any trade service, experience is the key to success. If you are a graphic arts novice, you'll probably get the best quality and service by letting your printer deal with converters. As you gain experience, you benefit by dealing with converters directly.

PACKING

The method of packing the final product affects shipping and storage and may also influence effectiveness and profit. No one wants damaged goods.

Bindery operators should pack materials tightly to prevent sliding and scratching.

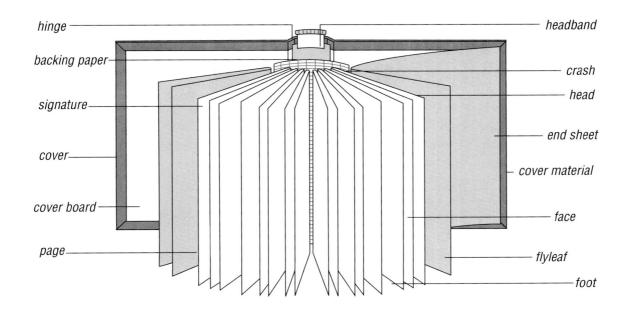

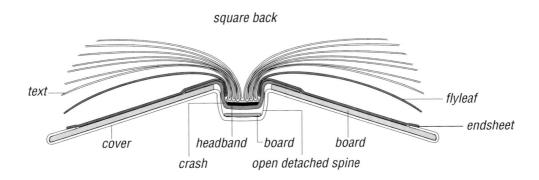

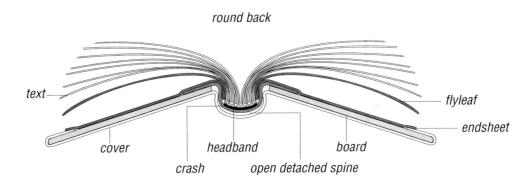

9-8 Case binding Case-bound books can have covers made from many materials: leather, buckram cloth, woven cloth and synthetic paper. Each material comes in a variety of patterns and grades. Binderies can case bind with round or square backs. Which material and style you prefer depends on your taste and budget.

Because of the large variety of materials and techniques available, case binding requires planning months ahead of production. Consult with both your printer and your bindery together to assure that printing and coating harmonize with binding.

Rubber or paper bands or shrink wrap should go around small bundles before they are put into boxes. Specify how many items you want per bundle. Books that are not shrinkwrapped, either individually or in bundles, should have slip sheets between each book. Workers should band cartons on skids.

Many industries have special standards for shipping and storage that affect specifications to binderies. For example, buyers for many retail outlets order by the gross, so binderies should put products in boxes containing either 72 or 144 units.

If you want each box to contain a specific number of items, make that requirement clear when you specify the job. Your printer may have to order boxes to meet your requirements.

Shrink wrapping is the process by which a plastic film surrounds and seals the products. You can see the items inside, but they are wrapped so tightly that they don't rub during transit and they stay dry during storage.

Shrink wrapping is suitable for anything from fliers to books. You can have each item, such as each book, shrink wrapped or you can wrap bundles of items. Unless you specify some particular number, bindery workers wrap as they find convenient—perhaps a handful to each package. Shrink wrapping also works for entire boxes and even pallets loaded with boxes. The plastic keeps material fresh during storage.

Pallets (also called skids) are standard wooden platforms used in every industry for shipping and storage. A pallet easily holds a ton of printed material packed in boxes. If you expect delivery on pallets and don't have a forklift and loading dock, ask for delivery by truck with a lift gate.

Customers often don't think much about labels; many simply get printing orders delivered with a sample of their product taped to the outside of the boxes. To make labels clear, tell your printer what information you want on the outside of boxes and packages. Bindery workers can write or stencil the information on each box. For larger jobs they can make peel-off labels.

FINAL COUNTS

Whether orders are for 1,000 books, 5,000 posters or 100,000 envelopes, they get counted at the end of bindery.

Controlling quantity is extremely difficult. Printers figure enough extra paper at the beginning of the job to allow for waste along the way. If everything goes smoothly, you'll have a few more pieces than you ordered and perhaps at no extra cost. If it's essential, however, that you have no less than the number you ordered, tell your printer as part of the specifications. Trade customs allow a 10 percent variation on orders up to ten thousand pieces. To ensure you get "no less than," your printer may insist on doubling percentage tolerances for overruns.

Pay careful attention when you pick up materials or receive delivery. Trade customs and business ethics both dictate that you claim shortages promptly. The best time to notice a problem is when the job is still on the printer's counter, loading dock or truck. Take time to spot check several boxes, then count the cartons to determine that everyone agrees on the totals.

On short counts you can either go back to press to complete the job or get a credit. From the printer's standpoint, going back to press costs far more than cutting the price. From your standpoint, the printed pieces are probably more important than the money. Don't hesitate to insist on going back to press if the additional material is crucial. If you do insist, however, don't feel surprised if that printer loses interest in you as a future customer.

[&]quot;I always ask a service bureau when they will actually start working on my job. Lots of shops have regular customers with magazines and newsletters. I don't want my copy sitting on a shelf for two days when I could have had those days to work on it."

STORAGE AND TRANSIT

Most printers and binderies are not in the warehouse business. When your job is done, they want you to have it. There are, however, two exceptions. Books and similar materials require a lot of storage space and may stay in inventory a long time. Printers who specialize in these products may offer inexpensive warehouse space. The other exception is material that must be later imprinted. It makes sense to keep that inventory in your printer's warehouse.

Storage at the printer's can be convenient and cheap, but it also requires some commonsense precautions. Check actual warehouse conditions to verify that the space is reasonably secure and free from moisture, dust and risk of fire. Double-check your insurance to learn who would pay for damaged or lost goods. Finally, ask about accessibility. Don't wait until next summer's convention to learn the whole print shop goes on vacation in July.

You need to keep track of jobs received and put into inventory. To assure correct monitoring, you need a working relationship with storage and distribution people in your organization. Tell them when to expect jobs and how to handle them when delivered. Ask them to recommend how to pack the job and what procedures they want for packing slips, bills of lading and other paperwork.

10. WORKING WITH PRINTERS

Your regular printers
Occasional printers
Specialty printers
In-plant printers
Locating printers
Evaluating sales
and service
Requesting estimates
Evaluating quotations
Interpreting alterations
Negotiating problems
Clarifying trade customs

Printing companies vary greatly in size, equipment, market and business goals. To manage a variety of printing jobs, you need to know the benefits that many printers can offer you. You may have two or three printers for routine work, but you should know how to work with printers on a job-by-job basis when your regular shops are not appropriate.

Printers have niche markets in which they are most competitive and efficient. Working with a variety of printers assures maximum control over quality, schedule and price. To get the best price, you must use specifications to shop among printers.

Willingness to shop does not mean soliciting bids for every job. On the contrary, your regular printers usually offer the most dependable way to get a job done. Those printers should know your needs so well that you don't have to worry.

In this chapter, you'll learn how to locate printers suited to your jobs and maintain a relationship with them that benefits both you and them. You'll discover how to cooperate with printers to achieve quality and service. And you'll learn criteria for evaluating quotations and analyzing bills.

Even with the guidelines, you often find yourself in a gray area where only experience can shape your judgment. The chapter concludes with tips about how to negotiate if things go wrong.

YOUR REGULAR PRINTERS

Most printing buyers like working with only one or two printers for routine jobs such as business forms, stationery and newsletters. Because so many printers can produce such products at satisfactory quality and price, your preferences should depend largely on service and convenience.

Your regular printers should know your organization so well that you trust them to take care of your printing needs. They become part of business relationships in the graphic arts that might also include a graphic designer and prepress service.

Having a quick printer as one of your regular printers saves time and money with basic quality, one- and two-color jobs in relatively short runs. With those jobs, the average commercial printer would take longer and have to charge more than the job is worth.

As a consistent customer of a quick printer, you should have several advantages over the walk-in trade. Ask for monthly billings rather than individual invoices. Look for special services such as overnight printing, after-hours pickup, and personal access to the light table or computer screen. Expect an instant call or fax when your job is ready or delayed.

As a consistent customer of a commercial printer, you may get priority press time and delivery scheduling. Staff may know your wishes with regard to packaging and delivery. You may get extended credit terms or be told about special values in paper.

With any regular printer, you may save money by negotiating a quantity discount. For example, whenever your monthly invoice exceeds a specific figure, say \$5,000, you might pay 2 percent less than invoice. At \$10,000 per month, you might pay 3 percent less.

10-1 SPECIFICATIONS

Specify every printing job in writing, even the most simple and routine. Written specifications along with a comprehensive mockup assure clear communication between you and everyone else involved in the job.

Good specifications are complete, precise and use language that graphic arts professionals understand. Specs benefit you in many ways.

Assure accurate comparisons. When each vendor quotes on the same specifications, you can compare prices accurately and fairly.

Look professional. Clear, carefully written specifications convey that you know what you are doing. You expect appropriate quality, attentive service and reasonable price.

Provide a checklist. Specification forms help you review the entire production

sequence and save you time in getting quotes. They make it obvious if you forgot an important detail.

Keep costs down. Specifications written on a standard form notify printers that you are soliciting competitive bids.

Reduce guesswork. With good specifications, printers can figure costs exactly, identify ways to save money and spot potential problems.

Help monitor changes. Almost every set of specifications changes at least a little as the job goes through production. With the original specifications as a guide, you can keep track of alterations.

Make payment easier. By comparing the final bill to the specifications, you can see exactly what was called for, what was done, and how alterations affected the final price.

Having regular printers helps you plan jobs to take best advantage of equipment in their shops. Presses at quick printers are quite similar from one shop to the next, but it helps if you know your printer can run 12" x 18" paper so that 11" x 17" products can have bleeds. Computers are similar from shop to shop, but the operator at your shop may work magic with an application that operators at other shops can't even seem to load into RAM.

Commercial printers have a more complex blend of equipment than quick printers. Being a regular helps you learn how to plan for a press that may be a perfector, a multicolor unit or both.

People who buy a lot of printing use five or six printers regularly. A book publisher must know several book printers. The marketing director for a restaurant chain needs to know about menu printers and perhaps about some screen printers for aprons and T-shirts.

Regular printers are especially convenient for reruns because the job already meets their specifications. They have computer files or flats. You can order over the phone and confirm by fax. With routine jobs, letting the original printer do the reruns usually works out best.

The trade custom giving printers ownership of negatives that they make helps printers get reruns. With major jobs, you may get lower prices when you keep control over plate-ready materials so you can solicit new quotes each time the job repeats. For one- and two-color jobs, keeping mechanicals or computer files works as well as owning flats. For four-color jobs where negatives may represent considerable work in prepress, you may want physical

"When I took over as Marketing Manager, I would call a printer asking if they did the kind of work I had in mind. Of course, everyone I called always said yes. Finally I got the picture, so I started asking what kind of work they felt was their strong suit. That question produced a much better match between my projects and their talents." control over the flats themselves.

If you want updated computer files or negatives after receiving the job, make sure your contract includes wording that gives you ownership. Printing trade customs state that printers own film. Most printers include a clause to that effect on their quotation forms that you sign as a contract.

OCCASIONAL PRINTERS

You may find that your regular printers cannot do jobs such as catalog sheets or presentation folders as fast or inexpensively as some other printer.

Knowing when to consider alternatives to your regular printers requires making judgments about individual jobs. You must decide whether a job is too large or small, has quality standards too high or low, or has some other aspect that makes it unsuited to one of your regular printers. For example, if you want five thousand booklets that are two color, sixteen pages, saddle stitched and in the good quality category, your regular commercial printer is probably the best bet. If you want fifty thousand booklets that include premium quality, four-color process work, it would make sense to get quotations from some other printers.

When you prefer not to use one of your regular printers, you survey the world of commercial and specialty shops for an alternative.

Commercial printers fall roughly into categories based on their ability to produce small, medium and large jobs. A shop suited to small jobs has eight or ten employees and small presses capable of printing one or two colors at a time. The shop also has simple preparation and bindery departments. You probably discuss work directly with the owner or manager.

Printing companies suited to medium jobs have fifteen to twenty employees and a blend of presses that give them great flexibility in scheduling and in the kinds of items they can print. Shops of this size compete with each other for business in a local area. You deal mainly with sales reps but might also know

some of the production supervisors.

At a printer seeking big jobs, equipment and staff handle large amounts of paper and printed goods. The shop may have fifty to one hundred or more employees and both web and sheetfed presses. Press time, especially for the webs, is scheduled days or weeks in advance. People in prep and bindery know how to deal with very complicated jobs. Some larger printing companies specialize because their web presses are configured to make specific products.

The size of a printing company is a poor guide to the quality of work it can do. Shops with small presses as well as those with large presses may do showcase work. Both kinds of shops may also turn out disappointing work. Routine work from ABC Litho may look identical to XYZ Graphics's maximum effort. Intelligent buying means knowing what you can reasonably expect from a specific printer. Don't settle for less, but don't ask for more unless higher than normal standards were part of an agreement made in advance.

Only you can decide whether your printing jobs are small, medium or large. Intelligent buying requires matching jobs with printers.

SPECIALTY PRINTERS

Many printers target their equipment, supplies, work flow and marketing to a particular category of products. For example, printers specializing in publications have prepress links and web presses configured to work with magazine and catalog publishers. A publications printer might also have facilities for selective binding and might operate as a lettershop as well as a printer.

A specialty printer focuses on doing only one kind of job, so materials and procedures stay consistent from prepress through bindery. For this reason, a specialty printer produces a specific product more efficiently than a commercial printer that produces brochures today, posters tomorrow and booklets next week.

Large specialty printers benefit from buy-

"When I send out requests for quotations, I tell all the sales reps that I plan to accept a quote somewhere near the middle of the range of bids for the job. I don't want some estimator to quote under cost to win my business, then try to rush the job through or need to cut corners to make a profit."

ing vast amounts of only a few kinds of papers. For example, a book printer may buy 100,000 pounds of 55# natural offset every few weeks. A printer specializing in software documentation may keep 50,000 pounds of #3 50# matte handy just to get through the night shift. The typical commercial printer can't compete with that kind of buying power. On the other hand, at a specialty printer you choose from six or eight house sheets, not from the large selection that commercial printers offer.

Specialty printers are known by product, as in "book printer" or "envelope printer." Some common products that printers specialize in include advertising inserts, books, checks, direct mailers, envelopes, financial documents (stocks and bonds), business forms, greeting cards, labels, publications (magazines and catalogs) and scientific journals.

Classified directories list specialty printers under the products in which they specialize. The companies also advertise in periodicals oriented to potential buyers of their products. For example, printers who specialize in large quantities of four-color fliers advertise in magazines for the gift and jewelry businesses.

Printers compete in a national market for products such as catalogs, books, direct mailers and showcase quality annual reports. Customers using printers who specialize in methods such as gravure and laser diecutting also deal at a distance.

Experienced printing buyers routinely send specifications, mechanicals and art over long distances and deal with proofs and shipments over the same distances. They may travel personally to the printers only for a press check.

Specialty printers in the national market can frequently produce a job at 30 percent or 40 percent less than the lowest local bidder. In addition, because of their focused equipment and work flow, production schedules for specialty printers are shorter than schedules for commercial printers doing the same job. With large jobs, you may save much more than the extra costs of doing business at a distance. Moreover, distant printers are often represented locally by brokers or sales representatives in daily contact with the distant shop.

You may feel nervous about sending jobs to out-of-town shops, thinking the printer needs personal contact. Dealing with a distant printer does limit close supervision. Whether it is worth the risk depends on your quality requirements, schedule and the cost savings. If in doubt, ask for references to local customers. Most previous customers feel happy that they learned to work with distant printers when circumstances called for it.

Working with a distant printer may involve sending electronic prepress files by modem. Make sure that you and the printer agree on how to identify and organize your files. Test your procedures, then test them again. Many specialty printers have large numbers of customers, which makes the task of keeping electronic information clear and orderly doubly important.

Sometimes experienced printing buyers snop in Asia or Europe. Dealing with printers in other countries involves learning their standard paper sizes, which are different from those in the United States, and being alert to nuances in process colors, whose hues may look slightly different because of techniques of making inks. Buying printing abroad also requires expertise in international financing and customs arrangements, matters best left in

the hands of a printing broker during your first few experiences.

IN-PLANT PRINTERS

Many businesses, governments and school systems have their own print shops, called inplant printers. If your organization has an in-plant printer, you should know what kinds of jobs the shop does and how it operates from a business standpoint.

In-plant print shops are an administrative arrangement unrelated to the size, skill, equipment or specialization of the shop. Both the U.S. Government Printing Office and an ancient mimeograph machine in a church office fit the definition.

The in-plant printer for a state government or large private company might perform the same full range of services as many large commercial printers. The typical in-plant, however, more closely resembles a quick or small commercial printer. Using small offset presses, the shop handles routine, basic and good quality jobs.

In-plant print shops exist for reasons of convenience, cost and security. Taking the job down the hall or to an adjacent building, especially for people in large, noncommercial areas such as college campuses, is more convenient than going outside. Staff at in-plants build their inventories, equipment and services to fit the needs of the host organization.

Because in-plant printers do not operate for profit and have no costs for sales or marketing, printing jobs cost less than from independent printers. Further savings occur when staff at the in-plant know postage regulations and paper needs as they relate to products made by the host organization.

Many businesses believe security offers the main reason for having an in-plant print shop. In-plants do not serve the public, so information such as new prices stays confidential during printing.

Critics of in-plants argue that the advantages sound fine in theory but don't work in

[&]quot;I had to argue for a year to send specifications for our catalogs to several new printers, but finally got approval. My boss was amazed at the results. There was a 50 percent cost difference between the highest and lowest quotations. I know professional printing buyers who consider that a typical spread."

practice. They claim that their in-plant may prove less convenient than working with some nearby business, especially when the in-plant seems part of a complex bureaucracy. They say that the security question is irrelevant for most jobs. Most important, they assert that in-plants don't have to compete for work, so are not as aware of cost and quality control as outside printers.

Sometimes the complaints are justified, but you should view them in their proper context. Although using the same equipment and materials as the world of independent printers, inplants have a different set of management problems.

Customers often bring in-plants poor mechanicals or electronic files that independent printers would either reject or correct at additional costs. People at in-plants may patch things together, even though they know the result is poor quality work.

In-plants tend to get the routine jobs such as forms, pads and staff directories. More challenging work goes outside, contributing to the stereotype that in-plants can't do quality printing. Some in-plants do excellent work on material that demands it, even winning awards for products such as annual reports.

Because in-plant printers don't have to compete in the commercial market, they often have old equipment that wasn't very high quality to begin with. They may get 100 percent out of their machinery, but that still may not be very good.

To get the best possible work from your inplant, give its staff good originals, adequate time and appropriate respect. Equally important, know what you can reasonably expect. Ask to tour the shop and learn about what its equipment can do. Think about your in-plant as you would any other printer: right for some jobs and wrong for others.

The typical manager of an in-plant print shop has a background in printing and is familiar with printers in your locality. The manager can help you write specifications, prepare copy "I wish customers would tell us when they feel unhappy with our work. When we print a job that they find unsatisfactory for whatever reason, it's probably because one of us wasn't clear with the other. A good percentage of any job turning out right is both printer and customer knowing what to expect."

and make decisions regarding jobs not suitable for in-plant printing. Taking advantage of this knowledge leads to managing all printing jobs better.

LOCATING PRINTERS

Every printing job is unique and every printer has an individual mix of equipment, skills and materials. Finding printers suited to your jobs requires hard work but pays many dividends when it develops dependable relationships.

Experienced buyers can help you identify printers suited to your needs. Large companies, hospitals, banks, associations, publishers and advertising agencies have one or two people who buy a lot of printing. To locate one, ask to speak with the printing buyer, marketing director, print production manager or director of public relations. Using one of these titles when you inquire should get you to the right person who, perhaps over lunch at your expense, can give you leads.

Classified directories do not distinguish between quick and commercial shops, but their ads and listings help tell who's who. The names of quick printers include words such as "jiffy," "rapid" and "instant." Commercial printers are more likely to include a family or regional name and to call themselves "full service" or "lithographers." Beyond distinguishing between quick and commercial printers, ads in directories do not reveal who is appropriate for a specific job.

In addition to listing companies under the classification "Printers," classified directories have a variety of other categories for printing. Most are related to the names of products, such as "Bags—paper" and "Postcards."

Regional trade associations of printers pub-

lish buyer guides that describe the equipment found at member companies. The guides are free to printing buyers. You can locate the association in your region by calling the national headquarters of Printing Industries of America (PIA) in Alexandria, Virginia.

Several national magazines publish annual directories of graphic arts services. Companies pay for listings, which focus on equipment. These directories concentrate on specialty printers for products such as magazines and catalogs.

To learn details about a printer that you might use, simply call the likely candidate and ask for information. Explain that you are calling to become better acquainted with shops whose services you might use. Ask for samples of the kind of work the shop does best and for references to satisfied customers.

If you are considering a shop from the standpoint of becoming a regular customer, ask previous customers if quality stays consistent and quoted prices are dependable. Learn from management at the shop what plans it has for buying new equipment or adding new services. Discuss how to design jobs that take advantage of particular machines. Ask about credit arrangements.

You may get invitations to tour printing companies. Accept the first two or three to get a feel for how various printers set up their shops and how jobs flow from one department to another. After the first few, plant tours lose their value except for an occasional visit to a specialty shop or trade service. Tours are educational and build business relations, but they

"After we wrote specifications, we decided to make a complete test of book printers in our region. We sent specs to fourteen companies. The prices we got ranged from \$5,415 to \$8,865, with the average at \$5,170. Three printers quoted on some variation of our specs that they thought we needed but didn't ask us about first. We ignored those. The job went to the shop with the third lowest price but that guaranteed delivery in twenty days."

.....

don't help much in making specific buying decisions.

EVALUATING SALES AND SERVICE

Knowing the capabilities and markets of printers helps put them into categories, but where you take a specific job depends more on service, quality and price. Most customers put service first. At a very small shop you may get personal attention from the owner who also runs the press. At most printers you deal with a sales rep, customer service rep or broker.

Service includes how rapidly you get estimates as well as printing, how conveniently a shop is located, and whether you get pick up and delivery. You should also take into account credit terms and additional services such as design.

Good sales reps and brokers ensure that printers produce jobs properly and on time. They suggest ways to raise quality and cut costs, pick up and deliver copy and samples, and answer technical questions. A good rep occasionally points out that you might get a particular job better, cheaper or faster elsewhere.

Sales reps work within the printing company on behalf of their customers. They monitor estimates to keep costs down, work with prepress staff and press operators to keep quality up, and check with production supervisors to keep jobs on schedule. As your advocate, your rep may compete with other reps in the same company for press time and priority in bindery.

Brokers work with many different printers. From your standpoint as a customer, a broker functions much like a sales rep. For more about brokers, see chapter one.

Sales reps and brokers spend much of their time working with customers away from the printing company, so larger shops also have customer service reps (CSRs). Customer service reps remain in the shop to support the sales force. Call your CSR with technical questions or to learn the status of a particular job.

Many sales reps earn commissions from the

10-2 FINDING PRINTING BUYERS

You can find printing buyers at local meetings of art directors, graphic designers, illustrators and professional photographers. Also at regional meetings and conferences of organizations such as the International Association of Business Communicators (headquarters in San Francisco), Public Relations Society of America and American Marketing Association (each with headquarters)

ters in New York), and American Society of Association Executives, Society for Technical Communication, and American Advertising Federation (all three with head-quarters in Washington, D.C.). If you can't find these organizations in your telephone directory, call their national offices for the names of local contacts.

printers who employ them. Customer service reps earn salaries. Printing brokers make their living by marking up jobs they sell.

People selling specialty printing are often brokers rather than sales reps. When dealing with specific people, ask about their status. Insist on recommendations from previous customers before signing anything but the most routine order.

REQUESTING ESTIMATES

Learning how much a printing job will cost begins with clear specifications set forth in writing and accompanied by a dummy or laser printout. Even the simplest job can run into problems, so don't make your printers guess about anything. Make everything clear by writing it down and, when you can, providing an example.

Good specifications do not prevent printers from making suggestions. In fact, good specifications encourage thinking about options. Even though you welcome alternatives, insist on knowing a price based on your original specifications. That dollar figure helps you compare printers.

Printers offer either formula or custom pricing. Formula pricing is based on specifications that fit the printer's price chart. Quick printers, for example, typically have price charts showing costs per hundred copies using black ink and standard papers. Formula pricing means

you know exactly what the job will cost before you hand mechanicals across the counter.

Many specialty printers use formula pricing. You can order envelopes, self-cover direct mailers, four-color fliers and even books whose unit costs you compute from price lists. These printers keep costs low by using a limited choice of paper weights, sizes, formats and trims and often by ganging jobs of different customers onto the same press sheets.

When you can use one of the formats that a shop offers, formula pricing may save you hundreds or thousands of dollars on jobs where the message is more important than customized production. Deviating from the standard format, however, means that your job may cost the same as it would at any commercial printer.

Commercial printers figure a custom price for each job. Using your specifications, their estimators compute the costs of paper, preparation and press time, and other factors they consider relevant. They calculate what each job costs to produce and what the printer should charge to make a profit. Estimators may also take into account how fast you want work finished, the quality level you want, and your reputation as an easy or demanding customer.

Printers feel reluctant to give rough quotes, estimates or ballpark figures. They figure prices using complex formulas and computer programs, so giving you a guess takes as much work as giving you a firm quote. Furthermore,

"I like the sales rep from Agency Litho because he takes extra time to understand my business, not just his business. He knows our critical deadlines and how we like to work in shipping and receiving. He keeps me informed every day about the status of every job so I never surprise my boss with bad news."

customers sometimes forget that a guess is not a quote, a memory lapse that may cause hard feelings when the invoice arrives.

A quotation, also called an estimate, is an offer to produce a job for a specific price. Printers base quotes on specifications. If you sign the quote based on your specifications, you have a contract.

Some printers give firm quotes only on seeing mechanicals, not specifications. They know that customers often overlook factors while writing specifications. Printers who follow this practice should make it clear by writing on the quotation forms that the price is subject to review of mechanicals.

Every printing job is unique, every print shop has a special blend of machines and skills and some shops want business more than others. These factors mean that prices on the same job may vary widely from shop to shop. Quotes from printers looking at identical specifications can vary as much as 50 percent even when every shop is well suited to the job.

Business conditions affecting individual printers influence what they quote on a job from one week to the next. A small shop owner might need business and give you a terrific price. A month later that same shop might have so much business that the quote on the same job is 50 percent more. A large shop might have an opportunity to gang your job with others or run it on paper it bought on a special offer.

Printers actually produce only one job for every eight or ten quoted. If you ask for quotes but never contract a job, you'll soon be ignored. Don't abuse printers' eagerness to figure costs. Don't ask a small commercial printer to bid on four thousand copies of a two hundred-page, perfect-bound book. Only ask for quotes from those printers suited to the job.

The printer whose quote was too high today may still be right for tomorrow's job. Thank the unsuccessful bidders and tell them you look forward to dealing with them again.

How many quotes to get depends on how familiar you are with general printing costs, particular printers and the specific job. For most jobs, you don't need more than three quotes—assuming each comes from a printer well suited to the job. With complicated jobs that might run either sheetfed or web, and jobs where you might use an out-of-town printer, you don't need more than four or five quotes.

Each printer quoting your job needs identical information. If specifications vary, you can't compare prices. Write specifications on a form such as the one in Visual 10-5. Even when you write precise specs, printers may interpret requests differently. To ensure clear understanding, ask that samples of paper and examples of previous work accompany quotations.

While insisting that printers give quotes based on identical specifications, don't hesitate to ask about additional costs on a small number of alternatives. Inquire about the cost of equivalent paper that may be a house sheet or for prices on one or two alternate quantities. Keep an open mind about cost-cutting alternatives, but insist on seeing prices on your specifications as well as on alternatives suggested by the printer.

Printers figure their costs using complicated formulas that take into account the capabilities of equipment, costs of paper and other supplies, wages and salaries, overhead needs and profit goals. You can't know all these figures, but you can learn prices for specific items such as tints and halftones. With that information, you can refigure some costs yourself as you consider certain kinds of changes.

EVALUATING QUOTATIONS

When evaluating quotes from printers, check first that the price actually relies on your specifications. The quote should refer to your job number or product name from your request for quotation.

The professionalism of the quote tells a lot about a printer. Look for an answer to every question about cost, condition of copy, type of proofs, packaging and delivery time. Quotes should arrive when promised. A printer that is efficient, thorough and on time with quotations is likely to be that way with jobs, too.

Printing jobs often include services such as foil stamping or case binding that a printer must subcontract. Printers should know what these buyouts will cost before quoting the price of the total job. Don't consider quotes that leave open lines saying something like "plus cost of dies."

The cost of paper may be an exception to the above rule about open price lines. Printers may be unable to anticipate price increases, so feel forced to tell you "paper prices subject to current rates."

Most printers hold quoted prices firm for thirty or sixty days. The time limit might mean you must sign the contract within that number of days or might mean that you actually bring in the job. Ask if you are unsure. And don't hesitate to ask for a little more time to think things over.

Remember that dollar amounts on quotation forms are not the only costs of printing. If working with the low bidder means considerable travel time and expense, the price might not look so attractive after all. The peace of mind that comes with close control over a job may be worth a few extra dollars, especially when you are new to a process or product.

As the last step in evaluating quotes, ask yourself what the job is worth to you and whether dollar amounts seem reasonable. Concentrate on value to yourself. For example, if selling a new product depends on a premium quality brochure, don't risk using a printer whose quality you doubt. If you keyed your membership drive to a mailing on the first of the month, don't risk using a printer who may not deliver on time.

When you solicit quotations, one of your regular printers may not submit the low bid. If the difference seems slight, ignore it. Stable

10-3 WHEN TO SOLICIT QUOTATIONS

Some customers get quotes too often. They would be better off simply handing most jobs to their regular printers. Other customers don't get quotes often enough. They spend too much money by not shopping and by not keeping their regular printers competitive.

You can take a balanced approach to shopping for printing by following these guidelines.

Costs. Get quotes when you think the job will cost an amount that you consider significant. That might be \$500 or \$50,000.

Familiarity. Get quotes when you're dealing with a printer, process or product

that's new to you. When handling your first job using separations or perfect binding, you probably lack sufficient experience to judge whether costs from your regular printer are reasonable.

Quantities. Get quotes when you might find significant savings at different quantities. The printer that bids low on 10,000 brochures might bid high on 25,000. Price breaks vary greatly from one printer to the next.

Competition. Get quotes on a routine job every couple of years just to remind your regular printer not to take your business for granted.

business relationships are worth far more than a few dollars saved on a particular job. If, however, your regular printer seems much too high, offer a chance to quote again. Maybe the printer will reduce the price to keep your steady business. Or maybe the estimator simply made a mistake.

Accept a quote in writing to assure that the contract is clear and enforceable. Sign the form and return it along with your purchase order.

INTERPRETING ALTERATIONS

Almost every printing job except the most simple or routine has at least one alteration. Some have many. Understanding how alterations affect costs helps keep budgets under control.

An alteration, also known as a change order, is any adjustment you make after giving copy or artwork to a prepress service or printer. Changes could occur in copy, specifications or both.

Some of the most common alterations are:

- Page count, when your membership drive proved so successful that your directory needed another signature.
- Paper, when your printer couldn't get what you wanted or you decided to try some-

thing that cost less or performed better.

- Copy, when you discovered a typo in the president's name or that prices just changed.
- Ink color, when design decided that the red was too red or that brown would look better than green.
- Halftones or separations, when half the originals turned out too grainy to enlarge.
- Quantity, when your boss learned that registration was down for this year's trade show.

Most alterations take place during film preparation, not press or bindery work. Mistakes fixed after seeing a proof cost someone money. If your printer made the mistake, there should be no charge to you. If you made the error, you pay.

You can find something wrong with any printing job at any stage of production. The question is whether you want to change it—whether it really matters. Always ask what alterations will cost before deciding to make them. When computing the costs of changes, remember to figure time for you and your staff. All that running around keeps you from getting the current job done and the next one started.

10-4 SETTING QUANTITIES FOR QUOTATIONS

To decide what quantities to use as bases for printers' price quotes, follow these steps:

- 1. Make the best guess that you can using procedures within your own organization. Don't let anticipated printing costs influence this number.
- 2. Using the quantity that you determined in Step One as a starting point, compute two additional quantities, each between 5 percent and 10 percent higher.
- 3. Write the three numbers on your specifications.

Examples

• If you need 5,000 brochures, ask for

quotes on 5,000, 5,500 and 6,000.

- If you need 1,500 manuals, ask for quotes on 1,500, 1,600 and 1,700.
- If you need 40,000 envelopes, ask for quotes on 40,000, 42,000 and 44,000.

Reasons

- Inventory control begins with you, not your printer.
- Closely grouped quantities let your printers explore possible price breaks while keeping the job suited to the shop.
- Pricing different quantities establishes the value of overs and unders. Refer to Visual 10-5.

When making or authorizing changes, put everything in writing. If your photographs turned out beautifully and you decide that you want them printed as duotones instead of halftones, don't just casually mention it to your sales rep over lunch. Write it down.

The cost of alterations varies from almost free to very expensive, depending on the nature of the changes and at what stage they occur. Follow the rule of thumb that a change that costs \$5 to make in an electronic file will cost \$50 at the negative stage and \$500 on press.

Alterations are invoiced to you, as compared to errors by a prepress service or printer that are not billed. Depending on when you make it, a change in type or ink color may cost nothing. Changes in quantity or paper, however, may yield a 50 percent difference from the original quote for your job.

Unfortunately for both printers and customers, no one keeps track of alterations very well. Customers give hurried instructions verbally over the phone or in person. A sales rep or CSR jots a hasty note along with other hasty notes relating to other jobs. Notes go into a purse or pocket. By some miracle, most of the alterations get made correctly. But most isn't good enough if it doesn't include your corrections.

To control costs and ensure accuracy, make every change order—no matter how trivial—in writing. Even if you decide on a change while meeting with the printer, confirm it in writing. Fax, mail or hand it to your printer. And keep copies for comparison to the invoice after you receive the job.

NEGOTIATING PROBLEMS

Despite everyone's best efforts, a printer occasionally delivers a job that doesn't satisfy you. When that happens, you must express your unhappiness, listen to the printer's point of view, and arrive at a solution that works for each of you. In addition, you need to feel clear about the relationship you want with the print-

er after you have settled today's issue.

Before you pick up the phone or rush to the print shop, ask yourself how serious the problem really is. If it's a critical error, you can't accept the job. This situation is rare. If it's a major defect, you need to judge its impact. This happens once in a while. If it's a minor flaw, you may choose to ignore it. Every job contains at least one minor flaw.

You have a right to reject a job that doesn't match the specifications on which your contract was based. Only exercise that right when you discover a critical error. Rejecting a job goes very hard on your printer and probably hard on you, too. Printers work on small profit margins that you destroy when you refuse a job. From your standpoint, refusing a job means missing your deadline and perhaps losing a client.

Notify the printer at once. Don't delay. Even if you need a few days to determine the extent of the problem, let the printer know immediately that you don't feel satisfied. If possible, get the printer involved in inspecting the shipment to verify the situation.

When considering a problem with quality, you need to explain your viewpoints clearly. Use the quality features listed in Visual 7-9 to verify whether you got what you wanted and organize your presentation to your printer. Tell your printer exactly what you don't like. Explain how the problem affects your message.

Successful resolution requires getting the printer to agree that (1) a problem exists, and (2) reponsibility lies with the printer, not with

"I used to contract our jobs to eight different printers and expected them all to walk through fire for me. One day my supervisor asked me about our status in the eyes of our vendors. She wondered whether I would provide superior service to every minor customer. I consolidated our work from eight printers to two. Those two don't just walk through fire, they stand in it. And I spend lots less time chasing our jobs all over town."

10-5 REQUEST FOR QUOTATION

verview				
Organization name				
Address				
Contact person	Phone	Fax		
PO #	Date	Customer #		
Job name		Job #		
Date quote needed	Job to printer	Delivery needed		
□ new job □ exact reprint	reprint with changes Previ	ous job #		
Comments				
	\square electronic files supplied to			
Prepress service		Contact		
Phone	Fax	Job #		
Comments				
	2)3)			
Quality ☐ basic ☐ good Comments	□ premium □ showcase □ S	SWOP □ CCUP □ PGS □ SNAP		
Format Trim sizex_ Comments	Page count □ ble	eds (see mockup)		
Ink colors cover text insert	side one	side two		

Comments

Coatin	g 🗆 varnisł	\square UV \square aqueous \square s	spot 🗆 flood 🗆	□ dull □ gloss	☐ tint	
Comme	nts					
Other 1	orinting	die cut □ foil stamp □ ei	mboss/deboss	other		
Comme		1	,			
Paper —						
•	weight	brand	color	finish	grade	
cover						
text	-					
insert						
		<u> </u>		_		
		separately □ no □ yes	Suggest alter	nate stock(s)	no 🗆 yes	
Comme	nts					
		ing _ fold tox				
		core \square perforate \square drill				
□ plasti	c comb 🗆 s	spiral plastic spiral wire	☐ double loop v	wire □ paste □	saddle stitch	
☐ side s	titch 🗆 per	rfect □ burst perfect □ la	y flat □ case	binding side		
Comme	nts					
Paakina i	and daliva	ry ———				
_		ss				
		nd □ shrink wrap in bund				
☐ pallet	pack max	ximum pallet size/weight				
		ver				
Comme						

you. You can't negotiate a solution until you establish these two facts.

After you and your printer agree on the facts, you can move toward a resolution. Your printer will ask you how you want to handle the situation. The most common technique is to deduct 10 percent or 20 percent from the invoice for this job.

Negotiating requires that you know how strongly you feel. Arguing with your printer may save you some money and enhance your reputation as a sophisticated customer. Haggling also takes time and energy and may detract from an otherwise smooth business relationship. Make sure the rewards justify the effort.

In addition to actions that you want from your printer, you should have in mind your own future with this printer. You might choose one of these outcomes:

- Forget that you ever heard of this printer.
- Maintain a long-term relationship with this printer and protect quality and service of future jobs.
- Get the next job from this printer for bare bones costs.
- Stick with this printer, but ask for a different sales rep.

Some disputes turn on the question of who takes responsibility for settling the matter with the printer. If a graphic designer or broker coordinated the job and brokered the printing, that person is the printer's customer and should settle any problems. If the poor work took place at a bindery or other trade service

10-6 ANALYZING A JOB FOR PAYMENT

Regardless of how carefully you plan and monitor printing jobs, final bills are often higher than you expect. Before you authorize payment, check each aspect of the job carefully. Examine the invoice and compare it to specifications. Keep in mind the following points.

Completeness. Examine one piece closely to determine that it has the reverses, tints, photos and other features that the invoice says you should pay for.

Quality. Study several pieces taken from different boxes to verify that the job meets the correct standard of quality.

Paper. Verify that the printer used the paper specified in the contract.

Quantity. Confirm that you have the right amount. Compare delivery records with your invoice. Count the contents of a box or two.

Alterations. Make sure that charges for alterations cover only changes that you asked for or agreed to.

Extra charges. Evaluate extra charges to make sure you understand why they appear and agree that you should pay them.

Schedule. Note whether delivery was on time and, if not, whether the contract allows a penalty for late delivery.

Shipping. If charges seem out of line, ask for copies of postal receipts, manifests or bills of lading.

Taxes. If your invoice includes a sales or value added tax, verify that local laws hold you liable.

Arithmetic. Check that accountants correctly figured all totals and discounts.

Examine invoices for reruns especially carefully. Some printers think of reruns as cash cows and charge accordingly. Remember that your rerun required much less prepress than the first run. And keep in mind that paper prices fluctuate. Stock that cost the printer \$125 CWT last year might cost \$121 CWT this year.

10-7 TERMS AND CONDITIONS OF SALE

Contracts for printing jobs deal with many business issues in addition to specifications. Terms are usually printed on the back of the document and become part of the agreement when you sign the contract.

Many printers reproduce standard trade customs on their quotation forms or contracts, then label the trade customs as terms and conditions. Other printers modify the published customs to suit their business needs. Customers and vendors often negoti-

ate further changes relating to specific jobs.

When printing is bought using a purchase order form, the business terms on the purchase order may be different from those on a printer's contract. It may be unclear whether the buyer's terms or the printer's terms govern the contract.

The printer's terms prevail when they were part of the offer to supply the service and the buyer accepted them by signing the contract.

subcontracted by the printer, you deal with the printer, not the trade shop.

Responsibility and money go hand in hand. The person who presents you with the bill is the person to confront about problems.

CLARIFYING TRADE CUSTOMS

The prepress and printing industries have practices concerning issues such as credit, delivery and insurance. The practices, known as trade customs, are codified and published by industry organizations such as Printing Industries of America (PIA) and National Association of Printers and Lithographers (NAPL).

Trade customs are guidelines—starting points for discussion and for contract terms. They have only vague legal standing.

Printing trade customs deal with thirteen key issues in the relationship between customers and vendors.

Quotations. An offer to print a job at a certain price is good for a specific length of time, usually sixty days. Contracts are not, however, clear about whether the sixty days begin on the date of the quotation, the date that you sign your side of the contract, or the date on which you deliver the job.

Cancellations. If you cancel a job, your printer may ask for payment for materials

ordered or work performed for that job. Materials would include paper; work performed would include prepress.

Ownership. Your printer may claim ownership of materials prepared at your request. The issue of ownership relates to physical objects, such as mock-ups and film, and to rights to creative work such as designs.

Copyright Law gives the rights to designs and illustrations to artists who create them unless (1) the artists were regular employees (not freelancers or contract artists) or (2) the contract between artist and customer says that the customer owns rights because the work was "work for hire." This law applies to printers, too. In practice, however, a printer rarely claims ownership of creative work.

If you feel concerned about ownership, you can ensure that you own materials and rights by making your wishes clear before signing a contract. Strike out the ownership clauses on the printer's contract and insert the phrase "All work performed is work for hire."

Specifications. Printers base price estimates on your specifications. If your job doesn't match your specifications, your printer may compute a new price.

Prepress includes the materials and procedures most difficult to specify and so is most likely to result in new prices. To keep the orig-

"I don't want to write specifications and choose a new printer for every job. That's too much hassle. I just want to call the printer down the street and say 'You know what I want' or 'Do another thousand like last time.' They take care of design and just show me color photocopies for approval. I like to meet with my printer for coffee and don't want to worry whether I'm paying a little too much for dependable service."

inal quotation valid, your hard mechanicals, electronic files and art must be exactly as you described.

Alterations. When you change any aspect of original specifications at any stage in the job, your printer can compute a new price. Consult page 170 for a list of most common alterations.

Contracts usually state that printers explain in writing charges for alterations. You have a right to review documentation before paying the final invoice. To communicate clearly, make your change orders in writing.

Proofs. You are responsible if you don't order proofs, don't review them quickly, or don't put your approval or changes in writing. Furthermore, the printer can charge extra if you arrive late for a press check or make lastminute changes.

Color proofing causes the most headaches. Trade customs say that you must accept "a reasonable variation in color between proofs and the completed job" but don't define "reasonable variation."

Overruns and underruns. Contracts vary in the percent of overruns or underruns that constitute acceptable delivery, but 10 percent is common, and the invoice is adjusted accordingly. If you need "no less than" a certain quantity, make sure to include that require-

ment in your specifications.

Customer property. Your printer insures your property while in the shop, but the insurance has little relationship to the property's actual value or your lost business if it's destroyed. Always keep backups as your only true insurance. If you supply photos or original art of unusual value, deal with a printer or insurance company who will provide extra coverage.

Delivery. Your job is delivered when ownership passes from your printer to you. If the printer delivers to your address, you own the job when the truck unloads. If the printer ships via common carrier, you own the job when it leaves the shop.

Schedule. Printers stay on schedule when customers stay on schedule. If you fall behind, your printer might not deliver by the date on the contract.

Supplied materials. Materials, such as flats or paper, must conform to printer specifications. If you supply materials and they don't conform, you pay for changes or delays. Paying for changes includes charges for incorrect chokes or spreads or for other problems with electronic files.

Claims. You report defects, damages or shortages in writing within fifteen days of delivery. Failure to report within fifteen days means that you accept the job as meeting specifications.

Liability. Your printer won't pay more than the printed value for defective goods or missed deadlines and especially won't pay for lost profits. Furthermore, you can't hold your printer liable for printing your job that violates a copyright or trademark or that has libelous or obscene content.

This glossary includes all the technical and business terms used in this book. In addition, it has many terms not used in book but which are part of the graphic arts lexicon. Definitions are abbreviated from those in my book *Graphically Speaking*, which also includes terms about type, design and products not found in the following pages.

Δ

acid-free paper Paper made from pulp containing little or no acid so it resists deterioration from age. Also called alkaline paper, archival paper, neutral pH paper, permanent paper and thesis paper.

additive color Color produced by light falling onto a surface, as compared to subtractive color. The additive primary colors are red, green and blue.

A4 paper ISO paper size 210 x 297mm used for letterhead.

against the grain At right angles to the grain direction of the paper being used, as compared to with the grain. Also called across the grain and cross grain. See also *Grain direction*.

airbrush Pen-shaped tool that sprays a fine mist of ink or paint to retouch photos and create continuous-tone illustrations.

alteration Any change made by the customer after copy or artwork has been given to the service bureau, separator or printer. The change could be in copy, specifications, or both. Also called AA, author alteration and customer alteration.

anti-offset powder Fine powder lightly sprayed over the printed surface of coated paper as sheets leave a press. Also called dust, offset powder, powder and spray powder.

antique paper Roughest finish offered on offset paper.

aqueous coating Coating in a water base and applied like ink by a printing press to protect and enhance the printing underneath.

artwork All original copy, including type,

photos and illustrations, intended for printing. Also called art.

B

back up 1) To print on the second side of a sheet already printed on one side. 2) To adjust an image on one side of a sheet so that it aligns back-to-back with an image on the other side.

base art Copy pasted up on the mounting board of a mechanical, as compared to overlay art. Also called base mechanical.

base negative Negative made by photographing base art.

basic size The standard size of sheets of paper used to calculate basis weight in the United States and Canada.

basis weight In the United States and Canada, the weight, in pounds, of a ream (500 sheets) of paper cut to the basic size. Also called ream weight and substance weight (sub weight). In countries using ISO paper sizes, the weight, in grams, of one square meter of paper. Also called grammage and ream weight.

blank Category of paperboard ranging in thickness from 15 to 48 points.

blanket Rubber-coated pad, mounted on a cylinder of an offset press, that receives the inked image from the plate and transfers it to the surface to be printed.

bleed Printing that extends to the edge of a sheet or page after trimming.

blind image Image debossed, embossed or stamped, but not printed with ink or foil.

blocking Sticking together of printed sheets causing damage when the surfaces are separated.

blueline Prepress photographic proof made from stripped negatives where all colors show as blue images on white paper. Because 'blueline' is a generic term for proofs made from a variety of materials having identical purposes and similar appearances, it may also be called a blackprint, blue, blueprint, brownline, brownprint, diazo, dyeline, ozalid, position proof, silverprint, Dylux, and VanDyke.

board paper General term for paper over 110# index, 80# cover, or 200 gsm that is commonly used for products such as file folders, displays, and post cards. Also called paperboard.

bond paper Category of paper commonly used for writing, printing and photocopying. Also called business paper, communication paper, correspondence paper and writing paper.

book block Folded signatures gathered, sewn and trimmed, but not yet covered.

book paper Category of paper suitable for books, magazines, catalogs, advertising and general printing needs. Book paper is divided into uncoated paper (also called offset paper), coated paper (also called art paper, enamel paper, gloss paper and slick paper) and text paper.

bristol paper General term referring to paper 6 points or thicker with basis weight between 90# and 200# (200-500 gsm). Used for products such as index cards, file folders and displays.

broken carton Carton of paper from which some of the sheets have been sold. Also called less carton.

build a color To overlap two or more screen tints to create a new color. Such an overlap is called a build, color build, stacked screen build or tint build.

bulk Thickness of paper relative to its basis weight.

burst perfect bind To bind by forcing glue into notches along the spines of gathered signatures before affixing a paper cover. Also called burst bind, notch bind and slotted bind.

butt register Register where ink colors meet precisely without overlapping or allowing space between, as compared to lap register. Also called butt fit and kiss register.

buy out To subcontract for a service that is closely related to the business of the organization. Also called farm out. Work that is bought out or farmed out is sometimes called outwork or referred to as being out of house.

C

C1S and C2S Abbreviations for coated one side and coated two sides.

calender To make the surface of paper smooth by pressing it between rollers during manufacture.

caliper 1) Thickness of paper or other substrate expressed in thousandths of an inch (mils or points), pages per inch (ppi), thousandths of a millimeter (microns) or pages per centimeter (ppc). 2) Device on a sheetfed press that detects double sheets or on a binding machine that detects missing signatures or inserts.

camera-ready copy Mechanicals, photographs and art fully prepared for reproduction according to the technical requirements of the printing process being used. Also called finished art and reproduction copy.

camera service Business using a process camera to make photostats, halftones, plates and other elements for printing. Also called prep service and trade camera service.

carbonless paper Paper coated with chemicals that enable transfer of images from one sheet to another with pressure from writing or typing.

carload Selling unit of paper that may weigh anywhere from 20,000 to 100,000 pounds (9,090 to 45,454 kilos), depending on which mill or merchant uses the term. Abbreviated CL.

carton Selling unit of paper weighing approximately 150 pounds (60 kilos). A carton can contain anywhere from 500 to 5,000 sheets, depending on the size of sheets and their basis weight.

case Covers and spine that, as a unit, enclose the pages of a casebound book.

case bind To bind using glue to hold signatures to a case made of binder board covered with fabric, plastic or leather. Also called cloth bind, edition bind, hard bind and hard cover.

cast-coated paper High gloss, coated paper made by pressing the paper against a polished, hot, metal drum while the coating is still wet.

catalog paper Coated paper rated #4 or #5 with basis weight from 35# to 50# (50 to 75 gsm) commonly used for catalogs and magazines.

chain dot 1) Alternate term for elliptical dot, so called because midtone dots touch at two points, so look like links in a chain. 2) Generic

term for any midtone dots whose corners touch.

chain lines 1) Widely spaced lines in laid paper. 2) Blemishes on printed images caused by tracking.

chalking Deterioration of a printed image caused by ink that absorbs into paper too fast or has long exposure to sun and wind making printed images look dusty. Also called crocking.

check copy 1) Production copy of a publication verified by the customer as printed, finished and bound correctly. 2) One set of gathered book signatures approved by the customer as ready for binding.

choke Technique of slightly reducing the size of an image to create a hairline trap or to outline. Also called shrink and skinny.

chroma Strength of a color as compared to how close it seems to neutral gray. Also called depth, intensity, purity and saturation.

CMYK Abbreviation for cyan, magenta, yellow, and key (black), the four process colors.

coarse screen Halftone screen with ruling of 65, 85 or 100 lines per inch (26, 34 or 40 lines per centimeter).

coated paper Paper with a coating of clay and other substances that improves reflectivity and ink holdout. Mills produce coated paper in the four major catagories cast, gloss, dull and matte.

color balance Refers to amounts of process colors that simulate the colors of the original scene or photograph.

color blanks Press sheets printed with photos or illustrations, but without type. Also called shells.

color break In multicolor printing, the point, line or space at which one ink color stops and another begins. Also called break for color.

color cast Unwanted color affecting an entire image or portion of an image.

color control bar Strip of small blocks of color on a proof or press sheet to help evaluate features such as density and dot gain. Also called color bar, color guide and standard offset color bar.

color correct To adjust the relationship

among the process colors to achieve desirable colors.

color curves Instructions in computer software that allow users to change or correct colors. Also called HLS and HVS tables.

color electronic prepress system Computer, scanner, printer, and other hardware and software designed for image assembly, color correction, retouching and output onto proofing materials, film or printing plates. Abbreviated CEPS.

color gamut The entire range of hues possible to reproduce using a specific device, such as a computer screen, or system, such as four-color process printing.

Color Key Brand name for an overlay color proof. Sometimes used as a generic term for any overlay color proof.

color model Way of categorizing and describing the infinite array of colors found in nature.

color separation 1) Technique of using a camera, scanner or computer to divide continuous-tone color images into four halftone negatives. 2) The product resulting from color separating and subsequent four-color process printing. Also called separation.

color sequence Order in which inks are printed. Also called laydown sequence and rotation.

color shift Change in image color resulting from changes in register, ink densities or dot gain during four-color process printing.

comb bind To bind by inserting the teeth of a flexible plastic comb through holes punched along the edge of a stack of paper. Also called plastic bind and GBC bind (a brand name).

commercial printer Printer producing a wide range of products such as announcements, brochures, posters, booklets, stationery, business forms, books and magazines. Also called job printer because each job is different.

complementary flat(s) The second or additional flat(s) used when making composite film or for two or more burns on one printing plate.

composite art Mechanical on which copy for reproduction in all colors appears on only one surface, not separated onto overlays. Composite art has a tissue overlay with instructions that

indicate color breaks.

composite film Film made by combining images from two or more pieces of working film onto one film for making one plate.

composite proof Proof of color separations in position with graphics and type. Also called final proof, imposition proof and stripping proof.

composition 1) In typography, the assembly of typographic elements, such as words and paragraphs, into pages ready for printing. 2) In graphic design, the arrangement of type, graphics and other elements on the page.

comprehensive dummy Simulation of a printed piece complete with type, graphics and colors. Also called color comprehensive and comp.

condition To keep paper in the pressroom for a few hours or days before printing so that its moisture level and temperature equal that in the pressroom. Also called cure, mature and season.

contact platemaker Device with lights, timing mechanism and vacuum frame used to make contact prints, duplicate film, proofs and plates. Also called platemaker and vacuum frame.

continuous-tone copy All photographs and those illustrations having a range of shades not made up of dots, as compared to line copy or halftones. Abbreviated contone.

converter Business that makes products such as boxes, bags, envelopes and displays.

copyboard Surface or frame on a process camera that holds copy in position to be photographed.

cover Thick paper that protects a publication and advertises its title. Parts of covers are often described as follows: Cover 1 = outside front; Cover 2 = inside front; Cover 3 = inside back; Cover 4 = outside back.

coverage Extent to which ink covers the surface of a substrate. Ink coverage is usually expressed as light, medium or heavy.

cover paper Category of thick paper used for products such as posters, menus, folders and covers of paperback books.

crash Coarse cloth embedded in the glue along the spine of a book to increase strength of binding. Also called gauze, mull and scrim.

creep Phenomenon of middle pages of a folded signature extending slightly beyond outside pages. Also called feathering, outpush, push out and thrust. See also *Shingling*.

crop marks Lines near the edges of an image indicating portions to be reproduced. Also called cut marks and tic marks.

crossover Type or art that continues from one page of a book or magazine across the gutter to the opposite page. Also called bridge, gutter bleed and gutter jump.

cure To dry inks, varnishes or other coatings after printing to ensure good adhesion and prevent setoff.

customer service representative Employ-ee of a printer, service bureau, separator or other business who coordinators projects and keeps customers informed. Abbreviated CSR.

cutoff Circumference of the impression cylinder of a web press, therefore also the length of the printed sheet that the press cuts from the roll of paper.

cut sizes Paper sizes used with office machines and small presses.

CWT Abbreviation for hundredweight using the Roman numeral C=100.

cyan One of the four process colors. Also known as process blue.

D

data compression Technique of reducing the amount of storage required to hold a digital file to reduce the disk space the file requires and allow it to be processed or transmitted more quickly.

deboss To press an image into paper so it lies below the surface. Also called tool.

deckle edge Edge of paper left ragged as it comes from the papermaking machine instead of being cleanly cut. Also called feather edge.

densitometer Instrument used to measure density. Reflection densitometers measure light reflected from paper and other surfaces; transmission densitometers measure light transmitted through film and other materials.

density 1) Regarding ink, the relative thick-

ness of a layer of printed ink. 2) Regarding color, the relative ability of a color to absorb light reflected from it or block light passing through it. 3) Regarding paper, the relative tightness or looseness of fibers.

density range Difference between the darkest and lightest areas of copy. Also called contrast ratio, copy range and tonal range.

desktop publishing Technique of using a personal computer to design images and pages, and assemble type and graphics, then using a laser printer or imagesetter to output the assembled pages onto paper, film or printing plate. Abbreviated DTP.

device independent colors Hues identified by wavelength or by their place in sytems such as developed by CIE. 'Device independent' means a color can be described and specified without regard to whether it is reproduced using ink, projected light, photographic chemistry or any other method.

die Device for cutting, scoring, stamping, embossing and debossing.

die cut To cut irregular shapes in paper or paperboard using a die.

diffusion transfer Chemical process of reproducing line copy and making halftone positives ready for pasteup.

digital dot Dot created by a computer and printed out by a laser printer or imagesetter. Digital dots are uniform in size, as compared to halftone dots that vary in size.

direct digital color proof Color proof made by a laser, ink jet printer or other computer-controlled device without needing to make separation films first. Abbreviated DDCP.

dot gain Phenomenon of halftone dots printing larger on paper than they are on films or plates, reducing detail and lowering contrast. Also called dot growth, dot spread and press gain.

dot size Relative size of halftone dots as compared to dots of the screen ruling being used. There is no unit of measurement to express dot size. Dots are too large, too small, or correct only in comparison to what the viewer finds attractive.

dots-per-inch Measure of resolution of input

devices such as scanners, display devices such as monitors, and output devices such as laser printers, imagesetters and monitors. Abbreviated dpi. Also called dot pitch.

double black duotone Duotone printed from two halftones, one shot for highlights and the other shot for midtones and shadows.

double bump To print a single image twice so it has two layers of ink.

double burn To expose film or a plate twice to different negatives and thus create a composite image.

double dot halftone Halftone double burned onto one plate from two halftones, one shot for shadows, the second shot for midtones and highlights.

doubling Printing defect appearing as blurring or shadowing of the image. Doubling may be caused by problems with paper, cylinder alignment, blanket pressures or dirty cylinders.

drawdown Sample of inks specified for a job applied to the substrate specified for a job. Also called pulldown.

drop out Halftone dots or fine lines eliminated from highlights by overexposure during camera work.

dropout halftone Halftone in which contrast has been increased by eliminating dots from highlights.

dry back Phenomenon of printed ink colors becoming less dense as the ink dries.

dry trap To print over dry ink, as compared to wet trap.

dual-purpose bond paper Bond paper suitable for printing by either lithography (offset) or xerography (photocopy). Abbreviated DP bond paper.

dull finish Flat (not glossy) finish on coated paper; slightly smoother than matte. Also called suede finish, velour finish and velvet finish.

dummy Simulation of the final product. Also called mockup.

duotone Black-and-white photograph reproduced using two halftone negatives, each shot to emphasize different tonal values in the original.

duplex paper Thick paper made by pasting

together two thinner sheets, usually of different colors. Also called double-faced paper and twotone paper.

duplicator Offset press made for quick printing.

Dylux Brand name for photographic paper used to make blueline proofs. Often used as alternate term for blueline.

E

electronic front end General term referring to a prepress system based on computers.

electronic image assembly Assembly of a composite image from portions of other images and/or other page elements using a computer.

electronic mechanical Mechanical existing exclusively in electronic files.

electronic publishing 1) Publishing by printing with a device, such as a photocopy machine or ink jet printer, driven by a computer that can change the image instantly from one copy to the next. 2) Publishing via output on fax, computer bulletin board or other electronic medium, as compared to output on paper.

emboss To press an image into paper so it lies above the surface. Also called cameo and tool.

emulsion Coating of light-sensitive chemicals on papers, films, printing plates and stencils.

emulsion down/emulsion up Film whose emulsion side faces down (away from the viewer) or up (toward the viewer) when ready to make a plate or stencil. Abbreviated ED/EU. Also called E up/down and face down/face up.

encapsulated PostScript file Computer file containing both images and PostScript commands. Abbreviated EPS file.

end sheet Sheet that attaches the inside pages of a case bound book to its cover. Also called pastedown.

English finish Smooth finish on uncoated book paper; smoother than eggshell, rougher than smooth.

engraving Printing method using a plate, also called a die, with an image cut into its surface.

ep Abbreviation for envelope.

equivalent paper Paper that is not the brand specified, but looks, prints and may cost the same. Also called comparable stock.

estimate Price that states what a job will probably cost. Also called bid, quotation and tender

etch To use chemicals to carve an image into metal, glass or film.

F

face Edge of a bound publication opposite the spine. Also called foredge.

fake duotone Halftone in one ink color printed over screen tint of a second ink color. Also called dummy duotone, duograph, duplex halftone, false duotone, flat tint halftone and halftone with screen.

fast color inks Inks with colors that retain their density and resist fading as the product is used and washed.

feeding unit Component of a printing press that moves paper into the register unit.

felt finish Soft woven pattern in text paper.

felt side Side of the paper that was not in contact with the Fourdrinier wire during papermaking, as compared to wire side.

fifth color Ink color used in addition to the four needed by four-color process.

film guage Thickness of film. The most common gauge for graphic arts film is 0.004 inch (0.1 mm).

film laminate Thin sheet of plastic bonded to a printed product for protection or increased gloss.

fine papers Papers made specifically for writing or commercial printing, as compared to coarse papers and industrial papers. Also called cultural papers and graphic papers.

fine screen Screen with ruling of 150 lines per inch (80 lines per centimeter) or more.

finish 1) Surface characteristics of paper. 2) General term for trimming, folding, binding, and all other post press operations.

finished size Size of product after production is complete, as compared to flat size. Also

called trim size.

fit Refers to ability of film to be registered during stripping and assembly. Good fit means that all images register to other film for the same job.

fixed costs Costs that remain the same regardless of how many pieces are printed. Copywriting, photography and design are fixed costs.

flat color 1) Any color created by printing only one ink, as compared to a color created by printing four-color process. Also called block color and spot color. 2) Color that seems weak or lifeless.

flat plan Diagram of the flats for a publication showing imposition and indicating colors.

flat size Size of product after printing and trimming, but before folding, as compared to finished size.

flexography Method of printing on a web press using rubber or soft plastic plates with raised images. Also called aniline printing because flexographic inks originally used aniline dyes. Abbreviated flexo.

flood To print a sheet completely with an ink or varnish. Flooding with ink is also called painting the sheet.

flush cover Cover trimmed to the same size as inside pages, as compared to overhang cover. Also called cut flush.

flyleaf Leaf at the front and back of a casebound book that is the one side of the end paper not glued to the case.

foil emboss To foil stamp and emboss an image. Also called heat stamp.

foil stamp Method of printing that releases foil from its backing when stamped with the heated die. Also called block print, hot foil stamp and stamp.

foldout Gatefold sheet bound into a publication, often used for a map or chart. Also called gatefold and pullout.

form Each side of a signature. Also spelled forme.

format Size, style, shape, layout or organization of a layout or printed product.

form bond Lightweight bond, easy to perforate, made for business forms. Also called register bond.

form roller(s) Roller(s) that come in contact with the printing plate, bringing it ink or water.

for position only Refers to inexpensive copies of photos or art used on mechanicals to indicate placement and scaling, but not intended for reproduction. Abbreviated FPO.

fountain Trough or container, on a printing press, that holds fluids such as ink, varnish or water. Also called duct.

fountain solution Mixture of water and chemicals that dampens a printing plate to prevent ink from adhering to the nonimage area. Also called dampener solution.

four-color process printing Technique of printing that uses black, magenta, cyan and yellow to simulate full-color images. Also called color process printing, full color printing and process printing.

free sheet Paper made from cooked wood fibers mixed with chemicals and washed free of impurities, as compared to groundwood paper. Also called woodfree paper.

full-range halftone Halftone ranging from 0 percent coverage in its highlights to 100 percent coverage in its shadows.

full-scale black Black separation made to have dots throughout the entire tonal range of the image, as compared to half-scale black and skeleton black. Also called full-range black.

G

galley proof Proof of type from any source, whether metal type or photo type. Also called checker and slip proof.

gang 1) To halftone or separate more than one image in only one exposure. 2) To reproduce two or more different printed products simultaneously on one sheet of paper during one press run. Also called combination run.

gathered Signatures assembled next to each other in the proper sequence for binding, as compared to nested. Also called stacked.

ghost halftone Normal halftone whose densi-

ty has been reduced to produce a very faint image.

ghosting 1) Phenomenon of a faint image appearing on a printed sheet where it was not intended to appear. Chemical ghosting refers to the transfer of the faint image from the front of one sheet to the back of another sheet. Mechanical ghosting refers to the faint image appearing as a repeat of an image on the same side of the sheet. 2) Phenomenon of printed image appearing too light because of ink starvation.

grade General term used to distinguish between or among printing papers, but whose specific meaning depends on context. Grade can refer to the category, class, rating, finish or brand of paper.

graduated screen tint Screen tint that changes densities gradually and smoothly, not in distinct steps. Also called dégradé, gradient, ramped screen and vignette.

grain direction Predominant direction in which fibers in paper become aligned during manufacturing. Also called machine direction.

grain long paper Paper whose fibers run parallel to the long dimension of the sheet. Also called long grain paper and narrow web paper.

grain short paper Paper whose fibers run parallel to the short dimension of the sheet. Also called short grain paper and wide web paper.

grammage Basis weight of paper in grams per square meter (gsm).

graphic arts The crafts, industries and professions related to designing and printing on paper and other substrates.

graphic arts film Film whose emulsion yields high contrast images suitable for reproduction by a printing press, as compared to continuous-tone film. Also called litho film and reprofilm.

graphic design Arrangement of type and visual elements along with specifications for paper, ink colors and printing processes that, when combined, convey a visual message.

graphics Visual elements that supplement type to make printed messages more clear or

interesting.

gravure Method of printing using metal cylinders etched with millions of tiny wells that hold ink

gray balance Printed cyan, magenta and yellow halftone dots that accurately reproduce a neutral gray image.

gray component replacement Technique of replacing gray tones in the yellow, cyan and magenta films, made while color separating, with black ink. Abbreviated GCR. Also called achromatic color removal.

gray levels Number of distinct gray tones that can be reproduced by a computer.

gray scale Strip of gray values ranging from white to black. Used by process camera and scanner operators to calibrate exposure times for film and plates. Also called step wedge.

grind edge Alternate term for binding edge when referring to perfect bound products.

grindoff Approximately 1/8 inch (3 mm) along the spine that is ground off gathered signatures before perfect binding.

gripper edge Edge of a sheet held by grippers on a sheetfed press, thus going first through the press. Also called feeding edge and leading edge.

groundwood paper Newsprint and other inexpensive paper made from pulp created when wood chips are ground mechanically rather than refined chemically.

н

hairline Subjective term referring to very small space, thin line or close register. The meaning depends on who is using the term and in what circumstances.

half-scale black Black separation made to have dots only in the shadows and midtones, as compared to full-scale black and skeleton black.

halftone 1) To photograph or scan a continuous-tone image to convert the image into halftone dots. 2) A photograph or continuous-tone illustration that has been halftoned and appears on film, paper, printing plate or the final printed product.

halftone screen Piece of film or glass containing a grid of lines that breaks light into dots. Also called contact screen and screen.

halo effect Faint shadow sometimes surrounding halftone dots when printed. Also called halation. The halo itself is also called a fringe.

hard dots Halftone dots with no halos or soft edges, as compared to soft dots.

hard mechanical Mechanical consisting of paper and/or acetate and made using pasteup techniques, as compared to electronic mechanical.

head-to-tail Imposition with heads (tops) of pages facing tails (bottoms) of other pages.

heat-set web Web press equipped with an oven to dry ink, thus able to print coated paper.

hickey Spot or imperfection in printing, most visible in areas of heavy ink coverage, caused by dirt on the plate or blanket. Also called bull's eye and fish eye.

high-fidelity color Color reproduced using six, eight or twelve separations, as compared to four-color process.

high-key photo Photo whose most important details appear in the highlights.

highlights Lightest portions of a photograph or halftone, as compared to midtones and shadows.

hinged cover Perfect bound cover scored ½ inch (3mm) from the spine so it folds at the hinge instead of along the edge of the spine.

HLS Abbreviation for hue, lightness, saturation, one of the color-control options often found in software for design and page assembly. Also called HVS.

hot spot Printing defect caused when a piece of dirt or an air bubble caused incomplete drawdown during contact platemaking, leaving an area of weak ink coverage or visible dot gain.

house sheet Paper kept in stock by a printer and suitable for a wide variety of printing jobs. Also called floor sheet.

hue A specific color such as yellow or green.

imagesetter Laser output device using photosensitive paper or film.

ı

imposition Arrangement of pages on mechanicals or flats so they will appear in proper sequence after press sheets are folded and bound.

impression 1) Referring to an ink color, one impression equals one press sheet passing once through a printing unit. 2) Referring to the speed of a press, one impression equals one press sheet passing once through the press.

impression cylinder Cylinder, on a press, that pushes paper against the plate or blanket, thus forming the image. Also called impression roller.

imprint To print new copy on a previously printed sheet, such as imprinting an employee's name on business cards. Also called surprint.

ink balance Relationship of the densities and dot gains of process inks to each other and to a standard density of neutral gray.

ink fountain Reservoir, on a printing press, that holds ink.

ink holdout Characteristic of paper that prevents it from absorbing ink, thus allowing ink to dry on the surface of the paper. Also called holdout.

ink jet printing Method of printing by spraying droplets of ink through computer-controlled nozzles. Also called jet printing.

inner form Form (side of the press sheet) whose images all appear inside the folded signature, as compared to outer form.

in-plant printer Department of an agency, business, or association that does printing for a parent organization. Also called captive printer and in-house printer.

intaglio printing Printing method whose image carriers are surfaces with two levels, having inked areas lower than noninked areas. Gravure and engraving are the most common forms of intaglio. Also called recess printing.

integral proof Color proof of separations shown on one piece of proofing paper, as compared to an overlay proof. Also called composition proof, laminate proof, plastic proof and single-sheet proof.

job lot paper Paper that didn't meet specifications when produced, has been discontinued, or for other reasons is no longer considered first quality.

job ticket Form used by service bureaus, separators and printers to specify the production schedule of a job and the materials it needs. Also called docket, production order and work order.

K

K Abbreviation for black in four-color process printing. Hence the 'K' in CMYK.

key 1) The screw that controls ink flow from the ink fountain of a printing press. 2) To relate loose pieces of copy to their positions on a layout or mechanical using a system of numbers or letters. 3) Alternate term for the color black, as in 'key plate.'

keylines Lines on a mechanical or negative showing the exact size, shape and location of photographs or other graphic elements. Also called holding lines.

key negative or plate Negative or plate that prints the most detail, thus whose image guides the register of images from other plates. Also called key printer.

kiss die cut To die cut the top layer, but not the backing layer, of self-adhesive paper. Also called face cut.

kiss impression Lightest possible impression that will transfer ink to a substrate.

kraft paper Strong paper used for wrapping and to make grocery bags and large envelopes.

laid finish Finish on bond or text paper on which grids of parallel lines simulate the surface of handmade paper. Laid lines are close together and run against the grain; chain lines are farther apart and run with the grain.

lap register Register where ink colors overlap slightly, as compared to butt register.

laser bond Bond paper made especially smooth and dry to run well through laser printers.

laser-imprintable ink Ink that will not fade

or blister as the paper on which it is printed is used in a laser printer.

lay flat bind Method of perfect binding that allows a publication to lie fully open.

leading Amount of space between lines of type.

leaf One sheet of paper in a publication. Each side of a leaf is one page.

ledger paper Strong, smooth bond paper used for keeping business records. Also called record paper.

letter fold Two folds creating three panels that allow a sheet of letterhead to fit a business envelope. Also called barrel fold and wrap around fold.

letter paper In North America, 8½" x 11" sheets. In Europe, A4 sheets.

letterpress Method of printing from raised surfaces, either metal type or plates whose surfaces have been etched away from image areas. Also called block printing.

lightweight paper Book paper with basis weight less than 40# (60 gsm).

lignin Substance in trees that holds cellulose fibers together. Free sheet has most lignin removed; groundwood paper contains lignin.

line copy Any high-contrast image, including type, as compared to continuous-tone copy. Also called line art and line work.

line negative Negative made from line copy.linen finish Embossed finish on text paper that simulates the pattern of linen cloth.

lithography Method of printing using plates whose image areas attract ink and whose nonimage areas repel ink. Nonimage areas may be coated with water to repel the oily ink or may have a surface, such as silicon, that repels ink.

live area Area on a mechanical within which images will print. Also called safe area.

loose proof Proof of a halftone or color separation that is not assembled with other elements from a page, as compared to composite proof. Also called first proof, random proof, scatter proof and show-color proof.

loupe Lens built into a small stand. Used to inspect copy, film, proofs, plates and printing.

Also called glass and linen tester.

low key photo Photo whose most important details appear in the shadows.

M

magenta One of the four process colors.

makeready 1) All activities required to prepare a press or other machine to function for a specific printing or bindery job, as compared to production run. Also called setup. 2) Paper used in the makeready process at any stage in production. Makeready paper is part of waste or spoilage.

making order Order for paper that a mill makes to the customer's specifications, as compared to a mill order or stock order.

male die Die that applies pressure during embossing or debossing. Also called force card.

mask To prevent light from reaching part of an image, therefore isolating the remaining part. Also called knock out.

master Paper or plastic plate used on a duplicator press.

matte finish Flat (not glossy) finish on photographic paper or coated printing paper.

mechanical Camera-ready assembly of type, graphics and other copy complete with instructions to the printer. A hard mechanical consists of paper and/or acetate, is made using pasteup techniques, and may also be called an artboard, board or pasteup. A soft mechanical, also called an electronic mechanical, exists as a file of type and other images assembled using a computer.

mechanical bind To bind using a comb, coil, ring binder, post, or any other technique not requiring gluing, sewing or stitching.

mechanical separation Color breaks made on the mechanical using a separate overlay for each color to be printed.

metallic ink Ink containing powdered metal or pigments that simulate metal.

metallic paper Paper coated with a thin film of plastic or pigment whose color and gloss simulate metal.

midtones In a photograph or illustration, tones created by dots between 30 percent and 70

percent of coverage, as compared to highlights and shadows.

mil 1/1000 inch. The thickness of plastic films as printing substrates is expressed in mils.

misting Phenomenon of droplets of ink being thrown off the roller train. Also called flying ink.

moire Undesirable pattern resulting when halftones and screen tints are made with improperly aligned screens, or when a pattern in a photo, such as a plaid, interferes with a halftone dot pattern.

monarch Paper size (7" x 10") and envelope shape often used for personal stationery.

mottle Spotty, uneven ink absorption. Also called sinkage. A mottled image may be called mealy.

multicolor printing Printing in more than one ink color (but not four-color process). Also called polychrome printing.

M weight Weight of 1,000 sheets of paper in any specific size.

N

natural color Very light brown color of paper. May also be called antique, cream, ivory, off-white or mellow white.

nested Signatures assembed inside one another in the proper sequence for binding, as compared to gathered. Also called inset.

neutral gray Gray with no hue or cast.

Newton ring Flaw in a photograph or halftone that looks like a drop of oil on water.

nonheatset web Web press without a drying oven, thus not able to print on coated paper. Also called cold-set web and open web.

nonimpact printing Printing using lasers, ions, ink jets or heat to transfer images to paper. Abbreviated NIP.

nonreproducing blue Light blue that does not record on graphic arts film, therefore may be used to preprint layout grids and write instructions on mechanicals. Also called blue pencil, drop-out blue, fade-out blue and nonrepro blue.

novelty printing Printing on products such as coasters, pencils, balloons, golf balls and ash-

trays, known as advertising specialties or premiums.

0

offset printing Printing technique that transfers ink from a plate to a blanket to paper instead of directly from a plate to paper.

opacity 1) Characteristic of paper or other substrate that prevents printing on one side from showing through to the other. 2) Characteristic of ink that prevents the substrate from showing through.

opaque 1) Not transparent. 2) To cover flaws in negatives with tape or opaquing paint. Also called block out and spot.

open prepress interface Hardware and software that link desktop publishing systems with color electronic prepress systems.

outer form Form (side of a press sheet) containing images for the first and last pages of the folded signature—its outside pages—as compared to inner form.

outline halftone Halftone in which background has been removed or replaced to isolate or silhouette the main image. Also called knockout halftone and silhouette halftone.

overlay Layer of material taped to a mechanical, photo, or proof. Acetate overlays are used to separate colors by having some type or art on them instead of on the mounting board. Tissue overlays are used to carry instructions about the underlying copy and to protect the base art.

overlay proof Color proof consisting of polyesther sheets laid on top of each other with their images in register, as compared to integral proof. Each sheet represents the image to be printed in one color. Also called celluloid proof and layered proof.

overprint To print one image over a previously printed image, such as printing type over a screen tint. Also called surprint.

P

page One side of a leaf in a publication.page count Total number of pages that a

publication has. Also called extent.

page proof Proof of type and graphics as they will look on the finished page complete with elements such as headings, rules, and folios.

painted sheet Sheet printed with ink edge to edge, as compared to spot color. The 'painted sheet' refers to the final product, not the press sheet, and means that 100 percent coverage results from bleeds off all four sides.

panel One page of a brochure, such as one panel of a rack brochure. One panel is on one side of the paper. A letter-folded sheet has six panels, not three.

parent sheet Any sheet larger than 11" x 17" or A3.

pasteboard Chipboard with another paper pasted to it.

pasteup To paste copy to mounting boards and, if necessary, to overlays so it is assembled into a camera-ready mechanical. The mechanical produced is often called a pasteup.

PE Proofreader mark meaning printer error and showing a mistake by a typesetter, prepress service or printer as compared to an error by the customer.

perfect bind To bind sheets that have been ground at the spine and are held to the cover by glue. Also called adhesive bind, cut-back bind, glue bind, paper bind, patent bind, perfecting bind, soft bind and soft cover. See also Burst perfect bind.

perfecting press Press capable of printing both sides of the paper during a single pass. Also called duplex press and perfector.

photoengraving Engraving done using photochemistry.

Photomechanical transfer Brand name for a diffusion transfer process used to make positive paper prints of line copy and halftones. Often used as alternate term for Photostat. Abbreviated PMT.

Photostat Brand name for a diffusion transfer process used to make positive paper prints of line copy and halftones. Often used as alternate term for PMT.

picking Phenomenon of ink pulling bits of

coating or fiber away from the surface of paper as it travels through the press, thus leaving unprinted spots in the image area.

pickup art Artwork, used in a previous job, to be incorporated in a current job.

pin register Technique of registering separations, flats, and printing plates by using small holes, all of equal diameter, at the edges of both flats and plates.

pixel Short for picture element, a dot made by a computer, scanner or other digital device. Also called pel.

planographic printing Printing method whose image carriers are level surfaces with inked areas separated from noninked areas by chemical means. Planographic printing includes lithography, offset lithography and spirit duplicating.

plate Piece of paper, metal, plastic or rubber carrying an image to be reproduced using a printing press.

platemaker 1) In quick printing, a process camera that makes plates automatically from mechanicals. 2) In commercial lithography, a machine with a vacuum frame used to expose plates through film.

plate-ready film Stripped negatives or positives fully prepared for platemaking.

pleasing color Color that the customer considers satisfactory even though it may not precisely match original samples, scenes or objects.

PMS Obsolete reference to Pantone Matching System. The correct trade name of the colors in the Pantone Matching System is Pantone Colors, not PMS Colors.

PMT Abbreviation for Photomechanical transfer.

point 1) Regarding paper, a unit of thickness equaling ½1000 inch. 2) Regarding type, a unit of measure equaling ½12 pica and .013875 inch (.351mm).

position stat Photocopy or PMT of a photo or illustration made to size and affixed to a mechanical.

positive film Film that prevents light from passing through images, as compared to negative

film that allows light to pass through. Also called knockout film.

post bind To bind using a screw and post inserted through a hole in a pile of loose sheets.

prepress Camera work, color separating, stripping, platemaking and other prepress functions performed by the printer, separator or a service bureau prior to printing. Also called preparation.

prepress proof Any color proof made using ink jet, toner, dyes or overlays, as compared to a press proof printed using ink. Also called dry proof and off-press proof.

preprint To print portions of sheets that will be used for later imprinting.

press check Event at which makeready sheets from the press are examined before authorizing full production to begin.

press proof Proof made on press using the plates, ink, and paper specified for the job. Also called strike off and trial proof.

press time 1) Amount of time that one printing job spends on press, including time required for makeready. 2) Time of day at which a printing job goes on press.

price break Quantity at which unit cost of paper or printing drops.

printer spreads Mechanicals made so they are imposed for printing, as compared to reader spreads.

printing Any process that transfers to paper or another substrate an image from an original such as a film negative or positive, electronic memory, stencil, die or plate.

printing plate Surface carrying an image to be printed. Quick printing uses paper or plastic plates; letterpress, engraving, and commercial lithography use metal plates; flexography uses rubber or soft plastic plates. Gravure printing uses a cylinder. The screen in screen printing is also called a plate.

printing unit Assembly of fountain, rollers, and cylinders that will print one ink color. Also called color station, deck, ink station, printer, station, and tower.

process camera Camera used to photograph

mechanicals and other camera-ready copy. Also called copy camera and graphic arts camera. A small, simple process camera may be called a stat camera.

process colors The colors used for four-color process printing: yellow, magenta, cyan and black.

production run Press run intended to manufacture products as specified, as compared to makeready.

proof Test sheet made to reveal errors or flaws, predict results on press, and record how a printing job is intended to appear when finished.

proofreader marks Standard symbols and abbreviations used to mark up manuscripts and proofs. Also called correction marks.

proportion scale Round device used to calculate percent that an original image must be reduced or enlarged to yield a specific reproduction size. Also called percentage wheel, proportion dial, proportion wheel and scaling wheel.

publishing paper Paper made in weights, colors, and surfaces suited to books, magazines, catalogs and free-standing inserts.

Q

quality Subjective term relating to expectations by the customer, printer and other professionals associated with a printing job, and whether the job meets those expectations.

quarto 1) Sheet folded twice, making pages one-fourth the size of the original sheet. A quarto makes an 8-page signature. 2) Book made from quarto sheets, traditionally measuring about 9" x 12 ".

quick printing Printing using small sheetfed presses, called duplicators, using cut sizes of bond and offset paper.

quotation Price offered by a printer to produce a specific job.

R

rainbow fountain Technique of putting ink colors next to each other in the same ink fountain and oscillating the ink rollers to make the colors merge where they touch, producing a rain-

bow effect.

raster image processor Device that translates page description commands into bitmapped information for an output device such as a laser printer or imagesetter.

reader spread Mechanicals made in twopage spreads as readers would see the pages, as compared to printer spread.

ream 500 sheets of paper.

recycled paper New paper made entirely or in part from old paper.

reflective copy Products, such as fabrics, illustrations and photographic prints, viewed by light reflected from them, as compared to transparent copy. Also called reflex copy.

register To place printing properly with regard to the edges of paper and other printing on the same sheet. Such printing is said to be in register.

register marks Cross-hair lines on mechanicals and film that help keep flats, plates, and printing in register. Also called crossmarks and position marks.

relief printing Printing method whose image carriers are surfaces with two levels having inked areas higher than noninked areas. Relief printing includes block printing, flexography, and letterpress.

repeatability Ability of a device, such as an imagesetter, to produce film or plates that yield images in register.

reprographics General term for xerography, diazo and other methods of copying used by designers, engineers, architects, or for general office use.

resolution Sharpness of an image on film, paper, computer screen, disc, tape or other medium.

resolution target An image, such as the GATF Star Target, that permits evaluation of resolution on films, proofs or plates.

reverse Type, graphic or illustration reproduced by printing ink around its outline, thus allowing the underlying color or paper to show through and form the image. The image 'reverses out' of the ink color. Also called knockout and

liftout.

RGB Abbreviation for red, green, blue, the additive color primaries.

right reading Copy that reads correctly in the language in which it is written. Also describes a photo whose orientation looks like the original scene, as compared to a flopped image.

rotary press Printing press which passes the substrate between two rotating cylinders when making an impression.

round back bind To casebind with a rounded (convex) spine, as compared to flat back bind.

ruby window Mask on a mechanical, made with Rubylith, that creates a window on film shot from the mechanical.

rule Line used as a graphic element to separate or organize copy.

ruleup Map or drawing given by a printer to a stripper showing how a printing job must be imposed using a specific press and sheet size. Also called press layout, printer's layout, and ruleout.

S

saddle stitch To bind by stapling sheets together where they fold at the spine, as compared to side stitch. Also called pamphlet stitch, saddle wire, and stitch bind.

satin finish Alternate term for dull finish on coated paper.

scale To identify the percent by which photographs or art should be enlarged or reduced to achieve the correct size for printing.

scanner Electronic device used to scan an image.

score To compress paper along a straight line so it folds more easily and accurately. Also called crease.

screen angles Angles at which screens intersect with the horizontal line of the press sheet. The common screen angles for separations are black 45°, magenta 75°, yellow 90°, and cyan 105°.

screen density Refers to the percentage of ink coverage that a screen tint allows to print.

Also called screen percentage.

screen printing Method of printing by using a squeegee to force ink through an assembly of mesh fabric and a stencil.

screen ruling Number of rows or lines of dots per inch or centimeter in a screen for making a screen tint or halftone. Also called line count, ruling, screen frequency, screen size and screen value.

screen tint Color created by dots instead of solid ink coverage. Also called Benday, fill pattern, screen tone, shading, tint and tone.

selective binding Placing signatures or inserts in magazines or catalogs according to demographic or geographic guidelines.

separated art Art with elements that print in the base color on one surface and elements that print in other colors on other surfaces. Also called preseparated art.

serigraphic printing Printing method whose image carriers are woven fabric, plastic or metal that allow ink to pass through some portions and block ink from passing through other portions. Serigraphic printing includes screen and mimeograph.

service bureau Business using imagesetters to make high resolution printouts of files prepared on microcomputers. Also called output house and prep service.

setoff Undesirable transfer of wet ink from the top of one sheet to the underside of another as they lie in the delivery stack of a press. Also called offset.

shade Hue made darker by the addition of black, as compared to tint.

shadows Darkest areas of a photograph or illustration, as compared to midtones and highlights.

sheetfed press Press that prints sheets of paper, as compared to a web press.

sheetwise Technique of printing one side of a sheet with one set of plates, then the other side of the sheet with a set of different plates. Also called work and back.

shingling Allowance, made during pasteup or stripping, to compensate for creep. Creep is

the problem; shingling is the solution. Also called stair stepping and progressive margins.

side stitch To bind by stapling through sheets along one edge, as compared to saddle stitch. Also called cleat stitch and side wire.

signature Printed sheet folded at least once, possibly many times, to become part of a book, magazine or other publication.

size Compound mixed with paper or fabric to make it stiffer and less able to absorb moisture.

soft dots Halftone dots with halos.

solid Any area of the sheet receiving 100 percent ink coverage, as compared to a screen tint.

soy-based inks Inks using vegetable oils instead of petroleum products as pigment vehicles, thus are easier on the environment.

specialty printer Printer whose equipment, supplies, work flow and marketing is targeted to a particular category of products.

specifications Complete and precise written description of features of a printing job such as type size and leading, paper grade and quantity, printing quality or binding method. Abbreviated specs.

spectrophotometer Instrument used to measure the index of refraction of color.

specular highlight Highlight area with no printable dots, thus no detail, as compared to a diffuse highlight. Also called catchlight and dropout highlight.

spiral bind To bind using a spiral of continuous wire or plastic looped through holes. Also called coil bind.

split fountain Technique of putting ink colors next to each other in the same ink fountain and printing them off the same plate. Split fountains keep edges of colors distinct, as compared to rainbow fountains that blend edges.

split run 1) Different images, such as advertisements, printed in different editions of a publication. 2) Printing of a book that has some copies bound one way and other copies bound another way.

spoilage Paper that, due to mistakes or acci-

dents, must be thrown away instead of delivered printed to the customer, as compared to waste.

spot color or varnish One ink or varnish applied to portions of a sheet, as compared to flood or painted sheet.

spread 1) Two pages that face each other and are designed as one visual or production unit. 2) Technique of slightly enlarging the size of an image to accomplish a hairline trap with another image. Also called fatty.

standard viewing conditions Background of 60 percent neutral gray and light that measures 5000 degrees Kelvin — the color of daylight on a bright day. Also called lighting standards.

stat Short for photostat, therefore a general term for an inexpensive photographic print of line copy or halftone.

statistical process control Method used by printers to ensure quality and delivery times specified by customers. Abbreviated SPC.

step and repeat Prepress technique of exposing an image in a precise, multiple pattern to create a flat or plate. Images are said to be stepped across the film or plate.

stocking papers Popular sizes, weights and colors of papers available for prompt delivery from a merchant's warehouse.

stock order Order for paper that a mill or merchant sends to a printer from inventory at a warehouse, as compared to a mill order.

string score Score created by pressing a string against paper, as compared to scoring using a metal edge.

strip To assemble images on film for platemaking. Stripping involves correcting flaws in film, assembling pieces of film into flats, and ensuring that film and flats register correctly. Also called film assembly and image assembly.

substance weight Alternate term for basis weight, usually referring to bond papers. Also called sub weight.

substrate Any surface or material on which printing is done.

subtractive color Color produced by light reflected from a surface, as compared to additive color. Subtractive color includes hues in color

photos and colors created by inks on paper.

subtractive primary colors Yellow, magenta and cyan. In the graphic arts, these are known as process colors because, along with black, they are the ink colors used in color-process printing.

supercalendered paper Paper calendered using alternating chrome and fiber rollers to produce a smooth, thin sheet. Abbreviated SC paper.

SWOP Abbreviation for specifications for web offset publications, specifications recommended for web printing of publications.

T

tag Grade of dense, strong paper used for products such as badges and file folders.

tagged image file format Computer file format used to store images from scanners and video devices. Abbreviated TIFF.

target ink densities Densities of the four process inks as recommended for various printing processes and grades of paper. See also *Total area coverage*.

text paper Designation for printing papers with textured surfaces such as laid or linen. Some mills also use 'text' to refer to any paper they consider top-of-the-line, whether or not its surface has a texture.

thermography Method of printing using colorless resin powder that takes on the color of underlying ink. Also called raised printing.

tone compression Reduction in the tonal range from original scene to printed reproduction.

total area coverage Total of the dot percentages of the process colors in the final film. Abbreviated for TAC. Also called density of tone, maximum density, shadow saturation, total dot density and total ink coverage.

touch plate Plate that accents or prints a color that four-color process printing cannot reproduce well enough or at all. Also called kiss plate.

trade shop Service bureau, printer or bindery working primarily for other graphic arts professionals, not for the general public.

transparency Positive photographic image on film allowing light to pass through. Also called chrome, color transparency and tranny. Often abbreviated TX.

trap To print one ink over another or to print a coating, such as varnish, over an ink. The first liquid traps the second liquid. See also *Dry trap* and *Wet trap*.

U

uncoated paper Paper that has not been coated with clay. Also called offset paper.

undercolor addition Technique of making color separations that increases the amount of cyan, magenta or yellow ink in shadow areas. Abbreviated UCA.

undercolor removal Technique of making color separations such that the amount of cyan, magenta and yellow ink is reduced in midtone and shadow areas while the amount of black is increased. Abbreviated UCR.

unsharp masking Technique of adjusting dot size to make a halftone or separation appear sharper (in better focus) than the original photo or the first proof. Also called edge enhancement and peaking.

up Term to indicate multiple copies of one image printed in one impression on a single sheet. 'Two up' or 'three up' means printing the identical piece twice or three times on each sheet.

UV coating Liquid applied to a printed sheet, then bonded and cured with ultraviolet light.

V

value The shade (darkness) or tint (lightness) of a color. Also called brightness, lightness, shade and tone.

varnish Liquid applied as a coating for protection and appearance.

vellum finish Somewhat rough, toothy finish.

Velox Brand name for high-contrast photographic paper.

viewing booth Small area or room that is set

up for proper viewing of transparencies, color separations, or press sheets. Also called color booth. See also *Standard viewing conditions*.

vignette halftone Halftone whose background gradually and smoothly fades away. Also called dégradé.

virgin paper Paper made exclusively of pulp from trees or cotton, as compared to recycled paper.

VOC Abbreviation for volatile organic compounds, petroleum substances used as the vehicles for many printing inks.

W

wash up To clean ink and fountain solutions from rollers, fountains, screens, and other press components.

waste Unusable paper or paper damaged during normal makeready, printing or bindery operations, as compared to spoilage.

watermark Translucent logo in paper created during manufacture by slight embossing from a dandy roll while paper is still approximately 90 percent water.

web break Split of the paper as it travels through a web press, causing operators to rethread the press.

web gain Unacceptable stretching of paper as it passes through the press.

web press Press that prints from rolls of paper, usually cutting it into sheets after printing. Also called reel-fed press. Web presses come in many sizes, the most common being mini, half, three quarter (also called 8-page), and full (also called 16-page).

wet trap To print ink or varnish over wet ink, as compared to dry trap.

window 1) In a printed product, a die-cut hole revealing an image on the sheet behind it. 2) On a mechanical, an area that has been marked for placement of a piece of artwork.

wire side Side of the paper that rests against the Fourdrinier wire during papermaking, as compared to felt side.

with the grain Parallel to the grain direction of the paper being used, as compared to against the grain. See also *Grain direction*.

working film Intermediate film that will be copied to make final film after all corrections are made. Also called buildups.

wrong reading An image that is backwards when compared to the original. Also called flopped and reverse reading.

INDEX

Accordion fold, illustrated, 148	illustrated, 98	of paper, 26, 84-85, 95
Advertising,	of photographs,	of screen tints, 22
agencies, 11	Bristol paper, 100	preprinting, illustrated, 29
separations for, 73	Brokering printing, 10-11, 164, 166	process, 26
Alterations, 170-171	Budgets, planning, 8	reference images, 30
trade custom about, 175	Bulk, of paper, 88	swatch books, 28, 31
Antique finish, 84	Burst perfect binding, 155	Color Association of America, 32
Apple Corporation, 30, 35, 122		Color control bars,
Approval slip, 66	C1S paper, 99	illustrated, 33
Aqueous coating, 124	Calendering, of paper, 84	Color Key proofs, 67
Audience, 3	effect on bulk and opacity, 98	Color Marketing Group, 32
	Caliper, of paper, 87, 88, 99, 101	Color matching systems, 28-30
Backups, of printing, 113	illustrated, 89	Color separations, 38, 44-45
Banding, 59	Cameras, 40	and alterations, 170
Base negatives, 61	formats of, 45	costs of, 45, 73
Basic quality printing,	Camera-ready copy, 52, 53, 58	illustrated, 27, 46, 48-49, 50, 51
and four-color process, 45	Carbonless paper, 100	proofing of, 65-68
and dot gain, 117	chart, 96-97	quality guidelines chart, 120-121
and press operations, 111, 114, 115	Carload, of paper, 89	quality of, 32-34
defined, 7	Carton, of paper, 89	specifying, 73, 117
evaluating photos for, 37	Case binding, 155-156	Comb binding, 152
mechanicals for, 54, 57	illustrated, 154, 157	illustrated, 154
plates for, 70	Cast coated paper, 99	Commercial artists, 23
proofs for, 14	CDs, photo, 40	Commercial printing,
quality guidelines chart, 120-121	Chipboard, 99	costs of, 167
screen tints for, 20	Chroma, of color, 26	paper for, 82
type for, 17	CIE, 25-26	typical schedule, 5
Basic size, of paper, 86	Clip art, 22-23	working with printers, 161-162, 165
chart, 96-97	CMYK colors, 26, 30, 48, 117	Composite film, 62
Basis weight, of paper, 86-87, 101	Coated book paper, 78, 80, 95-98, 116	Composite proofs, 64, 65
chart, 88, 96-97	and binding, 155	Comprehensive layouts, 9
illustrated, 87	chart, 96-97	Computers,
Bindery work, 144-159	common basis weights, 88	and electronic mechanicals, 54-55
quality guidelines, 145	Coatings, protective, 123-125	and plates, 70
Bindings, 149-156	Collating, 149	and proofs, 64
illustrated, 154	Color,	file compatibility, 22, 64, 70, 131,
Blanket, 105	and alterations, 170	164
illustrated, 106, 116	at press checks, 126	file ownership, 71, 73, 175
Bleeds, 107	breaks, 61	Continuous-tone copy, 12, 36
costs of, 81	builds, 28, 31, 59	Contracts, 175
illustrated, 108	illustrated, 29	Contrast, of photos, 38, 47
scaling photos for, 57	casts, 46	illustrated, 39
Blueline proofs, 53, 65-66	cool and warm, 26, 123	Converting, 156
Board paper, 99-100	correcting, 47, 50, 64	Copyright law, 175
Bond paper, 78, 89-93	evaluating, 85, 112	Cornering, 146
charts, 93, 96-97	fifth ink, 47, 110	Costs, controlling, 11, 13, 24, 43, 45,
common basis weights, 88	flat, 26, 31	61, 68, 80-81, 82, 87, 112, 142-
Book paper, see Coated book paper;	ink jet printing, 131	143, 155, 161, 169, 174
Uncoated book paper	language of, 24-26, 47	Cotton bond paper, 90
Brightness,	matching, 30-31	Cover paper, 78, 99
of color, 46	quality guidelines chart, 120-121	chart, 96-97
of paper, 85, 101	most popular, chart, 25	illustrated, 87

Creep, 151 illustrated, 150 graphic arts, 60 Ghosting, 118 ownership of, 71, 73, 162, 175 Gloss coated paper, 95, 116 Critical flaw, 65, 126 working, 62 illustrated, 98 Cromalin proofs, 68 Film laminates, 124-125 Gluing, 149 Cropping, 57 Final counts, 158 Goals, of printing jobs, 3 illustrated, 60 trade custom about, 176 Good quality printing, Crossovers, 113 Fine papers, 75 and press operations, 111, 114,115 Customer service, 166 Cutoff, web, 109, 110 Finishing, quality guidelines chart, defined, 7 Cutting, of paper, 145-146 120-121 evaluating photos for, 37 CWT, of paper, 89 Fixed costs, 8 halftones for, 40 Flat color, 25, 26, 28, 31 quality guidelines chart, 120-121 Design to print, chart, 129 illustrated, 27 Grain, Flats, 61-62 Delivery, trade custom about, 176 of paper, 86, 101, 109, 153 ownership of, 71, 73, 162, 175 Delivery unit, of press, 108 of photos, 38, 57 storage of, 70-71 illustrated, 39 Density, of ink, 31, 84, 114-115 Flaws, quality guidelines chart, **Graphic Communications** quality guidelines chart, 120-121 120-121 Association (GCA), 122 Density range, 47 Flexography, 123, 131-133 Desktop publishing, 55 Graphic designers, 11, 23 and dot gain, 117 Die cutting, 95, 139-140 Gravure, 123, 135-137 illustrated, 140 illustrated, 132 illustrated, 136 Dot gain, plates for, 69 plates for, 69 effects of paper on, 98 Flood varnish, 123 Gray scale, 42 illustrated, 33, 116 Fluorescent ink, 123 Gray levels, chart, 59 Fluorescent lights, effects of, 34-35 proofing for, 68 Gripper edge, 107 quality guidelines chart, 120-121 Focoltone colors, 30 Groundwood paper, 75, 77, 95, 100 Foil stamping, 95, 141-142 Dot printers, 13 Doubling, 119 illustrated, 141 Hairline, 18 illustrated, 33 Folding, 147-149 register, 121 Draw down, of ink, 30 illustrated, 148 Halftones, 38 Fonts, type, see Type fonts Drilling, of paper, 146 from color photos, 43 Dropout halftone, illustrated, 43 Format, illustrated, 22, 41, 42, 43 Dual-purpose bond paper, 93 of cameras, 45 quality guidelines chart, 120-121 Dull coated paper, 95, 116 of mail, 4 screen printing, 133 Dummies, 9 Form bond paper, 91, 93 screen ruling for, 41 kinds of, 79-82 Form web press, 109, 111 Half web press, 109 Duotones, 43 Fountain solution, 108 Headband, illustrated, 157 illustrated, 44 Four-color process, 45 Heat-set web press, 108, 111, 119 Dylux proofs, 66 illustrated, 27, 48-49, 51 Hue, 26 quality chart, 120-121 Hickies, 118 Embossing, 84, 140-141 register of, 51 illustrated, 119 illustrated, 141 Fourdriner wire, illustrated, 76 High-end system, 72 FreeHand (Aldus), 23 with laminating High-fidelity color, 47 Emulsion, of film, 44 Free sheet, 75, 77 High finish, 93 Engraving, 137-138 French fold, illustrated, 148 Highlights, 43, 47, 121 illustrated, 137 Full web press, 109 illustrated, 39, 46 Environmental impact, 40 Holography, 142 EPS files, 22 Galley proofs, 13 House sheets, 80, 82 Equivalent weights of paper, 87 Ganging, 51 halftones and separations, 43 Illustrations, 22-23 Fade-resistant ink, 123 printing, 110 halftoning of, 23, 43 Feeding unit, of press, 108 Gate fold, illustrated, 148 Illustrator (Adobe), 23 GATF control images, 33 Felt text paper, 94 Imagesetters, 14, 57-60 Fifth ink color, 47 Gathering, 149 Imposition, 59, 61-62 Film, illustrated, 150 illustrated, 63

composite, 62

Ghost halftone, illustrated, 43

Impression, 110	proofing, 67	Overprints, 123
Incandescent lights, effects of, 34-35	Match photo, 37	illustrated, 19
Index paper, 100	proofing, 67	proofing, 65
Infographics, illustrated, 21	Matte coated paper, 95, 116	Overruns, 80
Ink, 122-123	illustrated, 98	10% trade custom, 6, 176
costs of, 123	Maximum ink density, 117	
density of, 31, 114-115	Measured photography, 47	Packing, of printing, 156
fountain, 107	Mechanical bindings, 152-153	specifying, 5
holdout, 84, 94, 98, 101	illustrated, 154	Padding, 149
illustrated, 98	Mechanicals, 52, 54-55	Page counts, 88, 170
specifying color of, 31	checklist, 56	Page description language, 55
Ink jet printing, 131, 156	illustrated, 55	PageMaker (Aldus), 54
In-plant printers, 164-165	information to accompany, 71	Pages per inch, 88
Inserts, 153	ownership of, 71, 73, 175	Pallet, 158; see also Skid
Insurance, 71-72, 176	storage of, 70-71	PANTONE Colors, 25, 28, 30
	Metallic ink, 123	PANTONE Matching System, 28
Keylines, for photos, 55, 57, 61	Metameric swatch, 35	Paper,
illustrated, 60	Microsoft Corp., 122	and alterations, 170
Kraft paper, 100	Midtones, illustrated, 33	at press checks, 126
chart, 96-97	Mini web press, 109	basic size, 86
	Minor defect, 65, 126	basis weight, 80, 86-87
Label paper, 100	Mockups, 9	brightness, 85
chart, 96-97	Moire pattern,	bulk, 88
Laid finish, 90, 94	illustrated, 28	calendering, 84
Laser,	Mottling, 115	caliper, 87
bond paper, 93	Multicolor printing,	charts, 96-97
platemaking, 70	illustrated, 27	coated, 80
printers, 14, 91, 123	Munsell Color System, 25	color of, 84-85, 93, 95, 98
printing, 130	Manden Goldi Bystein, 25	costs, 74, 83, 85, 87, 94, 98
Lay flat binding, 155	National Assoc of Printers and	cost control chart, 80-81
illustrated, 154	Lithographers (NAPL), 175	folding, 147
Leading, illustrated, 15	Negotiating, 81, 171	for photocopy and laser, 131
Ledger bond paper, 93	Nesting, 149	
Letterhead sizes, 90	illustrated, 63, 150	free sheet, 77
Letterpress printing, 138-139	Neutral gray, 35	grades, 74, 77-78 guide to, 96-97
plates for, 69	Newsprint, 75, 100, 116	
Lightness, of color, 25	chart, 96-97	grain, 86
	Nonrepro blue, 60	gravure printing, 135
Lightweight paper, 94	r voin epro blue, oo	groundwood, 77
Line copy, 12	Offset paper, see Uncoated book	halftones and separations, effects
illustrated, 22, 42	paper	on, 41, 47, 117
Lithography, offset, 104-127	Offset printing, 94, 104-127	ink colors and gloss, effects on,
Loop stitching, 151	advantages of, 94, 104-105	30, 47, 122
Loose proofs, 64		making of, 75-77
Low-end system, 72	illustrated, 106 Offsetting, 108, 119	illustrated, 76
Low finish, 93		moisture, effects of, 113
	On-demand printing, 81, 130	most useful, chart, 75
Macintosh computer, 35	Onionskin bond paper, 93	names of, 79
Mailing lists, 81	Opacity, of paper, 85-86	opacity, 85-86
Major error, 65, 126	comparison bars, 86	comparison bars, 86
Makeready, 81, 83, 125	Open web presses, 111	quality, 78, 81, 93, 95
Manifold bond paper, 93	Outline halftone, illustrated, 43	quantities, 89
Markup, on paper, 82	Overlay proofs,	recycled, 100-102
Match color, 32, 37, 91, 99	illustrated, 53	samples, 79, 82
quality guidelines chart, 120-121	Overlays, on mechanicals, 52, 61	screen tints, effects on, 20, 115
Match original, 32, 37	illustrated, 55	sizes, 81, 88-89

illustrated, 91, 92	Printing brokers, 10-11, 164, 166	Raised printing, 138
specifying, 82, 83, 102-103	Printing Industries of America	Ream, of paper, 89
surface, 84, 93, 94	(PIA), 166, 175	Recycled paper, 100-102
see also specific grades	Printing unit, of presses, 108, 110	chart, 101
Parallel fold, illustrated, 148	illustrated, 106	grain direction, 86, 101
Parent sheets, 88	Problems, levels of, 65	opacity, 86
Paste binding, 151	Process camera, 38, 57-60	Register, 59, 61, 69, 107, 112-114
Pasteup, see Mechanicals	Process color, 26	at press checks, 126
Perfect binding, 153, 155	illustrated, 27, 48-49	illustrated, 51
illustrated, 154	register of, 112, 120-121	proofing, 68
Perfecting press, 110	Production time, checklist, 6	quality chart, 120-121
Perforating, 146-147	Proofs, 62-69	quick printing, 70
Photocopy, 130-131	approval slip, 66	Relief printing, 139
Photographs, 36-51	at press checks, 126	Repeatability, 59
cropping, 56	blueline, 53, 65-66	Reprints, 73
evaluating originals, 38	composite, 64, 65	Request for Quotation, 172-173
checklist, 37	digital color, 66-67	Reruns, 162
keying to mechanicals, 55-56	for quick printing, 65	Resolution, 13, 14, 58
illustrated, 60, 61	for typical jobs, 64	chart, 59
scaling, 51, 57	how to read, 67	Reverse, 18
Picas, 17	illustrated, 53	illustrated, 19
Pin register, 69	integral, 68	proofing, 65, 67
Planning, 3-9	loose, 64	RGB colors, 30
Platemaker, 58, 69	of duotones, 44	Ring binding, 153
Plates, printing, 69-70	of photos, 38	Roll fold, illustrated, 148
illustrated, 106	overlay, 67	Round back binding, illustrated, 15
Pleasing color, 32, 37	illustrated, 53	Rubylith
proofing, 67	press, 68	overlay illustrated, 55
PMT, 22, 40	responsibility for, 11	window illustrated, 61
Points,	trade custom about, 176	Rules, 17-18
paper, 87, 99	whiteprint, 40, 66	
type, 17	working, 53	Saddle stitching, 151
Position stats, 57	Punching, 146	illustrated, 154
illustrated, 61		Sales representative, 166
Poster board, 99	Quality, 111-112, 122	Sans-serif type, 13
PostScript (Adobe), 26, 55	and size of printer, 163	illustrated, 15
Ppi (pages per inch), 88	categories, 6-8	Saturation, of color, 25
Premium quality printing,	summarized in chart, 120-121	Scaling, 51, 57
and press operations, 111, 114, 115	flexographic, 133	illustrated, 58
defined, 7	three levels of problems, 65, 126	Scanner, 40, 45
evaluating photos for, 37	Quantities, 5-6, 158, 170	Schedule, factors affecting, 5, 9-10, 13
halftones for, 40	QuarkXPress, 54	chart to cut production time, 6
proofs for, 68	Quick printing, 108, 112, 114, 165	Scoring, 146-147
quality guidelines chart, 120-121	costs of, 167	illustrated, 147
Prepress services, 72-73	halftones for, 40	Screen density, 20
Press checks, 125-127	paper for, 82	illustrated, 19
checklist, 126	plates for, 58, 70	quality guidelines chart, 120-121
Presses, 108-111	proofs for, 65	Screen printing, 133-135
components of, 107	working with printers, 161-162	illustrated, 134
duplicators, 108	Quotations, 167-170	Screen ruling, 20, 98
illustrated, 106	evaluating, 168-169	chart, 59
number of colors, 27	form, 172-173	effects of scaling, 40
see also Sheetfed presses and Web	trade custom about, 175	for halftones, 41
presses	200000000000000000000000000000000000000	illustrated, 19, 41
Price breaks, 80	Railroad board, 99	Screen tints, 18-22, 115
,		,

evaluating color of, 22	Spreads and chokes, 59	specifying, 16
illustrated, 19, 22, 33	Square back binding,	text and display, 17
overlapping, 22, 28	illustrated, 157	Typefaces,
sources of, 20	Star Target, illustrated, 33	illustrated, 15
Screw and post binding, 152	Stitch bindings, 151	names of, 16
illustrated, 154	illustrated, 154	Type families, 14
Scuff-resistant ink, 123	Storage, 159	illustrated, 15
Scumming, 119	Stripping, 60-62	most useful, 13
Sealing, 151	Substance weight, 86	Type fonts, 14, 16
Selective binding, 156	Sulphite bond paper, 90	illustrated, 15
Separations, see Color separations	Swatch book,	,
Serif type, 13	illustration of ink, 31	Ultraviolet coating, 124
illustrated, 15	ink, 28	Uncoated book paper, 78, 93-94,
Setoff, see Offsetting	paper, 79	116
Shadows, 41, 43, 47, 121	SWOP guidelines, 84, 122	chart, 96-97
illustrated, 39, 46	Synthetic paper, 100	common basis weights, 88
Sharpness, of photos,	chart, 96-97	Underruns, trade custom about, 6
Sheetfed presses,	chart, 50 77	176
pros and cons, chart, 105	Tag paper, 100	Unit costs, 5
Shingling, 151	Target ink density, 84	
Showcase quality printing,		U.S. Postal Service, design and
and press operations, 111, 114, 115	Terms and conditions, 175	printing regulations, 4, 88
defined, 7	Text paper, 78, 94-95, 99 chart, 96-97	V-1 C1 25
evaluating photos for, 37		Value, of color, 25
halftones for, 40, 41	common basis weights, 88	Variable costs, 8
proofs for, 68	illustrated, 87	Varnish, 124
-	Thermography, 138	Vellum finish, 85, 94
quality guidelines chart, 120-121	illustrated, 139	Velox, 40, 66
Shrink wrap, 156 Side stitching, 151	Tinning, 151	Ventura Publisher (Xerox), 54
	Tint screens, see Screen tints	Viewing conditions, 34-35, 44, 64
illustrated, 154	Tipping, 149	Volatile organic compounds
Signatures, 147, 149	illustrated, 153	(VOCs), 123
imposition, 62	Tissue overlay, illustrated, 55	
illustrated, 63	Tone compression, 47	Washup, of press, 122
Silk screen, see Screen printing	Tours, of printers, 166	Waste, 83-84
Sizes, standard paper, 88-89	Tracking, 119	illustrated, 98
charts, 90, 96-97	Trade customs, 175-176	Waterless printing, 69, 105
illustrated, 91, 92	and ownership, 71, 73, 162, 175	Watermarks, 91
Sizing, in paper, 77	and quantities, 6, 158	Web presses,
Skid, 89; see also <i>Pallet</i>	Transfer lettering, 13, 20	and folding, 149
Slurring, 119	Transparencies,	and press checks, 125
illustrated, 33	evaluating, 37, 44	gravure printing, 135
Smooth finish, 84	keying to mechanicals, 55-56	illustrated, 109
SNAP guidelines, 122	Trapping,	pros and cons, chart, 105
Specialty printers, 163-164	images, 28, 59, 112	Whiteprint, 40, 66
and paper, 82, 163	proofing, 68	Window, 55
Specifications,	ink, 115	illustrated, 55, 61
case binding, 155	Trimming, 145-146	Wire-O binding, 152
form, 172-173	illustrated, 108, 146, 150	illustrated, 154
for paper, 102	quality guidelines chart, 120-121	Working film, 62
reasons for, 161, 168	Trim size, 80, 146, 156	Wove finish, 84
trade custom about, 175	at press checks, 126	Writing paper, see Bond paper
Spiral binding, 152	Trumatch colors, 25, 28	
illustrated, 154	Type,	Xerographic bond paper, 93
Spoilage, 83-84	measuring, 17	Xerography, see <i>Photocopy</i>
Spot varnish, 123		
Spot varinsii, 143	quality, 17-18	x height, illustrated, 15 ■

More Great Books to Help You Get It Printed!

Newsletter Sourcebook—Everything you need to produce an effective newsletter, including creative design tips, easy editorial cost savers, proven production and distribution techniques and solid advice for smart money management. #30488/\$26.99/144 pages/45 color, 160 b&w illus.

Graphic Designer's Guide to Faster, Better, Easier Design & Production—Everything you need to know to see any project through—from establishing cost guidelines and setting production schedules to following through on design essentials, proofing and special production considerations.

#30528/\$22.95/176 pages/45 b&w illus.

Graphic Design: Inspirations and Innovations—Seventy-five of America's top designers discuss how they work, the creative process and the client relationship. Included are discussions on where ideas come from, how to work out your ideas and selling ideas to the client. #30710/\$28.99/144 pages/201 color, 49 b&w illus.

Graphic Edge—This bold international collection explores nontraditional ways of using type. Over 250 color images of typographic rebellions from top designers are presented. #30733/\$34.95/208 pages/280 color illus./paperback

Graphic Design Basics: Creating Brochures & Booklets—Discover hands-on information on planning, designing and producing the kinds of brochures and booklets that entertain, notify, sell, inform and advise. You'll go through each step of the planning process, from selecting the right paper to copy-fitting, from handling visuals and type to printing the finished piece. #30568/\$26.99/128 pages/60 color, 145 b&w illus.

Graphic Design Basics: Working with Words & Pictures—Learn how to make type an attractive, effective communication tool and how to use visuals and graphics to beautify and communicate. In 150 examples, you'll discover achievable designs offering instructions and tips you can put to work in your own designs. #30515/\$26.99/128 pages/32 color, 195 b&w illus.

Graphic Design Basics: Making A Good Layout—Discover how to create

better, more effective layouts—layouts that attract the viewer's attention, organize the information and fulfill the purpose of the piece. In five highly illustrated chapters, you'll learn how to identify a good layout and how to use the elements and principles of design effectively. Then you'll practice what you learn by working side by side with the authors as they create a sample layout for an actual project. #30364/\$24.99/128 pages/40 color, 100 b&w illus.

Basic Desktop Design and Layout— This book shows you how to maximize your desktop publishing potential and use any desktop system to produce designs quickly. #30130/\$27.95/160 pages/50 color, 100 b&w illus./paperback

Getting Started in Computer Graphics—A hands-on guide for designers and illustrators with more than 200 state-of-the-art examples. Software includes Adobe Photoshop, Fractal Design Painter, Aldus FreeHand, Adobe Illustrator, PixelPaint and Micrografx Designer. #30469/\$27.95/160 pages/125 color, 25 b&w illus./paperback

Quick Solutions to Great Layouts—Get your creative juices flowing with hundreds of time-saving ideas! You'll find sample cases with real-world solutions including full specs for newsletters, brochures, ads and more! #30529/\$24.99/144 pages/200 illus.

Quick Solutions for Great Type Combinations—When you're looking for that "just right" type combination and you don't have the time or money to experiment endlessly, here are hundreds of ideas to create the mood you're after, in-

cluding all specs. #30571/\$26.99/144
pages/175 b&w illus./paperback

Graphic Idea Notebook—This innovative, problem-solving source book for magazine editors and art directors provides over 1,000 editorial design ideas. #30303/\$19.95/206 pages/1,250 b&w illus./paperback

Getting Unlimited Impact With Limited Color—Discover how to deliver high-impact colors on a budget by mixing two screen tints, replacing four-color photos with duotones or tritones and dozens of other techniques! #30612/\$27.99/144 pages/120 color illus.

Using Type Right—121 no-nonsense guidelines for designing with type. Dozens of examples demonstrate good versus bad type design, and help you make the statement you want.

#30071/\$18.95/120 pages/paperback

Creativity for Graphic Designers—If you're burned-out or just plain stuck for ideas, this book will help you spark your creativity and find the best idea for any project. #30659/\$29.99/144 pages/169 color, 81 b&w illus.

More Great Design Using 1, 2, & 3 Colors—Make your ideas soar and your costs plummet. Dozens of ingenious examples will help you create great work without four-color expense. #30664/\$39.95/192 pages/225 color illus.

The Designer's Commonsense Business Book—Get nuts and bolts business advice for setting up shop, pricing, self-promotion, project management and more!

#30663/\$27.99/224 pages/30 b&w illus.

Other fine North Light Books are available from your local bookstore, art supply store, or direct from the publisher. Write to the address below for a FREE catalog of all North Light Books. To order books directly from the publisher, include \$3.50 postage and handling for one book, \$1.00 for each additional book. Ohio residents add 5½% sales tax. Allow 30 days for delivery.

North Light Books 1507 Dana Avenue Cincinnati, Ohio 45207

VISA/MasterCard orders call TOLL-FREE 1-800-289-0963

Prices subject to change without notice.

Stock may be limited on some books.

Write to this address for information on *The Artist's Magazine*, North Light Books, North Light Book Club, North Light Art School, and Betterway Books 8548